Deconstructing the Elements with 3ds Max
Second Edition

Dedication

For Laura, who is a constant source of inspiration and constructive criticism and who I love dearly, and for my family and friends, no matter where they are or how far away, for giving me the guidance and drive throughout my turbulent career.

Deconstructing the Elements with 3ds Max

Second Edition

Create natural fire, earth, air and water without plug-ins

Pete Draper

Autodesk®
Media and Entertainment
Techniques

AMSTERDAM · BOSTON · HEIDELBERG · LONDON · NEW YORK · OXFORD
PARIS · SAN DIEGO · SAN FRANCISCO · SINGAPORE · SYDNEY · TOKYO
Focal Press is an imprint of Elsevier

Focal Press

Focal Press
An imprint of Elsevier
Linacre House, Jordan Hill, Oxford OX2 8DP
200 Wheeler Road, Burlington MA 01803

First published 2006

British Library Cataloguing in Publication Data
A catalogue record for this book is available from the British Library

Library of Congress Cataloguing in Publication Data
A catalogue record for this book is available from the Library of Congress

ISBN 13: 978 0 240 52019 3
ISBN 10: 0 240 52019 X

For information on all Focal Press publications visit
our website at www.focalpress.com

Typeset by Newgen Imaging Systems (P) Ltd., Chennai, India
Printed in Canada.

Working together to grow
libraries in developing countries

www.elsevier.com | www.bookaid.org | www.sabre.org

ELSEVIER BOOK AID
 International Sabre Foundation

Contents

THE ELEMENTS:

Foreword

Spending a half day or more scouring the Internet for a plug-in that will help you save one hour of production time is not a cost effective workflow when you already have all the tools you need at hand. Pete Draper and Focal Press have assembled an excellent compendium of 3ds Max exercises that can save you time in current and future projects by utilizing these existing tools in inventive ways.

A book of step-by-step exercises that leads you to an acceptable, or even spectacular, result has only limited value in the greater scheme of things; the exercises work as advertised, the job is done. What differentiates *Deconstructing the Elements with 3ds Max* from other books is that it's about process and workflow, not just about achieving a set goal.

The excellent layout of the exercises walks you through a few relevant steps that accomplish a task, followed by an informational paragraph that explains the "how and why" of the steps you performed. This transforms the lessons from merely a reading exercise into a learning experience that you will be able to apply to your own projects.

Each exercise is then followed by a Taking It Further section in which Pete helps you brainstorm through some "alternative endings" to develop variations on the lesson and to help you learn to think of ways you could apply the same processes to come up with different solutions.

You might even look at the book and decide that because you don't normally make fire, earth, air and water the book is not for you. Resist the temptation to put the book down. Working your way through these tutorials will help you develop a pattern of thinking and analyzing problems and then help you develop a solution with the tools built into 3ds Max. Pete aids you further by providing real world images of the effect you are trying to re-create in 3ds Max.

Congratulations Pete. Your hard work is an inspiration to 3ds Max users and professional visualization trainers alike.

To all the readers of this fine book: good luck and have fun.

Ted Boardman
tbdesign
www.tbmax.com

Acknowledgements

Many thanks to **Laura James** for the love, constant inspiration, editing and grammar changes, patience while I was still writing copy at 5 a.m. and honest replies to my frequent questions of 'realistic or rubbish?'; **my parents Russell and Diana Draper** for the love and support over the past 31 years and the explicit instructions to find something you love doing; **Carol and Jenny Baker** for their love, support, roast dinners, cheap room when we moved down to the relaxed part of the country and the use of their scenic photography; **my friends and family** for their patience and understanding why I couldn't afford the time to come out on social occasions!; **Marie Hooper at Focal Press** for giving me a shot at this in the first place and for not going nuts when copy was a 'little' late, plus **Paul Temme** and **Georgia Kennedy** for guiding through the rocky road of Second Edition territory www.focalpress.com; **Jim Thacker (3D World) and Vicki Atkinson (ex Computer Arts)** and the rest of the gang at Future Publishing who, after all this time, still want me to write tutorials for them. And I promise the next one will be delivered on time... honest guv! Additionally, many thanks to **Garrick Webster**, without whom none of this is likely to have happened; **Matthew Jones and Annette Lewis** for the use of their scenic photography; **Robert James** for going through each tutorial in the first edition with a fine toothed comb and for being a good mate and 'brother', even though he's ginger; **Darren Brooker** for the first edition technical checking and **Alan Wilson** at **Autodesk** for the second edition technical checking; **Robert 'Beaker' James** (again), **Matthew 'Monkey' Jones** (again), **Andrew 'Radiator' Hawkes, Caroline 'Radiator Co-Conspirator' Baylon, Ash 'Special' Hall** and **Owen & Gav 'Cocktail' Thomas** for throwing, firing, smashing and burning things when I needed reference material/guinea pigs/a good laugh; **Marlon Seecharan** the constant support from **Autodesk** www.autodesk.com; **Jason 'Buzz' Busby** for the absolutely ace Foreword in the first edition (you *need* to go to his site. Now! Go now! This man is a living legend with the amount of training he provides and he's a great bloke too – www.3dbuzz.com) and Ted Boardman for the brilliant foreword in this second edition – www.tbmax.com; **Cris 'Ol Blue' Hodgson** for light-hearted banter and being an all-round top chap (next round of beers are on me mate!). Another site you must visit: www.3d-palace.com (certified Ewok free); **Digital Vision** and (now) **Getty Images** for letting me use an exceptionally large amount of images and animation samples as reference material and animated maps within the tutorials, else I'd have to blow stuff up in the back garden, which would slightly annoy the neighbors and jeopardize our security deposit. www.gettyimages.com; **Andrew Dymond, Jonathan Brown, Sue Witheridge and Chris Harwell** at Lightworx, Bristol www.lightworx.co.uk, **Harrys Photo Digital, Taunton, UK** for the great advice and who pulled out all of the stops when the camera went on the blink. You guys really excelled yourselves! www.harrysphotodigital.co.uk; **the firemen and staff of Bristol International Airport's Fire Safety Training** for the ability to film and photograph reference material. www.bristolairport.co.uk; **Nathan James** and **Ed Bell at the NASA Goddard Space Flight Center** and the **SOHO** team for the use of their space images. www.nasa.gov | nssdc.gsfc.nasa.gov; **Mark Newell at the United States Geological Survey (USGS)** for the use of their images. www.usgs.gov; **Skip Theberge at the National Oceanic and Atmospheric Administration (NOAA)** for the use of their images. www.noaa.gov; **Chuck Wardin** for getting me some great snowflake footage and images when it finally decided to

snow in Colorado!; **Tim Johnston** for the use of his images of the beautiful New Zealand landscape; **Rob 'Demondo' Rolnick** for the use of his snow images. www.3dbuzz.com; **Chris Williams at Teesside University** for inviting me back for another helping of **Animex**, and all the cool people I met there, especially **Rachelle Lewis, Ed Hooks, Ed Harriss, Tom Martinek, Stuart Sumida, Curtis 'Mister Bling' Jobling** and **Mark Walsh**. And many thanks to **Badger, Steve** and **Nikki** for ferrying us around. www.animex.net; **Paul Docherty at Teesside University** for giving this book the thumbs up for the green light; **Chris Ollis** for regular 3ds Max brainstorming sessions and discussion on how much we need another series of Spaced. I reckon I might actually be able to take you at Unreal now, sonny! www.intertwined.co.uk; **Allan Johnson** for constant banter and regular movie news. www.whyonearthhaventyouSTILLgotasiteyetallan?!.com and all the people who I have met who have made a difference in my life, but I have lost touch with over the years ... and above all, **Amillo** for cheering me up/clambering all over the computer and leaving cat hairs in the keyboard.

Equipment

All photos shot by the author were taken using Nikon Coolpix 5000, 5700, Canon IXUS 50 and Olympus E300 digital cameras. All film-based photos taken by the author were shot with either Nikon or Canon film SLRs and scanned using an Epson Perfection 3200 Photo scanner and Silverfast software.

All footage filmed by the author was shot using a JVC & Panasonic digital camcorders, and color corrected and edited as necessary in Autodesk Combustion.

About the author

Pete Draper is a UK-based visual effects animator and artist who has been in the industry for well over a decade, whose work has seen the large and small screen. Starting out as a fine artist and designer, he was drawn to CG animation and joined companies aimed more at film, TV and multimedia production, and has held key roles such as Lead and Senior Artist, Head of Media and, more recently, Visual Effects Supervisor/Director.

Pete writes several publications, none more so than for 3D World magazine, providing tips, tricks, reviews and tutorials for 3ds Max and other animation and graphics tools. In addition to the initial edition of this book, Pete has also contributed to 3ds Max 4 Magic, 3ds Max 6 Killer Tips, and has produced several covers and artwork for other leading publications in the industry. Pete's work covers a broad range of disciplines and genres from visual effects to reconstructions, commercials to in-house training, and due to his professional expertise in these fields, he is also an external examiner for Teesside University, England.

He can be found producing animated media for film, TV and interactive media, static imagery for print, writing for numerous publications or speaking at several workshops around the country. Pete tends to get about 4 hours sleep a night and consumes way too much caffeine.

For more examples of Pete's work and free articles he's published in the past, please visit his site at www.xenomorphic.co.uk.

Introduction

Why 3ds Max?

Okay, this is a question a lot of you might be asking. Why should I use 3ds Max above all other products that are out there? And to be honest, I don't have a reason at all. There are numerous products out there, each with its pros and cons, prices and deals, license costs, feature sets, stigmas and so on. I guess the main reason that I use 3ds Max is due to being brought up on the DOS version, so it was a natural progression to move onto the (then) new Windows version – 3D Studio MAX 1.0. I have used the majority of products out there in my time in the industry, but I still keep coming back to 3ds Max, mainly due to my familiarity with its intuitive interface, workflow, architecture, modeling toolkit, (now) excellent particle system and so on. But that's just my own history. You've obviously got an interest in the software and are reading this book which says you want to further your knowledge of the software and want to put time and effort into it. If you do just that, then you'll find that using the software can be a rewarding experience, especially when you create and animate something that has never been seen before, only in your mind. It is also billed as the software with the largest registered install base – 200,000+ at the time of writing this second edition this will more than likely go up substantially as time passes. Because of this amount, the knowledge base is huge, which you can find on many of the max-related support boards, newsgroups, IRC channels and websites available to the Max community, none more so than Autodesk's own support board which includes users worldwide, beta testers and Autodesk's own developers. It's a great community and I'm proud to be a member of it.

3ds Max Versions

With each version of 3ds Max comes a batch of new toys to play with, some more useful than others when dealing with recreating natural effects. For example, in 3ds Max 6 we had Particle Flow and Mental Ray added to the base kit, and in later versions Cloth and Hair have been added; the latter being ideal for creating grasses. Being a second edition of the book, the original version (for version 6) dealt with having to create effects such as grass without being able to call on hair effects to create the grass strands. So why haven't the tutorials that deal with these effects been updated? Well, I must admit I did painstakingly throw the idea around for quite some time, however I feel that these tutorials, which are currently particle-orientated, demonstrated a novel use of particle wrangling and without these I felt that the level of particle work in this book wouldn't have been achieved. This isn't to say that use of hair isn't suggested, in fact it is advised to be looked into in the tutorial's Taking It Further section. As with any tool, we will use any feature as and when it is required; not putting ourselves out of the way to utilize the new tools if not necessary. For example, there is little use in spending an age creating a Mental Ray material and tweaking GI lighting settings, caustics (etc.) if we can produce a similar result with the standard Scanline renderer. However, if we require a feature that is not possible with the Scanline renderer or is easier and quicker to produce using Mental Ray, we shall use that instead. It's all about using the tools available to us. In addition, there are other tools such as architectural materials and objects, dynamics in the form of Reactor, scene management tools, modeling amendments and

object type additions. Again, we will use these as and when required. The majority of the tutorials in this book were designed for 3ds Max 6 onwards, however the additional tutorials (Glacier, Solar Flare and the extra Video tutorials) have been created using the latest version of the software – 3ds Max 8. Therefore previous versions of the software will not be able to open the scene files included on the DVD-ROM, however you should still be able to follow the tutorial for the most-part with your version of the software, or download the trail version of 3ds Max from the Autodesk website.

Your level of experience

With a product the size of 3ds Max, no single publication is going to turn you into a 3ds Max guru overnight. The software is huge, and takes time to learn the full extent of its toolkit, so before you contemplate tackling the tutorials in this book *you should at least have read the excellent manual provided by Autodesk, and gone through the tutorials bundled with the software.* I cannot stress this enough as you will therefore be able to follow the tutorials in this book without any problem. By going though the documentation you will gain experience as to where feature 'X' or item 'Y' is located and their basic operation, so that the main content of this particular publication can be spent teaching you how to use these elements, either individually or combined to create dramatic effects, rather than how to find them, access them and use them. If you have not seen the tutorials which ship with the product, or do not know how to transform (move, rotate or scale) an object, link one object to another, bind an object to a Space Warp, open up and access materials and maps, change shaders, hide/unhide/freeze/unfreeze objects, add modifiers, or copy and paste modifiers, now is the time to put this book down and work through them as they will tell you everything that you need to know before you read your first tutorial in this book.

You are only as good as your reference material

Believe it or not, this is the case with almost every medium in the artist's world; be it when working with oils, ceramics, pixels or polygons. If you are trying to simulate something that exists in the real world, then you *have* to source as much reference material as humanly possible to get as much information about the thing you are trying to create. The elements are one of the hardest things to create in CG, especially if they have to be animated (landslides, water, air (smoke) and fire for example). The main reason behind this is that we see these elements, in some shape and form, every single day, so any slight discrepancy or flaw in the scene is going to stick out like a sore thumb. In motion graphics this can ruin the rest of the scene as the main focus of the audience's attention is on the problem element and not on the (possibly) more important aspects of the scene, such as the hero object/character. So we grab as much reference material as possible and study it until our eyes bleed. Each aspect of the effect should be scrutinized over and over again until you understand how and why an effect behaves, reacts or shades the way it does. Using this knowledge we can begin to lay out our scene. If we have understood the effect correctly, it will be a simple matter of adding one sub-effect (e.g. shape) on top of another (e.g. animation) on top of another (e.g. additional animation) on top of another (e.g. further animation) on top of another (e.g. material effects) and so on, until our overall effect is complete. This way of working runs true for any type of medium in the art world: start off with the basic features and build up in layers until you have the final result. The format and writing of this book holds true to this methodology, calling on a large amount of animated and still reference

material on the DVD-ROM that accompanies it. Hopefully by the end of your first tutorial you will begin to see the world slightly differently.

Format

As there are four elements, this book is split into four sections – Earth, Air, Fire and Water, with each element being broken down further, such as Earth: *Frozen Wasteland*, Air: *Tornado*, Fire: *Coals*, and Water: *Stormy seas* for example. Within each tutorial we will analyze each individual effect and break it down into its core components: how it moves, its color and tone, shape and form and if any third-party item affects it to enhance or even create the effect. To do this we need to analyze as much reference material as possible of the element we are trying to simulate to get as realistic an effect as possible; this material is included on the DVD-ROM that accompanies this book, and should be viewed at given points when following the tutorial (additional reference material may be included but not called on directly in the text, but should also be viewed if possible to gain a further understanding of the effect). Once the analysis of the effect is complete, we will either start constructing our scene from scratch, or load in a pre-constructed scene (depending on the scene's complexity and/or relevance with respect to creating the effect) to add our effect to.

Structure of each tutorial

To keep a form of consistency throughout the book, we are going to adhere to a certain format throughout. This will take on the form of the following:

Introduction – A summary of what we are going to achieve, what tools we are going to use and what the final result should look like.

Analysis of effect – A comprehensive breakdown of the effect using some of the reference material included on the DVD to give us a better understanding of the effect and what tools we have in 3ds Max that can create this effect. Now I have to stress that I am in no way a geologist, oceanographer, climatologist or any other such scientist, so the analysis of the reference material is purely derived from scrutinizing the images and footage and from reading up on the effect while researching and sourcing the material. If you are experienced in a specific field and you feel I have gone way off the mark in one of the analysis sections, please let me know by posting a message in this book's support forum which is listed at the back of the book.

Walkthrough – Starting from either a pre-constructed scene or from a blank canvas, we will gradually build up our effect, referring to our reference material as necessary as we progress though the construction process. This process is split up into sections and each section consists of three main parts: firstly an introduction to the section – explaining what we are going to accomplish, secondly the detailed process – noting which settings to use, and finally extra information about what parts of the section does to the overall effect and, if there are limitations, how we can get around them. These parts are laid out logically, so each screenshot (or part thereof) has instructional and informative text to accompany it, so you do not get lost. The screenshots show the settings mentioned in action, and any other information such as gradient design which relies more on illustration than description; this is mentioned in the text, but the screenshots are there to illustrate and help inform, plus to illustrate curve settings (etc.) that would be too difficult or confusing to write out. The full screen is used in the

screenshot thumbnail for a good reason – changing one setting in 3ds Max can affect other elements right across the UI. For example, adding an operator to Particle Flow (left-hand side of screenshot) can drastically change the way a particle system behaves (right-hand side of screenshot). To illustrate this properly, the full screenshot has to be used. There may well be in some instances that not much else occurs in the screenshot apart from, say, adding an operator or two. This may make the screenshot aesthetically boring, but it is still an important step towards the final effect and is included in full, not only to keep things consistent, but to also include every single piece of information possible. If you feel like your eyes are straining trying to read the text on a screenshot in this book, worry not as there are full sized versions on the DVD-ROM.

Taking it further – How successful was the emulation of the effect and what pitfalls should we look out for when creating and rendering the scene? How can we enhance the effect, either by tweaking or modifying the scene, using a third-party solution or compositing the effect into another scene or in pre-shot footage? It also explains and/or gives you suggestions on how to expand on the scene – if there is a certain effect that occurs after the main effect that has not been covered, here you will find suggestions and hints on how to create this and what areas to look into.

Note – Because of the nature of tutorial books, there will be some repetition from one chapter to the next. This is because of the way that they are read. You will more likely jump right into a specific effect that interests you than to read the book from cover to cover. Therefore some statements will have to be repeated as you may not have read the previous chapters and therefore will not have gained the knowledge beforehand.

The DVD

The DVD contains as much reference material that could be sourced for each tutorial, and is structured so that you can find everything relating to that tutorial within one folder group. Within each group there are several sub-folders which contain *Source* – the 3ds Max files and maps, plus any other asset, and *Reference* folders – material for you to peruse in the *Images* and *Movies* (if the effect we are trying to emulate moves, distorts, etc.) folders to get a better understanding of how the effect works, so we can emulate it more convincingly. There are several reference files which are not called upon in the main text in this book, but should also be viewed as these will demonstrate additional circumstances where this effect occurs, provide further examples of the effect, or suggest ways of new adaptations for you to try. There is also a folder within each main tutorial folder that contains all of the full-size screenshots used in this book so you can use them instead of having to view the thumbnail versions if they are too small for you to make out in a specific step. The reference material has been filmed and photographed by the author where available; each sample has been reduced in quality to squeeze everything on the DVD – images have been resized and JPEG compressed and animations have been converted from DV to MPEG video. Other images and footage have been sources from third parties and are used with their permission. To keep things consistent, all images and movies have been resized to a generic size.

The video tutorials

In addition to the reference material, full-sized screenshots, and resulting 3ds Max files, there are extra tutorials in the form of videos. These are tutorials which were originally going to be in print, but

due to the scale of each tutorial and the limited amount of pages, it soon became clear that we could not squeeze them all in without compromising on tutorial quality and explanation, which I was not prepared to do. These video tutorials adhere to the same format as the tutorials in the book, with the Introduction, Analysis (etc.), but in this case I'm talking you through each step while demonstrating it all on-screen in the 3ds Max interface and calling on the reference material throughout.

Tutorial support

Should you have any problems with the tutorials in this book, a forum has been set up in order for you to post your question to the author. Please visit **www.deconstructingsupport.com**

Fire

Creating realistic fire is one of the most difficult tasks in CG and we normally have to resort to a plug-in solution to get the effect looking right, but even then the effect can look completely fake because we have not analyzed the motion of the flame we are trying to emulate. Fire comes in all shapes and sizes and behaves differently depending on the combustible material, so in this section we have got a selection ranging from wood to oil based fires. See the DVD-ROM for more fire effects in the Videos section.

1 Candle

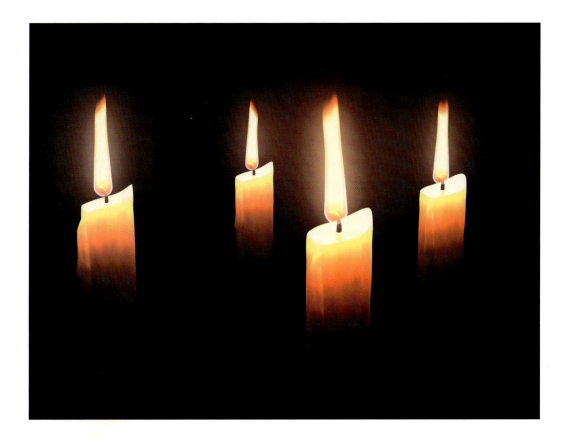

Introduction

In this tutorial we will create, shade and animate a realistic candle flame. Because the flame will also illuminate the surrounding areas, we will have to add lighting to the scene that ties in with the animation of the individual flame. Even though we already have the initial candle built, due to the way the light penetrates the wax, we will fake sub-surface scattering – a method to describe the way external light illuminates a material internally, or else the resulting effect will not look realistic. We are faking this method instead of relying on 3ds Max's Mental Ray SSS Shader (3ds Max 7+) as we will gain more experience handling multiple nested maps in Standard materials than simply applying a shader to our object. Firstly, we will create the flame using simple modeling before using animated modifier gizmos to generate the animation. The flame's material is relatively complex but shouldn't take too long to generate; however, the candle's material is slightly more complex due to the amount of masking and nested gradients needed to generate the desired result. But before we start designing the material, we must look at the way the flame is displayed depending on different exposures, because if the exposure is too high then the nice scattering effect will be lost.

Analysis of effect

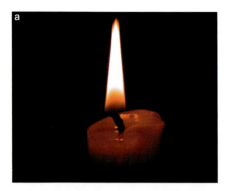

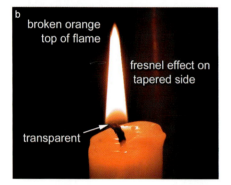

broken orange
top of flame

fresnel effect on
tapered side

transparent

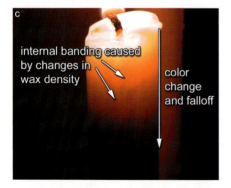

internal banding caused
by changes in
wax density

color
change
and falloff

(a) Open up the *Fire/01_Candle/Reference/Movies/candle03_exposure_change.mpeg* on the DVD. In this clip we notice that as the exposure decreases, the different colors become more visible and are not so washed out by the light emitted from the flame. The flame itself is not just a single color, but a variety, depending on the way the image is captured. At the base of the flame around the wick where the fuel has not fully ignited, the flame is almost transparent albeit from a slight perpendicular coloration and intensity. This color quickly diminishes and becomes more orange with a hint of pink and finally turns a bright desaturated yellow or white. (b) Depending on the exposure, a faint orange Fresnel effect can be seen around the sides of the flame which converges at the top of the flame. With a low exposure, we can see a more prominent red tint around the top of the flame which is more 'noisy' than the rest of it – meaning that the flame breaks up around this area. The flame's shape is tapered inwards in the middle, yet bulges out somewhat and can reduce in height when the flame is subjected to a gust of wind. Due to the flame emitting light, the candle itself is illuminated from this light. (c) If no other light sources are present in the scene, the internal scattering of the light from the candle is more visible and, again depending on the exposure, distinct colors can be seen quite clearly. The candle is not perfectly formed; there is wax running down the side, a slight lip, differences in internal wax density and a variety of streaks can be seen inside the wax which are illuminated by the flame. To get the most effective and interesting result, we will attempt to recreate the candle at a relatively low exposure, using *Fire/01_Candle/Reference/Images/candle12.jpg* as our main source of color and intensity reference, else all of the internal candle detail is lost and washed out at higher exposures, but at too low exposures the internal scattering of light in the wax is lost (d).

The trickiest part of the flame is the creation of the transparent part at the base; the rest of the flame's material setup can be handled with standard procedural maps. For the transparent part we are going to have to use a few gradient and falloff tricks to create the linear increase in opacity the further we go up the flame, while mixing and changing colors as we go – from a blue falloff at the base which changes into the orange falloff at the sides, culminating with the orange cap at the top. The animation is relatively simple and will be handled with a few animated Noise modifiers, by simply moving their Gizmos upwards over time to suggest the flow of fuel up the flame and any slight wind affecting its motion. The faked sub-surface scattering will

be handled by mixing different intensities of the same gradient based on normal angle (controlled by falloff maps), and a translucency map to create the streaks within the Translucency shader we are using, to generate the basic scattering effect.

Walkthrough

PART ONE: After loading in the initial scene, we will first create the flame shape using simple modeling, and set up the required mapping to handle the material we will create later on.

1 Open up the *Fire/01_Candle/Source/01_candle_start.max* file included on the DVD. In the Left Viewport, create a circle with a radius of about 0.35, position it just over the candle's wick and label it Flame. Add an Edit Spline modifier to the stack and move the top most vertex vertically upwards as illustrated.

Information: The basic scene has the candle already created for us and a basic material already assigned. The circle is going to be the basis of our flame shape – all we need to do is to sculpt one side of the flame and then simply lathe it to get the general mesh we are looking for.

2 Go to Segment sub-object mode in the Edit Spline and remove the right-hand side segments of the deformed circle. Go back to Vertex sub-object mode and click on the Refine button. Click on the large segment on the left-hand side near to the top of the segment to insert another vertex. Add another vertex half way down the left-hand side of the Spline as shown.

Information: We have to remove the right-hand side of the Spline to successfully lathe the Spline later on, else the resulting mesh will be distorted and will have overlapping geometry. Refining the Spline allows us to amend the contours of the shape a little. Simply deleting the right-hand vertex is not an option in Edit/Editable Spline as the segment on the right-hand side will automatically be joined from the top to the bottom vertex.

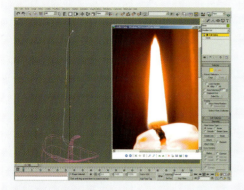

3 Starting at the middle vertex, and referring to the *candle12.jpg* reference image, amend the Bezier handles of the vertices along the side of the Spline (not the bottom ones) to sculpt the side of the flame to create the desired shape, as illustrated. Move the middle vertex inwards slightly to create the slight indentation in the side of the flame as shown in the reference image.

Information: It is always advisable to keep referring to the reference images and footage so that we get the correct shape and, later on, color for the effect that we are trying to emulate.

4 Add a Lathe modifier to the stack and, ensuring the number of segments is set to 16, enable Weld Core. If the Spline does not lathe correctly, try changing the axis (using the Axis buttons at the bottom of the modifier) or going into sub-object mode in this modifier and amending the position of the Axis gizmo. Finally, add a UVW Map modifier to the stack and reposition the object in the Top Viewport so that it is over the top of the wick.

Information: Lathe problems are common; it all depends on which Viewport you originally created the Spline, and if any part of the Spline deviates out of two dimensions. You may also discover that, when viewed in a shaded Viewport, the faces are flipped. Simply enable Flip Faces in the Lathe modifier to get them facing the right way around so you cannot see inside the object. The UVW Map modifier has been added to control the placement of any textures, procedural or otherwise, we assign to the object later on, otherwise max will not know where to place them correctly. The wick is slightly off-center, so the flame position needs to be amended slightly.

PART TWO: Before we set up the flame's animation, we will first link lights to various positions on the flame so they adhere to it as it deforms during animation.

5 In the Top Viewport, create an Omni light and label it flameOmni01. Set the Multiplier to 5 and the color to RGB 255,225,168. Set the Decay to Inverse Square, enable the Decay Show and set the Decay Start to about 0.8 (which is roughly double the width of the flame). Enable Use and Show Far Attenuation set the start setting to 0 and the End setting to 30. Set the Contrast to 50. Click on the Exclude button in the General Parameters rollout and send the Flame object across to the right-hand pane in the box that pops up.

Information: We are using Inverse Square decay, which is as close to the way real light behaves, so the falloff of the light 'emanating' from the flame appears realistic. The light is relatively low in intensity because we are using Inverse Square decay, but as we will clone the light several times, this intensity will increase. The Far Attenuation setting is used to tell the decay where to stop calculating – to suggest where it has decayed down to 0, or else it will continue calculating it across the scene to infinity.

6 With the flameOnmi01 light still selected, go to the Motion tab and expand the Assign Controller rollout. Select the Position Controller and click on the Assign Controller icon to bring up the Assign Position Controller selection floater. Choose Attachment and click OK to exit this selection floater. In the resulting controller's Attachment Parameters rollout, click on the Pick Object button and choose the Flame object. Click on the Set Position button and click part way down the side of the flame (as illustrated) to attach the light to this area of the object. Click the Set Position button again when you are happy with the position of the light.

Information: As we are going to animate the flame we want the light to move accordingly, so that highlights and light intensities appear correct on the objects in our scene. The Attachment controller allows us to 'weld' a light to a specific face in the Flame object so that when it deforms and moves, the light follows. The light has been positioned in this area as this is around the point where the brightest part of the flame is situated.

7 Select the Move tool and shift-click the light to clone it. Select Instance when prompted. Using the Set Position tool on the instance, reposition the new light further up and around the side of the Flame object where it is 'brightest'. Clone the light another couple of times and reposition them as before, around the base of the flame on opposite sides of the mesh, so that we have an even distribution of light over the surface of the object where the flame in the reference material is the most intense.

Information: Again, refer to the reference image that we are working from to determine where the brightest area of the flame is situated, and position the lights accordingly around the surface of the object so they are evenly positioned (so they won't create an overly concentrated area of illumination).

8 Select the Flame object in the Front Viewport and add a Volume Select modifier to the top of the stack. Enable Vertex in the Stack Selection Level section. Enter the Volume Select's Gizmo sub-object mode and reposition the gizmo vertically so that the top four rows of vertices are selected, as illustrated. Enable Soft Selection and set the Pinch to 1.35. Amend the Falloff so that the resulting falloff gradient just falls short of affecting the bottom six or so rows of vertices (as illustrated).

Information: We do not need to animate the base of the flame as this remains pretty much stationary throughout. The animation of the rest of the flame on the other hand has more influence the further up we progress, therefore the Volume Select's Falloff is used to control this increase in influence. Volume Select is used and not a Mesh Select as we can amend the detail of the flame further down the stack if desired as this selection relies on an area within the selection gizmo, not specified individual or groups of vertices which may be repositioned or lost if the mesh density is increased or decreased below this selection modifier.

9 Add a Noise modifier to the stack and set its Scale to 5.28. Enable Fractal and set the Roughness to 0.37 and Y strength to 2. Select the Noise's Gizmo sub-object, turn on Auto Key, go to frame 100 and, in the Left Viewport, reposition the gizmo so that it is about 25 units left of the flame as illustrated. Turn off Auto Key and right click the generated keyframe at frame 0. Select the Flame:X Position keyframe in the resulting menu and amend the Out curve so it has a linear attack as shown. Click on the small arrow to the right of this curve to pass the same type of curve to the In curve of the next keyframe (frame 100).

Information: Instead of animating the position of the gizmo, we could use the Phase in the Noise modifier, but this would simply make the flame ripple up and down – we require it to pass over the flame to create the desired effect. The attack curve was amended or else the noise would speed up and slow down, which is not right for the flame – it should be linear, so changing the curve to a linear attack is the correct solution.

PART THREE: With the animation set up, we will now concentrate on creating the flame's material.

10 Add another Noise modifier to the stack. Set the Scale to 10 and set the X and Y Strength settings to 1. Turn on Auto Key, go to frame 100 and in the Left or Front Viewport, drag this Noise modifier's Gizmo 150 units vertically upwards. Turn off Auto Key and amend the new Y Position keyframe curves, as before.

Information: This Noise modifier generates the impression that there is a slight breeze in the scene and makes the flame wave from side to side. Used in conjunction with the other Noise modifier, this produces a realistic effect with the flame rising and falling slightly while moving around somewhat.

11 Open the Material Editor and, in the next available blank slot, label the material Flame and assign it to the Flame object. Set the Material Effects Channel ID to 1, enable 2-Sided, Self-Illumination and, in the Extended Parameters rollout, Additive Transparency.

Information: We are using Additive Transparency so that any object or material that is situated behind the Flame object will appear brighter, such as the opposite side of the flame due to the material being set to 2-Sided. The Material Effects Channel has been set so that we can assign a Glow render effect to this material once the image has been rendered. You will notice that the objects in the screenshot are now illuminated more. As we will want to see some progress in the Viewport, right-click the Perspective text in the Viewport, select Configure and in the resulting panel, enable Default Lighting and set to 1 or 2 lights, depending on your preference.

12 Expand the Maps rollout, add a Mix map to the Diffuse slot and label it Flame Side Mixer. Set the Color 2 swatch to RGB 220,105,65. Add a Falloff map to the Mix Amount slot and label it Side Mix Control. Amend the Mix curve as illustrated, and set the Output Amount to 3. Add a Gradient Ramp to the Side slot and label it Side Mix Height Control. Set the W Angle setting to 90, remove the middle flag and add flags at positions 16, 31, 53 and 84 with colors black, white, white, and RGB 228,228,228 respectfully. Set the Flag at position 100 to RGB 117,117,117. Click on Show Map in Viewport to see this map in action.

Information: The Mix map will blend together a map we have yet to create, with the orange color that appears on the perpendicular of the flame. This perpendicular effect is controlled by a Falloff map, which is in turn controlled by a Gradient Ramp map to fade in and fade out the perpendicular effect.

13 In the Flame Side Mixer's Color 1 slot, add a Gradient Ramp map and label it Flame Color. Set the W Angle to 90, remove the middle flag and add flags to positions 16, 30, 68, 77 and 86. Set flags 0 and 16 to RGB 180,70,5, flags 30 and 68 to white, flag 77 to RGB 250,220,190, flag 86 to RGB 255,195,96 and flag 100 to RGB 220,115,50. Click on Show Map in Viewport to see this map in action.

Information: These actual colors and positions are based on the reference image that we are working on. As we can see in the Viewport, the gradient is designed to change color in the correct places.

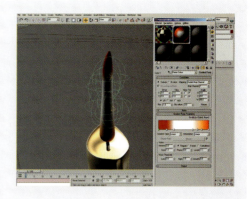

14 Back at the top of the material, add a Mix map to the Self-Illumination slot and label it Blue Tint Self Illumination. Set the Color 2 swatch to RGB 130,110,195 and instance the Flame Side Mixer Mix map into the Color 1 slot. Add a Falloff map in the Mix Amount slot and label it Blue Tint Mix Control. Amend the Mix Curve, as illustrated, and set the Output Amount to 3. Add a Gradient Ramp map to the Side slot and label it Blue Tint Height Control. Set the W Angle to 90, the middle flag to black and move it to position 55. Add a flag at position 77 and set it to white. Click on Show Map in Viewport to see this map in action.

Information: As before, the Falloff map is controlled by a Gradient Ramp map which ensures that the blue color in the Mix slot is only present at the bottom of the flame. Because of this control the mix then goes into an instance of the Flame Side Mixer map tree we are using in the Diffuse slot, which intensifies the diffuse color with its own color.

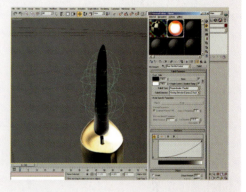

15 At the top of the material, add a Mix map in the Opacity slot and label it Flame Opacity. Instance the Blue Tint Mix Control Falloff map into this Mix map's Mix Amount slot. In the Flame Opacity Mix map's Color 1 slot, add a Gradient Ramp map and label it Flame Overall Opacity Control. Set the W Angle to 90, and remove the middle flag from the gradient. Add a flag at position 7 and set it and the one at position 100 to black, and add flags at positions 18 and 80 and set them to white. Click on Show Map in Viewport to see this map in action.

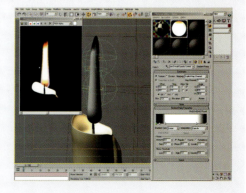

Information: This Mix map tree mixes the existing Blue Tint Mix Control, which already defines the mixing and therefore the opacity of the blue tint at the base of the flame, with a gradient which controls the way the rest of the flame fades in from the bottom and out from the top. Perform a quick test render if desired to see the final result of our flame, but bear in mind that we still haven't set up the wax illumination material yet.

PART FOUR: Next we will amend the existing material that is assigned to the candle itself to make it appear like light is illuminating its interior, using faked sub-surface scattering.

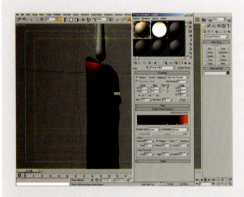

16 Select the Candle material in the Material Editor and select the Wax sub-material. With Self-Illumination enabled, add a Mix map in the Self-Illumination slot and label this Wax SI Falloff Mix. Add a Mask map to the Mix's Slot 1 and label it Orange Falloff Mask. Add a Gradient Ramp map to the Map slot and label it Orange Falloff. Set the W Angle to −90, the middle flag to black and move it to position 60. Add a flag at position 79 and set it to RGB 68,18,3, create a flag at position 95 and set that and the one at position 100 to RGB 217,84,0. In the Orange Falloff Mask map, copy the Orange Falloff map into the Mask slot and rename it Orange Mask. Remove all flags and create a white one at position 94. Set the one at position 100 to white and the one at position 0 to RGB 107,107,108. Set the Noise Amount to 0.3, Size to 2.05 and noise type to Fractal.

Information: A rather large step, we are simply creating a gradient which (after being mixed with another map) travels down the cylinder mapping of the candle. This is also controlled by the use of a noisy gradient which generates the streaks within the wax to simulate wax density.

17 In the Wax SI Falloff Mix map, add an Output map to the Color 2 slot and label it Orange Falloff Mask Intensifier. Set the Output Amount to 2 and instance the Orange Falloff Mask map into the Output's Map slot. Back up at the Wax SI Falloff Mix map, add a Falloff map in the Mix Amount slot, label it Edge Intensity Mixer and set the Falloff Type to Fresnel.

Information: As we simply want to increase the color intensity around the perpendicular of the candle, so that areas of detail become more prominent, we can reuse the existing gradient we have set up by using an Output map to add extra intensity. The Falloff map simply mixes the normal version of the gradient with the more intense version.

18 At the top of the Wax material, add a Mask map to the Translucency color slot and label it Translucency Mask. Instance the Orange Mask gradient into the Mask slot. Add a Gradient Ramp map to the Map slot and label it Translucency Color. Set the W Angle to −90. In the gradient, set the middle flag's color to black and reposition it to position 62. Add a flag at position 94 and set to RGB 58,55,45 and set the flag at position 100 to RGB 166,160,130. Change the Interpolation to Ease In.

Information: The Translucency color does not have to be very intense to be effective. This color, which falls off further down the candle, is also controlled by the same gradient which controls the streaks in the orange gradient, therefore suggesting that where there denser patches of wax within the candle, the light does not pass through as easily, which is exactly the case.

PART FIVE: To finish off the candle's material, we will add a slight glow at the tip of the wick which is being burned by the flame.

19 At the top of the Candle Multi/Sub-Object material, go in the Wick material. As Self-Illumination is already selected, add a Gradient Ramp map to the Self-Illumination slot and label it Wick Glow. Set the W Angle to −90. Set the middle flag to black and add another flag between this one and position 100. Set this flag to RGB 255,40,0 and the one at position 100 to RGB 255,255,0. Reposition the red flag to position 99 and the black flag to position 98.

Information: As the UVW map covers the entire of the candle object from top to bottom, we want the wick glow to be right at the top of the gradient as it needs to be right at the top of the wick. A simply self-illumination will suffice as it will be mainly occluded by the flame anyway.

PART SIX: To finish off the scene and to give the flame a hint of intensity, we will add a slight glow to the flame material.

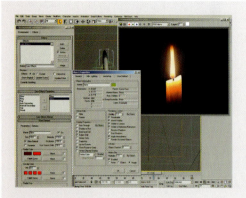

20 Open up the Render Effects panel and add a Lens Effects effect. Add a Glow to the right-hand panel in the Lens Effects Parameters rollout and in the resulting Glow Element rollout, set the Size to 1, Intensity to 50 and Use Source Color to 100. In the Options tab, enable Effects ID. Add another Glow to the right-hand panel of the Lens Effects Parameters rollout and in the resulting Glow Element rollout, set the Size to 10 and Use Source Color to 30. Set the Radial Color on the left to RGB 140,41,0 and in the Options tab, enable Effects ID which, as before, defaults to 1. Add Image Motion Blur to the Flame object if desired and render out the animation.

Information: The final step sees us assigning a two stage glow to the flame – the first creates a subtle glow around the flame to blur and intensify it somewhat, and the second creates the large faint glow that surrounds the flame, as illustrated in the reference image. The resulting animation is a quite convincing recreation, made even more realistic thanks to the lighting and materials.

Taking it further

With the one candle done, it's relatively straightforward to duplicate the flame, lights and candle numerous times. However, ensure that the other lights do not illuminate the other flames (ensure that they are excluded as with the original flame) or else they will be overly illuminated and the self illumination effect we have set up will be lost – see the *01_taken_futher.max* on the DVD for an example of this in action. In addition, you will want to change the Seed of each Noise modifier so that the animation is not identical; however, if you want the 'wind' to be consistent, leave the second Noise modifier as it is, so even though the general noise has been made unique for each flame, the subtle motion to simulate wind is the same.

In addition, if you want to place these candles in situ, then you will have problems with shadows as none of the lights are shadow casting, because of the limitations of the translucency shader – if shadow maps are enabled there will be a harsh band where the translucency kicks in. Using Raytraced shadows will rectify this problem, but the render times will increase dramatically.

Alternatively, enable shadow maps on the existing lights but exclude the candle(s) from casting shadows themselves. However this does pose the problem of any adjacent candles not casting shadows onto nearby objects. A mix of different shadows should resolve the problem.

Try amending the scene so that you can tweak the exposure yourself using 3ds Max's own Exposure feature, so light emitted from the candle affects the wax and surrounding areas accordingly. Also, try placing the candle in an illuminated scene and amend it so that it works correctly with the lights on or off; see the Wood Fire video tutorial for an example of this.

If you are running a version of 3ds Max later than version 7, you could try adding the Mental Ray Sub Surface Scattering shader to the candle instead of using our own faking technique. As mentioned in the introduction, we have gone down the faked route so you gain experience at handling multiple nested maps and materials as you will undoubtedly come across problems while working with 3ds Max when a quick solution is not the best. If you just converted your original scene to Mental Ray, you will notice upon rendering some irregularities in the flame material which are not present in the original Scanline scene. This is due to the way Mental Ray handles additive transparency. Therefore, reduce the white flag values in the Flame Overall Opacity Control map to RGB 240,240,240 so the result is slightly transparent, which will therefore brighten the end result and reduce and/or remove the banding. There is a Mental Ray SSS shader solution included on the DVD-ROM which uses the original basic wax color parameters (beige diffuse and orange SSS colors). However, you will notice that the entire of the model has the SSS shader applied; this is because this particular shader does not work with Multi-SubObject materials, so if you want the Wick material to be applied, you will need to add extra wick geometry and apply the material accordingly.

2 Match

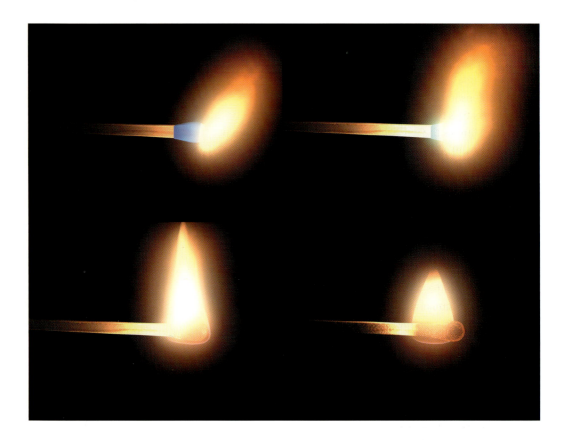

Introduction

This flame effect is not dissimilar to the Candle we created previously; the main construction of the flame is very similar, but with a few noticeable differences, mainly because of the way the flame is generated, and also because of the material that the flame burns. In this tutorial we are going to 'strike' a match (that has already been modeled out) by using a particle system to create the ignition of the phosphorous on the end of the matchstick that will quickly 'change' into geometry to form the flame. We can just use a simple particle system to simulate the ignition of the match and flame, but the way it is ignited plays a big part in the overall effect. Anyone got a light?

Analysis of effect

(a) The initial strike of the match head is situated right at the tip and spreads like a shockwave right across the surface of the phosphorous head, scorching the surface as it passes, leaving behind a charred and pitted material. The wave itself emits an intensely vigorous flame which flies out at some velocity and emits a bright yellow, almost white flame (mostly white around the emission point), and depending on the level of exposure of the viewing camera, can occlude any other effect due to its brightness. As this flame passes and consumes the phosphorous it rises somewhat so that the flame always tries to point vertically upwards, after which the fire spreads and ignites the wood (which is treated with a petroleum-based substance) and catches fire as the vigorous flame catches it and 'calms' the flame down. (b) By this time the phosphorous will have burned away leaving only this gentle flame which will gradually stretch out towards the remaining combustible material (the wood) and consume it. (c) During this consumption process the wood is gradually charred and deformed, even though the flame does not appear to be present in the leading edge of the flame (it is quite transparent), leaving a slightly glossy yet highly textured material. As the flame stretches out, the leading edge of the flame, which is colored similarly to the candle flame in the first tutorial, grows slightly stronger while the trailing end gets weaker (as there is less combustible material to consume). (d) This results in the flame breaking up, diminishing and eventually extinguishing, leaving a trailing glow on the charred wood.

As the initial strike of the match starts at one end and passes over the tip of the match in a shockwave type effect, we will have to create this using a selection method to get any particles we need to emit from the tip and spread over the match in the correct manner. A simple procedural gradient map will suffice for this, as long as its selection is clipped off so that we get a steep transition from black to white which will define the thin wave effect. This gradient has its flags animated, with a few additional elements to get the wave effect to travel across the surface of the tip. Using the resulting map in a Volume Select modifier we can create our selection to emit facing particles which will be generated using one of the 'legacy' particle systems. Facing particles are used to keep the geometry count down to speed up rendering times, and also allows us to map on some gradient-masked procedural textures which will be displayed face on to camera. These particles will fade out quite quickly (with a little randomness thrown in), but will intensify for a time as they pass over the surface, which will occlude and

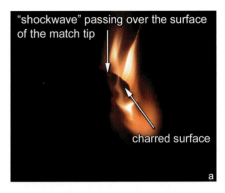

"shockwave" passing over the surface of the match tip

charred surface

a

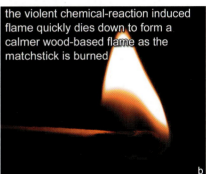

the violent chemical-reaction induced flame quickly dies down to form a calmer wood-based flame as the matchstick is burned

b

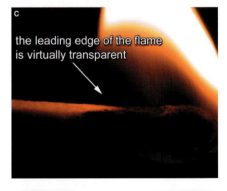

c

the leading edge of the flame is virtually transparent

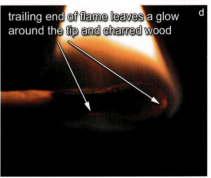

d

trailing end of flame leaves a glow around the tip and charred wood

form the leading edge of an animated slice passing over the flame geometry. This geometry will be generated by a simple lathe, as in the Candle tutorial, but deformed a little lengthways and with a couple of extra modifiers; one to construct the flame (the slice) and another to add an extra leading edge opacity once the initial mass of particles has passed. Because of the flame spreading over the match, we can also use an animated UVW Map modifier to mix the existing material with a charcoal effect. The tip of the match can also make use of an amended version of the same material to create a glowing pitted effect.

Walkthrough

PART ONE: First we will load in the basic scene and set up any Space Warps required to drive the particle system.

1 Load in the *Fire/02_Match/Source/02_match_start.max* file included on the DVD-ROM. In the Top Viewport, create a Wind Space Warp and set the Strength to 0.5.

Information: Our initial scene consists of a couple of pieces of geometry that make up the matchstick and tip, plus a single camera. The tip and matchstick have some basic materials assigned to them that we will change later on, so they are charred when the match is 'struck'. The Wind Space Warp has been introduced to force the ignition particles upwards so they cover the construction of the flame.

PART TWO: Next we will generate the map to control the selection which drives the particle emission and assign this to the tip of the match.

2 Assign a UVW Map modifier to the Match Tip object in the scene and set its Mapping to Cylindrical. Add a Volume Select modifier to the stack and set its Stack Selection Level to Face and Select By to Texture Map. Open up the Material Editor and add a Gradient Ramp map to a blank slot. Label this map Ignition Generator and instance it into the Volume Select's Texture Map slot.

Information: Once we have modified the gradient a little, it will generate a sub-object selection that we can use to emit particles. We can use the UVW Map modifier to animate the position of the gradient as it sweeps over the surface of the Match Tip object.

3 Turn off U and V Tiling, set the gradient's W Angle setting to 90, the Noise Amount to 0.5 and Size to 5 and enable Fractal as the Noise type. Reposition the flag at position 50 to position 81 and set it to black. Add flags to positions 84 and 94 and set them to white, add one to position 96 and set it and the one at position 100 to black also. Go to frame 20, enable Auto Key and animate the keys at positions 81, 84, 94 and 96 to the other end of the gradient, as illustrated. Turn off Auto Key. Instance this map into a material, create a Box and assign this material to it. Move the keys at frames 0 and 20 forward 20 frames so they are at frames 20 and 40 respectfully. Delete the box as it is no longer needed.

Information: By creating a block in the gradient and animating it from one side to the next, we have created a shockwave effect which 'reaches out'; i.e. it does not just travel across the surface of an object, it appears to spread and grow. As we are going to animate the position of the UVW Map modifier's Gizmo we do not want the gradient to be repeated, therefore tiling is turned off. Even though we have the gradient assigned to the Volume Select modifier, it does not show up in the object's keyframe information in the Time Bar. Therefore, adding it to a material and assigning it to a temporary object allows us to view the keyframes and shift them forward 20 frames as we need them to sit there for a while before moving to get the initial burst of ignition flame.

4 Set the Volume Select's Selection Type to Crossing. Go to the UVW Map modifier's Gizmo sub-object, scale it down horizontally to about 70% of its original size and offset it to the right of the geometry in the Top Viewport so that it intersects the geometry by about 2/3 on 1/3 off. Go to frame 30 and turn on Auto Key and reposition the gizmo so that it is half-off the left-hand side of the geometry as illustrated. Turn off Auto Key. Right click the resulting keyframes at frame 0 and select the Z Position keyframe. Amend the Out curve so that it has a gradual output curve (ease from), and amend the one at frame 30 so that it has a steep attack curve (accelerate to), as illustrated.

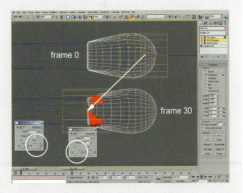

Information: We have amended the Volume Select's selection type so that more polygons can be selected. The UVW Map gizmo was scaled so that it did not stretch out the selection. The gizmo was also offset at the beginning and end of the animation to ensure that no polygons were selected, and therefore no particles emitted by accident. The motion of the gizmo was amended by changing the curve information of the position keyframes to get the gizmo to speed up and come to an

abrupt stop, therefore delaying around the strike point and then 'rushing' over the surface of the tip. Note that the screenshot illustrates the same tip at two different times – frames 0 and 30; the screenshots have simply been merged together in Photoshop.

PART THREE: With the selection complete we will now generate and animate the shape of the flame.

5 In the Front Viewport, create a spline over the tip of the match that represents one side of an outline of a flame about the same height as illustrated. Label it Flame and add a Lathe modifier and a UVW Map modifier. Scale up the object horizontally to about 170% of its original size and add another UVW Map modifier. Set its Map Channel to 2 and scale its sub-object gizmo down vertically so that it is about 1/3 of its original height. Reposition this gizmo so that it is covering the bottom of the flame as illustrated. Copy this modifier, set the copy's Map Channel to 3 and offset it to the left of the geometry so that it half-intersects it.

Information: The construction of the flame's geometry is not dissimilar from that of the Candle's, so if you get stuck please refer to that tutorial's flame construction. However the mapping of this flame is more complex as we need to occlude part of the leading edge of the flame so that it is more transparent, therefore we need an additional UVW Map modifier (#3) to achieve this.

6 Add a Slice modifier and set the Slice Type to Remove Bottom. Rotate the gizmo by 90 degrees in the Z axis and move it to the right of the flame. Go to frame 30 and turn on Auto Key. Animate the position of the Slice modifier's gizmo from the right-hand side of the flame to the left so that it reveals or 'draws out' the flame geometry. Turn off Auto Key and reposition the keyframes at frame 0 to frame 25. Go to frame 100 and turn Auto Key back on. Reposition the Flame object so that its center is to the left of the Match Tip object as illustrated. Turn off Auto Key, amend the resulting X Position keyframe's Out curve at frame 0 to an Ease From curve and amend the In curve at frame 100 to a linear attack. Reposition the keyframes at frame 0 to frame 30.

Information: We have amended the position of the keyframes so that they start animating at the correct times; the Slice modifier is animated while the sub-object selection is being made over the Match Tip object, which therefore will emit particles (when we have introduced them later on)

occluding the slice and therefore giving the impression that the particles are forming the flame. The motion of the flame is to simply get it to start spreading down the Matchstick object, to give the impression that the fire is spreading and is looking for more material to burn.

7 Add a Volume Select modifier. Set the Stack Selection Level to Vertex and, in the Front Viewport, reposition its gizmo vertically so that the top vertex and the top most ring of vertices are selected. Enable Use Soft Selection and amend its Falloff setting so that the selection influence ceases just above the base of the flame as illustrated.

Information: To finish off the animation of the Flame geometry, we need to deform it somewhat, but also need to keep the base of the object virtually unaffected, else the entire effect will be ruined. Using Soft Selection enables us to influence the top most part of the flame but hardly any, if at all, around the base of the flame so any deformations we add on top of the modifier stack will hardly influence the area where the Flame and Matchstick objects meet.

8 Turn off the Slice modifier and add a Noise modifier to the top of the Flame's modifier stack. Set the Scale to 20, enable Fractal and set its Roughness to 0.5 and Y Strength to 3. Go to frame 30, enable Auto Key and set the Roughness to 1 and Y Strength to 10. Go to frame 40 and set the Roughness back to 0.5 and the Y Strength to 3. Move the keyframes at frame 0 to frame 25. With Auto Key still enabled, go to frame 100 and reposition the gizmo about 100 units to the right of the Flame object. Turn off Auto Key, right-click the resulting keyframe at frame 0 and set the X Position keyframe's Out curve to a linear attack, click on the arrow next to the curve to pass this curve information to the keyframe at frame 100's In curve. Turn the Slice modifier back on.

Information: The Slice modifier was disabled for the duration of this step so that we could see exactly what was going on in our scene and made the construction process easier. We now have a two-stage animation on the Flame object; the exaggerated Noise modifier which simulates the vigorous flame when the match is ignited (generated by the animated Roughness and Strength settings), and also the gently waving of the flame after ignition (generated by the animated gizmo).

PART FOUR: With the flame geometry complete we will use the selection on the match tip to generate the particles so that they occlude the leading edge of the flame.

9 Create a PArray particle system. Click on its Pick Object button, select the Match Tip object and enable Use Selected SubObjects. Set the Viewport Display to Mesh and the Use Rate to 300. Set the Speed to 1.5 with 20 Variation. Set the Life to 3 with 2 Variation, Size to 2 with 25 Variation and set Grow For to 3 and Fade For to 2. Set the Particle Type to Facing. Set the Rotation and Collision's Spin time to 10 with 50 Variation. Enable Auto Key and go to frame 30. Set the Speed to 0 and turn off Auto Key. Move the resulting keyframe at frame 0 to frame 25. Right-click the object, select Properties in the resulting menu and turn off Cast and Receive Shadows. Bind the Wind Space Warp to the particle system.

Information: Even though the particle system is active during the initial frames of the animation, no particles are being emitted, as there is no sub-object selection made on the emitter object. Here we have created a fast moving vigorous particle system that rises after its birth, completely occluding any construction. We have simply added some randomness to the motion (which also slows down as the 'phosphorous' is used up) which adds a little more realism to the particles. The burning phosphorous spreads over the surface of the tip of the match, as does our particle system thanks to the Gradient Ramp map driving the sub-object selection. The resulting particles grow as they are ejected and rise up after being caught by the Wind Space Warp, generating a realistic effect. As we will be setting up shadow casting lights later on, we do not want this particle system (which represents fire) to cast or receive shadows.

PART FIVE: To correspond with the animation of the flame and particle system, we will create and animate the scene's materials.

10 Select the Match Tip object in the Material Editor and click on the Standard button. Select a Blend material and select Keep Old Material as Sub-Material when prompted. Go into the material in Material Slot 2 and label it Charred. Set the shader to Oren-Nayar-Blinn, the Diffuse color to black and enable Self-Illumination. Set the Specular Level to 6 and Glossiness to 12. Add a Falloff map to the Self-Illumination slot and label it Edge Glow. Set the Side color to RGB 255,71,0 and set the Falloff Type to Fresnel. Expand the Output rollout and set the Output Amount to 2.

Information: By simply changing the material type we can automatically assign this new material to the object(s) in the scene. We do not see any change to the material in the sample swatches in the Material Editor, as we have not amended the new Blend material's Mix Amount to add the Charred material to the blend. This material has been set so that we have a slight rim glow effect which will give the impression that the surface is still exceptionally hot, even though the phosphorous will have been burned off already, as the flame is interacting with it causing it to glow. This glow is intensified by increasing the Falloff map's Output amount.

11 At the top of the Charred material, set the Bump amount to 200, add a Noise map to the Bump slot, label it Charred Bump and set the Size to 0.2. Go back to the top of the material, go to frame 30 and enable Auto Key. Set the Blend material's Mix Amount to 100 and turn off Auto Key. Select the Match Tip, right-click the keyframe at frame 0 and select the Mix Amount keyframe. Amend this keyframe's Time setting to 20 to offset it to frame 20.

Information: By animating the Blend material's Mix Amount we can blend the two materials together over time, therefore charring the tip of the match. This effect may not be seen due to the amount of particles being emitted, but the end result will be worthwhile as even though we may not be able to see the transition, we need to change the material, which we have therefore achieved.

12 Select the Matchstick object in the scene and select its material (the Wood_Ash material in slot 2). Click on the Standard button as before, select a Blend material and select Keep Old Material as Sub-Material when prompted. Instance the Charred material from the Match Tip material into the Material 2 slot in this new material. Add a Gradient Ramp map to the Mask slot of the new Blend material and label it Matchstick Charring Control. Set the Map Channel to 2, turn off U and V tiling, reposition the flag at position 50 to position 5 and set it to black, add a flag at position 10 and set it to white and set the Noise Amount setting to 0.04. Add a UVW Map modifier to the Matchstick object, set its Map Channel to 2 and Alignment to Y.

Information: As we have already got the Charred material set up we can save time by re-using it, by simply instancing it into the Material 2 slot in this new Blend material. We are using a gradient to control the blending between the two materials as we need to gradually scorch the wood of the Matchstick as the flame progresses down its length; tiling has been turned off again to prevent accidental use of the Charred material and so that it only appears in the white areas of the gradient.

13 Select this modifier's Gizmo sub-object and scale it vertically to about 1000% in the Front Viewport. Reposition the Gizmo to the right of the Matchstick, go to frame 33 and animate it so that it just intersects the Matchstick and the gradient has some influence. Go to frame 100 and animate it further down the length of the Matchstick, so that it follows the Flame object. Turn off Auto Key and reposition the key at frame 0 to frame 30. Amend the In and Out curves of the resulting X Position keyframe at frame 30 to ease in and ease out respectfully, and set the In curve of the keyframe at frame 100 to a steep attack.

Information: The gradient is controlled using an additional UVW Map modifier which does not need to be present on the material (else we would have initial charring on the match). Therefore the charring effect is introduced to the material quickly as the flame is being constructed and then gradually moves down the Matchstick as it follows the Flame geometry (due to the flame burning the wood). We have amended the keyframe information again so that the scorching effect does not travel linearly down the flame, but gradually speeds up because the wood needs to burn right through before the flame searches for more fuel.

14 Label a new material Flame and assign it to the Flame object in the scene. Set the Material Effects Channel ID to 1, enable 2-Sided, Self-Illumination and, in the Extended Parameters rollout, Additive Transparency.

Information: We are using a 2-sided material with Additive Transparency so that the material will appear brighter. The Material Effects Channel has been set so that we can assign a Glow to this material once the image has been rendered. Note that the construction of this flame material bears a similar resemblance to the Candle flame material; the majority of the text here is almost identical as there is no point in me re-wording something. However additional comments have been added (or removed) where items are more relevant or are different. As with the other flame-based tutorials in this book, Additive Transparency works best in low light scenes. In scenes with higher background illumination, the material will become whited out due to being overlaid on top of additional illuminated objects. To get around this problem, try increasing the output of the Self-illumination Map instead of using Additive Transparency.

15 Expand the Maps rollout, add a Mix map to the Diffuse slot and label it Flame Side Mixer. Set the Color 2 swatch to RGB 220,105,65. Add a Falloff Map to the Mix Amount slot and label it Side Mix Control. Amend the Mix curve as illustrated, and set the Output Amount to 3. Add a Gradient Ramp to the Side slot and label it Side Mix Height Control. Set the W Angle setting to 90, remove the middle flag and add flags at positions 16, 31, and 77 with colors black, white, and RGB 174,174,174 respectively. Set the Flag at position 100 to black. Click on Show Map in Viewport to see this map in action.

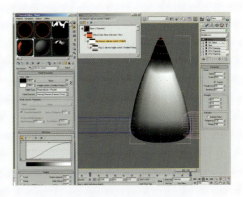

Information: The Mix map will blend together a map we have yet to create with the orange color that appears on the perpendicular of the flame. This perpendicular effect is controlled by a Falloff map, which is in turn controlled by a Gradient Ramp map to fade in and fade out the perpendicular effect.

16 In the Flame Side Mixer's Color 1 slot, add a Gradient Ramp map and label it Flame Color. Set the W Angle to 90, remove the middle flag and add flags to positions 16, 30, 50, 60 and 71. Set flags 0 and 16 to RGB 180,70,5, flags 30 and 50 to white, flag 60 to RGB 255,195,95, flags 71 and 100 to RGB 220,82,31. Click on Show Map in Viewport to see this map in action.

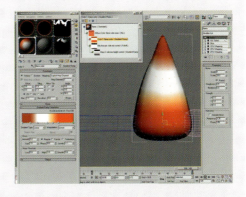

Information: These actual colors and positions are based on reference images that we are working on. As we can see in the Viewport, the gradient is designed to change color in the correct places.

17 Back at the top of the material, add a Mix map to the Self-Illumination slot and label it Blue Tint Self Illumination. Set the Color 2 swatch to RGB 130,110,195 and instance the Flame Side Mixer Mix map into the Color 1 slot. Add a Falloff map in the Mix Amount slot and label it Blue Tint Mix Control. Amend the Mix Curve as illustrated and set the Output Amount to 3. Add a Gradient Ramp map to the Side slot and label it Blue Tint Height Control. Set the W Angle to 90, the middle flag to black and move it to position 55. Add a flag at position 77 and set it and the flag at position 100 to RGB 146,146,146. Click on Show Map in Viewport to see this map in action.

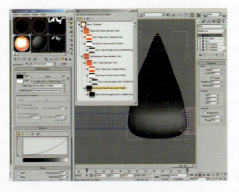

Information: As before, the Falloff map is controlled by a Gradient Ramp map which ensures that the blue color in the mix slot is only present at the bottom of the flame. Because of this control, the

mix then goes into an instance of the Flame Side Mixer map tree we are using in the Diffuse slot, which intensifies the diffuse color with its own color.

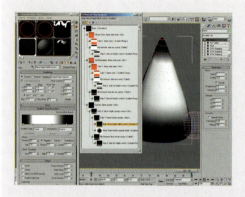

18 At the top of the material, add a Mix map in the Opacity slot and label it Flame Opacity. In its Color 2 slot, add a Mix map and label it Flame Height Opacity Control. Instance the Blue Tint Mix Control map into the Flame Height Opacity Control map's Mix Amount slot. In the Flame Height Opacity Control map's Color 1 slot, add a Mask map and label it Flame Bottom Opacity. Add a Gradient Ramp map to the Mask slot and label it Flame Bottom Opacity Radial. Set the Map Channel to 2 and turn off U and V tiling. Add a flag to position 14 and move the one at position 50 to position 71. Set flags at positions 0 and 14 to white, the one at position 71 to RGB 136,136,136 and the one at position 100 to black. Set the Gradient Type to Radial and enable Invert in the Output rollout. Add a Gradient Ramp map to the Flame Bottom Opacity map's Map slot and label it Flame Height Falloff Control. Set its W Angle setting to 90 and set the Interpolation to Ease In. Relocate the flag at position 50 to position 88, add flags at positions 3, 21 and 58. Set the flags at positions 3, 88 and 100 to black and the ones at positions 21 and 58 to white.

Information: This Mix map tree mixes the existing Blue Tint Mix Control, which already defines the mixing and therefore the opacity of the blue tint at the base of the flame, with a Mask map which controls the radial opacity of the base of the flame. This radial masking has to be introduced else the flame would not be transparent at its base. We have turned off tiling for this radial gradient so that it is not repeated over the flame, and we have designed the gradient as such so that it has to be inverted, so there are no visible edges where the edge of the gradient map exists.

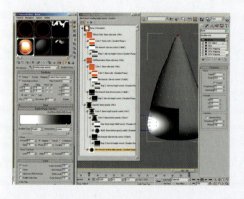

19 Copy the Flame Bottom Opacity Radial map to the Flame Opacity map's Mix Amount slot and label it Leading Edge Opacity. Amend its Map Channel setting to 3. Reposition the flag at position 14 to position 33, the one at position 71 to position 92 and set this flag to black.

Information: Again, as we have already got the majority of the settings already set up for this gradient in another map, we can simply clone and amend it to create the new map. This new map uses Map Channel 3 which is positioned half-off the base of the flame, therefore making its leading edge transparent, which gets more opaque the further we progress into the flame, thanks to the radial gradient.

20 Label a new material Ignition Flame and assign it to the PArray system in the scene. Set its Material Effects Channel ID to 1 and enable Face Map. Set the Self-Illumination to 100 and enable Additive transparency. Add a Particle Age map to the Diffuse slot and set Color 1 to white, Color 2 to RGB 255,195,95 and Color 3 to RGB 220,80,330. Set the position of Color 2 to 10. Add a Mask map to the Opacity slot of this material and add a Particle Age map to its Mask slot. Swap Colors 1 and 3 and set Color 1 to RGB 130,130,130 and Color 2 to RGB 65,65,65. Add a Gradient map to the Mask's Map slot and set it to Radial. Set the Noise to 0.7, Size to 5 and enable Turbulence.

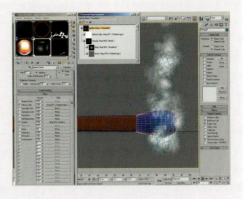

Information: We have used the Material Effect Channel ID, as before, to assign a post effect to the particle system so we can get it to glow a little to suggest intensity. As we are using Facing particles, we are using Face Mapping to apply the radial gradient to the particles. The colors and opacities of the particles are amended over their lifespan (which is not all that long) so they quickly change color and become transparent before fading. We have used a noisy gradient purely to break up any visible radial gradients in the particle system when it is rendered. Note the use of Additive Transparency, as mentioned previously.

PART SIX: Finally, we will illuminate the flame matchstick (and surrounding environment) by creating and placing fill lights before adding a subtle glow to the flame.

21 Create an Omni light in the Front Viewport and position it just to the right of the Match Tip so it is almost touching it. Label this light Ignition Omni01. Enable Shadow Map, set its Multiplier to 0 and Color to RGB 255,220,194. Click on the Exclude button and set the Flame geometry so it does not receive illumination or shadows from this light. Set the Decay Type to Inverse Square, Start to 1 and enable Show. Enable Use and Show Far Attenuation and set its Start to 5 and End to 200. Expand the Advanced Effects rollout and set the Contrast to 50.

Go to frame 20, enable Auto Key and set the Multiplier to 20 and Decay Start to 5. Turn off Auto Key and reposition the resulting keyframe(s) at frame 0 to the frame at which the particles begin emitting (frame 4 in this scene). Copy the keyframe at frame 20 to frame 30 and the one at the emission frame to frame 35. Instance this light four times and position the instances around the tip of the match as illustrated. Animate the position of the original Ignition Omni light so that it moves outwards from the particle emission frame to frame 20.

Information: These lights have an exceptionally high Multiplier setting due to the type of Decay that is being used. We are using Inverse Square Decay to get a nice intensity falloff down the side of the match, and are using Far Attenuation to tell the Decay where the value of 0 is, else it will keep being calculated to infinity which takes up additional render time. Positioning the lights around the tip (as illustrated) illuminates all sides of the match, and allows us to have an intense glow at the point of the particle emission which then spreads outwards; amending the light's position emphasizes the particle distribution by illuminating the tip accordingly. We have cloned the keyframes to get the intensity to dwell for a period and then fade away back to its original setting of 0.

22 Copy the Ignition Omni05 light and rename it Flame Omni01. Remove all keyframes from this new Omni light, set the Decay Start to 5, enable Auto Key and, at frame 40, set the Multiplier to 10. Turn off Auto Key and reposition the resulting keyframe at frame 0 to frame 30. Go to the Motion tab and select the light's Position controller. Click on the Assign Controller button and assign an Attachment controller. Go to frame 100 so that the flame is not being deformed, click on the Attachment controller's Pick Object button and select the Flame object. Click on the Set Position button and choose a point in the top half of the flame. Turn off Set Position. Instance this light another three times, position one instance slightly lower down on the opposite side of the flame and position the other two on opposite sides of the flame so that they are close to the sides of the Matchstick as illustrated.

Information: We have used the Attachment controller so that as the geometry deforms, the lights adhere to the surface, creating a flickering effect. The lights are also positioned at strategic places so that they represent illumination from the flame where it is brightest – in the middle to top part of the flame. The illumination from these lights do not affect the rest of the geometry in the scene, because their Multiplier settings have been animated so that they only illuminate the scene once the Flame geometry is present in the scene.

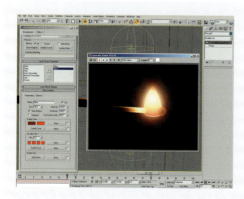

23 Open the Effects panel and add a Lens Effects effect. In the resulting Lens Effects Parameters rollout, add a Glow element. In the Glow Element rollout, set the Size to 1, Intensity to 50 and Use Source Color to 100. Go to the Options tab and enable Effects ID. Add another Glow element and in its Glow Element rollout set its Size to 10, set Use Source Color to 30 and set the first Radial color to RGB 140,41,0. Go to the Options tab and enable Effects ID. Finally, select the Flame object and enable Object Motion Blur in its properties. Render off the animation.

Information: As we have assigned a Material Effects ID of 1 to both our particle system and Flame geometry, they both have the Glow assigned to them which complements the effect. We have used a reduced Use Source Color for the second glow as we need to tint the environment a little more orange, or else the effect would be too intense. However, if you are simulating a longer exposure shot then increase this setting and the glow intensities accordingly. We have added an Object Motion Blur to the scene so that the Flame geometry blends together with the particles nicely and to remove any visible edges. It also makes the flame appear more vigorous. We have used Object Motion Blur instead of Image Motion Blur because the facing particles occlude the majority of the Flame geometry, so the Image Motion Blur post effect cannot see it properly. As Object Motion Blur is generated at render time we can blur the flame nicely without compromising on render times (as it is only one object). If you have the CPU power, try enabling Object Motion Blur on the particle system as well, for added effect.

Taking it further

At the end of the day this basic construction gives quite a nice effect, yet it isn't without its limitations. The Slice modifier used to generate the transition from particles to geometry has to be completely occluded, else the effect is lost because the rear side of the sliced geometry (which will show a gaping hole) is visible.

You might try reducing the exposure of the scene by reducing the Multiplier settings for the Omni lights that are illuminating the flame, and also reduce the intensity of the particle materials. You may also want to increase the length of the animation for the initial match strike, therefore slowing down time and showing the initial strike, and the spread of the ignited phosphorous, in more detail.

Currently, the initial strike is quite effective, but the way the flame moves over the wood isn't, since the flame geometry simply passes over its surface and appears to scorch the wood as it travels. By observing the reference material we can see that the flame stretches out and 'reaches' for the combustible material. This causes two things: firstly that the flame becomes longer and more intense, and secondly that as the flame intensifies it burns up more material, therefore reducing the flame and breaking up its shape. This causes parts of the flame (normally the trailing end) to become detached from the main 'body' and, as there is no more wood left to burn, the flame dies out. This could be simulated by using FFD modifiers to sculpt the flame and also careful use of Slice modifiers to create the gap in the flame. The sides of these flames could then be capped and smoothed out using a Relax modifier to remove any harsh edges.

Additionally, depending on the conditions of the environment, you may want to extinguish and/or intensify the flame more, or even increase the amount of 'wind' subjected to the effect by intensifying the animated Noise modifier used in the Flame geometry.

We are using a PArray system purely out of ease of use as we don't need anything overly fancy for this scene. However, as PArray is now classed as a "legacy" system, it is possible that it may be retired in the near future, so try converting the PArray system to a basic Particle Flow setup. This will be especially handy is you want to add additional effects like a small flame at the tip away from the main flame, or smoke effects during ignition or when the flame is extinguished!

3 Gas hob

Introduction

In this tutorial we are going to add a realistic gas flame to an existing scene, and use it to illuminate the surroundings. To do this, we will have to model the flame (similar to what we did in previous tutorials in this book) in two separate stages – one for the outer flame and one for the inner cone of unburned gas, which is prominent in this effect. Next, we will distribute this flame around one of the gas hobs in the existing scene. We will use particles to animate the positioning of the flame as the hob ignites and offset any animation we give to them. We will next generate an irregular motion to make the flames 'dance' a little, before adding illumination to the scene and an additional post effect or two to blur the flames together and to give the effect a little more intensity.

Analysis of effect

(a) From the reference material on the DVD-ROM, we can see how the flame is ignited. Firstly, the gas passes through an internal jet and is then forced out through the small gaps in the sides of the metal disc. The igniter is situated at the top of the hob, so once it ignites at this location, the resulting flame spreads around the sides of the hob igniting the escaping gas. As the gas has been turned on for some time before it ignites, the resulting ignition from all around the sides of the hob is of a larger flame than normal as all of the released gas is ignited. Due to the small amount of light being emitted from the flames, we get two different effects depending on the amount of light we allow into the camera's lens (exposure). (b) A smaller exposure will result in the blue flame being almost invisible (hence your old science teacher always telling you to put your Bunsen Burners on yellow flame when you're not using them), but at a larger exposure we can clearly see the flame's colors and the illumination of the surrounding hobs. (c) The external flame is a dark blue that fades internally and externally, and changes to a slight purple the further we progress up the flame. The internal cone of the flame is actually the gas that has not been ignited. This brighter 'cone' also has a fading effect but is a little more opaque than the external part of the flame. This type of flame effect is best suited for scenes that have little or no light. (d) As viewed in the reference material, in illuminated scenes we can hardly see the flame, let alone any illumination from it.

Starting out with a scene that is based on the reference material, we can use simple geometry to design our flame – two basic lathed splines to form the outer and inner areas of the flame. We are using two separate pieces of geometry and not merging them both into one object as we have to animate them being constructed to simulate the flame igniting. To do this we will just animate a Slice modifier on the two objects, which leaves the geometry open. To close it, we can just add a Cap Holes modifier, in which lies the reason for keeping the geometry separate – the Cap Holes may inadvertently cap one piece of geometry to the other, which would result in a mesh that would look like it had gone through a grinder once we had refined it using Meshsmooth. To distribute the flame geometry around the gas hob we can use a particle flow system which will emit particles from the 'ignition point' at the top of the hob. Each copy of the geometry's animation will be keyed off when the particle is born, with a bit of scale variation. After which, we will feed the particles into a looping event to randomize their

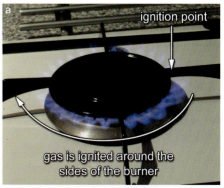

ignition point

gas is ignited around the sides of the burner

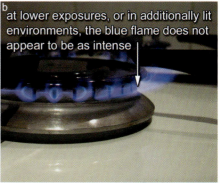

at lower exposures, or in additionally lit environments, the blue flame does not appear to be as intense

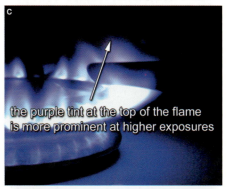

the purple tint at the top of the flame is more prominent at higher exposures

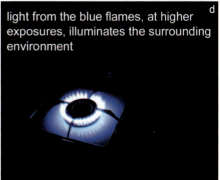

light from the blue flames, at higher exposures, illuminates the surrounding environment

scale every few frames. The materials will be colors which will be point-sampled from the reference material and assigned as a gradient going up the flame geometry, which will be handled by a (deformed) UVW map assigned to the source geometry.

Walkthrough

PART ONE: First of all we will load in the basic scene, create the building blocks to drive the animation and generate the initial shape of the flame.

1 Open up the *Fire/03_Gas_Hob/Source/03_gas_hob_ start.max* on the DVD-ROM. In the Front Viewport, create a Circle shape with a radius of about 7 and label it Flame Outer Cone. Clone this shape and label it Flame Inner Cone. Add an Edit Spline modifier to both shapes and, in Segment Sub-Object mode, remove the right-hand side of the circles. Go into Vertex sub-object mode and amend the position of the top vertex as illustrated for both shapes.

Information: A lengthy step to start off with, but relatively basic. Here we have designed the two main parts of the flame – the inner and outer cones. As we are going to lathe the shapes, we do not need their opposing sides else we will get overlapping geometry.

2 Add a Lathe modifier to both flame shapes and set the number of Segments to 8. Select both objects and add a Slice modifier. Rotate the Slice's gizmo if necessary so that it slices the flame horizontally, and Enable Remove Top (or Remove Bottom, depending on the direction you have rotated). Reposition the Slice's gizmo so that it is below both flames (therefore removing them). Turn on Auto Key and go to frame 5. Reposition the Slice's gizmo so that it is a little above the flames, therefore redrawing them out. Turn off Auto Key.

Information: We are working with a low amount of Segments in our lathes as we can refine them later on. The Slice modifier was introduced to animate the flame's ignition when the gas is ignited on the hob. Using the Slice leaves a gaping hole in the top of our two flame meshes. Therefore …

3 With both flame meshes still selected, add a Cap Holes modifier. Deselect the Flame Inner Cone object so we have only got the Flame Outer Cone selected, go to frame 5 if you're not there already, and add a UVW Map modifier.

Information: The Cap Holes modifier will simply close the hole in our mesh automatically, while the UVW Map modifier adds mapping to the mesh so that we can add a gradient later on to our flame. We have added our mapping this far down the stack so that it can be deformed by any other modifiers we decide to add afterwards. If the mapping was added on top of everything, it would not be deformed and the mesh would appear to pass underneath the texture that uses this mapping.

4 Select both flames and add a Volume Select modifier. Set the Stack Selection Level to Vertex and reposition its gizmo so that its bottom boundary intersects between the 2nd and 3rd rows of vertices in the outer flame, as illustrated. Enable Soft Selection and amend the Falloff so that the selection's influence travels all the way down the flame, but does not affect the bottom couple of rows of vertices of either flame.

Information: We have added this modifier so we can animate the top of the flame, while keeping the position of the base of the flame static (again, check the reference material for examples of this).

5 With both flames still selected, add an Xform modifier to their modifier stacks. Go to frame 5, enable Auto Key and, in the Top Viewport scale out the Xform modifier's gizmo a little horizontally and more so vertically, therefore scaling the flames, as illustrated. Turn off Auto Key. Click on the Open Mini Curve Editor button underneath the Timebar and scroll down until you get to the Modified Object controller menu. Expand this and expand the resulting Xform modifier in this list. Select this modifier's keys at frame 0 and shift-drag them to frame 10 to clone them. Click on the Close button to close this editor.

Information: Here we have animated the scale of the added Xform modifier's gizmo to give the impression that the gas fire billows out a little when it is ignited. We have cloned the keys so that the flame returns to its normal shape afterwards. We could also have cloned the keys in the timebar by shift-dragging them, but this would have resulted in existing keys at frame 0 (e.g. the Slice modifier's Gizmo position) to be cloned also. We could always delete the duplicated Slice key if desired, so you may wish to clone the keys this way instead of having to navigate through the curve editor. I'm using Isolation mode at the moment just to hide unwanted objects temporarily. As the modifier is instanced, cloning a key on one will do the same on the other.

6 With both flames still selected add a Mesh Select modifier to clear the Sub-Object selection. Add a Meshsmooth modifier and set the number of Iterations to 2. Turn this modifier off temporarily while we construct the rest of the scene. With both flames still selected, in the Front Viewport add a Bend modifier to the top of the stacks. Set the Angle to 120 and adjust the Bend Axis as necessary to get the meshes to bend to the right of this Viewport. Go into this modifier's Center Sub-Object mode and reposition the Center so that it is situated around the middle of the bottom of the flame, as illustrated.

Information: If we did not clear the sub-object selection, any additional modifiers would only affect the selected vertices of the meshes. We do not need the Meshsmooth on at the moment, but it is good to have it present at this stage so that we can easily flip it on later on. The Bend's center was relocated so that the majority of the Bend's influence is apparent at the top of the flame, getting it to curve.

PART TWO: Next we will animate a basic mesh to distribute the particles around our hob.

7 Select the Flame Emitter object in the scene. Add a Volume Select modifier to its modifier stack and set the Stack Selection Level to Face. Check on Invert in the Selection Method section and set the Selection Type to Crossing. Select the Volume Select's Gizmo sub-object and reposition it down slightly in the Top Viewport so that the top most piece of geometry is selected. Go to frame 10 and enable Auto Key. Move the gizmo down in the Top Viewport, so that the top of the Gizmo's bounding area is beneath the geometry, as illustrated. Turn off Auto Key.

Information: We have started with one of the polygons in this ring selected with the Volume Select so that the particles begin emitting immediately. If this is not what you want, you could offset the animation slightly so there is a delay before ignition. We are animating the selection around this object as this is how the flame ignition starts when the gas is ignited (again, see the reference material).

PART THREE: With the source geometry complete, next we will design the material that is to be assigned to each part of the flame.

8 Open up the Material Editor and label a new material Flame Outer. Set the Material Effects Channel ID to 1 and enable 2-Sided and Self-Illumination. Set the Diffuse color to RGB 35,37,116, expand the Extended Parameters rollout, set the Falloff to Out, Amt to 100 and enable Additive transparency. Add a Gradient Ramp map to the Self-Illumination slot and label it Flame Outer SI. Set the W Angle to 90 and the colors of flags 50 and 100 to RGB 35,37,116. Reposition the flag at position 50 to position 38 and set the flag at position 0 to RGB 97,37,116. Set the Noise amount to 0.1 and Size to 5 and enable Fractal.

Information: Here we have set up the basic properties of the outer flame. As the visible strength of the flame color diminishes the further we progress to the outer edge of the flame, we have simulated this by adding Falloff in the Extended Parameters rollout. As we need the flame to be intense, we are using additive transparency which will add the brightness of one material onto another when rendered (see the Taking it further section); we have also made the material two sided so this additive brightness is applied to itself as well. The colors and positions of the flags in the gradient were derived from sampling colors from the reference material and noting down their approximate positions in relation to the rest of the flame. We have added a little noise just to break up the pattern of the linear gradient a little.

9 At the top of the material, add a Mix map to the Opacity slot and label it Flame Outer Opacity. Add a Gradient Ramp map to the Mix slot and label it Flame Outer Opacity Control. Set the W Angle setting to 90. Set the flag at position 50 to white and move it to position 41. Add a flag to position 3 and set it to black. Add a Falloff map to the Color 2 slot of the Flame Outer Opacity map and label it Flame Outer Inner Falloff. Amend the Mix Curve to that illustrated. Expand the Output rollout, set the Output amount to 2.

Information: As we need the inner area of the outer flame to be slightly transparent to allow the inner flame to be visible through it, we need to add a Falloff map to control this. However, we also need the strength of this to diminish the further up the flame we progress; therefore the Gradient Ramp map controls the blending of the black color in the Mix map with the colors in the Falloff map; the end result is the strong blue color at the base of the flame, going to the more transparent purple tinted flame at the top, just like in the reference material.

10 Label a new material Flame Inner. Turn on 2-Sides and Self Illumination. Set the Diffuse and Self-Illumination color to RGB 70,112,225. Increase the Advanced Transparency Falloff Amt to 100 and set the Type to Additive. Add a Falloff map to the Opacity slot, label it Flame Inner Opacity and swap the black and white colors around.

Information: Here we have developed the basic material for the inner flame. We have a two stage falloff assigned to this material – the main one which fades out the center of the material (in the Extended Parameters rollout), and the additional one added in the Opacity slot to fade out the outer edges of the object. Additive transparency is used for the same reasons as before.

PART FOUR: We will now design the particle system which will utilize the elements we have created to distribute the flame geometry.

11 In the Top Viewport, create a Particle Flow system and label it Gas Flame. Set the Viewport Quantity Multiplier to 100 to see all of the particles in the Viewport. Click on the Particle View button or press 6 to open Particle View. Rename the Event 01 event to Flame Outer. In the Birth operator, set the Emit Stop to 10 and Amount to 32. Remove the Position Icon, Speed and Shape operators. Select the Rotation operator and set the Orientation Matrix to Speed Space Follow with Y and Z settings set to −90.

Information: Here we have created the basics of our particle system. We have removed the majority of the operators from the initial system as they are not required; the initial ones control the particles based on the system's icon for birth and speed. We want to use existing geometry to control the birth positions. There are 32 particles born as this is

how many faces exist in our animated emitter. The Rotation operator has been amended to get the particles (our flame geometry which will be set up shortly) to face the correct way. If you have created your flame geometry a different way, you may need to amend these settings slightly to get them to point in the right direction (out from the sides of the emitter and bending upwards).

12 Add a Shape Instance operator and click on the Particle Geometry Object's None button and select the Flame Outer Cone object. Set the Scale Variation to 10, enable Animated Shape and set the Animation Offset Keying to Particle Age. Add a Position Object operator and add the Flame Emitter object to the Emitter Objects list. Enable Animated Shape and Subframe Sampling. Change the Location to Selected Faces, enable Separation and set the Distance to 20. Add a Speed By Surface operator, set the Speed to 0.01 and add the Flame Emitter to the

Surface Geometry list. Move the Rotation operator below the Speed By Surface operator and change the Display operator to show geometry.

Information: As both the emitter and the particle type's source geometry is animated, we have had to enable Animated Shape in both. Subframe Sampling has had to be enabled in the Position Object operator to correctly distribute the particles. The Separation has been enabled to force the particle to be born away from other ones, therefore forcing them to fill out the available faces that are gradually being made available to the particle system due to the animated emitter. The Rotation operator has been relocated so that the Speed Space Follow orientation works correctly, and the Speed By Surface Speed set to a low amount so that this information is passed on to the Rotation operator so the particles (flames) can be properly aligned. The speed is low enough not to have any visible effect on the animation.

PART FIVE: With the particles now born, we need to be able to amend their scale slightly over the duration of the animation to get them to twitch a little.

13 Add an Age test to the event, set the Test Value to 10 and Variation to 0. Drag out a Scale operator to the canvas to create a new event and label this event Flame Outer Scaler. Wire the output of the Flame Outer event's Age test to the input of this new event. Uncheck the Scale operator's Scale Variation Constrain Proportions, set the X Scale Variation to 10 and Y Scale Variation to 5. Add an Age test to this event and set the Test Value and Variation to 3. Drag out a Send Out test to the canvas to create a new

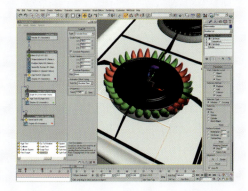

event, label this event Flame Outer Bypass, wire the Age test in the Flame Outer Scaler event to this event, and the output of the Send Out test to the input of the Flame Outer Scaler, to form a loop. Set all of the Display operators to show geometry to see the system in action.

Information: This event loop generates a random scale each time a particle is passed through the event, making it slightly bigger or smaller than the last time. We have had to add the Bypass event in as the particle system will not allow us to wire the output of the event directly to the input of the same event.

PART SIX: With one system set up, we need to duplicate the majority of it so we can generate the inner flame cones.

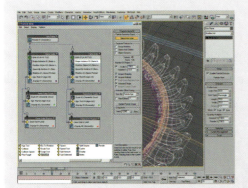

14 Select the Flame Outer, Flame Outer Scaler and Flame Outer Bypass events, copy and Paste Instanced them. Rename the copies Flame Inner, Flame Inner Scaler and Flame Inner Bypass. Ensure the wiring is still intact; if it is not then re-wire the new events as in the original events. Wire the output of the Gas Flame event to the input of the Flame Inner event. Make the Flame Inner's Shape Instance operator unique and change the Particle Geometry Object to the Flame Inner Cone object.

Information: As we have got two objects we want to distribute over the surface of the hob, we need to split the particle system into two separate sections – one to handle the birth and deformation of the outer flame and one for the inner flame. As a lot of the parameters can be shared, we can use instanced operators and even clone the majority of the event(s) for the other particle type. We could pass both emitter events to the same scaling event, but as we now need to assign materials to the system and as we are using multiple materials in one system, we need to assign the desired material operators to the correct event, else we would cause both particle types to have the same material, which is not desired.

15 Add a Material Static operator to the Flame Outer event. Copy it, and Paste Instanced it into the top of the Flame Outer Scaler and the Flame Outer Bypass events. Add a Material Static operator to the Flame Inner event. Copy it, and Paste Instanced it into the top of the Flame Inner Scaler and the Flame Inner Bypass events. Open the Material Editor and instance the Flame Outer material to the slot in one of the Flame Outer sets' Material Static operators. Instance the Flame Inner material to the slot in one of

the Flame Inner sets' Material Static operators. Select and right click the Gas Flame event and select Properties. Turn off Cast and Receive Shadows for this particle system.

Information: We have used instanced operators here, as before, to cut down on the amount of repetition in the particle system. Even though the Bypass events only hold onto the particles for a brief time, it is still long enough for them to be affected and to lose their material, so a copy of the material operator needs to be present here also. We do not want our flames to cast or receive shadows so we disable them in the root of the particle system.

PART SEVEN: Finally, we will design and distribute Omni lights to suggest that the flames are illuminating our scene before adding a render effect to add some extra glow to the scene.

16 Create an Omni light in the Top Viewport where the first flame will be emitted, and in the Left or Front Viewport position it so that it is in the center of the flame. Enable shadows, set the Multiplier to 0 and the color to RGB 70,112,225. Click on the Exclude button and add all of the Particle System's events to the right-hand list, so they are not illuminated by the lights. Change the Decay Type to Inverse Square, enable Show decay and set the Start to 0. Enable Use and Show Far Attenuation and set the Start to 0 and the End to 500. In the Shadow Map

Params rollout, set the Bias to 0.01 and the Sample Range to 20. Go to frame 5 and enable Auto Key. Set the Multiplier to 10, Inverse Square Start and Far Attenuation Start to 13. Go to frame 10 and set the Inverse Square Start and Far Attenuation Start to 8. Turn off Auto Key.

Information: Here we have simply positioned and animated the intensity and falloff of an Omni light to simulate the illumination from a single flame. We have used Inverse Square Decay as it is the best one that illustrates the true decay of light over distance. We have animated the size of the Start settings to suggest the size of the initial flame. The Far Attenuation's End setting is set at 500 to tell the decay where a setting of 0 will occur. Because of the way Inverse Square calculations are performed, the value will never reach zero and will continue on to infinity, which takes a little processing power. With the End setting we can tell the decay where to stop calculating, therefore saving resources. The Shadow map's Bias setting has been reduced to bring the shadows as close to the objects as possible, and the Sample Range increased to blur the shadows a little more. The particle events are excluded from receiving any lighting from these lights, as this will intensify them too much.

17 Using the Hob Lid as the rotational transformation axis, position another 31 copies (not instances) of the light around the hob at intervals of 11.25 degrees so that each one is centered in the middle of a flame. Working from top to bottom in the Top Viewport, select all of the keyframes of each individual light and offset them so that its animation kicks off when the relevant flame particle is born.

Information: This is a painstaking task and no other way (apart from distributing the lights using scripted operators in the particle system) to do it, but it is worthwhile at the end of the day, because the illumination from the light(s) complements the flame's color and intensity. To cut the workload down a bit, I used instanced lights across on the other side of the hob, so I only needed to offset the animation of one side of the hob's lights as they have virtually the same timing on the opposite side.

18 Open up the Effects panel and add a Lens Effect effect to its Effects list. In the resulting Lens Effects Parameters rollout, add a Glow to the right-hand list. In the Glow Element rollout, set the Size to 0.1, Intensity to 60 and Use Source Color to 100. In the Options tab, enable Effects ID (which already defaults to a value of 1). Finally enable the Meshsmooth modifiers in the particle's source geometry, hide these objects and the Flame Emitter objects and render off the animation.

Information: The final step sees us adding a subtle glow to each flame which is being controlled by the Material Effects ID we set earlier on. The resulting animation gives us a convincing effect, not only because of the animation of the flame, but because of the animation of the lighting. You may also want to add some Image Motion Blur to the particles to get them to smear together a little. You may find that this scene renders quite slowly. To speed it up a little, try reducing the Shadow Map's Size to 256 for each light. Also, try reducing the amount of Raytrace bounces in the scene (currently defaulting to 9, which is too high for just a simple reflection – a setting of 3 will suffice). As the Material Effects IDs are reflected in Raytraced maps or materials, the glow can also be seen in the Raytraced reflections in the scene.

Taking it further

The end result, especially with the introduction of the irregular motion to the flame, makes the scene very convincing. However, there are one or two things that could be done to improve the scene some-what. Firstly, try remodeling the scene – currently it's only a hob unit; try expanding the work surface, add tiling, an extractor and so on. All of these elements make the scene more realistic, even though they may not be visible in the shot, as they will be visible as reflections in the objects that are in shot.

Try adding a pan to the hob so that the flames start to heat its contents. If you have a gas stove, place a pan on the hob and observe how the flame bends and licks around the surface of the pan. To create this, you may have to rethink the flame construction method, such as using Blobmesh to generate the flame shape and multiple particles to create an individual flame so that they could be displaced by a surface (base of pan). Also, have a look at the wood-based fire tutorial on the DVD-ROM for a suitable solution.

If you have a look at the footage on the DVD-ROM, you will notice that there is the occasional flick of yellow color. This is caused by either the flame not being able to burn oxygen at that time (remem-ber your science lessons at school), or due to some debris being present in the gas jet that is quickly burned up. Either way, including this effect into our flame system would be advisable. To produce this, add the effect as part of an animated material. You could then offset the animation at random so it occurs on all flames but only on occasion and at random.

You may also want to change the lighting conditions in the basic scene so that it is illuminated from spot lights from the 'ceiling'. In which case you will need to amend the flame material a little and also the distributed lighting so that it is not overly intense. This intensity is due to the Additive Transparency used in the Material setup which will white-out the effect if used in a scene with addi-tional scene lighting. Therefore, try using increased output settings in the Self-illuminated material instead. For an example of this, please view the wood-based fire video tutorial on the DVD-ROM.

4 Oil fire

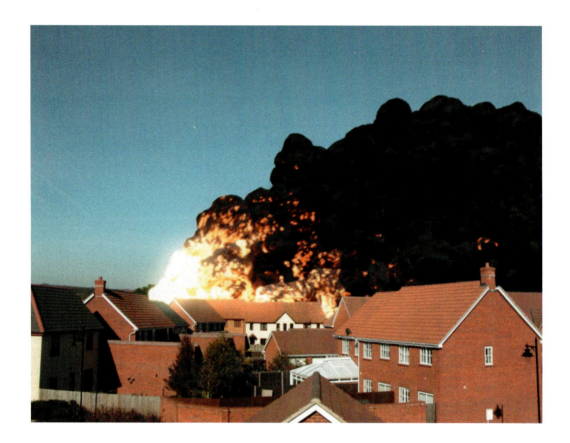

Introduction

As we do not have a dedicated smoke and/or fire generating system in 3ds Max (apart from the volumetric effects, which are not suitable), we will have to resort to using geometry to fake the fire and smoke. To do this we will design a particle 'puff' and assign it to a particle system that we will design and distribute across the scene. Next we will illuminate the scene based on the pre-shot background image that we are using, and then generate a material that will change in relation to the particle's age, converting it from fire to smoke. Finally, we will composite our rendered image with an overlay of the original background image using a mask to place the fire behind a row of houses.

Analysis of effect

(a) These specific fires have certain characteristics, namely a large mass of fire which is small in comparison to the huge plume of smoke that is emitted from the burning material. Bear in mind for this particular tutorial we are going to be basing the analysis on small-scale footage and images; the final result (and where you would see it in real life should you ever have the misfortune) is based on very large scale industrial accidents. In the reference material, we can see that even though the fire does lick up from the surface, it does not billow as much as, say, a gaseous fire. (b) Viewed from a distance, the intensity of this fire will merge into one large glowing mass, especially when viewed with a higher exposure (i.e. above 1:125 s shutter speed), however the resulting smoke plume will be more visible. As the fire licks and shoots up the smoke stack, some of the smoke still contains fire as it begins to billow and fold over on itself. (c) The smoke is also illuminated from the fire as well as from surrounding light (i.e. the sun and any bounced light) and appears solid due to the sheer mass of the material being consumed. This can result in slight highlights being picked out on the smoke as it folds over, giving an effect not dissimilar from a volcanic ash cloud. (d) From the initial combustion of the fire, we have a transition from fireball (condensed fire when viewed with a high exposure) through to dense fiery ash and smoke, which quickly diminishes and just forms a black plume which rises from the source in the wind and does not dissipate very much.

As mentioned in the Introduction section, we have no dedicated smoke or fire generation system built into 3ds Max (something like Afterburn for example), so we will have to create geometry, then shade and texture it so that it looks like a puff of smoke or fire. To do this, we can create a template object using scattered spheres over a larger sphere to generate a basic shape of what the puff should look like. We can then use this object in a Blobmesh object to smooth out the surface of the scattered object and create one solid mesh. This object can then be used in a long and thin particle system (to simulate the fire having already spread out) which has a low speed and slight divergence, just to get the particles on their way and to create a little bit of random motion. The main motion of the particles will be handled by a Wind Space Warp which will have a slight amount of turbulence to add a little more random motion to the puffs of smoke, and will also spin them more or less in the direction of travel (again to add a little randomness to the effect) which will therefore create a billowing effect. Next, we will illuminate the

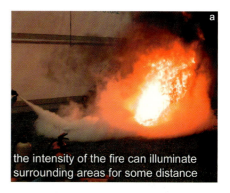
the intensity of the fire can illuminate surrounding areas for some distance

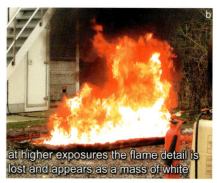
at higher exposures the flame detail is lost and appears as a mass of white

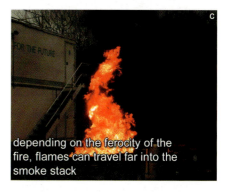
depending on the ferocity of the fire, flames can travel far into the smoke stack

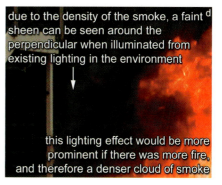
due to the density of the smoke, a faint sheen can be seen around the perpendicular when illuminated from existing lighting in the environment

this lighting effect would be more prominent if there was more fire, and therefore a denser cloud of smoke

scene using a lighting rig to simulate illumination from the surrounding environment, and generate a material that will change color based on the particle's age. This material will consist of multiple Particle Age maps that will drive the Diffuse color and the Self Illumination, to create a slight rim effect on the smoke making it appear softer. The Bump strength will be controlled by another Particle age which will fade it in after the fiery glow has diminished. Finally, we will jump into Video Post and overlay the foreground houses in the background image back on top of the render, so it appears as if the fire and smoke are coming from behind them.

Walkthrough

PART ONE: First we will lay out the basics of the initial scene to drive the particle system.

1 In the Top Viewport, create a large Deflector Space Warp approximately 4000 × 2000 and set its Bounce to 0. Drop it down in the Left Viewport a little, say 100 units. Right-click the Play Animation button and set the Animation Length to 400 frames.

Information: We have created a Deflector so that any particles we create that have an erratic motion derived from any variation in speed or Space Warp's influence will not pass beneath the ground, but will travel along it. We have increased the amount of frames so we can set keyframes to drive the smoke's characteristics.

2 In the Top Viewport, create a Wind Space Warp. In the Front Viewport, rotate it 75 degrees clockwise so that it is pointing to the right and facing upwards. Set the Strength to 0.01 and Turbulence to 0.1.

Information: As it is smoke, we do not want it to ricochet off the surface, hence setting the Bounce to 0. We have added a little turbulence so that the particles move around erratically as if being caught in the wind a little.

PART TWO: Next we will add in a background image, and position a camera accordingly so they match up.

3 Open up the Environment window and click on the Environment Map's slot. Add a Bitmap map to this slot and load in the *oil_background.jpg* image that can be found in this tutorial's folder on the DVD-ROM. Open up the Material Editor and drag this map to an empty slot in the Material Editor. Go to the Views menu and select Viewport Background. In the resulting panel that pops up, select Use Environment Background and enable Display Background. Click OK to exit this window.

Information: We have loaded in the background image so that we have got something to render out our smoke and fire onto. Even though the map has been loaded into the Environment Map's slot, amending the map is more difficult than normal because you have to load in a new Bitmap map to set new settings every time. Therefore if we drop this map into the Material Editor we can amend it later on, if desired, without having to completely reset any tiling, mapping, Output settings and so on that we may have already set up.

4 In the Top Viewport, create a Camera along the middle of the scene and drag up to create its Target. In the Left Viewport, select the Camera and reposition it across to the right in this Viewport (so it is forward in the scene at approximate co-ordinates of 0, –1110, 30 with its Target at co-ordinates –6,745, 400). Set the camera's Lens size to 35 mm. The Camera Viewport should be referred to at all times to ensure that the ground level is positioned correctly with respect to the background image.

Information: We have repositioned the camera so that it represents the position at which the image was taken – out of a third floor attic window, looking up slightly (hence the target being repositioned higher than the camera) and showing a lot of sky so we can render off the smoke onto a large blank sky canvas.

PART THREE: Before we create the particle system we will create the particle shape using compound geometry.

5 In the Top Viewport, create a Geosphere primitive and set its Radius to 25. In the same Viewport, create another Geosphere and label it Smoke Puff Template. Set its Radius to 5 with 2 Segments and enable Base to Pivot.

Information: Our smoke, as illustrated in the reference material and in the Analysis section, needs to be quite detailed, so we need to create a particle which has as much detail as is necessary. To do this we will create the basic shape using a number of small scattered spheres over a larger sphere, and then use the result to create a Blobmesh object to be used as our smoke puff. Base to Pivot is used so that the small detailed spheres are sitting on top of the larger sphere and are not intersected half-way through the geometry.

6 With the small Geosphere still selected, create a Scatter Compound Object. Click on the Pick Distribution Object and select the large Geosphere. Set the Duplicates between 30 and 50 and expand the Transforms rollout. Set the X and Y Rotation to 90 and the Z to 360. Enable Use Maximum Range and Lock Aspect Ratio in the Scaling section and set the X Scaling to 75. Hide the original large Geosphere as it is no longer needed.

Information: Here we have taken a single small sphere and distributed it numerous times (at random) over the surface of a larger sphere. Because of the Base to Pivot option in the source geometry, the smaller spheres are not intersecting with the larger sphere because their pivot point has been relocated. However, we do want some to intersect a little, so the Rotation values are amended to get them to rotate in all axes at random. We have also added a scale variance so that the spheres are distributed with different sizes. Should you feel the shape is too uniform, try upping the amount of spheres a little or select the Distribution object in the Objects list and add a Noise modifier, or some other deformation based modifier, above the Geosphere's modifier.

7 Add a Blobmesh object to the scene and ensure the size is set to 8. Set the Render and Viewport Evaluation Coarseness to 6 and add the Smoke Puff Template object to its Blob Objects list. Add a UVW Map modifier to its modifier stack and set the Mapping type to Shrink Wrap. Go to the Hierarchy tab, click on Affect Pivot only and click in Center to Object.

Information: Using this object on the Scatter Compound object blends all of the spheres together to form one large, err, blob. Depending on the positioning of some of the spheres you may notice a few small holes in the Blobmesh where it has not closed them properly. To get around this, try entering a new seed for the Scatter's distribution, or amend the rotation values slightly. We are using Shrink Wrap mapping to lock the procedural texture to the object, else it will float. Depending on the speed of your machine, you may want to increase the coarseness setting to about 10 to reduce rendering times. The Blobmesh pivot point has been centred as it was located where the object was originally created, and the particle system takes this point as the particle center.

PART FOUR: Next we will position and design the particle system that will make use of the Space Warps we have already placed in the scene.

8 In the Top Viewport create a long thin Particle Flow system, roughly behind the houses at co-ordinates –120,750,20 (depending on your scene setup) approximately 100 long by 800 wide. Set the Viewport Quantity Multiplier to 10 and set the Render Integration Step to Frame. Open Particle View and set the Birth operator's Emit Start to –300 and Emit Stop to 400 with Amount set to 2500. Select the Speed operator and set the Speed to 20. Enable Reverse and set the Divergence to 2.5.

Information: We have created the particle system so that it is quite long and thin to simulate an area where the fire has spread. The Birth operator's Start time was set back to frame –300 giving the particles enough time to populate the scene before we join the scene at frame 0, else we would have to join the scene at frame 300 to have smoke already emitted.

9 Replace the Shape operator with a Shape Instance operator. Click on the Particle Geometry Object's None button and select the Blobmesh object. Add a Force operator and add the Wind Space Warp to its Force Space Warps list. Add a Spin operator and set the Spin Rate to 25 with 25 Variation. Set the Spin Axis to Speed Space Follow with X and Y set to 0.25 and Z to 1. To see the Shape Instance operator in action, set the Display operator to display geometry.

Information: Here we have removed the standard particle shape and replaced it with an operator which uses our Blobmesh object as the particle shape. The Spin operator has been amended so that it spins at a slow rate and follows in the direction of the particle's motion, albeit with a little bit of randomness added thanks to the small X and Y values.

10 Add a Scale operator to the particle system. Turn the particle system off. Set the Scale Type to Relative First and set the Scale Factor and Scale Variation to 50 for all axes. Set the Animation Offset Keying Sync By to Event Duration. Go to Frame 300, enable Auto Key and set the Scale Factor to 380 for all axes. Turn Auto Key back off. Add a Material Dynamic operator and a Collision test to the event. Add the Deflector to the Deflectors list in this test. Finally, add a Delete operator, enable By Particle Age and set the Life Span to 600 with 100 Variation. Turn the particle system back on.

Information: We have disabled the particle system so we can quickly go to a higher frame without it having to calculate the particles. We have set the Scale operator to increase the size of the particles over 300 frames, relative to the time of their birth. This means that they are born with 50% of their original size (set in the original instanced geometry) and are then scaled up over 300 frames to 380%. The Deflector prevents any wayward particles sinking below the ground and the Material Dynamic operator allows us to change particle color depending on particle age, which we will set up shortly. Finally, as this operator needs to know how old a particle is, it needs to work out when it is going to die, hence the addition of the Delete operator, which is set to a high value so the particles will be way off frame before they die, and don't just disappear.

PART FIVE: With the particle system almost complete, we will create the lighting to illuminate the scene.

11 Change the Display operator to something a little more manageable (I'm still using the geometry to display the lighting). Select the Blobmesh and Smoke Puff Template objects and hide them. In the Top Viewport, create an Omni light, set its Multiplier to 4 and color to RGB 233,66,18. Enable Far Attenuation's Use and Show and set them to 80 and 500 respectfully. Instance this light another nine times (10 lights in total) and arrange them so that there are three lights either side of the particle emitter 'strip' and the rest around the left edge as viewed in the Front Viewport as illustrated.

Information: We have created these lights and positioned them around the base of the particle emitter to simulate a glow from the emitter, and also to intensify any colors and smoke around these areas. The intensity is reduced with distance due to the attenuation. Note that there are no shadows enabled for these particular lights.

12 In the Top Viewport, create a Direct light coming from behind the camera and slightly to the left and label it Sun. Reposition it up in the Left Viewport so that it is at about 2 o'clock in relation to the particle system, as illustrated. Enable Shadows, set the light's color to RGB 255,255,247, enable Overshoot and set the Falloff/Field so that it covers the entire particle system (plus a little more) as visible in all Viewports. Set the Shadow Map Bias to 0.01 and the Size to 1024.

Information: We have positioned and colored this light to simulate the main key light in the scene, which is the Sun because it has linear shadows, not fanned out like an Omni light or a Spot light. Overshoot has been enabled to illuminate any other objects in the scene which are outside the Falloff/Field boundary. This boundary has been increased as no shadows are cast outside it. The Bias has been reduced to reduce any shadows detaching from the objects that cast them. The Shadow Map Size has been doubled to increase the definition and detail of the shadows.

13 In the Top Viewport, drag a Direct Light from the left side of the scene to the center (so the target is at 0,0,0) and label it Sky. Enable Shadows, set the Multiplier to 0.05 and the color to RGB 140,200,220. Enable Overshoot and set the Falloff/Field to 1500. Turn off Specular and set the Shadow Map Size to 128 with a Bias of 0.01 and a Sample Range of 8. Instance this light at right angles to the original so they are the same distance from the center of the scene with both targets in the center. Instance these again so you have a total of 4 lights, each at right angles to one another as illustrated.

Information: We have created a few low level lights to simulate illumination from the sky by point-sampling a color from the background image. As there are going to be a lot of lights in this array we only need them to be low intensity, else they will completely wash out the entire scene. With the large number of lights, the cloud will be shaded properly with numerous shadows and diffused lighting. We have turned Specular off else we would get numerous highlights all over the smoke, which would look odd, plus we have reduced the map size to reduce light calculation times and memory at the expense of a little quality, but this is negligible. *Please be aware that the high amount of polygons generated by the particle system, and the high amount of lights, have a big effect on rendering times. If rendering times are too high for you, either turn off shadows for these lights or remove them entirely, replacing them with a single non-shadow casting Skylight light.*

14 Select all four of these lights (not their targets) and rotate-clone them at intervals of 22.5 degrees to create a ring of 16 lights. In the Left Viewport, move these lights upwards as illustrated, then clone them to create another ring pointing down onto the scene and another ring below looking up. Select all of the Sky lights and their targets and reposition the entire array so the targets are right in the center of the particle system.

Information: The final array covers almost all areas of illumination from the 'sky'. We have even created a ring of lights to simulate uplighting from the ground. This illumination creates an even, diffused lighting effect.

PART SIX: Next we will create a material for the fire and smoke so they blend together over time, plus we will drop in extra lighting to suggest illumination from the fire.

15 Open the Material Editor and label a new material Oil Fire. Set the Shader to Oren-Nayar-Blinn and enable Self-Illumination. Expand the Maps rollout and add a Particle Age map to the Diffuse slot and label it Smoke Color. Set Color 1 and Color 2 to RGB 75,75,75 and Color 3 to RGB 40,40,40. Set the Color 2 position to 30 and the Color 3 position to 40.

Information: We have amended the shader type so that it gives us a nice diffused falloff that is suited to the smoke effect. We have also enabled Self-Illumination so that we can add some glowing parts to the smoke around the emission point. The Particle Age map was added to the Diffuse slot so that the smoke will change color and darken more over time, as illustrated in the reference material. The position settings were amended to make the colors change earlier in the particle's life, so that immediately after the 'fire' is born it changes color to the dark 'smoke'.

16 At the top of the material, add a Particle Age map to the Self Illumination slot and label it Fire/Highlight Mixer. Set the Color 2 position to 30 and the Color 3 position to 40. Expand the Output rollout and set the Output Amount to 2. Add a Falloff map to the Color 1 slot and label it Fire Glow. Set the Front color to RGB 227,177,82 and Color 2 to RGB 180,40,0. Expand the Output rollout and set the Output Amount to 2.

Information: As we want the glow from the fire to diminish relatively quickly, leaving a black plume of smoke, we set the Color 2 position of the Fire/Highlight Mixer to a lower value so its initial intensity fades away relatively quickly. The Output amounts have been increased to increase the intensity of the fire effect, and the Falloff map has had its colors changed to simulate a fiery edge glow effect with a bright center.

17 Add a Falloff map to the Color 2 slot of the Fire/Highlight Mixer map and label it Glowing Embers Control. Swap the colors, set the Mix Curve's point at the top right of the curve to Bezier-Corner and drag out the resulting handle all the way across to create an arced curve. Set the Output Amount to 5, add a Noise map to the Front slot and label it Embers. Set the Source to Explicit Map Channel, Noise Type to Fractal, Size to 0.01, High to 0.6, Low to 0.5, Levels to 10 and set Color 2 to RGB 180,25,0. Disable the particle system, go to frame 400, enable Auto Key and set the Phase to 3. Turn Auto Key back off.

Information: Here we have created a Noise map which has its phase animated a little over time to break up any repetition in the animation. It is also masked out by the Falloff map so that it does not appear on the perpendicular, where the smoke would have had chance to cool down and stop glowing. The Mix curve was amended to exaggerate this effect a little.

18 Add a Falloff map to the Fire/Highlight Mixer map's Color 3 slot and label it Smoke Rim Mask. Set its Falloff Type to Shadow/Light. Add another Falloff map to its Light slot, label it Smoke Rim Color and set the Falloff Type to Fresnel. Set the Side color to RGB 10,10,10.

Information: The combination of these two Falloff maps enables us to create a slight rim glow which makes the smoke appear softer. This rim effect is masked out by a Shadow/Light falloff so that it is most prominent when it is in direct illumination, and not in shadow.

19 At the top of the material, set the Bump amount to −100. Add a Mask map to the Bump slot and label it Smoke Bump Control. Add a Particle Age map to the Mask slot of this map and label it Bump Age Control. Set Color 2 to black, set its position to 20 and Color 3's to 30. Add a Smoke map to the Mask map's Map slot and label it Large Smoke. Set the Source to Explicit Map Channel, Size to 0.2, Iterations to 3 and the Exponent to 0.7. Enable Auto Key at frame 400 and set the Phase to 3. Turn Auto Key

back off. Copy this map into the Color 2 slot, go into this map and rename it to Small Smoke. Set the Size to 0.002, Iterations to 20 and Exponent to 1. Set Color 1 to RGB 185,185,185 and Color 2 to white.

Information: The Mask in the Bump map is so that the glowing fire is not assigned any bump at all. The bump only comes into play once the particles have reached a certain age, at which time the material colors have started to change and the self illumination is being broken up into embers. At this point the smoke will start to billow, which is when we need the bump to increase. We have two animated Smoke maps which control the bump; one to generate a large billowing effect and the other small one to add detail around each cloud. The Bump value was set to a negative amount as the white color(s) in the Smoke map would cause the bump to be indented, which we do not want. Therefore a negative setting was used to get the bump facing the correct way; we could have flipped the colors of the Smoke maps, but this is an easier method.

20 Open up Particle View and instance this map to the slot in the Material Dynamic operator. Create a Box and assign this material to it. Right click the keys at frame 0 and select one of the Phase keyframes. Amend the Out curve to a linear attack and click on the arrow next to it to send this information to the next keyframe. Perform this to every Phase keyframe assigned to this box and hide it when finished.

Information: We needed to amend the keyframe curve information of the smoke so the phase did not speed up and slow down. As the keyframe information was not accessible via the keyframes in the particle system, we could simply assign it to a box and amend them there. We could of course have navigated through the Function Curve Editor to find the relevant maps to amend their keyframes, but this would have taken longer.

PART SEVEN: Finally we will drop in a copy of the background image on top of the entire render and use a mask to only reveal the smoke and fire behind the houses.

21 Open Video Post and click on the Add Scene Event button. Click on the Add Image Input Event button and load in the *oil_background.jpg* image as before. Highlight both of the events and click on the Add Image Layer Event button. Select Alpha Compositor from the menu and load in the *oil_background_mask.jpg* image. Change the Mask type to Luminance and click OK to exit the panel. Add an Image Output Event (if desired) and render off the animation.

Information: The Alpha Compositor overlays the image on top of the render (the result of the Scene Input Event), using the mask map to control how the images are put together. The result is the smoke is rendered off against the background environment image, with the composited houses from a copy of the background image added on over the top. The final result is an effective smoke effect with hot embers, but it appears too pixilated. To remove this, add a little Image Motion Blur to the particle system by right-clicking the root event of the system in Particle View, selecting Properties and enable Image Motion Blur with a setting of 1 or 2.

Taking it further

Due to the masking of the houses, the majority of the intense glowing area of the fire section of the particle system will be occluded from the final render. Therefore, you may wish to raise the particle system a little off the ground (and the Omni lights accordingly), or reposition the camera further towards the ground to get the smoke emitter to raise up a little. This scene's camera matching, as it currently stands, does not have to be completely accurate as we have only got a single particle system in there which is virtually side-on to camera and travels off-frame. However, should you want to drop in other elements such as the odd fire engine arriving to put out the fire, you may have to amend the camera's positioning and settings to get it to match exactly.

You will also want to add a few post effects to the fire to get elements to glow a little. The best way to do this would be to assign Material Effects ID's to the Fire Glow and Embers maps, and add a Glow effect which uses this ID and also the brightness of the image (so that no grays are brightened in the embers map); the Taking it Further max file included illustrates this procedure. You could also do the glows 'manually' in post using selective color ranges to assign any glow or illumination-based blur. The main problem with this is that the background image will have some of these elements in there as well due to the orange in the brickwork. Therefore you will have to render off the smoke animation on its own without any background or foreground so you can just assign the glow to the smoke layer. The final rendered image, which is at the beginning of this tutorial, uses this method and was composited in Photoshop, with the *04_oil_fire_glow_ps.mpeg* using exactly the same method on every single frame of the animation, by using an action. However, if you have a compositor such as Combustion this process can be done a lot easier.

Due to the geometry count (it hits about 5 million), this scene may take a very long time to render – the light calculation time takes the longest, so I would seriously advise you that you render it off overnight. You may also want to turn off the shadows in the lighting rig and just keep the single shadow from the sun light, as this will ensure the scene renders off a lot faster. If your machine is quite a low spec, try reducing the amount of particles in the scene and/or increase the Blobmesh's Viewport and Render Evaluation Coarseness so that there is not as much geometry in each smoke puff. Even increasing this setting by a small amount will improve render times. If all else fails, try creating a low polygon Geosphere with a Shrink Wrap UVW Map applied and use that as the particle type instead. If you have a later version of 3ds Max, it might be worthwhile using Render to Texture to bake out a normal map of the high polygon smoke puff and apply that to a lower res puff to seriously reduce rendering times!

5 Flamethrower

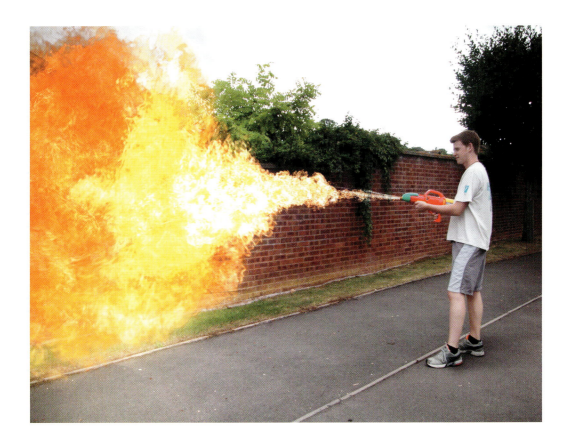

Introduction

Now I must admit that I had been looking forward to doing this particular effect ever since the idea for this book turned up. Now before anyone starts emailing me and calling me a weirdo, the reasoning behind this is because of the way Particle Flow can now handle materials; more to the fact, the way it can handle animated maps. Previously, if we wanted to create this kind of effect we had to produce some weird filmstrip-type map on a plane and animate the filmstrip like a flipbook, then use this plane as the particle type with its animation (the animation of the filmstrip using a UVW Map modifier) set to fire off when a particle was born. Well, not any more. Particle Flow now enables us to key off our pyro animations automatically, and thanks to those spiffing chaps at Getty Images for the use of these sequences and an Oscar-winning performance from Rob 'Tutorial Checker' James armed with the mighty water pistol, we can now create some very convincing effects.

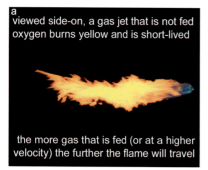

a
viewed side-on, a gas jet that is not fed
oxygen burns yellow and is short-lived

the more gas that is fed (or at a higher
velocity) the further the flame will travel

Image courtesy of Getty Images

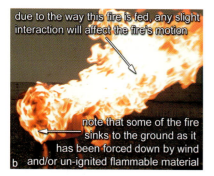

due to the way this fire is fed, any slight
interaction will affect the fire's motion

note that some of the fire
sinks to the ground as it
has been forced down by wind
b and/or un-ignited flammable material

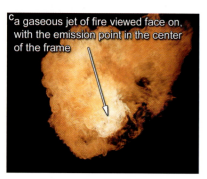

c a gaseous jet of fire viewed face on,
with the emission point in the center
of the frame

Image courtesy of Getty Images

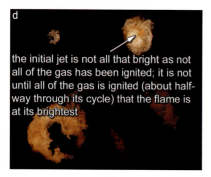

d

the initial jet is not all that bright as not
all of the gas has been ignited; it is not
until all of the gas is ignited (about half-
way through its cycle) that the flame is
at its brightest

Image courtesy of Getty Images

Analysis of effect

(a) Okay, first things first. Now this may sound like an excuse to you, but sourcing this type of material for reference is very difficult (due to the nature of the object in question). Many atrocities have been performed, and some avoided, by the use of this type of weapon, but it is something that I, and the publishers of this book, are not keen on showcasing. (b) We are therefore going to base our effect on a widespread gas jet effect (such as a jet engine, afterburner or gas fire) and not the petroleum-based stream of fire that you see in war films and other footage. If this is the type of effect that you want to try, have a look at some of the movies available that use this type of weapon – *Aliens* is a good example, not only because of its usage but because of the close-ups, high crane shots, side shots and illumination from the flame in a dimly-lit environment. Perfect for reference material (plus it's a good film). (c) As we are basing our flamethrower effect on a gaseous fire, we have sourced a front-shot of a gaseous fire emission, so we do not have to worry about the motion of the fire and the way it billows (etc.) as this is already handled in the animated maps provided. What we do need to concentrate on is the way the fire behaves after emission from the weapon. This particular type interacts with the air more than other types and has a tendency to fan out, with some progressing to the ground creating a large fire cloud a short distance away from the person holding the weapon. This results in a wide expansion of the flame and also, when the fire interacts with another surface, a rolling effect as it flows over the surface. (d) The colors are quite intense, with the main jet being very bright after the gas has been ignited, which diminishes to bright oranges and yellows before the gas is finally burned off without leaving a trace of smoke (unless a surface is scorched or set on fire). Due to the intense colors the flamethrower would illuminate the scene somewhat and cast diffused shadows around the objects that cast them.

As mentioned in the Introduction section, we are going to use a feature in 3ds Max that allows us to key off the timing of an image sequence or animation file (e.g. an AVI or MOV file) that is assigned to a particle, so that when the particle is born the animated map assigned to it also begins to play. We will utilize this feature with an animated sequence which was extracted from pyro footage provided by Getty Images. This animated sequence will be assigned to facing particles that will be emitted from a finite point, and positioned and aligned at the end of an animated non-renderable proxy object that roughly matches the angle and positioning of Rob's water pistol; therefore we have the correct trajectory. In this backplate footage, Rob fires the water pistol at a certain frame so we will start the particle system from this point. The resulting water arc in the backplate

needs to be occluded so we can fan out the particles a little. When he stops firing the pistol we will turn off the particle system as well. As the flamethrower needs to interact with a nearby wall we will create Deflector Space Warps so that the particles can react with the 'wall' and roll off it. Using additional particle spawning and the Shape Mark operator with a gradient texture assigned to it, we can create a scorch mark and rising smoke from the impact of the particles hitting the deflector – we just ensure that the backplate animation cuts off before Rob walks in front of this mark else we would have some additional masking to do. Finally, to increase the intensity of the flame we can link an Omni light to the end of the flamethrower and animate its Multiplier setting. In addition to this we can add a glow effect to this light so that it brightens the scene including the backplate and simulates light being emitted from the flame, albeit very basically.

Walkthrough

PART ONE: First we will load in the initial scene and set up any additional Space Warps that we need to drive the particle system's motion.

1 Open up the *Fire/05_Flamethrower/Source/05_ flamethrower_start.max* file included on the DVD-ROM. Select the Top Viewport and create a Gravity Space Warp. Select the Left Viewport and create a Wind Space Warp. Set the Strength to 0.01, Turbulence to 0.15 and Scale to 0.1. Finally, rotate this Space Warp 180 degrees in the Front Viewport so that it is pointing in the opposite direction.

Information: Our basic scene has a few items already set up for us. As our background footage is PAL (25 frames per second), this time base has been pre-set and the length of the animation set to 380 frames (0–379 inclusive). The objects in the scene are non-renderable so they will not appear in the final render, but we can use them to position other objects that we will create later on. The Environment background has been set to the footage of Rob firing the water pistol against the wall, and has also been put to the background of the Camera Viewport which matches the field of vision of the camera which shot the footage. The cylinder in the scene has been positioned and animated to approximately match the positioning and rotation of the water pistol over the duration of which the water is fired, which is the only time period we are interested in for our particle emission. We have created these Space Warps to get any smoke to rise up, and also for the emitted fire particles to spread out and fall to the ground a little (due to the liquid gas propellant being heavier than air).

2 In the Left Viewport, create a Deflector Space Warp which overlays the Box01 object in this Viewport. Label it Deflector Wall. Set the Bounce to 0.1, Variation and Chaos to 50 and Friction to 75. Using the Align tool, position this Deflector in the same position as the Box01 object. In the Top Viewport, reposition the Deflector as necessary so that it is situated just to the right-hand-side of the Box. Copy this Space Warp and label it Deflector Ground. Using the Align tool again, position and align it to the Plane01 object in the scene. Scale or increase its dimensions to completely cover the Plane object and set its Bounce and Variation to 0.

Information: As we have objects in the scene already positioned in the right places, we can use them to position these new Deflectors in the right positions using the Align tool. Okay okay, we could have used a couple of UDeflectors, but as the deflection would be based on the object's geometry, we may get a little particle leakage, which we would have to combat by increasing the Integration Step of the particle system we are going to create later on. This would also have an adverse effect on particle calculation times.

PART TWO: Next we will set up the flame material for our particle system, and also a bright material which will be emitted as a spray from the gun.

3 Open the Material Editor. Label the material in material slot 2 Flame Sprite. Enable Face Map and Self-Illumination. Expand the Map's rollout and add a Bitmap map to the Diffuse slot. Load in the *flamesprite01.avi* animation to this map. Expand this map's Time rollout, Playback rate to 2, enable Sync Frames to Particle Age and set the End Condition to Hold.

Information: Please be aware that enabling the Sync Frames to Particle Age option results in a lag while 3ds Max loads in the animation. This will be apparent whenever this material is viewed for the first time or if the map is amended (i.e. reloaded etc.), so do not worry if 3ds Max hangs for a little while. This is also apparent when rendering for the first time while it loads in the frames, so render off a small frame to start with to get it out of the way. Face mapping has been used even though the facing particles in the particle system we will create has mapping by default, it is a good habit to get into for these types of particles should we decide to assign the material to another facing planar object, such as the legacy particle system. The Playback Rate has been increased to speed up the playback of the sprite as it is too slow for the effect we desire; the source animation was originally filmed using a speeded up film camera, so

we have a time distortion effect visible when played back. This is not something we want so we can pretty much restore the clip back to what it is supposed to look like – fast moving and billowing fire by increasing the Playback Rate. As our sprite animation, which is timed to the birth of particles in the forthcoming particle system thanks to the Sync Frames to Particle Age option, may finish before the particle dies, we need it to remain transparent. Setting the End Condition to Hold ensures this and sets it so that the animation does not loop and start off again for the remainder of the particle's life.

4 Back up at the top of this material, instance the Bitmap map in the Diffuse slot into the Self-Illumination slot, and copy it into the Opacity slot. Go into the map in the Opacity slot and replace the animation in this map with the *flamesprite01m.avi* animation.

Information: As we are using the Self-Illumination option, we are using the intensity of the animation to create the self-illumination effect. This has its pros and cons – pros in the fact that it appears more realistic and is not completely washed out, cons in the fact that, in some places (i.e. at the end of the sequence) the animation can appear quite dull. However, due to this type of self-illumination, we can set up additional illumination in the scene to intensify any objects with this material assigned to it, e.g. the particle system.

5 Label a new material Spray. Set its Diffuse color to white and set the Self-Illumination of this material to 100. Set the Opacity to 75. Expand the Extended Parameters rollout and set the Advanced Transparency Type to Additive.

Information: A very simple material for a very simple reason. The initial sprites, when emitted from the particle system we will create, will be quite small and will not expand for a few frames. This therefore results in gaps being visible between particles as these sprites expand. We could generate a lot more particles to fill in the gaps and then kill the majority of them off once the gaps had been filled; I would only advise this if you have a fast processor as max still has to work out a lot of opacities to fill in these gaps. Covering up these gaps with a smaller system takes less time to render and also looks like a jet of unignited fuel.

PART THREE: We will now create and set up the particle system which will drive the motion of the flames.

6 In the Top Viewport, create a small-sized Particle Flow system and label it Flamethrower. Set the Viewport Quantity Multiplier to 100, expand the System Management rollout and set the Viewport Integration Step to Half Frame. With this particle system still selected, click on the Align tool and select the Cylinder01 object. Enable X Y and Z Align Position and Align Orientation and change the Current Object and Target Object options to Pivot Point. Finally, link this particle system to the Cylinder01 object.

Information: The size of the system is not relevant as the particles will be emitted from the Pivot point of the particle system's icon – it is small purely to keep the Viewport tidy. The Quantity Multiplier has been set to 100, to match those of the renderer, so we can see how many particles we are dealing with in the system. The Integration step has been set to match the renderer so we can see what rendered results we are going to get. As the amount of particles is quite low (in comparison with other systems we have devised in this book) increasing these two settings will not have much of an effect on our Viewport interaction. As the pivot point of the Cylinder01 object is at the nozzle end of the water pistol in the background footage, the particle system is repositioned and aligned correctly. As the cylinder moves and rotates to match the motion of the water pistol in the background footage, we need the particle system to follow suit. Therefore it is linked to the cylinder so that the particles appear to be emitted from the nozzle of the water pistol at every frame, else the system would remain in the same position while the nozzle moves around slightly, therefore ruining the effect.

7 Click on the Particle View button in the Particle Flow's Setup rollout, or Press 6 to open up the Particle View window. Rename the Event 01 event to Flames. Select the Birth operator and Emit Start to 49, Emit Stop to 155 and Amount to 500. Select the Position Icon operator and set the Location to Pivot. Select the Speed operator and set the Speed to 500 with a Variation of 200. Enable Reverse and set the Divergence to 3.

Information: Here we have the basic properties of our flamethrower effect, and as you can see they are quite straightforward. As Rob pulls the trigger of the water pistol at frame 49 (we can see this by viewing the water jet at frame 50 in comparison to frame 49 by scrubbing forward in our

animation) we have set the particles to be emitted at the same time. We have set the Position Icon operator's Location to Pivot so that the particles are emitted from a fine point, simulating them being emitted from the fine nozzle of the water pistol; if this were a 'true' flamethrower, the nozzle would be bigger, therefore a circular Icon would be used to distribute the particles. The Speed has been set to a higher setting to match the velocity of the water jet, which is used as reference, and the Variation increased to cover any gaps in the particle system and to get particles to pass one another, breaking up any similarities that might be visible due to using just one animated sprite in the particle system.

8 Select the Rotation operator and set it to Random Horizontal. Drag out a Shape Facing operator to the event and overwrite the existing Shape operator with it. In this new operator, click on its Look At button and select the Camera in the scene. Set the Size/Width In World Space Units to 300 with 35 Variation, expand the Orientation menu and select Allow Spinning. Add a Spin operator and set the Spin Rate to 100 with 200 Variation.

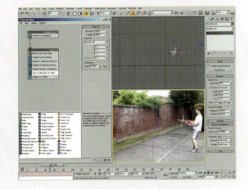

Information: The Rotation operator adds an initial rotation as the particles are born (else they would all be facing the same way), and the Spin operator allows them to spin which is restricted by the Shape Facing operator so that they do not tumble in all axes.

9 Add a Material Dynamic operator to the event and Instance the Flame Sprite material to the material slot in this operator. Add a Force operator, add the Gravity01 Space Warp to its Force Space Warps list and set the Influence to 100. Add a Delete operator to the event, enable By Particle Age, set the Life Span to 38 and Variation to 0. Add a Collision test to the event and add the two deflectors in the scene to its Deflectors list.

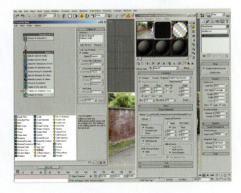

Information: As the material assigned to the particle changes with time, we have to use a Material Dynamic operator. The Force operator's Influence is reduced to bring the particles down slightly, to suggest some fuel that has not yet been fully ignited and is therefore heavier than air. The original sprite's animation is 75 frames long, therefore playing it back at twice the speed means that it will run for 37.5 frames. Therefore after the particle is older than 38 frames, it will have played the sprite and will just be transparent, so it can be deleted. The Collision test has been added to send the particles onto the next event should they hit the wall or ground.

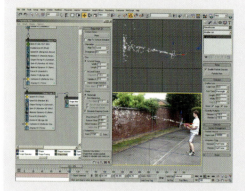

10 Select the event, copy, and Paste Instanced it onto the canvas to create a new event. Label this new event Flames Wall. Remove the Birth, Position Icon and Rotation operators. Make the Speed and Force operators unique. Select the new Speed operator and set the Speed and Variation to 100 and Random 3D Direction. In the new Force operator set its Influence to −100. Add a Spawn test to the very top of this new event and set the Spawnable % to 4. Wire the output of the Flames event's Collision test to the Input of this event. Drag out a Shape Mark operator to the canvas to create a new event. Label this event Scorch Mark and Wire the Output of the Flames Wall's Spawn test to the input of this new event.

Information: We have had to duplicate a lot of the features we have set up in the first event as their properties get changed or lost if they are passed onto another event. The Speed has been amended so that the particles (fire) get dispersed more when they hit the wall and also now rise more thanks to the inverted Influence value of the Force operator. The Spawn test has been added to create extra particles to be overlaid on top of the wall, by using a Shape Mark operator to control where and how they are displayed.

11 In the Shape Mark operator, add the Box01 object to the Contact Object button. Set this operator's Width, Length and Impact Angle Distortion to 200. Enable Box Intersection and set its height to 0.01. Create a new material and label it Scorch Mark. Set the Diffuse color to black and enable and Self Illumination. Add a Mask map to the opacity slot and add two Gradient maps set to Radial to both slots in this map. In the Gradient map in the Map slot, set Color 2 to RGB 25,25,25 and Color 3 to RGB 65,65,65. Set the Noise Amount to 0.5 and Size to 5. Add a Material Static operator to the Scorch Mark event and instance this material to this operator. Add a Spawn test to the event, set to Per Second and set the Rate to 3. Drag out a Shape Facing operator to the canvas to create a new event and label it Smoke. Wire the output of the Scorch Mark event's Spawn test to the input of this new event.

Information: Quite a big step, but all quite self-explanatory. The Shape Mark operator is set to Box Intersection so that the top of the resulting particle type does not overlap the Box01 object in the scene, which represents the wall, therefore not scorching (using the material we have set up) the sky and surrounding foliage. Angle Distortion has been used to suggest that the fire has run across the wall and scorched a strip along it (depending on the angle of the incident particle hitting the surface) instead of just a uniform scorch mark.

12 In the new Shape Facing operator, set the Size to 40 with 50 Variation. Add A Force operator and add the Wind Space Warp to its Space Warps list. Add another Force operator and add the Gravity Space Warp to its Space Warps list. Set the Influence to −30. Add a Material Dynamic and a Delete operator to the event and set the Delete operator to By Particle Age with a Variation of 20. Instance the Collision test from the Flames event into this event. Label a new material Smoke, set its Diffuse color to RGB 45,45,45, enable Face Map and set Self-

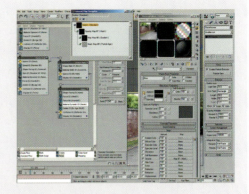

Illumination to 100. Add a Mask map to its Opacity slot. Add a Gradient map to the Mask map's Map slot and set it to Radial. Set Color 2 to RGB 45,45,45 and Color 3 to RGB 80,80,80. Add a Particle Age map to the Mask map's Mask slot. Swap Colors 1 and 3. Set Color 1 to RGB 175,175,175 and Color 2 to RGB 115,115,115. Instance this material to the slot in the Material Dynamic operator in the Smoke event. Reposition the Deflector Wall so that it is situated just inside the Box01 object.

Information: Another big step but, again, quite self-explanatory. Here we have used a Shape Facing operator without any facing object, so that the particles are parallel to the object that emits them. Now this would not work for all circumstances, but it works for this one as we do not want the particles to intersect with the scorch mark or the wall. The two Force operators add a little upward motion (Gravity) and irregular motion (Wind), while the Collision test prevents intersection with the wall. The Delete operator was introduced so that the system can be told how old a particle is, so it drives the Particle Age map accordingly. The Deflector Wall has been repositioned so that the smoke particles interact with it, else they would be born behind it.

13 Copy and Paste Instanced the Flames event onto the canvas to create a new event. Label this new event Spray. Remove the Rotation, Spin, Material Dynamic and Force operators and the Collision test. Select the Birth, Speed, Shape Facing and Delete operators and make them unique. Go to the Birth operator and set the Amount to 5000. In the Speed operator, set the Divergence to 10. Select the Shape Facing operator and make the Size 1.5 with 50 Variation. Amend the Delete operator's Life Span to 2 with 1 Variation. Add a Material Static operator to

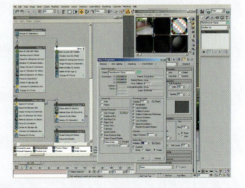

this event and add the Spray material to the slot in this operator. Wire the output of the Flamethrower root event to the input of this event. Right-click this event, select Properties, enable Image Motion Blur and set the Multiplier to 2.

Information: Again, as the majority of the leg work has already been done for us, we do not need to set up the particle system from scratch; we can simply utilize the existing setup in the initial system and make a few slight amendments. As before, we can share settings across multiple events, such as the Position Icon operator, should we decide to change it later on, or adapt the system for a new scene or backplate. The Image Motion Blur was added and its Multiplier increased to smear the surrounding areas to give the impression of a hot substance that is distorting the view of the background image and also to blend the fire sprites together to fill in any gaps.

PART FOUR: Finally we will add in extra illumination with falloff to control the illumination of the flame around the weapon, and also add a lens effect to suggest intensity.

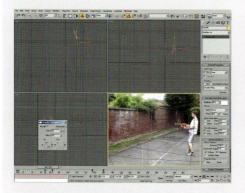

14 In the Top Viewport, create an Omni light and position it between the camera and the particle system, close to the particle system's icon. Set the Multiplier to 0. Enable Use and Show Far Attenuation, set the Start to 0 and the End to 500. In the Advanced Effects rollout, set the Contrast to 100. Enable Auto Key and go to frame 65. Set the Multiplier to 1. Copy the resulting keyframe at frame 65 to frame 155 and the one at frame 0 to frame 180. With Auto Key still enabled and the timebar still at frame 65, reposition the Omni light so that it is close to the particles in the middle of the particle stream. Select all of the keyframes at frame 0 and move them to frame 49. Turn off Auto Key. Right-click the keyframes at frame 49 and amend the Out curve of each one in turn, so it has a steep attack as illustrated.

Information: We have added the Omni light to intensify the self-illumination of the flame around the brightest part which is positioned around the center of the scene. Falloff has been added so that the entire flame effect does not get totally whited out. Contrast has been used to bring out the colors of the flame and to intensify them more. As our flames begin to emit at frame 49, the resulting keyframes, which are automatically generated at frame 0, are repositioned to this frame. The keyframe's Out curve was amended so that the intensity increases faster. This Omni light will now be used to drive a subtle glow over the scene to add a slight illumination effect to the background plate, hence the need for its intensity to be reduced at the end of the sequence, else the glow would remain on.

15 Open up Video Post and add a Scene Event with the Camera being used. Click on the Add Image Filter Event button and add a Lens Effect Flare Filter. Click on Setup. In the resulting Flare panel, click on the Load button and load in the afterfx6.lzf file that ships with 3ds Max. Click on the Node Sources button and select the Omni01 light from the list. Set the Size to 90 and click on the M button next to the Intensity setting. Turn off all elements apart from the Glow and set the Glow's Occlusion to 0.

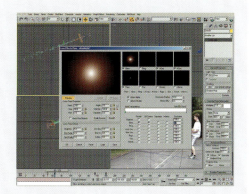

Information: We are using the intensity of the Omni light in the scene to generate the intensity of the Glow element in the flare, which is enabled by the M Intensity button. As we do not want any of the other flare elements, these are turned off. The Occlusion was reduced so that if any particles passed in front of the Omni light, the glow would not suddenly turn off.

16 Go to the Glow tab and set the Size to 120. Copy the flag at position 31 in the Radial Color gradient and remove the three middle flags, including this one. Paste the flag information in the flag at position 0. In the Radial Transparency gradient, remove the flag at position 7 and set the flag at position 0 to RGB 100,100,100. Click on OK to accept these settings for the Flare. Finally, add an Image Output Event, specify an output file and filetype (I would recommend an animated sequence), click on the Execute Sequence button, specify an output canvas of 480 × 360 and render off the scene.

Information: By amending the Glow settings of the flare, we have created a large subtle glow that will increase in intensity as the fire gets larger, then diminish after the flames are no longer being emitted. This creates a gentle glow over the entire scene brightening up the scene a little which fools the brain a little in thinking that the fire has actually been shot.

Taking it further

The result of our animation, because of the animated map sequence, produces a very nice result, although due to the amount and size of the opacity mapped particles in the scene this will take a little while to render. However, if you have a powerful system and/or have access to numerous machines to render this animation, add some object motion blur to the pyro particles. Bear in mind though that

the number of samples in the object motion blur will multiply the rendering time; for example, the default setting of 10 will (just about) increase the render times to ten times the original time, so if it takes five minutes per frame, having object motion blur enabled with these default settings will result in a render time of around 50 minutes. Therefore reduce the number of samples to about three or so, although this may result in banding being apparent in the render. Therefore, try to bring these bands closer together by Duration (frames) to, say, 0.25 or break up the blurring by increasing the Duration Subdivisions, although this will result in a slightly grainy blur.

You may see some intersection of the particles on the wall; even though the wall is not rendered (the Box01 object in the scene), some of the fire is still clipped off. This is due to the scorch mark particles being present and the billboard facing particles of the fire sprites intersecting them. This can be rectified by rendering the animation off in two passes – one to create the scorch mark on the backplate via the normal Render panel, and the other to render off the fire via Video Post. To do this, turn off the Shape Facing operators in the previous events (including the Spray event, but leaving the Smoke event alone) and render off the scene. Once this is complete, replace the background with the rendered animation, turn off the Scorch Mark and Smoke events and turn off the Spawn test that generates the Scorch Mark particles, re-enable the disabled Shape Facing operators and render off the scene again via Video Post so that the scorch mark does not intersect the geometry and the Glow is applied. There is a 3ds Max file and background animation with this already set up; all you need to do is to render off the scene (or view the final Taken Further animation).

Try adding a burst of flame at the beginning to suggest Rob is testing the flamethrower, and also right at the end of the animation as he gestures to camera. Then try getting the flame to backfire and setting light to his hair or eyebrows or something. I'm sure he won't mind! The animation could be improved with the use of several more animated maps (there is an additional one on the DVD-ROM) plus, if you can source them, set the particle system to spawn static particles that burn the grass – another animated sequence of licking flame, such as a wood fire or spilt ignited petrol would look good on the grassed area next to the wall. Failing that, use self-illuminated particles and a dark charred material effect to add some glowing embers and charred grass to the scene. Try shooting your own footage and have a good ol' traditional flamethrower fight – a little like a water fight, but you don't get as wet.

Again, as mentioned in the Analysis section, if you want to try to recreate the petroleum-based effect, have a look at some of the more recent films which feature such a weapon. This type of weapon emits a thin jet of ignited petrol which travels a distance, fanning out slightly due to the ignited liquid's resistance to the air. As the liquid is flying through the air, some droplets will fall to the ground due to air resistance and gravity and will leave a fiery trail as it falls. I would suggest that the best way to create this type of motion would, again, to use Particle Flow and would be best using a single thin stream of particles which emit individual trails that could be mapped with animated fire sequences and set to rise up into the air a little, plus the occasional particle trail being emitted to simulate the ignited liquid falling to the ground.

6 Tunnel explosion

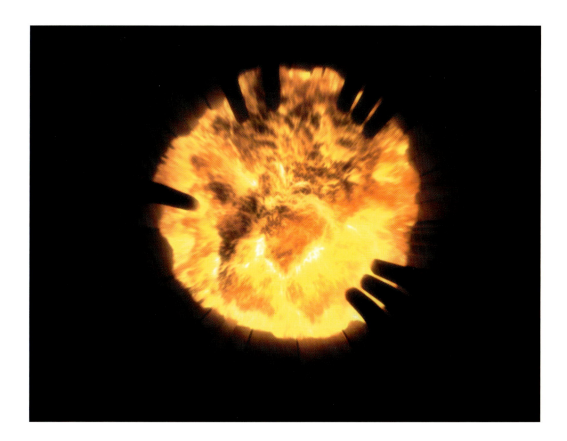

Introduction

In this tutorial we will take a basic un-illuminated scene and light it with a large fire ball. Maybe there's just something inside us that gives us, okay maybe just me, that warm fuzzy feeling when we see something go bang, and this is one of the coolest ones to do. I must admit, this is a tutorial I was really looking forward to developing as it is one of the most challenging and, if it can be pulled off, one of the most effective. The main problem is how to get the billowing effect just right so that the geometry folds over on itself as it expands, illuminating the scene as it progresses up the length of the tunnel before colliding into camera.

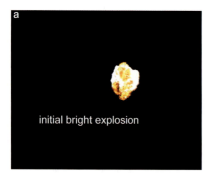

initial bright explosion

Image courtesy of Getty Images

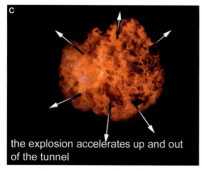

intense white and bright yellow areas
are visible where the fire billows and
folds back in

Image courtesy of Getty Images

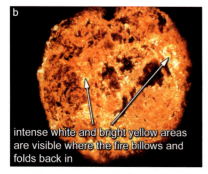

the explosion accelerates up and out
of the tunnel

Image courtesy of Getty Images

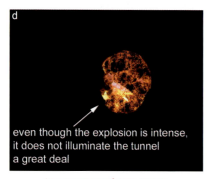

even though the explosion is intense,
it does not illuminate the tunnel
a great deal

Image courtesy of Getty Images

Analysis of effect

The actual combustible material used to fuel the fire is quite difficult to nail – in some reference material the fire can be seen as having gaseous properties, in others it is more petroleum based. Therefore a combination of the two can be derived, by assumption, as there is not only the initial accelerator used by the explosion, but also the combustible material situated in and around the scene, which fuels the fire and also causes it to change color as the fire 'ages'. Referring to the reference material, we can see that the intensity of the fire changes dramatically (reduces) after the initial explosion, and becomes more red with black patches; are quickly burned away as the fire expands in an effect that looks almost like a small shockwave consuming these dark areas. There are still highly intense areas, mainly around the 'folds' of the fire, where the fire billows over and folds back in on itself, forming bright yellow and orange veins, which can also be seen when an object interacts with the flame. As the fire is being contained in a confined space, it only has one direction to travel – upwards. So, due to the restricted space around the point of ignition, any additional expansion of the fire is simply going to accelerate its motion exponentially. Therefore, we will get an initial burst of speed from the original explosion, a lull in which the fire gets sucked back in (because of displaced air), then, due to lack of room for expansion, the fire rushes outwards along the length of the tunnel. You would think that the illumination of such a scene would be quite intense. Not so (judging from our reference material). As there is no additional lighting in the reference material, it can be determined that the fire only really illuminates the surfaces which it comes into contact. Granted, the camera's exposure will also have a part to play in this, but for the most part the fire's luminance in the reference material is not all that high, so therefore our CG scene's luminance will not be high either.

In addition to the reference footage on the DVD-ROM, you may want to take a look at some of the Hollywood blockbusters which feature this kind of scene – one of the final scenes in *Hollow Man* springs to mind (which is what our source scene is based on) in which Kevin Bacon, looking a little worse for wear, gets flambéed, or in *End of Days* when Arnie's running away from a pretty mashed up Gabriel Byrne, close to the final confrontation in the film.

As with any replication in CG that does not require precise measurements, we do not have to be 100% technically accurate. As long as the Director says it *looks* correct, then it *is* correct, even if the settings are way off on a tangent. So if we can get the colors correct, as well as the motion and illumination, the combination of these elements will be enough to fool the eye into thinking that the effect is real.

For this scene, with the amount of complex surfaces present, and the fact that we need to use the material assigned to the fire object(s) to illuminate the scene, we will look to Mental Ray to render off our animation. We could use the standard Scanline Renderer with Light Tracer to illuminate the surrounding geometry, but with the extra detail required to produce a realistic fire effect we would have to use material displacement. Couple this with Light Tracer and we are looking at very high render times, even for a single frame. Using Mental Ray will cut down the render times because we can utilize its displacement, motion blur and Indirect Illumination. As we need to remove all lighting from the scene, we need to add a light and then turn it off, else we will be stuck with the default scene lighting. Using the Indirect Illumination we can use the material setup we have assigned to our fireball, which will be a simple deforming sphere, to illuminate the surrounding surfaces. The material will consist of multiple layers of Smoke maps to control the animation and scale of the billowing flame, Falloff maps to control the more intense areas, and Smoke driven material displacement.

Walkthrough

PART ONE: Firstly we will load in the initial scene, set up the basic animation of the fireball sphere and turn off any existing scene lighting.

1 Open up the *Fire/06_Tunnel_Explosion/Source/ 06_tunnel_explosion_start.max* on the DVD-ROM. In the Top Viewport away from the tunnel, create an Omni light. Turn the light off. Turn on Grid Snap and create a Geosphere right in the center of the Viewport. Label it Fireball, set the Radius to 0, Segments to 10 and enable Base To Pivot. In the Left Viewport, move it up slightly to raise it off the bottom so that any light cast from its base will illuminate the bottom of the tunnel.

Information: Our basic scene consists of several static objects with basic materials assigned to them. We have a few metal pipes running down the length of the tunnel, a few blocks and the tunnel itself which is a low polygon Cylinder primitive. This cylinder has got a Tile map assigned to it, making the faceted sides appear to be a concrete structure. The Fireball Geosphere is set to a radius of 0 as we need it to grow, so therefore need to animate its radius. Base to Pivot has been enabled as we need the fireball to grow from the bottom of the sphere, not from its center. The light has been added simply to remove all lighting from the scene; try rendering off the scene in the Camera Viewport with and without the light present and see the difference.

2 Add a UVW Map modifier to the Fireball Geosphere and set the Mapping type to XYZ to UVW. Go back to the Geosphere level in the modifier stack. Go to frame 50 and turn on Auto Key. Set the Radius to 25. Go to frame 100 and set the Radius to 47. Turn off Auto Key. Right-click the keyframe at frame 0, select Radius and change the Out curve so there is a steep attack, as illustrated. Go to the Radius keyframe at frame 100 and set the In curve to the same attack. Scale up the Geosphere uniformly by about 780% so that the top of it is just underneath the camera at frame 100.

Information: The keyframe curves have been amended so that the radius 'bursts' outwards from frame 0, with the intensity slowing down around frame 50 and then races to the value set at frame 100, suggesting that there is a large amount of fire pushing the cloud forwards along the tube as we discussed in the analysis section. We have scaled up the fireball so the resulting material we assign will also be scaled, resulting in a large fire effect to displace the mesh.

PART TWO: As we have an initial explosion, we are bound to have some initial debris. Therefore, we will generate this debris using a Particle Flow system.

3 In the Top Viewport, create a Particle Flow system in the center of the tunnel and label it Explosion Debris. Set the Icon Type to Circle and the Diameter to 20. Set the Viewport Quantity Multiplier to 10. Still in the Top Viewport, create a UDeflector Space Warp. Click on the Pick Object and select the main tunnel cylinder. Set the Bounce to 0.5 with a Variation and Chaos of 25.

Information: We need the initial debris to explode from the same location as the fireball's emission, so they are created in the same place. As the fireball is to be contained within the tunnel, so will the debris, therefore the debris particles need to ricochet off the walls of the tunnel. As there is going to be a lot of particles floating around the scene, we need to have some scene interaction, so the Viewport multiplier has been reduced.

4 Press 6 or click on the Particle View button in the Explosion Debris particle system. In Particle View, select the Birth operator and set the Emit Stop to 0 and the Amount to 2000. Select the Speed operator and set the Speed to 850 with 600 Variation. Enable Reverse and set the Divergence to 85. Add a Spin operator and set the Spin Rate to 600 with a Variation of 300. Select the Shape operator and set the Size to 3. Add a Scale operator and set the Scale Variation for all axes to 100. Set the Display operator to show Geometry to see the particle system working so far.

Information: We have basically just tweaked a few settings here and there to get our particle system behaving as we'd like. We've increased the amount of particles and set it up so that they are all born at the same time (when the explosion occurs). We have also added a high velocity and wide angle of dispersion (the divergence), plus an fast erratic spinning motion and a high variation in particle sizes. All we now need to do is to get them to fall back down and to interact with the tunnel.

5 In the Top Viewport, create a Gravity Space Warp. Add a Force operator to the Particle Flow event and add the Gravity Space Warp to its Force Space Warps list. Add a Material Dynamic and a Delete operator to the event and set the Delete operator to By Particle Age with a Life Span of 30 with 20 Variation. Add a Collision Spawn test and add the UDeflector Space Warp to its Deflectors list. Set the Offspring to 3 with a Variation of 50. Turn off Restart Particle Age. Set the Inherited Speed to 75 with 25 Variation and 45 Divergence. Set the Scale Factor to 25 with 50 Variation. Add a Collision test and add the UDeflector to its Deflectors list.

Information: In this step we have told the debris particles to break up into smaller pieces (a percentage of the original size of the particle) when it hits the wall of the tunnel. However, this collision only generates spawned particles, the next time the particles come into contact with the surface, there is no collision deflection, so we have to introduce the other Collision test. The Delete operator has been included to get the debris to be 'burned up' in the fire and to keep the geometry count down once the Fireball Geosphere has occluded them as they will no longer be relevant to the render. This operator also drives the dynamic (changes over time in relation to the particle) which will make use of a Particle Age map. Because of this type of map, we need to tell the system when it is going to die so the colors assigned by the Particle Age map can be positioned correctly.

PART THREE: With all of the objects in our scene fully animated, we now need to set up the materials and assign them to these objects.

6 Open up the Material Editor and label a new material Debris. Enable Self-Illumination and add a Particle Age map to the Diffuse Slot. Set Color 1 to white. Change the position of Color 2 to 25 and change its color to RGB 255,207,0. Change the color of Color 3 to RGB 255,71,0. Back at the top of this material, instance the Particle Age map to the Self-Illumination slot. Instance this Debris material to the slot in the Material Dynamic operator in the particle system.

Information: We have used the Particle Age map to change the colors of the particles over their lifespan. We start off with a brief flash of white before they quickly change to a bright yellow and gradually trail off to orange. Because we have not reset the particle age of the spawned particles in the Collision Spawn test, these spawned particles will maintain the color transition from the color at which they hit, through to the orange color when they die.

7 Label a new material Fireball and set its shader to Oren Nayar Blinn. Turn on Self-Illumination and add a Smoke map to the Diffuse slot. Label it White and set the Source to Explicit Map Channel. Set the Size to 0.001, Phase to 3 with 20 Iterations and an Exponent of 0.001. Set the Color 2 swatch to white. Drag this map to its own Color 1 slot and select copy when prompted. Go into this new map and label it Yellow. Set the Phase and Exponent to 1 and Color 2 to RGB 253,195,84. Drag this map to its own Color 1 slot and select copy when prompted. Go into this new map, label it Red/Black, Set the Color 2 swatch to RGB 255,0,0 and set the Exponent to 1.5.

Information: Here we have set up the basics of our fireball material. We have used the Oren Nayar Blinn shader as it has the right shading style for the fire we are trying to create. As the fire grows and billows out, we need to animate the size of the flame, hence the current size for all Smoke maps is set very small. There is also a low setting for the Exponent in the White map. This is to be animated to reduce the intensity of the overall material over time.

8 Back at the top of the material, add a Falloff Map to the Self-Illumination slot and label it Initial Intensity Control. Set the Falloff Direction to World Z-Axis. Expand the Output rollout and set the Output Amount to 20. Instance the Yellow smoke map (and therefore its Red/Black smoke sub-map) into the Front slot. Add a Falloff map to the Side slot and label it Fold Intensity Color. Set the Front Color to RGB 252,168,0 and amend the Mix Curve, as illustrated, to make the yellow more dominant.

Information: We have set the Output amount to a high value as we can animate it reducing, revealing the detail in the fire, which is added to the self-illumination by instancing the smoke map(s) to the Front slot of the main falloff map. The additional falloff map is purely to create an intense blend from yellow to white, so we have white right on the perpendicular which blends into the yellow and then into the smoke maps in the other falloff map.

9 Back at the top of the material, set the Bump amount to 50. Add a Smoke map to the Bump slot and label it Fireball Bump Large. Set the Source to Explicit Map Channel, Size to 0.001, Phase to 1, Iterations to 20 and Exponent to 0.6. Set Color 2 to white and swap the colors. Copy this smoke map to the Color 2 slot (now black), go into it and label it Fireball Bump Small. Set the Exponent to 0.5. Go back to the top of the material and add an Output map to the Displacement slot and label it Bump Inverter. Enable Invert and instance the Fireball Bump Large map to the Map slot in this Output map.

Information: As our fire needs to be textured, the quickest and easiest way to do this is to assign a lot of bump to the material. As we are using Smoke maps to drive the texture, it was just a logical step to use Smoke maps to drive the Bump mapping as well. We have used two maps to control the bump, to break up any consistency and add some irregularity to the Bump texture. As we also need to displace the mesh with material displacement, we can use the inverse of the Bump map (white = inwards bump, outwards displacement) so they do not oppose one another. Failing that we could just use a negative displacement to generate the same effect, but a negative Output map works just as well.

PART FOUR: We now have all of the materials set up for our scene, but we now need to animate virtually every part of our main fireball material so it billows and expands properly.

10 Assign the Fireball material to the Fireball Geosphere in the scene. Go to frame 30 and navigate to the White map in the Diffuse slot. Turn on Auto Key and set the Exponent to 0.5. Go to frame 100 and set the Size to 40. Go to the Yellow map and, while still at frame 100 with Auto Key enabled, set the Size to 40 and Phase to 3. Go to the Red/Black map and set the Size to 40 and Phase to 3.

Information: We have reduced the Exponent of the White map to let the other colors come through after the initial 30 frame intense explosion. The maps have been increased in size to simulate the expansion of the billowing fire. This animation has to occur for all of the maps because if one was animated and the others were not, then one color would appear to pass over (or under) the other.

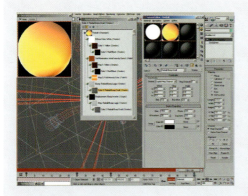

11 Go to frame 50 and, with Auto Key still enabled, set the Output Amount in the Initial Intensity Control falloff map to 1.25. Go to the Fireball Bump Large map in the Bump slot. Go to frame 100 and set the Size to 60 and the Phase to 3. Go to the Fireball Bump Small map and set its Size to 10 and Phase to 3. Back up at the top of the material, set the Displacement amount to 200. Turn off Auto Key.

Information: Reducing the Output amount reduced the intensity of the initial explosion, and allows the other detail to show through the fire. Again, we have animated the size and Phase of the map; this time with the Bump mapping (and therefore the displacement) but we have also animated an increase of Displacement so that the billowing fire grows as it travels up the tunnel.

12 Open the Function Curve Editor. Click on the Filters button and turn on Show Only Animated Tracks. Expand the Fireball material's Maps entry in the editor. Expand all of the maps including the Texture Output of the Initial Intensity Control. Select each of the highlighted entries individually and amend the Out curves of their first keyframes at frame 0 one by one so they all have a steep attack as illustrated. Amend all of their second keyframes In curves so that they have a linear attack.

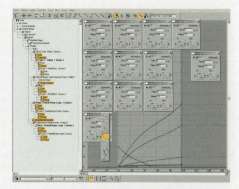

Information: Even with the animation assigned for the maps, the motion simply speeds up at the beginning of the animation and slows down at the end. We want a hard attack of motion right at the start of the animation and no slow down at the end as if the animation will continue. Therefore, amending the In and Out curves for these keyframes allows us to add this attack and remove the decay in motion and texture animation.

PART FIVE: Finally, we need to assign and configure Mental Ray to work with our scene.

13 Right-click the Fireball Geosphere and select Properties. Enable Object Motion Blur. Press 6 to open Particle Flow, select the Explosion Debris root event, right-click and select Properties. Enable Object Motion Blur and click OK. Press F10 to open the Render Panel. Expand the Assign Renderer rollout and change the Production Renderer to the mental ray Renderer. Go to the Renderer tab. Enable Motion Blur and change the Shutter to 2. In the Shadows and Displacement enable Displacement and set the Max Displace to 200. Go to the Indirect

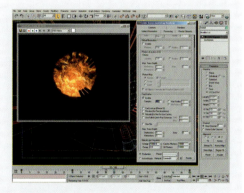

Illumination tab and enable Final Gather. Set the number of samples to about 200. Render off the animation.

Information: We have to use Object Motion Blur with mental ray as Image Motion Blur does not work with it. We have increased the Max Displace to 200 because that is how high we have set our displacement in the Material Editor, else we would have a clipping effect. We have reduced the amount of Final Gather samples to 200 to reduce rendering times (at the expense of quality). NOTE: If you are using a version of 3ds Max 7+, due to the Mental Ray updates in the software, you will only need half the amount of Final Gather samples.

Taking it further

Firstly, a word of warning. We have turned on some of the features in Mental Ray that have an adverse effect on each other. For example, due to Motion Blur being enabled, the displacement has to be calculated several times, and because the displacement has to be calculated several times, so does the illumination. And vice versa. Because of which this scene may take a fair while to render, so I would suggest that you test the odd frame out and, if everything is to your taste, render it off overnight (and maybe a little longer), because when we get further into the animation more motion blur and displacement has to be calculated per frame. If your machine isn't a supercomputer, then it would be advisable to turn off motion blur for the interim until you can, at least, get a few samples rendered out! Additionally, if you have a later version of 3ds Max (v7+) you might want to use Rapid Motion Blur as this might improve your render times!

Saying that, to be perfectly honest, there isn't much else we can do to this scene as we have pretty much nailed the effect – okay, maybe add a little bit more red to the latter part of the flame and a few more distinct dark patches, but that's about it. I'd suggest that the only other things to add to the scene would be debris being caught up in the fire, sparks flying off surfaces as the fire passes over, or maybe piping being ripped from the walls. We could also add one or two extra elements to the fire to make some darker areas more prominent where surface material is burning, which would make the fire smokier.

One other thing that springs to mind is the way that the reference footage licks and billows around the side of the tube. To produce this effect we could add additional particle systems to control this action, or tweak the displacement on the animated sphere so that the faces close to the edge of the tube are stretched out and deformed a little to create this 'licking' effect. The final element we could introduce is a constant stream of particles emanating from the expanding fireball. If you scrub through *tunnel_explosion05.mpeg* on the DVD-ROM you will notice small particles of fire flying off the surface of the fireball as it progresses through and out of the tube. To emulate this, assign a relevant material to a particle system that uses the Fireball Geosphere as an emitter for these particles, get them to spawn trails as they travel and have them interact with the sides of the tunnel. Quite simply we can break up any hard edges of the fire effect we have generated.

In the Taken Further *mpeg* on the DVD-ROM I have taken the original render and put it through Combustion to bring out the oranges of the fire, to add an animated flare for the initial explosion and also a subtle glow.

7 Fireworks

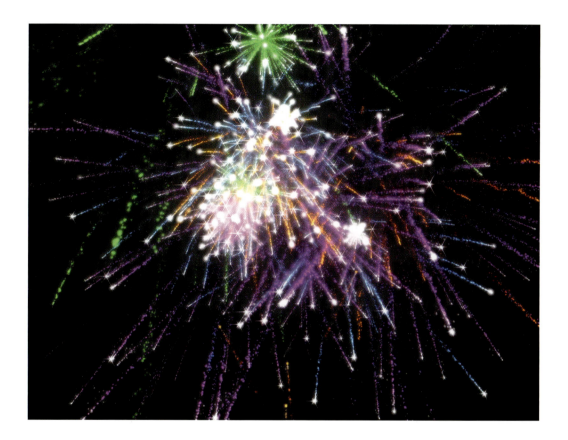

Introduction

Guy Fawkes night, 4th of July celebrations, the turn of the New Year. All very expensive times as we set light to our hard-earned money and watch it go up in smoke for a few brief seconds of 'ooo' and 'aaaah'. With the use of Particle Flow we can create our own convincing fireworks display that isn't going to break the bank, scare the family pet, endanger nearby wildlife or shower your car in burnt cardboard. Thanks to the way Particle Flow is structured, we can create the various effects and then sit back and let the system pick which display to show us. All we now need are toffee-apples, hot dogs and the smell of a bonfire.

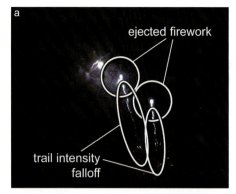

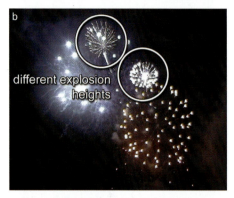

Analysis of effect

This one is quite tricky to nail down, mainly due to the sheer variety of fireworks out there; Flares, Flare splitters, Flaks, Explosion Trails and so on. For this example, we will stick with the traditional Explosion Trails effect.

Open up the *Fire/07_Fireworks/Reference/Movies/fireworks_trails04.mpeg* on the DVD. This particular clip gives a good example of the entire duration of a firework's life. (a) Firstly, the firework is ejected from the cannon (off camera), which, when ignited, glows an intense color and emits a trail as it travels up into the sky. This trail is not as intense as the firework itself, and quickly diminishes, although not before being affected by the wind and breaking up a little in shape and form. (b) Once the firework has reached a certain point, which is different for each firework, it explodes into numerous fragments. These fragments are ejected at a high velocity, but appear to slow down immediately and fall back to earth, (c) each of which emitting a trail of its own with properties not too dissimilar from the initial firework ejection trail; sometimes a different color – normally the initial trail is a faint orange and the fragment trails are brightly colored blues, purples and greens. Depending on the type of firework, some extra sparks are emitted from the fragments as well, at a higher velocity than the trails, creating a sparking effect as the fragment falls back to earth. (d) Also, depending on the type of intensity and/or material burning, extra glows and flares are present at the ends of these trails, so these must also be introduced. Once the intensity of these glowing explosion fragments have diminished, the trails cease to be emitted.

Using this information, we can have a look at 3ds Max and determine what features we can use to simulate the effect. As this effect is best suited to particles, we shall use Particle Flow to create the desired result. Initially, a single particle will be ejected upwards, which will spawn a trail of particles, which will be affected by wind, as it travels. The main ejected particle will be colored one shade and the trails another, which will make use of Particle Age maps to fade out the trail particle after it has been born, and Material Effects ID's to assign glow post processes to these colors. Upon a randomly determined age (within a certain threshold), the particle will spawn additional particles which will be shaded differently (they may also have a different effects ID to assign alternative glows and effects to them), have a random direction, a slight variation in velocity and will be affected by gravity. To slow down the exploded particles

right after their birth, a Drag Space Warp will be utilized. As these particles fall, they will emit trails which will also be affected by wind.

Finally, because we want several different fireworks effects in our fireworks display, we should set up a few Split Amount operators in a particle set so the system splits the initial particles up and passes them to different fireworks effects.

Walkthrough

PART ONE: First we will set up the basic elements our effect requires, such as Gravity and Wind Space Warps, and the basic Particle Flow system.

1 Turn on Grid and Angle Snap and create a Particle Flow system in the Top Viewport so its icon size is set to 140, and Length and Width set to 200. Set the Viewport Quantity multiplier to 100% and Particle Amount's Upper Limit to 10000000 (add a couple of extra '0s') and mirror or rotate the system so it is pointing directly upwards.

Information: The Viewport multiplier is set to 100% so we can see all of our initial emitted particles. If this setting is too high for your computer, leave it as it is. The Upper Limit has been increased because if is too low, the particle system will not display any more particles after this amount has been generated. This is simply a failsafe device built into the system.

2 In the Left Viewport, create a Wind Space Warp. Set the Strength to 0, Turbulence to 0.12, Frequency to 0.18, and Scale to 0.01. Create a Gravity Space Warp in the Top Viewport so it is pointing vertically down.

Information: We only want the wind to break up the particles a little, so the turbulence feature is used. We do not need the particles to be blown across the scene so the strength is set to 0. The Gravity Warp's settings can be amended in the particle system so it is left the way it is.

3 Right click the Play Animation button and set the End Time to 500. Create a Drag Space Warp in the Top Viewport and set its Time Off setting to 500. Set the Linear Damping X, Y and Z Axis settings to 10%. Create a Camera in the Top Viewport −5000 down the Y axis with its Target pointing up about 2500 up the Z axis, as illustrated. Set the Camera's Lens size to 28 mm.

Information: The length of the animation has been increased, as has the Drag Space Warp's duration and strength. A Camera has had to be introduced because the facing particles that are to be used later on require something to look at. A 28 mm lens is used to give a wide field of vision, thus giving a sense of scale to the scene.

PART TWO: Now we have the basic scene constructed, we can go into our particle system and set up the particle events.

4 Select the particle system and go into Particle View. Rename the event 01 event to Rocket Particle. In the Birth operator, set the Emit Stop to 500 and Amount to 75. In the Speed 01 operator, set the Speed setting to 2500 and Divergence to 35. Delete the Rotation and Shape operators. Add a Shape Facing operator underneath Speed 01, select the Camera as its Look At object, turn on Use Parallel Direction, and set the World Space size to 50. Change the Display operator's Type to Geometry.

Information: This sets up the basic properties of the initial ejected firework particle. We have used a facing particle because we do not need to see the rear of the particle, only be able to assign a glow to it, and a single face keeps the geometry count down. Geometry is used as a display here because there are not many particles to draw in the Viewport.

5 Add a Material Static operator underneath the Shape Facing operator. At frame 0, add a Spawn test under the Material Static operator, set the Spawn rate to 300 Per Second. Set the Inherited speed to −20 with a 100% Variation and a Divergence of 15. Add an Age test underneath the Spawn test, and set the Test Value to 55 with a Variation of 20.

Information: Because the material assigned to this particle is not going to be changed, it does not need a Material Dynamic operator. The negative inherited speed is used to thrust the spawned particles out in the opposite direction to give the impression of a rocket. The Age test is to send the particle onto the next event if it is ready to be exploded (once it has reached a certain age).

6 Drag a Force operator out to the Particle View canvas to create a new event. Label this event Rocket Trails. Wire this new event's input to the Output of the other event's Spawn test. Add the Wind Space Warp to the Force's Space Warp list. Add a Material Dynamic operator underneath the Force operator and add a Delete operator underneath the Material Dynamic. Set the Delete operator to By Particle Age and set its Life Span setting to 15 with 5 Variation. Add a Scale operator underneath the Force operator and set the Type to Relative First. Set the

Scale Factor X Y and Z spinners to 25 with 50 Variation on all axes and set the Animation Offset Keying Sync By to Event Duration. Click on Auto Key to enable animation and go to frame 20. Change the Scale Factor to 0. Turn off Auto Key and wire the Rocket Particle's Spawn test output to the Rocket Trails event. Go back to frame 0.

Information: This entire step designs the behavior of the ejected firework's particles. By sending the spawned particles to another event we can change their properties. This new event changes the material (which we will introduce later on), assigns a lifespan/event duration using the Delete operator, and animates the Scale to make the particles shrink as they age. Set this event's Display operator to Geometry as before to see this in action. We have wired the Rocket Trails event to the Spawn test before animating the Scale operator, else the Spawn test will generate too many particles for our system to handle, as they are not being passed to the next event.

PART THREE: With the ejection particles and their respective trails now designed, we can use the Age test to send the particle to an event to choose how to blow it up.

7 Drag a Split Amount test to the canvas to create a new event, and label it Explosion Splitter. Drag another two Split Amount tests to this event. Set the first Split Amount test's Fraction of Particles Ratio to 25, the second one to 33 and the third one to 50. Add a Send Out test underneath the last Split Amount test. Wire this event to the Rocket Particles Event's Age test.

Information: As we are going to have multiple fireworks effects, we need to have the ability to pass the particles down to random events. The first test lets 75% through to the second test. The second test has 75% which lets 67% of 75% through to the third test (50% of the total) which sends the last 50% (25% of the total) to the final Send Out test, which sends the rest of the particles out to the next event, so each event has an equal share of the particles. Whew! Everybody follow that?!

8 Drag a Spawn test to the canvas to create a new event, and label this event Explosion Fragments01. In this Spawn's settings, check on Delete Parent, and set the Offspring number to 60 with a 10% variation. Set the Inherited speed to 0. Add a Speed operator underneath this Spawn test and set the Speed to 1300 with a 300 Variation and Random 3D direction.

Information: As we do not need the explosion particles to carry on along the original trajectory, the inherited speed is reduced to 0 and a new speed with random direction is introduced to simulate the exploded particle's initial velocity.

9 Add a Force operator to the event and add the Gravity and Drag Space Warps to its Space Warp list. Reduce the Influence to 100%. Add another Force operator and add the Wind Space Warp to this new Force's Space Warp list. Add a Scale operator and set the Type to Relative First, Scale Factor to 40 and Scale Variation to 20 for all axes. Add a Spawn test and label it Spawn Explosion Trails. Set its Rate to 100 Per Second and Inherited Speed to 10 with 50 variation.

Information: The Gravity and Drag Space Warps are used to bring the particles back down to earth after their initial explosion velocity and to slow them down a little, simulating wind resistance as we noted in the reference material. 100% is a reduction in strength as the default setting for the Space Warp to have to the same effect as it would on the Legacy systems is 1000%. The new Spawn test outputs several particles per second and has a low inherited speed to simulate these particles falling behind the particle emitting them.

10 Add another Spawn to the Explosion Fragments01 event and label it Spawn Sparkly Bits. Set the rate to 150 Per Second and set its Inherited Speed to 0. Add Material Dynamic and Delete operators to the event and set the particle deletion by Particle Age, with a Life Span of 75 with 25 Variation.

Information: The second Spawn test is designed to trail particles behind with no inherited velocity. As the exploded particle will fade over time, we have to use a Material Dynamic operator to utilize any particle information relating to material settings later on. Again, the Delete operator sets the lifespan of the particle.

11 Drag a Material Dynamic operator to the canvas to create a new event and label it Explosion Trails01. Instance the Force operator with the Wind Space Warp in the Explosion Fragments01 event into this new event. Add a Delete operator to the event and set it to By Particle Age, with a Life Span of 50 with 25 Variation. Add a Scale operator underneath the Material Dynamic operator and set the Type to Relative First. At frame 0, set the Scale Factor to 75 and variation to 50 for all axes and set

the Animation Offset Keying Sync By to Event Duration. Go to frame 50, turn on Auto Key and set the Scale Factor to 0. Turn Auto Key back off.

Information: Again, we have animated the scale of this trailing particle so that it reduces in size over the duration of the event, which is the life of the particle. We are using instanced settings for the Wind force so that any affected particles look like they are being dissipated by the same wind.

12 Add a Material Static operator to the canvas to create a new event and label it Sparkly Bits01. Add a Speed operator and set the Speed to 600 with 300 Variation and Random 3D direction. Add a Delete operator and set it to Particle Age, with a Life Span of 10 and 5 Variation. Add a Scale operator, set the Type to Relative First, Scale Factor to 50 with a Variation of 50 for all axes and Sync By to Event Duration. At frame 10, turn on Auto Key and set the Scale Factor to 0 for all axes. Turn off Auto Key. Finally, wire this event to the Explosion Fragments01 event's Spawn Sparkly Bits output, the Explosion Trails event to the Explosion Fragments01 Spawn's Explosion Trails output, and wire the Explosion Fragments01 event to the first Split Amount test's output in the Explosion Splitter event.

Information: As the sparkly bits will diminish rapidly due to their short lifespan and small size, there is no point in using a dynamic material. Here we wire up all of the remaining events, leaving the other Split Amount tests vacant until the other systems are designed later on.

PART FOUR: With the particle system virtually completed, we can now move onto designing the materials to make the particles glow different colors.

13 Label a new material Rocket Particle. Turn on Face Map, set the Diffuse to RGB 255,223,0 and set the Self-Illumination to 80. Add a Gradient map to the Opacity slot and set its Gradient Type to Radial. Instance this material to the Material Static operator of the Rocket Particle event. Check on Show Map in Viewport to view the material in action in the Viewport.

Information: This material only needs to be basic and does not need to change in intensity or color. The face map and radial opacity gives the impression of circular particles when assigned to the flat facing particles of the particle system.

14 Label a new material Rocket Trails. Set the Material Effects Channel ID to 1, check on Face Map and Self-Illumination and set the Advanced Transparency type to Additive. Add a Particle Age map to the Diffuse slot, label it Rocket Trails Color and set the colors to white, orange and red at positions 0, 10 and 100 respectively. Instance this map to the Self Illumination Slot. Add a Mask map to the Opacity slot and label it Rocket Trails Mask. Add a Particle Age map to the Mask slot and set Color 1 to RGB 70,70,70, Color 2 to RGB 30,30,30 and Color 3 to black. In the Rocket

Trails Mask's Map slot, add a Gradient map and set its Gradient Type to Radial. Assign this material using instancing to the Material Dynamic operator in the Rocket Trails event.

Information: By using Particle Age maps we can control the color and opacity of the particle throughout its lifespan. The particle has a very low opacity due to the sheer number of particles being emitted, and because of additive transparency being used. In addition, we don't want the rocket trails to be too intense because, if we refer to the reference material, they are as intense as the explosion trails.

15 Label a new material Explosion Fragments01 and set its Material Effects Channel ID to 2. Check on Face Map and set Self Illumination to 100. Set the Diffuse color to white and enable Additive Transparency. Add a Mask map to the Opacity slot and add a Particle Age map in the Mask slot. Set Colors 1 and 2 to white and Color 3 to black, with Color 2's position set to 60. In the Mask's map slot, add a Gradient map and set the Gradient Type to Radial. Assign this material to the Material Dynamic Operator in the Explosion Fragments01 event.

Information: As before, the material's opacity is controlled by the particle's age which masks a radial gradient and fades out the gradient the older the particle gets. As we want these particles to be intense for a long amount of time, the Particle Age map's colors are set to white, making the particle opaque for the majority of its life.

16 Copy the Rocket Trails material to a new slot and label it Explosion Trails. Rename the Particle Age map in the Diffuse slot to Explosion Trails Colour01 and set Colors 2 and 3 to purple and blue respectively. Rename the Mask in the Opacity slot to Explosion Trails Mask and set the Particle Age colors 1 and 2 in the Mask slot to RGB 150,150,150 and RGB 90,90,90 respectively. Instance this material to the Material Dynamic operator in the Explosion Trails01 event.

Information: As we had the majority of the structure of this material already set up in another material, it was pointless to reproduce everything when we could simply copy the material and tweak a few settings. Using the reference material, we have chosen a common color scheme for our fireworks trails – purple to blue as the particle trail ages.

17 Copy the Explosion Fragments01 material to a new slot and label it Sparkly Bits01. Set the Material Effect Channel to 1 and remove the maps from the Opacity slot. Add a new Gradient map set to Radial in the Opacity slot, set colors 2 and 3 to RGB 100,100,100 and the Color 2 position setting to 0.9. Instance this material to the Material Static operator in the Sparkly Bits01 event.

Information: Again, as the majority of the leg work has already been done, we do not need to recreate the material. The high position of the color 2 setting in the gradient is to create a harder edge to the gradient, thus creating a more solid color.

18 Select the Explosion Fragments01, Explosion Trails01 and Sparkly Bits01 events and shift-drag them to instance them. Keep settings like forces and particle age constant across the duplicate events, but make the other settings unique and tweak them a little to create different explosion speeds and different particle velocity variations. In addition, copy the materials for the Explosion Trails and Sparkly Bits (should you decide to use this event in the other systems) and, using the reference material provided,

choose different colors for the new event's trails and label and assign them accordingly. Once you have another three sets of events, wire them together to the splitter event, as you did with the original.

Information: Here we design new colors and styles for the additional firework explosions by using the original explosions as a foundation. By simply amending a few settings, like particle spawning, and creating new materials and colors to assign to these particles, we can create completely different effects very quickly and easily.

PART FIVE: With the particles and materials finished, we can add the finishing touches to our fireworks by adding glows and lens effects to simulate intense illumination.

19 In the Render Effects window, add a Lens Effects effect and label it Glows. Add three Glow elements to the right-hand pane of the Lens Effect Parameters rollout and label them Glow Inner, Glow Middle and Glow Outer. Set each Glow's Image Source to Effects ID 1, and Use Source Color to 100. For Glow Inner, set the Size to 0.02 and Intensity to 60, for Glow Middle set the Size to 1 and the intensity to 60, and for Glow Outer set the Size to 10 and the intensity to 50. Add another Glow and label it Glow Fragments. Set the Image Source to Effects ID 2, Size to 0.02, Intensity to 150 and Use Source Color to 100.

Information: The Material Effects ID's have been passed from the render to the post process glows we have created, therefore only the materials that have been assigned these corresponding effects ID's will glow.

20 In Video Post, add a Scene Event and OK to exit the dialog that pops up as the Camera is already highlighted. Add an Image Filter Event and choose Lens Effect Highlight. Click Setup, turn off Object ID and enable Effects ID and set it to 2. In the Geometry tab, set the Clamp to 70 and check on Alt Rays. In the Preferences tab, set the Size to 3 and Points to 6. Click OK to exit the dialog.

Information: The highlight effect is assigned just to ID 2, therefore the fragments will have this effect applied to it,

not the trails. Pixel intensity is used as a guide for highlight strength and Alt Rays used to create slightly different highlights so the effect is not uniform.

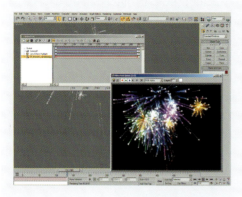

21 Finally, add an image output event to the Video Post queue and render off the entire animation.

Information: Typically, we should always use a sequence of images in case the render goes awry. If you render out to an animation file, such as an AVI (etc.) your image will be degraded due to compression used in the AVI. Plus, if the render dies, you will have to re-render the entire sequence again. I have used AVI's on the DVD purely to keep file sizes down, but I'd recommend that you use a TIFF or, if space is limited, a high quality JPEG sequence.

Taking it further

We have used Video Post to design our highlights due to the speed at which it calculates them; a normal render effect takes an age to calculate them which would dramatically increase the render times. Because glows are calculated on pixel size and not based on actual rendered image size, should you decide to increase (or decrease) the rendered canvas size you will have to adjust the glow's size accordingly else it will look either too intense, too faint or will appear as just a large splodge.

The result of our efforts is a convincing fireworks system. Because of the way Particle Flow is designed, we can add multiple effects, adding layer upon layer of particles and firework styles.

After the scene has been rendered off, you could composite the rendered plate onto a backdrop of your house so it would appear as if you have had your very own private fireworks display!

The *07_ fireworks_taken_ further.mpeg/07_ fireworks_taken_ further.max* file on the DVD uses this technique – the rendered fireworks animation was brought back into 3ds Max as a Bitmap map in the Diffuse and Opacity slots of a self-illuminated material with additive transparency, and assigned to a Plane object with the same dimensions as the rendered image.

This object was positioned right in front of a plane with a background image of cloud and a building assigned (file *07_ fireworks_background.jpg* in the fireworks source folder) which was darkened in 3ds Max to create a darker environment. The fireworks plane had the *07_ fireworks_background_ mask.jpg* as an opacity map to allow the building and bush silhouette to pass through, while the background plane used a blurred copy of the fireworks animation to control self-illumination, thus illuminating the building when a firework got close to it.

The whole scene was rendered off with a moving camera to simulate a camcorder. Finally, the animation was taken into Combustion and blurred slightly when the camera zooms into the firework to suggest that the camcorder couldn't focus while zooming, which, when there is low light, is normally the case.

Have a further look at the fireworks samples on the DVD and try to add extra effects to make the scene more believable such as small bright flak explosions when the firework initially explodes, and smoke from flares and trails from previous fireworks being illuminated by more fireworks. Try different styles and settings using the reference material on the DVD to create your own effects and, using the knowledge you've gained in this tutorial, adapt the construction process to design your own fireworks display!

8 Coals

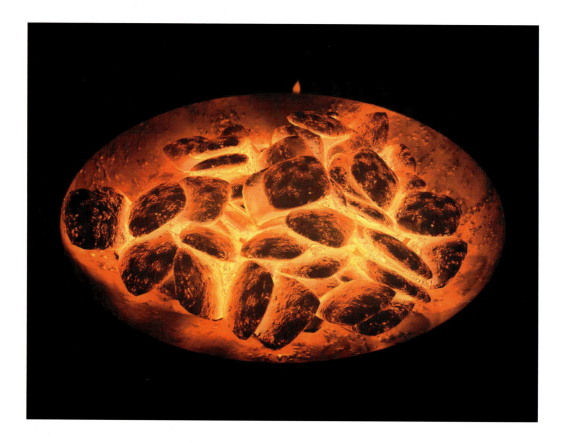

Introduction

You would think that creating glowing coals would be a relatively simple procedure. Not necessarily so. Like any other natural effect, a lot of elements come into play – it's not just a case of bung in a few lights, crank up the glow and render. The way the coal burns, and disperses either through friction from an adjacent brick or through third party interaction, it never glows in a uniform fashion. In this tutorial we will first create and distribute the bricks using a basic Reactor dynamics setup (purely to save time and to create a more natural arrangement). Next, using lights distributed with these bricks, we will illuminate the pile of coal, which will have materials we have designed assigned to them to control the broken-up and partially burning coal texture. Finally, we will assign a glow render effect to intensify the hot areas somewhat.

Analysis of effect

Depending on the time of day, this particular effect is viewed differently. To illustrate this, open up the *Fire/06_Coals/Reference/ Movies/coals02_night_high-low_exposure.mpeg* on the DVD. (a) In this clip you will notice that as the exposure is reduced, and less light is passed into the camera's lens, the more intense the colors become. (b) Compare this to the *coals01_night_high_exposure.avi* in the same folder – the colors are more desaturated and the surrounding areas brighter, as there is more light passing into the camera's lens. The same can be said when viewing the scene in daylight – there is very little hint that the coals are actually hot at all, apart from the smoke and occasional lick of fire poking its way from beneath the coals. (c) Open up the *coals05_day.mpeg* (in the same folder) and notice that there is no hint of a glow whatsoever in the footage. This is also consistent in the other daylight clips because the sun is so intense; it is washing out the subtle glow from the hot embers. Therefore, to get a recognizable glowing coals effect, we should design our scene so that there is very little light, if any at all.

(d) Analyzing the dark clips, we notice that the glow of the individual coals are most prominent where they are adjacent or touching one another. The coals on the exterior of the pile do not glow as much as the others because they are more exposed to fresh air, which cools them down a little, and also because the heat is not concentrated in a confined space (as it is within the center of the coal pile). Some parts of the charcoal have also broken off, leaving some interior parts of the coal brick more exposed than others, which are hotter than the exterior parts and therefore glow more. The occasional spark or debris also escapes from the pile – be it part of the brick, or charred paper which has got caught in the updraft of the rising heat emitting from the hot coals.

First of all, we will have to create the positioning of the coals. To do this, we could either manually place every single piece of coal on a plinth, in a bowl or on a barbeque, but it is a lot easier and quicker to automate the process using Reactor, as we can literally drop a load of coal onto the surface and there we have our 'naturally' placed bricks. Easy! To create the intense glowing inside the center of the coal pile, we can use Omni lights with falloff. Now we could just drop a few lights in and around the pile, but there will be some areas which will be more intense than others, and some of the sides of some of the coal bricks will not be illuminated correctly. Therefore, we can link lights to the bricks that we drop onto our surface so they illuminate the adjacent

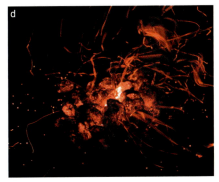

bricks with their 'glow', but won't illuminate themselves as the light source will be contained within the brick geometry. The cracked and glowing effect will be the trickiest part, with the majority of the legwork coming from procedural maps and a complex material setup, but it's nothing we can't handle. Finally, the odd spark or rising debris will be generated with a simple particle system and basic Space Warp setup.

Walkthrough

PART ONE: After loading in the initial scene, we will first create the charcoal bricks, link lights to them and distribute them in the vessel provided.

1 Open up the *Fire/06_Coals/Source/08_coals_ start.max* file included on the DVD. In the Top Viewport, create a Sphere primitive with a Radius of 100 and label it Charcoal01. Set the Segments to 16.

Information: The initial scene consists of a basic dish that is currently set to a low polygon density so that when we perform our dynamics calculations, it doesn't take all that long to work out any collisions. The low polygon sphere, as it will not be collapsed and is therefore going to be parametric, can also have its polygon density increased later on if so desired.

2 Add a FFD 3 × 3 × 3 modifier to the Sphere's modifier stack. In the Left Viewport, select all of the FFD handles and scale them down vertically to about 50% of its original height. Next, in the Top Viewport, select the handles in the outer corners and scale them along the X and Y axes so that they are 200% of their original size. The resulting shape should be that of a flattened and rounded cube as shown.

Information: By adding an FFD modifier, we can squash and stretch the geometry to our heart's content. As this modifier is non-destructive – i.e. no vertices or polygons have been created, welded or deleted – we can amend the mesh at the base of the stack later on if desired.

3 Next, create an Omni light in the Top Viewport and position it in the center of the Charcoal01 object. Label it Omni Charcoal Glow01 and link it to the Charcoal01 object. Enable Shadows and set the Multiplier to 3. Set the color to RGB 198,73,0 and set the Decay Type to Inverse Square. Enable the Decay Start Show and increase the Start setting until it reaches the external horizontal boundary of the Charcoal01 object in the Left Viewport – about 160 should suffice.

Information: Typically, you should not really increase the multiplier of a light over a value of 1 else colors are washed out (for values greater than 1, a clone of the original light should be used). For this instance, as we are using Inverse Square decay, which is as close to how real light behaves as we're going to get, this doesn't matter. As the light's decay should start from the exterior of the Charcoal object, the Start setting is amended.

4 Enable Use in the Far Attenuation section and set the End setting to 1000. In the Advanced Effects rollout, set the Contrast and Soften Diff. Edges to 100. In the Shadow Map Params rollout, set the Bias to 0.001, Size to 128 and Sample Range to 10. In the Left Viewport, scale the light down vertically by about 50% so that its Inverse Square Decay Start guide is close to the top of the Charcoal01 object.

Information: The Far Attenuation is used to specify to the Inverse Square Decay exactly where the decay reaches the value of 0. If this attenuation setting is not used, the decay will continue to be calculated to infinity which will increase render times. The Contrast has been increased to make the light more intense in places and the Soften Diff. Edge setting increased to diffuse the falloff from lit to shaded areas somewhat. The Bias has been reduced to tuck the shadows behind any shadow casting objects so that they are not detached, the Size reduced as we do not need any detailed shadows in our scene, and the Sample Range increased to diffuse the shadows at render time.

5 Copy the Charcoal01 object and label it Charcoal Proxy. At the base of this new object's modifier stack, amend the Segments to 8. In the Left or Front Viewport, select the Charcoal01 and Omni Charcoal Glow01 and Shift-Move them vertically to create a copy on top of the original with a gap in-between the copies. In the resulting dialog that pops up, use Instanced cloning and enter 15 copies. Offset every other Charcoal copy; or as many as you see fit, so they are not exactly lined up.

Information: The low polygon Proxy object has been created so that it can be used in the dynamics simulation instead of the original Charcoal geometry, which has more polygons and will therefore take longer to calculate. The cloned stack is offset slightly (with the linked lights following suit) so that when the dynamics simulation is calculated, the bricks will slide off one another and not just sit there for an age until they tumble. Just to give them a helping hand.

6 Instance clone the Charcoal and light stack another three times so that there are about 40 to 50 instances in total, and offset the stacks so that they are still above the dish but not touching one another. Next, create a Rigid Body Collection and add all of the Charcoal objects (not including the Proxy object) and the Dish to the Rigid Bodies list.

Information: Offsetting the Charcoal reduces the chance that they will pass through one another when the dynamics simulation is calculated. The Dish is added to the Rigid Body collection so that it can be included in the simulation for the Charcoal to settle on.

7 Open reactor in the Utilities tab. Right click the Play Animation button and set the Length to 1000. Exit this panel by clicking OK. Select all of the Charcoal objects and set the Mass to 0.1 kg, Elasticity to 0.3 and the Friction to 0.6 in reactor's Properties rollout. In the Simulation Geometry section, enable Use Proxy Convex Hull, click the None button and select the Charcoal Proxy object. Select the Dish and set its Mass to 1 kg, Elasticity and Friction to 0.3, enable Unyielding and set the Simulation Geometry

to Concave Use Mesh. Test the simulation by clicking on the Preview in Window button. Ignore any messages. If the simulation is not to your liking, re-arrange the objects and run the simulation again. Once satisfied, go to the MAX menu in the preview window and select Update MAX.

Information: A very large step yet quite straightforward, this section sets up the dynamics properties of all of the elements in the simulation. Not being happy with the original simulation result, I have also added another stack of bricks, which brings the total up to 64. The timescale has been increased so we have adequate time to calculate the dynamics of the objects when the animation is created, should you wish to generate the animation and not just update the Max scene. We're not overly concerned about any messages that pop up as we only require the end result of the simulation, not the animation itself. Using the Update MAX option enables us to use the positions in the preview window to position our geometry in max. Because of which, we can manually position objects in the preview window which gives us a lot more flexibility as to where our objects will finally rest.

8 Select the Dish and select the Circle at the base of the Modifier Stack. Expand the Interpolation rollout and enable Adaptive. Go to the Lathe modifier and increase the amount of Segments to 64. Hide the Charcoal Proxy object. A quick test render shows our glow effect working nicely. If there are any objects and/or lights which are not quite right, re-arrange them slightly or delete them.

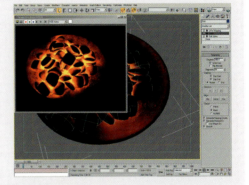

Information: As the Dish has its Modifier Stack maintained, we can easily refine it because we are not manually creating any additional polygons, but simply adjusting a few settings. The light intensities appear to be working properly, however in some areas the shadows seem a little harsh. To rectify this, you can amend shadow settings a little to smooth them out somewhat, although a lot of this can be sorted out with materials, which we will tackle next.

PART TWO: With the illumination all set up, we now need to create the material for our coal.

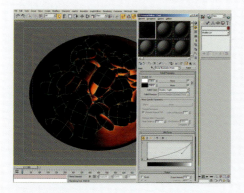

9 Open the Material Editor and label a new material Coal. Change the Shader to Oren-Nayar-Blinn, set the Diffuse color to RGB 65,65,65 and check on Self-Illumination. Expand the Maps rollout and add a Mask map to the Bump slot. Set the Bump amount to −100. Label this Mask Charcoal Bump. In the Mask slot, add a Falloff map and label it Bump Illumination Mask. Set the Falloff Type to Shadow/Light and swap the colors. Amend the Mix Curve to that illustrated.

Information: The Oren-Nayar-Blinn shader is used because it gives a material falloff more suited to the effect we are trying to emulate. We have created the basic shade for our charcoal brick, which we will add self illumination to later on in the desired places. The Falloff map masks the bump so that where light hits it is not as bumpy – i.e. the irregular surface of a normal charcoal brick is textured. The glowing one has had these irregularities burnt off.

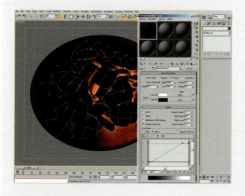

10 Add a Noise map in the Map slot of the Mask Charcoal Bump map and label it Craters. Set the Noise Type to Turbulence with a Size of 12.8, High of 0.71, and Levels to 10. Add a Noise map to the Color 2 slot and label it Noise Breakup. Set the Noise Type to Fractal, Size to 50, High to 0.605 and Low to 0.08. Set the Color 1 swatch to white. Set the Color 2 swatch to RGB 30,30,30, check on Enable Color Map and amend the Output Color Map curve as shown.

Information: The Falloff map masks out the bump that has been created using the nested Noise maps. The first Noise map creates a general small bumpy surface that is relatively regular. The use of the second Noise map is to break up the repetition using a larger noise with a different Noise Type. The Color map is used so that the broken up noise does not fade in or out very much, if at all.

11 At the top of the material stack, add a Mix map to the Self-Illumination slot and label it SI Intensity Increase. Set the Color 2 Swatch to RGB 198,37,0. Add a Falloff map to the Mix slot and label it Intensity Mask. Set the Falloff Type to Shadow/Light and amend the Mix Curve to that illustrated. Add another Falloff map to the Lit slot and set the Falloff Type to Fresnel. Label this map SI Edge Intensity.

Information: The Mix map overlays a color which is controlled by a masked Fresnel map, which is more prominent where light is present, therefore being most intense in the areas of high illumination – i.e. in the 'hot' areas of the pile of coals.

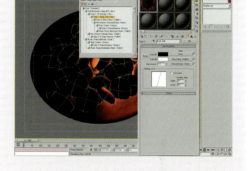

12 Add a Mix map to the SI Intensity Increase Mix map's Color 1 slot and label it SI Intensity. Add another Mix map to this map's Color Slot 1 and label it Back Side. Add a Falloff map to this Mix map's Color 2 slot and label it Glow Color. Set the Side slot to RGB 251,60,5 and set the Output Amount to 4 in the Output rollout. In the Back Side Mix map, instance the Charcoal Bump Mask map to this map's Mix slot.

Information: As there is no additional mixing at the moment, we have just created a glow using a Falloff map (which is set to a high intensity) that is controlled using the material's Bump map, which positions the glows where there is texture in the surface.

13 In the SI Intensity Mix map, add a Mix map to the Color 2 slot and label it Intense Side. Instance the Glow Color Falloff map to the Color 1 slot of this new Mix map, add a Falloff map to the Mix slot and label it Intense White Mixer. Set the Falloff Type to Shadow/Light and amend the Mix Curve as illustrated.

Information: We want the same glow pretty much across the board, but broken up around non-intense areas. Therefore, the same glow is used in the intense parts of the material. It is also mixed with a white color to show even more intensity where there is light which is automatically controlled using a Shadow Light Falloff map.

14 To put it all together, add a Gradient Ramp map to the SI Intensity Mix map and label it Intense/Back Side Mixer. Set the Gradient Type to Lighting and Interpolation to Ease In. Move the current flag at position 50 to position 20, create a flag at position 38 and set it to white. Back up at the top of the material, set its Material Effects Channel ID to 1. Select all of the Charcoal objects in the scene and assign this material to them.

Information: Using a Gradient Ramp gives us more control over falloff with respect to lighting than using either a nested Falloff map tree or by playing around with Mix curves. This map is used to create a nice transition from illuminated to non-illuminated areas of the coal, so the intense colors are on the illuminated areas, whereas the subtle self illumination is on the non-illuminated or shadowed areas. The Effects Channel ID is used to pass the material information across to the renderer so we can assign a glow to objects that have this material assigned to them.

PART THREE: With the main material set up, we will now create a new material that will be assigned to a Particle Flow system to simulate rising debris.

15 Label a new material Debris and set its Material Effects Channel to 1. Set the Diffuse color to RGB 255,75,0, enable Self-Illumination and set its color swatch to RGB 255,115,0. Add a Particle Age map to the Opacity slot and label it Debris Quick Fade. Set Colors 1 and 2 to white, with Color 2 at position 75, and Color 3 to black.

Information: A quick step and pretty self-explanatory. By viewing the reference footage, we can see that any rising debris glows for quite a long time, and then suddenly diminishes in intensity, hence the large amount of white in the Particle Age map.

16 In the Top Viewport, create a Wind Space Warp in the center of the Dish and label it High Turbulence. Set the Turbulence to 10. Copy this Space Warp, label the copy Low Turbulence and set the Turbulence to 3. In the same Viewport, create a Particle Flow system and label it Debris. Set the Viewport Quantity Multiplier to 100 and open Particle View.

Information: As we want two types of turbulence, a strong and a more subtle one, we need to create two different Space Warps with different turbulence settings.

17 In the Birth operator, set the Emit Start to −50, Emit Stop to 200 and Amount to 200. Replace the Position Icon operator with a new Position Object operator and add all of the Charcoal objects to the Emitter Objects list. Remove the Speed operator and add a Spin operator. Add a Split Amount test under the Shape operator and set the Fraction of Particles Ratio to 10. Add a Send out test underneath the Split Amount test.

Information: The basic setup for our particle system simply defines the shape and what is going to emit the particles in the scene – namely all of the charcoal bricks. We are going to send out a small percentage of particles to one event and the rest to another event.

18 Drag out a Scale operator to the canvas to create a new event and label the event High Turbulence. Set the Scale variation to 100 for all axes. Add a Material Dynamic operator and drag the Debris material to the slot in this operator. Add a Force operator and add the High Turbulence Space Warp to its list. Add a Delete operator and set the By Particle Age's Life Span and Variation to 30. Wire this event to the Split Amount test in the other event.

Information: The 10% sent out from the first event have the High Turbulence Space Warp assigned to them so that an occasional particle flies up with more vigor than the others.

19 Instance the High Turbulence event and label the copy Low Turbulence. Make all operators unique apart from the Material Dynamic operator. Set this new event's Scale operator's Scale Factor to 20 for all axes, remove the High Turbulence Space Warp from the Force operator's list and add the Low Turbulence Space Warp in its place. Amend the Delete operator's Life Span to 10 and Variation to 5. Wire this event to the Send Out test in the first event. Finally open the properties of the Debris root, enable Image Motion Blur and turn off Cast and Receive Shadows.

Information: We have cloned the original turbulence event and, by making a lot of the operators unique, we can amend the settings and not affect the originals. We do, however, want to keep the materials the same, so this operator is not made unique. The result is two sets of particles – one with a shorter lifespan which rise slowly, and the other which shoots off particles a lot faster, suggesting that the particle is lighter and getting caught in the updraft of heat emanating from the coals.

PART FOUR: With all our scene elements finalized, we can complete the effect by adding a subtle glow.

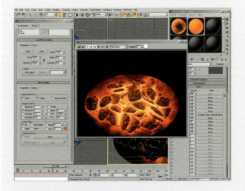

20 Right-click the Play Animation button and amend the Animation Length to 200. Open the Render Effects window and add a Lens Effects effect. Add a Glow element to the right-hand Lens Effects Parameters list. In the resulting Glow Element rollout, set the Size to 10, Intensity to 60 and Use Source Color to 100. Click on the Options tab and enable the Effects ID. Render off the scene.

Information: As the Effects ID corresponds to the ID we assigned to the materials earlier on, the glow is only assigned to these materials. Because we do not need the animation to be as long anymore it has been reduced to a feasible amount.

Taking it further

Our final scene shows the glowing embers, err... glowing, with the odd glowing particle rising up in the heat from the coals.

If you observe glowing coals on a fire or barbeque, after a while the stack collapses, showering the coals in sparks as they rub against one another and break apart, revealing a brighter glow. This could be simulated by running a Reactor simulation again on the coals with a lower friction (or with the same friction but with a downwards force applied to get them to move). Volume Select modifiers could be used to detect when an object collides or rubs up against another object, therefore generating a selection for another particle system to generate a load of sparks, which could be affected by the wind system we already have in the scene.

Alternatively, try breaking up the geometry of the coals and use the Fracture feature in Reactor to get them to break up realistically and to start emitting particles when they move (hint: Speed Test).

You may also want to add some extra texture to the illuminated areas so the colors are broken up a little more, and even try using the Bump map and/or Self Illumination map in conjunction with material displacement. Finally, try animating the hot embers a little by using a Noise map to control the color and animating its Phase slightly to give the impression that there is a hint of a flame in there, licking the sides of the coals and making them glow in places (see the Wood Fire video tutorial on the DVD-ROM).

In the additional 3ds Max file (and rendered animation) included on the DVD ROM, I have animated each Omni light using a Noise controller on the Multiplier value. This makes the coals flicker as if there was a subtle breeze blowing over them making them glow. This, in turn, complements the existing motion of the particles in the scene.

9 Solar flare

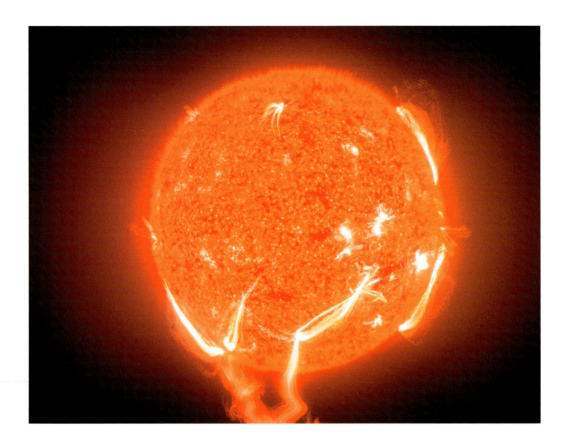

Introduction

This tutorial was pretty much inspired by one that I wrote some time ago using 3ds Max's legacy particle system and, since Particle Flow was introduced, had always meant to re-visit but never had the opportunity. Compared to the original tutorial, this system is a lot more complex and, dare I say it, more convincing in color and animation. By breaking down some excellent source material from NASA we can, with a little bit of effort, design the system to be totally procedural so that the tricky parts of the particle system (emission and attraction) can be handled by materials and multiple nested maps. I'm not saying that the particle system itself is going to be pretty straight-forward as it isn't, however we can set initial properties and then feed the particles into one main setup to ease the load somewhat.

Analysis of effect

(a) For this tutorial, we are going to be basing our reference material on the more aesthetically pleasing SOHO EIT He II 304 Å images; an actual true light image would be simply blown out or would, for the most-part be yellow with not much visible detail for us to simulate. The sun surface material consists of different sized features, ranging from the larger sunspot areas down to smaller "surface fires" and patchy darker areas. Each larger white (in this type of image) sunspot is surrounded by an outer border of light yellow-orange which, in turn, blends into the finer surface material. The color range is quite consistent throughout with three "primary" colors – white, yellow-orange and dark orange-red, which also applies to the main stream ejections which emit from the sunspots. (b) These can mainly be seen on the perpendicular against the outer corona and background of space, however they are present in front of the sun, yet they blend into the main colors, creating streak color variations over the visible facing surface. (c) Each (main) ejection appears to have several secondary ejections which are at different velocities, therefore creating arcs of different heights above the surface. These ejections are fired off at varying angles with varying widths and are attracted back down to the sun's surface, with the majority being attracted to the main ejection points, resulting in a collation of ejection streams from multiple emission points. (d) The stream colors vary in intensity depending on the distance from the surface, from white to our darker orange-red color and back to white as it gets attracted to the surface. The outer corona is stronger around the equator, as are the main emission sunspot points, resulting in an outer glow which is larger horizontally than vertically. We can also make out additional band detail in this region. The outer corona appears, on most samples, to fade in just above the surface and inner corona region. The outer edge of the surface, viewed on the perpendicular, is broken up by smaller orange-colored surface fires which dissipate shortly after emission.

To create the stream effects we are going to rely on Particle Flow, however we are also going to be using materials to drive the overall emission and general control/direction of the particles. First of all we will design the main material for the sun, as we will use this in the particle system later on. The main texture for the sun's surface will be created using multiple nested Cellular maps which will be masked to confine the bright sunspot areas to the equator region of the sun, and away from its poles. This will consist of a few layers to blend each sun "element", from the finer surface fires to each brighter sunspot and its surrounding blend between the bright area and finer surface. We will use a derivation of this map tree, apply it to a new material and

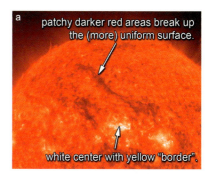

patchy darker red areas break up the (more) uniform surface.

white center with yellow "border".

Image courtesy SOHO (ESA & NASA)

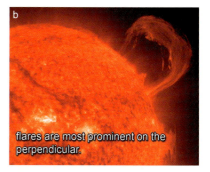

flares are most prominent on the perpendicular.

Image courtesy SOHO (ESA & NASA)

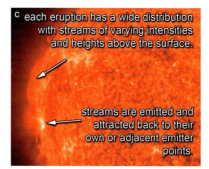

each eruption has a wide distribution with streams of varying intensities and heights above the surface.

streams are emitted and attracted back to their own or adjacent emitter points.

Image courtesy SOHO (ESA & NASA)

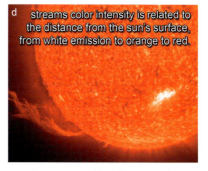

streams color intensity is related to the distance from the sun's surface, from white emission to orange to red.

Image courtesy SOHO (ESA & NASA)

assign it to a non-renderable copy of the sun geometry so our particle system will emit particles only in these bright areas. Our initial born particles will simply sit on the surface and spawn additional particles which will be split into different stream velocity groups. These particles will then create streams at different velocities resulting in each emission point generating streams of differing heights! After a time, the particles will be passed to another event which will draw them back down to the surface to their (current) closest point on the sun geometry's surface, however due to the attraction of the emission spots we need the steams to be drawn to their nearest one. We use this initial delay before being passed to the additional event else the particles will simply rush back to their origin which will ruin the effect. To get the particles to draw back to specific points (the emission points) on the surface, we will use another copy of the sun's surface and, using the emission map to select faces, remove all faces outside the emission points. Therefore restricting a Find Target test to only attract particles to the remaining emission point geometry. The surface fires will be created in a similar way, using the orange areas of the sun material as emitters, but without the emission point attraction effect, although they will be affected by a subtle Wind Space Warp. Finally, we will finish off the scene with volumetric lighting to simulate the intensity of the sun and to add the glow which is stronger around the equator.

Walkthrough

PART ONE: First we will load in the initial scene and set up our Sun Surface material.

1 Open up the *Fire/09_Solarflare/Source/09_solarflare_start.max* file included on the DVD-ROM and accept the unit change if prompted. Press M or click on the Material Editor button to open up the Material Editor. In the first available slot, and label a new material Sun Surface. Assign this material to the Sun Renderable object in the scene.

Information: We are starting from an initial scene already provided to ensure that we are both working with the same unit setup. This is because we will be working with procedural materials using XYZ co-ordinates, so if our units and scaling are different we may end up with different results! We have also assigned a standard material to our object (a simple Geosphere primitive) for us to set up our surface material before breaking it down and using it to emit particles later on.

2 Set the material's Self Illumination setting to 100 and add a Mix map to the Diffuse slot. Label this Poles Mix. In the Color 1 slot, add a Cellular map and label it Large Red Tear Poles. Set the Cell Color and first Division Color to RGB 255,135,10 (a vivid orange) and the second Division Color to RGB 190,20,0 (a darker red). Leave the Cell Characteristics as Circular and set the Size to 20. Set the Spread to 0.8 and enable Fractal. Set its Iterations to 20, ensure Adaptive is enabled and set the Roughness to 0.5. Finally, amend the Low Threshold value to 0.15.

Information: A chunk of heavy setting editing to start with! The Mix Map will blend two similar nested maps, one with more white spots than the other, resulting in less white around the polar regions. We are going to be using nested Cellular maps for the majority of our Sun Surface material as it is the best procedural map that creates the desired broken and patchy effect. Our subsequent nested Cellular maps are going to be derivations of the settings we have just entered, so the majority of the legwork has now been established – we just need to tweak these values from now on! This particular map creates a large orange background (which will be broken up with subsequent maps) with red streaks for the polar region where not much white sunspot patches exist. The size settings are designed to be suited for our Sun Renderable object in the scene, so if the object were larger the settings would have to be amended. We have enabled Fractal to break up the circular cells and Adaptive is enabled to aid render time and increase detail dependant on distance to camera; this is useful as our Iterations are set at a high value. Roughness breaks up the surface creating the patches we need. The Low Threshold setting has been increased so that we have a more defined solid orange color in the center of any subsequent smaller Cellular maps we drop into the first Division Color slot (which we will perform next). The RGB color values were derived from color-sampling the source reference material included on the DVD-ROM. Whew!

3 Copy the Large Red Tear Poles map to its own first Division Color slot and rename this map copy Uniform Surface. In this new map, set the Cell color to white and set the Size to 3. Amend the Roughness value to 0.4, drop the Low Threshold value to 0.1 and the Mid Threshold to 0.35.

Information: Here we have used the existing cellular settings to create a finer map that generates a noisy border effect between the central orange and outer red in the Large Red Tear Poles map. We have amended the colors in the new map to create some central white patches and adjusted the Threshold values to correct their prominence, reducing the strength of the white and making the orange a little stronger in relation. The Roughness has been reduced to reduce the red gaps between the patches of white and orange.

4 Copy the Uniform Surface map to its own first Division Color slot and rename this map copy Large Red Tear. In this new map, copy the orange swatch to the Cell color, set the new map's Size to 20 and the Spread to 1. Amend the Roughness value back to 0.5, the Low Threshold value to 0.15, the Mid Threshold to 0.7 and reduce the High value to 0.9.

Information: To break up this uniform surface pattern, we need to add some large red tears over the surface, just like those in the reference material. By dropping this map into the Uniform Surface map's first Division Color slot we have, in essence, subtracted areas of orange. The settings we have entered have increased the size of the tears while increasing the prominence of the reds in this particular map. The Spread and Roughness work against one-another, but we can create a nice broken effect by getting a nice balance between the two.

5 Back up in the Poles Mix map, copy the Large Red Tear Poles map into the Color 2 slot and rename the new map Large White Spots. In this new map, remove the map in its Division Color 1 slot and set the Cell color to white. Set the Size to 30, Spread to 0.6 and Roughness to 0.4. Set the Low Threshold to 0.2, Mid to 0.4 and High to 0.7.

Information: Starting from the largest sized spots and working down in size, we will now create the equatorial maps, utilizing some of the maps which we have already created so that when we blend the two together there is a seamless transition between the polar and equatorial maps. Here we have amended an existing map as before, and removed a sub-map we don't need to create some large white patches for our sunspots, with the Threshold values designed to define borders between each color/map swatch that we will add next.

6 Copy the Large White Spots map into its own Division Color 1 slot and label the new map White to Orange Veins. In this new map, swap the Cell and Division Color 2 swatches and set the Cell Type to Chips. Set the Size to 10 and Spread to 1.5. Amend the Mid Threshold to 0.7 and High to 0.9. Copy this map to its Cell color slot and rename the new map Large Orange Border. Swap the Cell and Division 2 colors back, set the Cell color to orange and set the Cell Type back to Circular. Set the Size to 30, Spread to 0.6, Mid Threshold to 0.4 and High Threshold to 0.7.

Information: To break up the transition from white to orange in the sunspot's border, we have used a sub-map to create some small veins by amending the Cell Type and defined the threshold and Spread settings to distribute them accordingly. As this causes the Orange color to drop back somewhat and we lose the defined outer orange border, we have defined it in an additional sub-map by tweaking the Threshold and Spread settings so we have an overall transition from white to white veins to orange to red.

7 Back up in the Large White Spots map, instance the Uniform Surface map into the Large White Spots map's Division Color 2 slot. Back up in the Poles Mix map, add a Gradient Ramp map to the Mix slot and label it White Spot Mask. Enable V Mirroring in this map and set the W Angle spinner setting to 90. Design the gradient as illustrated with black flags at positions 0, 15, 85 and 100 and white at positions 35 and 65 and set the Noise Amount to 0.2, Size to 3 and set the Noise Type to Fractal.

Information: As we have done the majority of the legwork for the "background" map structure in the poles section of this material, we can simply instance this map tree into our existing Large White Spots map, resulting in the background red area being replaced with our high detailed surface effect! Our two main map trees (poles and equatorial) are mixed together using a noisy Gradient Ramp map to break up any visible transitional lines. We have enabled V mirroring so we don't get any vertical seam down our map due to the noise at either end of a (non-mirrored) gradient not matching exactly. The W Angle setting simply orients the gradient so that it is polar and wraps around the Geosphere correctly.

PART TWO: With our sun material established, next we will set up a material to distribute our particles

8 Instance the Sun Renderable object in the scene and label the instance Sun Stream Emitter. Assign a new material to it and label this material Sun Stream Emitter. Copy the Large White Spots map from the Sun Surface material to the Stream Emitter's Diffuse slot, label the copy Large White Spots Birth and remove all sub maps from it. Set the Division Colors to black and the Cell Color to white. Set the Low Threshold to 0.3, Mid to 0.5 and High to 0.4. Instance the White Spot Mask Gradient Ramp map to this maps's Cell Color slot.

Information: The particle system, that we are going to design shortly, will utilize this material to position the initial birth particles based on grayscale map information, e.g. particles will be positioned where the map is white and varying grey intensities. Therefore by stripping out all color from the map copy, we can confine the particles so that they are only positioned around the sun spots. As the sun spots are masked out by the Gradient Ramp map in the Sun Surface material, we needed to use this map as a sub-map within the White Spots Birth map to control the white cell color, thus restricting the birth particles to the equatorial sun spots.

9 Copy the Sun Surface material and label the copy Sun Surface Fires Emitter. Next, go through the entire material copy and amend the color swatches in each Cellular map, so that each orange swatch is white and each white and red swatch is black. Instance the Sun Renderable object again, label it Sun Surface Fires Emitter and assign the Sun Surface Fires Emitter material to it. Select both Sun Stream Emitter and the new Sun Surface Fires Emitter objects, right-click and select Properties. Un-check Renderable and click OK.

Information: As with the Sun Stream Emitter, we will be using grayscale information to position birth particles for the sun's surface fires. As we will shade these particles orange (as in the reference material) and use them to break up the perpendicular hard edge of the Geosphere, we need to emit the particles only where the surface material is shaded orange, hence turning the material copy's orange swatch white (particles) and other colors black (no particles). We have made the Geosphere emitter objects non-renderable for safety (incase we forget to hide them before rendering!)

PART FOUR: Next we will set up our main particle systems to create the emission stream effects and surface fires.

10 In the Top Viewport, create a Particle Flow system in the exact center of the scene (the middle of the Geospheres at 0,0,0), label it PF Source Sun Streams, set its Particle Amount Upper Limit to 10000000 and the Render Integration to Frame. Open Particle View and rename Event 01 to Flare Birth. Remove all operators from this event apart from the Birth and Display operators. In the Birth operator, set Emit Stop to 500, enable Rate and set the Rate value to 10. Next, add a Position Object operator and add the Sun Stream Emitter object to its Emitter Objects list. Enable Density By Material.

Information: Our stream solar flare effect is going to be generated by a Particle Flow system, emitted from certain points (sun spots) over our sun. We have removed operators from the standard Particle Flow system that we don't need, and added a Position Operator to get the particles to be born from points defined by the emitter object's assigned grayscale material as discussed previously. We have increased the Particle Amount Upper Limit so we can have more particles in the scene, and the Integration Step has been reduced to Frame to reduce calculation times at the expense of accuracy. We have set the Emit Stop value to the duration of the animation.

11 At frame 0, add a Spawn test to the event, rename it to Spawn Emission Amount and enable Delete Parent. Set the Offspring to 10 and Variation to 100. Create a new event by adding a Speed operator to the canvas, label the new event Flare Stream Splitter and wire the output of the Spawn test to the input of this new event. Rename the Speed operator to Speed Stream Direction. Set this operator's Speed value to 0.01, set the Direction to Icon Center Out and Divergence to 85.

Information: We are adding the Spawn test at frame 0 so that the system does not keep re-spawning spawned particles which can result in the system being immediately bogged down. Before scrubbing through the animation when adding a Spawn test, always ensure that there is somewhere for these Spawned particles to go. The Spawn test has been added to generate the parents (10 of them with a variation of 100%) for the multiple streams emitting from a single emission point. These spawned particles are given a subtle speed to indicate which direction the streams should travel. We are using Icon Center Out so the streams will be directed outwards and away from the surface but in multiple directions thanks to the Divergence value.

12 Add a Split Amount test to the event. Add another Split Amount test and set its Ratio % to 75. Finally, add a Send Out test to catch the remaining particles in this event and direct them down this channel. Next, create a new event at frame 0 by adding a Spawn test to the canvas and rename the event to Flare Direction Distribution01. Rename the Spawn test to Spawn Stream Width01. In this test, enable Delete Parent and set the Offspring to 3 with a Variation of 100. Set the Inherited Speed Divergence to 10. Add a Delete Operator to the event, set it to By Particle Age and set the Life Span and Variation to 50.

Information: Here we are splitting off the parent stream particles so that we can next assign speed strength properties for each stream that we will create next. The Spawn test was added to create a slight width (hence the Divergence setting) to an individual stream so that we have multiple streams of the same speed (height above the sun's surface) adjacent to one-another. The Delete operator sets the lifespan of the eruption, to say how long the stream eruption should last, not the lifespan of the stream itself.

13 Add a new Spawn test to the event and rename the test to Spawn Stream Emission Amount01. Set the Spawn Rate And Amount group to Per Second and amend the Rate amount to 50. Set the Spawnable Variation to 100 and set the Speed Divergence to 0. Instance the entire event another two times and wire the Output of the Split Amount and Send Out tests in the Flare Splitter event to the input of a Flare Direction Distribution event as illustrated.

Information: This Spawn test defines how constant the flare stream is. By increasing the Rate amount, we can close the gaps between the stream particles, giving a more defined stream but greatly increasing the particle amount and therefore render times in the scene. We have removed any Divergence so that the streams do not become broken up and mixed together. We are using multiple instances of this same event and not piping the entire lot to this event as the streams would get jumbled up later on resulting in non-defined streams as mentioned before. In this event we are simply defining the stream eruption lifespan and the stream detail.

14 Add a Shape Facing operator to the canvas to create a new event and rename the event to Small Streams. Set the Variation to 25. In the Top Viewport, create a new Camera and position directly face-on as illustrated so we can see the entire sun in the resulting camera's Viewport. Back in the Shape Facing operator, click on the Look At Camera/Object's button and pick the Camera01 object in the scene. Add a Material Dynamic operator to the event and add a Speed operator. Rename the Speed operator to Speed Small Streams and set the Speed to 20 with a Variation of 3. Set the Direction to Inherit Previous with a Divergence of 2.

Information: Our Shape Facing operator, which now makes the particles renderable from here on needs something to look at, else all of the particles will face directly upwards, hence creating the camera and getting them to face it. The Material Dynamic operator has been added so that we can design a material later on that will change color depending on the particle's distance from the sun surface. The Speed operator is the most important as it defines the altitude the stream will get to before getting sucked back down to the nearest sun spot later on. We have added a slight speed variation and divergence just to break up the individual stream so that the adjacent streams (created in the Spawn Stream Width test in the previous event) all blend together nicely to create one thicker stream. We are using Inherit Previous as our speed direction type as the stream direction has already been established in the first Speed operator; we just now need to set how fast each stream travels!

15 Add a Force operator to the event. In the Top Viewport, create a Spherical Wind Space Warp in the center of the Geospheres at 0,0,0. Set the Strength to 0 and Turbulence to 1. Set the Frequency to 1 and Scale to 0.1. Rename this object to Wind Streams. Copy this Space Warp and rename the copy to Wind Streams Large. Set the Frequency to 0 and Scale to 0.01. Add these two Space Warps to the Force operator and set its Influence value to 50. Add an Age test to the event, set it to By Event Age and set its Test

Value to 3 with 0 Variation. Instance the entire event twice and wire the input of each event to the output of its corresponding Spawn Stream Emission Amount test as illustrated.

Information: We have added a Force operator with a reduced Influence (to control the overall strength of the added Space Warps) and added two new Wind Space Warps to the scene to add some variation in motion to the streams, giving a more "fluidic" effect. We have two Wind "waveforms" – one large and one small, driven by the settings in the Space Warps. We have instanced the events and wired them ready to make certain parts unique and to amend their settings, which we will do next, to set individual stream velocities. The Age Test has been added so

that, after a given time, the particles will be sent to the next event where they will be attracted back to the nearest sun spot point on the surface; if we had set the attraction immediately using the Find Target test, which we will add shortly, the particles will get directly attracted back to their emission point, which is not what we want. Therefore we wait a period of time for the particles to gain some distance before the attraction back to the surface is applied resulting in them finding different points!

16 Rename the first event copy to Medium Streams. Make this event's Speed operator unique, rename it to Speed Medium Streams and set its Speed to 30. Rename the second event copy to Large Streams. Make this event's Speed operator unique and Rename it to Speed Large Streams. Set its Speed to 50.

Information: Here we have set the velocity parameters for the two remaining stream types. The result will be a variation in stream height so we get multiple stream arcs at different sizes when our system is complete. It is important that we make these operators unique, else we will affect the instances in the other events.

17 Instance a Shape Facing operator to the canvas to create a new event and wire the output from each Age test in the Small, Medium and Large Streams events to this new event. Label the new event Stream Find Target Search. Instance the Material Dynamic and Force operators and an Age Test to this event. Add a Find Target test to the event and set its Cruise Speed and Accel Limit to 100. Set the Target Point to Closest Surface. In the Viewport, copy (not instance) one of the existing non-renderable Geospheres and label the copy Sun Stream Receptor. Set this copy's Segments to 50 and add a Volume Select modifier to the stack. In the Find Target test, enable Mesh Objects and add this object to its Mesh Objects list.

Information: We are using instanced operators from the other events so that the material parameters are maintained, plus are continued to be affected by winds so there is no discernable change in particle behavior. We have also instance the Shape Instance across so that the particles still face the camera; if we hadn't done this and amend the position of the camera, a particle's orientation will not be adjusted – it will take the last known orientation as it left the last event. To attract the particles back down to the surface, we are using a Find Target test to hunt for nearest

geometry points. To restrict these points to the sun spots, we will use an enhanced version of the white particle emitter map to remove unwanted faces in the new Geosphere so that the Find Target test can only find the remaining sun spot faces. We have increased the amount of Segments in this new Geosphere so that the Volume Select modifier will pick out more face selection detail and we will have a nicer defined selection and more remaining faces for the Find Target test to work with.

18 In the Material Editor, create a new Output map in a material slot, label it Stream Receptor Face Selection and instance the Large White Spots Birth map (from the Large White Spots material) into its map slot. Open up the Output map's Output rollout, click on Enable Color Map and set the point at 1,1 to Bezier and design the curve as illustrated. Instance this entire map tree to the Texture Map slot of the Volume Select modifier and enable Texture Map in its Select By group. Set the Volume Select's Stack Selection Level to Face, enable Invert in the

Selection Method group and set the Selection Type to Crossing. Finally, add Delete Mesh and Mesh Select modifiers to the stack.

Information: We have used the Output map to intensify the white areas of the sub-map so that we have a larger solid white area (instead of a white core and grey outer area) to be used in the Volume Select modifier to drive the sub-object face selection. Crossing has been enabled so that any selection that borders another face will select that face, resulting in a larger number of selected faces before the selection invert. The sub-object face selection has been inverted so that the Delete Mesh operator removes all faces that aren't "white" and the Mesh Select simply clears the sub-object selection to make things neat.

19 Back in Particle View, add a Collision test to the latest event. In the Top Viewport, create an SDeflector in the center of the Geospheres and set its Diameter to 201. Add this deflector to the Collision test's Deflectors list. Add a Delete operator to the canvas to create a new event and label the new event Killer. Wire the Output of the Find Target and Collision tests to the input of this new event. Finally, instance the entire Stream Find Target Search to create a new event and label it Stream Find Target

Final. Wire the output of the Stream Find Target Search's Age Test to the input of this new event. Remove the Age Test from this new event and wire the output of the Find Target and Collision tests to the Killer event as before.

Information: We have added an SDeflector to encompass the Geosphere to catch all particles that are attracted back down to the surface before they come into contact with the Find Target test. This is to improve performance somewhat and also to ensure that particles that do not meet the Target Point test value of 1.0 don't just skip by the point and loop back round to try again. This also catches any other particles that hit the surface of the sun. We have (again) passed the particles that haven't hit the surface after three frames to another event where the particle properties, forces and other influences are identical, so that the Find Target is reset and the particles search for new points to be attracted to, therefore creating more widespread arcs and thus a nicer result.

20 In Particle View, create a new Standard Particle Flow system, label it PF Source Sun Surface Fires, set its Particle Amount Upper Limit to 10000000 and the Render Integration to Frame. Rename the system's event to Surface Fires Emitter. Remove all other operators from this event apart from the Birth and Display operators, select the Birth operator, set the Emit Stop to 500 and Rate to 10000. Add a Position Object operator to the event and add the Sun Surface Fires Emitter object in the scene to its Emitter Objects list. Enable Density By Material and enable Delete Particles in the If Location Is Invalid group. Add a Delete operator to the event, set it to By Particle Age and set the Life Span to 50 with 50 Variation.

Information: As with the stream system, we are going to create particles at positions over a surface emitter object using its grayscale information in the assigned material and use them to spawn additional particles which will then be controlled and made renderable by another event (as we have removed the Shape operator from this current event). We have enabled Delete Particles in the If Location Is Invalid group to ensure that no occasional wayward particles are born in areas outside the defined birth areas. We have added a Delete operator to the event so we get birth particles which are born and then die within a given timescale, creating "cycling" plumes of fire particles and not an amount of surface fire that keeps growing and growing!

21 Add a Spawn test to the event and set it to Per Second with a Rate value of 5. Instance one of the other system's Shape Facing operators to the canvas to create a new event, wire the output of the Spawn test to the input of this new event and label the new event Surface Fire Tendrils. Add a new Material Dynamic operator to the event and add a Force operator. Add the two Wind Space Warps in the scene to the operator's Force Space Warps list and set the Influence to 10. Add a Speed By Surface operator

to the event, set the Speed to 1.5 with a Variation of 0.5 and add the Sun Surface Fires Emitter object to the Surface Geometry list. Finally, add a Delete operator to the event, set it to By Particle Age with a Life Span and Variation of 25.

Information: We are using the Spawn test to emit particles at a designed rate which are made renderable by the instanced Shape Facing operator in the next event. These particles have their speeds controlled by the emitter object – where the surface material assigned to the emitter object is white the speed is set to its maximum (defined) value (etc) so we end up with a mass of surface fires at varying heights creating a more natural effect. We have added a new Material Dynamic operator to the event as we will create a new material to be assigned to this system that is slightly different to the material that will be assigned to the main stream system. The Wind Space Warps have been added to get the surface fire particles to disperse and move more like tendrils and to break up any uniformity. Finally, the Delete operator kills off the particles after a given time so the particles don't travel millions of miles out into space!

PART SIX: Finally, we will set up and assign our particle system's materials and set up volumetric lighting to simulate the sun's outer glow.

22 In the Material Editor, label a new material Sun Streams. Set its Self-Illumination to 100 and Opacity to 0, add a Gradient Ramp map to the Diffuse slot and label it Stream Color. Set the Gradient Type to Mapped, set the Interpolation to Ease In and remove the middle flag. Set the flag at position 0 to RGB 190,20,0 (the red color used in our sun surface material) and set the flag at position 100 to white. Add a flag to position 97 and set that to white also. Add a flag to position 80 and set it to RGB 255,135,10 (the orange in our sun surface material). Next, add a

Falloff map to the Source Map slot of the Gradient Ramp map and label it Stream Sun Distance. Set the Falloff Type to Distance Blend and Falloff Direction to Object. In the resulting Mode Specific Parameters Object button, add the Sun Renderable object and set the Near Distance to 100 and Far Distance to 130. Instance the Gradient Ramp map to the material's Opacity slot, set the Opacity slot's Opacity value to 40 and instance the entire material into a Material Dynamic operator in the Stream system.

Information: Quite a large step here, yet quite straight-forward. Here we have used the same colors as the original sun surface material for our streams in a Gradient Ramp map which are driven by a Falloff map which changes color depending on the distance from a designated object. However it should be noted that the distances entered into the Distance Blend Parameters are related to the axis co-ordinates of the object in question, NOT its surface co-ordinates, therefore the value for near

distance is the radius of the Geosphere and the Far Distance the extremity of our color change from the Geosphere's axis. As we have instanced the Material Dynamic operator several times throughout our stream system we only need to add it to a single operator.

23 Label a new material Sun Surface Fires. Set its Self-Illumination to 100, Opacity to 40, add a Gradient Ramp map to the Diffuse slot and label it Surface Fires Color. Set the Gradient Type to Mapped, set the Interpolation to Ease In and remove the middle flag. Set the flag at position 0 to RGB 190,20,0 and set the flag at position 100 to RGB 255,135,10. Next, add a Falloff map to the Source Map slot of the Gradient Ramp map and label it Surface Fires Sun Distance. Set the Falloff Type to Distance Blend and Falloff Direction to Object. In the resulting Mode Specific Parameters Object button, add the Sun Renderable object and set the Near Distance to 100 and Far Distance to 120. Instance the Gradient Ramp map to the material's Opacity slot, set the Opacity slot's value to 40 and instance the entire material into the Material Dynamic operator in the Sun Surface Fires system.

Information: Another large step here, yet virtually identical to the one before. Technically, we could have copied the existing material and simply edited a few parameters, yet the amount of workload would be pretty much the same. Here, as our surface fires are (in essence) being emitted from orange areas of the original renderable sun object, we needed the first color of the particle to be orange which then changes depending on (a slightly smaller) distance to red.

24 In the Top Viewport, create an Omni light in the center of the Geospheres and label it Omni Inner Corona. Set the Multiplier color to the red used in the Sun Surface material (RGB 190,20,0), set the Decay Type to Inverse Square and set its Start value to 98. Enable Use and Show Far Attenuation and set the Start setting to 98 and End to 150. In the Atmospheres and Effects rollout, add a Volume Light environment effect, select it in the list and click on Setup. In the resulting Environment panel, enable Exponential and set the Density to 2. Rename the Volume Light effect to Volume Light Inner Corona.

Information: The inclusion of this light generates a subtle red haze around the sun. We are using Inverse Square so that we get a realistic falloff coupled with the attenuation, so that the volumetric density decays nicely.

25 In the Left Viewport, create a Free Spot light in the middle of the Geospheres as before. Rename the light Fspot Outer Corona Cone01. Set its Multiplier to 2, color to RGB 230,70,0, set the Decay to Inverse Square with a Start value of 95. Enable Use and Show Near Attenuation and set the Start value to 95 and End to 115. Enable Use and Show Far Attenuation and set the Start value to 115 and End to 350. Expand the Spotlight Parameters rollout and set the Hotspot/Beam to 0.5 and Falloff/Field to 120.

Information: Here we have generated the properties for one of two spotlights which will create the strong equatorial corona effect as illustrated in the reference material. We have used Near Attenuation (which creates the effect of the light fading in) to generate the subtle gap between the inner and outer corona as mentioned in the Analysis section. We have used a low setting for the Hotspot/Beam and high value for the Falloff/Field so that we don't have any visible outer edge line where the outer cone limit is situated. Again, the light's color was point-sampled from the reference material as well as its attenuation.

26 Expand the Atmospheres and Effects rollout and add a Volume Light effect as before. In the Environment panel, rename the new Volume Light effect to Volume Light Outer Corona, enable Exponential and set the Density to 1. Instance the Fspot light and rotate it 180 degrees so it is facing in the other direction. Copy the light, rename it to Omni Outer Corona, change the light type to Omni and turn off Use and Show Near Attenuation. Finally, select the Sun Renderable object, right-click and select Properties. Enable Image Motion Blur. In Particle View, apply Image Motion Blur and render off the animation.

Information: As we have only created the volumetric light for one side of the sun, we needed to add it to the other side, hence instancing it and rotating it 180 degrees. So that the polar regions also have an outer corona, we have used the same settings for an Omni version of our volumetric Spot lights which makes the resulting effect more realistic. The volumetric effect from this Omni light overlays on top of the existing Spot light volumetrics and the Inner Corona Omni light, generating our final result. All we now need to do is render off the final scene!

Taking it further

Again, as with any scene with an absolute ton of particle, this one is going to take a while to render... mainly due to the amount of overlapping semi-transparent particles and volumetrics and also for the particle calculation times because of the way they are initially distributed and how they are attracted (a lot of particles trying to find geometry surface points!). Therefore if you find your system can't handle the particle count, try reducing the amount of initially spawned particles a notch or two, or reduce the amount of spawned stream particles to reduce the overall amount (although with this latter setting amendment you may find you will start to see gaps in the stream which may break up the effect somewhat).

So how can we improve on this scene? Well so far we have only designed the smaller stream system and surface fires, so you might want to have a go at creating a larger eruption or three from the emission points. To do this we simply need to design an additional event which has an increased ejection velocity and a larger mass of spawned particles, then split off a tiny percentage of the original particles to this event so it occurs only one or twice throughout the entire sequence. We can then feed the particles back into our main control events so that the particles are draw back down to their nearest emission attraction point or, if you're feeling pretty adventurous, split them off again so that the large ejection carries out into space! Part of this is included on the book's DVD-ROM as the Taking It Further scene. You may also want to add in the ray banding effect which is present in the outer corona and described in the Analysis section by incorporating an additional volumetric light setup that uses a projector map to create the rays. Again, this is added to the Taken Further scene, however it significantly increases render times, especially when our particle count is at its peak!

As the entire system is parametric with its emission and Find Target geometry driven entirely by materials, we can amend the material settings to animate the surface of the sun to give a nice boiling effect, however as Cellular maps does not have a Phase setting to animate, we will have to drive this by having additional animated nested Noise (etc) maps to create the animated effect. Additionally, be warned that animating these maps and their corresponding particle emission maps so that, by enabling Animated Emitter in the Position Object operator, we can emit particles accordingly over the animated surface, will increase particle calculation times considerably. You will also need to source close proximity footage to get the effect right which, judging from footage I have seen is akin to bubbling porridge...!

Finally, this scene is really only suitable for mid and distant shots due to the particle count. If you really want to get close to the surface, try limiting the particle emission to only that section that you are viewing, therefore you don't have to calculate particles for areas outside of the camera's field of view. You may want to amend the material setup further as you will see more of the surface and have smaller particles and perhaps an additional system or two to create smaller surface fires and finer particle detail. In the scene on the DVD-ROM I have also animated a camera around the sun to give the impression of the sun rotating by parenting the camera and spotlights to an animated Dummy. This is because the particles will not follow the sun's surface, so if we animated the sun rotating, the emission particles would remain static while the bright emission areas would rotate, ruining the effect. Often the simplest solutions are the best...!

Water

At first glance, water effects appear quite easy to do, and so a lot of the time it results in failure. Water dynamics are exceptionally difficult to simulate, which is why research still continues into producing the most effective fluid dynamics system. In this section we will concentrate on creating fluid effects, from calm to stormy seas, rising bubbles in a glass of lemonade and even create convection effects with a lava lamp, amongst others. See the DVD-ROM for more water effects in the Videos section.

10 Lemonade

Introduction

I was originally going to include a tutorial on how to make a glass of water, then I thought 'what is exciting about that?' And it's true; we've got virtually everything we need built right into 3ds Max to make a simple glass of water. Aaaaaahh, but what if you want the water to be lemonade? What is so interesting about that? Well, the bubbles are; the way they travel and react with the surface, the way they are formed on the bottom and from weird traveling single spots suspended in the liquid. This can result in quite a challenging particle system to set up. Okay, technically this tutorial should really be in the Air section as it's about creating bubbles of gas, but we're going to be adding the (basic) materials to the glass and the liquid. So open a bottle of supermarket's own brand, and let's get started.

Analysis of effect

dirt and imperfections in the glass allow bubbles to form around them

floating debris in the liquid causes bubbles to form around them and immediately float up to the surface

after rising to the surface, the bubbles either pop or travel to the side of the glass

if they reach the side of the glass intact, the bubbles either linger or travel the glass, following the liquid's meniscus

the bubbles at the base (and sides) of the glass expand until the bubble is big enough to detach from the glass and rise up through the liquid to the surface

(a) The actual glass and lemonade effects are pretty straightforward as these are generic right across the board (albeit from a slight amount of distortion due to imperfections in the glass). These imperfections are actually what increases the amount of bubbles in the lemonade. For example, in a freshly poured glass of lemonade, stick your finger into the liquid. You will notice that bubbles will form around the whorls of your fingerprint, any loose skin and any other debris present on your finger. The same can be attributed to the formation position of the bubbles on the inside of the glass; they form where there are imperfections, dust and debris on the surface of the glass. (b) This can also be seen in the small vigorous trail bubbles which casually drift around inside the liquid and emit a stream of trailing bubbles at a fast rate. Look very closely and you will see a small piece of debris which the bubbles are forming around. As there is nothing much for them to form around, they immediately slip off the surface of the debris, accelerate upwards and hit the surface of the water at which point, due to surface tension, they either pop or travel (due to the meniscus of the fluid) to the side of the glass. (c) If they make it (they might pop en-route) they either get stuck in the meniscus or travel around the glass a little before bursting. Other bubbles also behave the same way when they reach the surface of the liquid; these are born by forming around imperfections or debris near, or on the base (which is what we will concentrate on for this tutorial) of the glass. (d) After the gas has collated, and the pull upwards from the difference in pressure is greater then the tension on the surface, the bubble detaches and travels upwards (at roughly the same speed as the tiny trail bubbles), where it hits the surface and behaves as the small trailing bubbles do.

The actual construction of the glass and lemonade objects has already been done for us; they are both derived from a single lathed spline which has been modified to create the two separate objects (so their geometry is close to one another). The lemonade geometry has also been reduced slightly in size so that the outer polygons of its geometry are not fighting with the inner polygons of the glass for which one is displayed on top, which occurs when two faces occupy the same co-ordinates. We will need to create materials for them, which can be done very easily with the use of the Architectural Material. The bubbles themselves will be generated using a Particle Flow system in two separate stages. Firstly, the small particle trails will be created using the lemonade geometry as an emitter for a couple of

individual particles which will move around the volume of the 'liquid' at random. As they travel, they will emit a stream of particles which will be passed to an event containing Wind to make them accelerate upwards to the surface. Upon reaching the surface, they will come into contact with a deflector that will force them to spawn an additional particle (with the parent particle being deleted) to kill the velocity. This particle will then be passed to another event to make a transition to the nearest side of the glass which, if it makes it without bursting, will linger and move around the edge of the glass for a short period before popping. The other stage is the bubbles forming and rising from the bottom of the glass. These particles will scale up and, once they reach a certain size, will be passed to an event which accesses the same wind as the other particles. Upon hitting the deflector, the particles will be passed to the same event as the trails particles so that they behave in the same way (and to save us extra work).

Walkthrough

PART ONE: First we will load in the initial scene. After which, we will create and assign the materials for our glass, lemonade and bubbles.

1 Open up the *Water/10_Lemonade/Source/10_lemonade_start.max* file included on the DVD-ROM. Press M or click on the Material Editor button to open up the Material Editor. In the first available slot, create a new Architectural material and label it Glass. Choose the Glass-Clear preset from the pull-down menu in the Templates rollout and set the Diffuse color to white. Assign this material to the Glass object in the scene.

Information: A quick word of warning before we go any further – this scene makes heavy use of raytracing and reflective Architectural materials, so if you are using a slow machine it may take a while to render it off. Our basic scene is comprised of a (rough) café style layout with a few tables and ashtrays situated on them. This is the same scene that is used in the Cigarette Smoke tutorial. We are using the Glass architectural material as it already has the basic features set up within the preset, so we do not need to generate our own glass material from scratch. As a rule, if it ain't broke, don't try to fix it. We have adjusted the Diffuse Color of this material because in this material type it has an affect on transparency.

2 Clone this material a couple of times and label them Lemonade and Air accordingly. In the Lemonade material, change the Template preset menu to Water and in the Air material change it to User Defined and set the Index of Refraction to 1.02. Assign the Lemonade material to the Lemonade object in the scene.

Information: As we have got the basics of the other materials already set up, we do not need to repeat ourselves, therefore we can just clone the material to save ourselves extra work. The Air material is going to be assigned to the particle system in the scene which will act as the bubbles. We have used an Index of Refraction (refractive properties of a medium) setting that is not air else the bubbles would not be all that visible. Therefore, a low IOR will not distort the scene elements behind the object with this material assigned too much (as air wouldn't), but will reflect and refract enough on the perpendicular to suggest that there is a bubble of air in the liquid, instead of another substance inside the liquid, which is what we are really creating. But because of the low IOR, we can get away with it.

PART TWO: With the materials set up, we will now set up additional objects in the scene to control the motion and interaction of the bubble particles.

3 In the Top Viewport, create a UDeflector Space Warp. Click on its Pick Object button and select the Glass object in the scene. Set the Bounce to 0.1. Still in the Top Viewport, create a Deflector Space Warp over the top of the Glass and Lemonade objects. In the Left Viewport, reposition this Deflector so that it is situated underneath the meniscus (the curved part) of the Lemonade surface, along the main surface of the Lemonade.

Information: The UDeflector is to detect collisions for events later on, and to prevent any particles passing through the sides of the glass. This is highly unlikely due to their motion, but it is better to be safe than sorry. The meniscus of a fluid is the curved area where it comes into contact with a solid object, e.g. the side of a glass or cup. When viewed in the Left Viewport, the top of the meniscus of the Lemonade is (obviously) higher than the majority of its surface, so ensure that you place the Deflector in the correct place or else the particles will pass through the surface of the Lemonade. There is no Bounce set in the UDeflector as we want the particles to just brush off the side of the glass. The Bounce remains in the Deflector as we are simply using this Space Warp in a Collision test to send the particles to the next event, so the Bounce will have no effect.

4 In the Left Viewport, select the Lemonade object, create a reference copy of it and label it Lemonade Base Emitter. Add a Slice modifier to this reference copy and enable Remove Top. Still in the Left Viewport, rotate the Slice modifier's Gizmo 90 degrees anti-clockwise to remove the top half of the mesh. Move this gizmo down so that 1/3 of the curved geometry at the bottom of the glass has been sliced off. Add a Normal and a Push modifier. Set the Push Value to 1.5. Right-click this object and select Properties in the resulting Quad menu. Turn off Renderable in the resulting Properties panel and click OK to exit. In the Top Viewport, create a Wind Space Warp in the middle of the Glass and set its Turbulence to 0.5.

Information: This reference copy is used to emit the growing bubbles emanating from the bottom of the glass. We have flipped the normals and pulled in the mesh so that the particles are being born (and grow) on the inside of the glass. If we did not have the Push modifier added, the bubbles would grow and intersect the Lemonade and Glass geometries. This object has been made non-renderable as it is simply an emitter object, yet has been kept as a reference just in case we do anything to the source geometry, such as change its shape later on. The Wind Space Warp has been added so the particles accelerate up the glass and don't just travel with a linear speed.

PART THREE: We will now develop the first part of the particle system which generates the small bubble trails.

5 In the Top Viewport, create a Particle Flow system and label it Bubbles. Set the Viewport Quantity Multiplier to 100 and click on the Particle View button. In Particle View, rename Event 01 to Bubble Trails Emitter. In the Birth operator, set the Emit Start and Emit Stop to −100 and Amount to 2. Remove the Rotation and Shape operators and overwrite the Position Icon operator with a Position Object operator. In this new operator, add the Lemonade object to the Emitter Objects list and change the Location to Volume.

Information: As we want the particles to be already born when we 'join' the scene, we need to set a negative frame for the birth of the particles. −100 was used to give the trailing particles (which we will set up shortly) time to move up and interact with the surface. Currently, we are only using two trails (hence the Amount setting of 2), but this could be increased to any setting you want, as the information will be passed on down through the events to come and acted on accordingly.

6 Select the Speed operator and set the Speed to 3 with 10 Variation and a Random 3D Direction. Add a Collision test and add the Deflector and UDeflector to its Deflectors list. Turn off the entire particle system. Add a Spawn test and enable Per Second. Set the Rate to 50 and the Inherited Speed to 0. Drag a Material Static operator to the canvas to create a new event and label this event Trails Motion. Instance the Air material from the Material Editor to the slot in the Material Static operator. Wire the output of the Spawn test to the input of this event. Turn the particle system back on.

Information: We have added the deflectors in case the emitter particles move through the sides of the glass; even though they are moving very slowly, there is a chance so we will prevent this just in case. We have had to turn off the particle system before setting the Spawn test's settings else, as we have set the birth time back to −100, the particle spawning will have to be calculated for 100 frames which, with the default settings and other operators in this event, can take a while, because of the spawned particles being stuck in the same event, spawning even more particles! Once the spawned particles have been passed to the next event we do not have the update lag problems, so the system can be turned back on.

7 Add a Shape test to this new event and set the Shape to Sphere with a Size of 2. Add a Scale operator to the event, set the Scale Factor to 40 for all axes and the Scale Variation to 5 for all axes. Add a Force operator and add the Wind Space Warp to its Force Space Warps list and set the Influence to 250. Add a Collision test to the event and add the UDeflector to its Deflectors list. Add a Collision Spawn test and add the Deflector to its Deflectors list. Set the Spawnable setting to 50. Drag out a Speed operator to the canvas to create a new event and label this event Glass Attraction. Set the Speed operator's Speed and Variation to 10 with a Random Horizontal Direction, and wire the Collision Spawn test to the input of this event.

Information: We have used a Shape operator, set its size to a certain amount, then reduced it dramatically using a Scale operator as we will use an instance of this Shape operator in another event, so we required an additional operator to sort out its scale and scale variation. The Force operator has the Influence dropped to 250% (a setting of 1000% is the same as 100% influence on the legacy particle systems) to get the bubbles to accelerate up through the liquid and to disperse a little near to the top of the liquid. We have added a Collision test so that the Wind-affected particles do not pass through the sides of the Glass. We have used a Collision Spawn test because it kills the speed of the spawned particle so that we can assign a single Speed operator which disperses the bubbles across the surface of the lemonade. We don't want all of the bubbles to be dispersed; some need to pop, hence the reduction of the Spawnable setting to 50%. To illustrate this in the Viewport, set the Display operators to show Geometry.

8 Copy the Material Static operator in the Trails Motion event and Paste Instanced it into this new event. Add a Find Target test and change it to Control By Time. Set the Time setting to 20. Enable Mesh Objects and add the Glass object to the Target list. Change the Point to Closest Surface. Copy and Paste Instanced the Collision test from the Trails Motion event. Add a Delete operator, enable By Particle Age and set the Life Span to 10 with 0 Variation.

Information: The Find Target test is set to look for the Glass's closest geometry, then spend 20 frames (give or take 5) getting there. However, some along the way (those with further to travel) will burst. For this to occur, the Delete operator was introduced and set to a value of 10 which ensures that the bubbles have to be pretty close to the edge of the glass to make it without being deleted or popped.

9 Copy either of the Material Static operators present in the particle system and Paste Instanced it onto the canvas to create a new event. Label this new event Bubble Glass Travel. Wire the output of the Collision test in the Glass Attraction event to the input of this new event. Add a Speed By Surface operator to the new event and change it to Control Speed Continuously. Set the Speed and its Variation to 5, add the Glass object to the Surface Geometry list and set the Direction to Parallel To Surface. Add a Delete operator to the event, enable By Particle Age and set the Life Span to 20.

Information: We have got several instances of the same Material operator throughout this system because the particle loses its assigned material as soon as it leaves an event. The Speed By Surface operator pushes the bubble around the surface of the glass geometry; however, this does not last very long as the bubble will burst after a short time of moving around the glass. Scrub through the animation so far. Depending on the positioning of your original two particles, you may never see the particles drifting to the side and working their way around the edge of the glass. If this is the case, amend the Seed of the Position Object operator to distribute them in different positions. You may also notice that some of the particles, when rising, hit the UDeflector and the Deflector, occasionally pass through the sides of the glass. This is due to the particle system's Integration Step is set to Frame, and so is not very accurate when detecting collisions, especially on geometry-based deflectors. To rectify this, lower the setting to half or even lower, and test again, but don't forget to amend the Render Integration Step as well. Also bear in mind, that as max now needs to do more work in calculating collisions, that this will take longer to calculate. If needs be, use a new position seed to relocate the emitter particles.

PART FOUR: Now we have the bubble trails sorted out, we will create the rising bubbles from the base of the glass.

10 Drag a Birth operator to the canvas to create a new event and label it Rising Bubbles Emitter. Wire the input of this event to the output of the Bubbles root event. Select the new Birth operator, set the Emit Start to −100, Emit Stop to 200 and Amount to 300. Add a Position Object operator to the event and add the Lemonade Base Emitter to its Emitter Objects list. Copy the Shape and Material Static operators from the Trails Motion event and Paste Instanced them into this event.

Information: As before, we can re-use previously created settings from the other event(s) and reuse them in the new event. Thanks to the Push modifier assigned to the Lemonade Base Emitter object we have very little intersection of the particle geometry in the glass.

11 Add a Scale operator to the event and set the Type to Absolute. Set the Scale Factor to 0 and the Scale Variation to 25 for all axes. Set the Animation Offset Keying to Event Duration. Turn on Auto Key and go to frame 30. Set the Scale Factor to 100, turn off Auto Key and go back to frame 0. Add a Scale test and set the Test Value to 80 and Variation to 20. Copy the Force operator in the Trails Motion event and Paste Instanced it onto the canvas to create a new event, labeling it Rising Bubbles Motion. Wire the output of the Scale test to the input of this event.

Information: Typically, the bubble would grow and expand with one side of the bubble touching the base of the glass. There is no way to do this with a standard particle shape, but if we used a sphere primitive with Base to Pivot enabled, we could simulate it quite easily. With the Scale Variation and the Variation in the Scale test, our bubbles will grow to different sizes and detach themselves at different intervals, before accelerating after being caught by the Wind Space Warp in the instanced Force operator, making the effect more realistic.

12 Copy the Material Static operator, Collision and Collision Spawn tests from the Trails Motion event and Paste Instanced them into this new event. Wire the Output of the Collision Spawn test in this event to the input of the Glass Attraction event. Right-click the Bubbles root event and select Properties. Turn off Cast Shadows and Receive Shadows and click OK to exit this panel. Finally, if desired, right-click the Play Animation button and extend the animation to 200 frames. Render off the animation.

Information: As these rising bubbles interact in exactly the same way as the other ones, we can pipe these particles into the same event as the others, saving us recreating the event(s) all over again. We do not want the bubbles to cast or receive shadows so the entire system has those options disabled.

Taking it further

Now, I have to stress again that this is going to take a very long time to render due to the amount of ray-tracing in the scene, this is definitely going to be an overnight job! You could try reducing the Maximum Depth in the raytracer's control settings, but you may lose some refraction detail. Additionally, you will also get some aliasing in the reflections and refractions; this is normal as anti-aliased raytracing takes a few lifetimes to render. Help is at hand though. As we have mental ray with its advanced raytracing, we can always convert the scene to use the mental ray renderer. Because of this, there are also more advanced materials and shaders to create better glass and water effects than the Architectural materials we have used here. Plus you have got the added bonus of caustics and all of the other lovely effects to refract the existing lighting in the scene to make the liquid and glass behave as they should in this lighting scenario. Suffice to say, even without converting the scene, the animation does its job and is very convincing in the way the particles behave, so in that sense, we have achieved our goal.

With regards to the actual motion of the bubbles in the liquid, there is not much more you can do, save adding a few tiny droplets of liquid being expelled when the bubbles finally pop, or increase the ferocity of the bubbles and get the droplets to be emitted and fly upwards once the bubbles pop (as soon as they hit the deflector) then have them fall back down to the surface and create small ripples (have a look at the Rain tutorial in this book to see how to generate an animated Bump map based on the droplet interacting with the surface).

Don't forget that this effect can be adapted for other liquids and glasses, such as a Cola drink or even Champagne! Change the glass shape and deflector accordingly (hence the reference copy of the particle emitter) and simply assign new materials to it.

As mentioned in the analysis, bubbles are formed around the glass due to the presence of a small particle or rough surface on the glass. As we have not created any particles on the inside of the glass, clone the lemonade geometry again and create an emitter, as we did before, for just the sides of the lemonade. You can then emit growing particles from this object, as before, either by introducing this object as an emitter to the existing Position Object operator in the Rising Bubbles Emitter event and

increasing the particle count, or create an extra emitter event with its own characteristics and feed them back into the particle system.

According to the 3ds Max manual, we can use an IOR below 1 to suggest bubbles underwater as the effect is shown right on the perpendicular of the bubble geometry. Unfortunately, the IOR cannot be reduced below 1 for an Architectural material, hence the higher IOR value in this tutorial. If you want to try a lower IOR value, convert the material to a standard or raytrace material, set the material up and assign the IOR below 1 as desired.

You may want to also include some condensation on the side of the glass to suggest that the liquid is very cold; try creating a condensation material to drive this effect, and use a noisy gradient to distribute it around the surface of the glass by mixing it with the original glass material. You may also want to add the odd water droplet running down the side of the glass (a simple hand-animated object would suffice here) and additional water droplets which condense, grow and fall – try using the same technology we have developed for the rising particles; get them to grow on the side of the glass, and when they get big enough, have them fall to, and puddle on, the table (suggestion: use a Blobmesh object on the puddle particles at rest). Finally, to suggest that all of this condensation is being caused by something, add an ice cube or two to the lemonade; a few deformed boxes should do with a nice Ice material assigned to them (try adapting the material developed in the Hailstones tutorial in this book). Don't forget though that bubbles will form quite vigorously around the ice cubes, which will also need to be simulated (and used as deflectors for rising particles) and fed into the events which drive the motion of the particles on the surface of the lemonade.

11 Calm seas

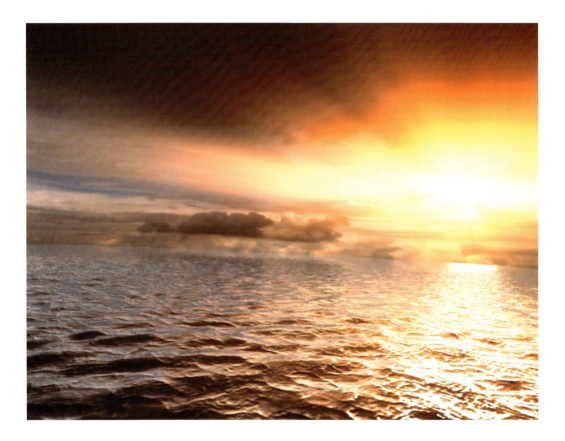

Introduction

When starting out in 3D, the first thing we tend to do is take a sphere, wrap a planet texture around it and then blow it up. But the second thing we do is to create a nice peaceful ocean – maybe it's a Yin and Yang thing, I don't know, but it's safe to say that our first efforts are, well, not all that great. In this tutorial we will try to emulate the motion of the waves so that they are not just moving up and down, but also travelling in several directions at the same time, and adding extra ripple motion caused by light winds, before finishing the scene off by animating a static bitmap effect to give the impression that the clouds are moving relative to the distance they are from camera, so that those in the foreground move more than those in the background, therefore giving the scene a sense of scale.

Analysis of effect

weather conditions can affect the color of the water due to the reflection of the sky in the surface water

the water also appears more blue during sunny days as the light passes into the water and is scattered due to refraction and interaction with sub-surface particles

a

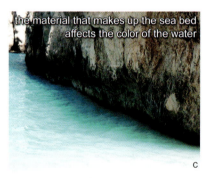

b

reflections appear broken and blurred in the water surface, and appear strongest on the perpendicular of a wave or ripple

Image courtesy of Carol Baker/Jenny Baker

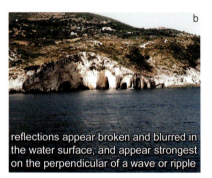

the material that makes up the sea bed affects the color of the water

c

Image courtesy of Carol Baker/Jenny Baker

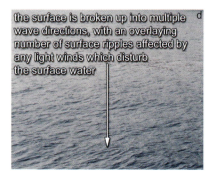

the surface is broken up into multiple wave directions, with an overlaying number of surface ripples affected by any light winds which disturb the surface water

d

Image courtesy of Carol Baker/Jenny Baker

(a) The color of the sea is based on two main issues – the first being the conditions of the sky. This has an immediate effect on the color of the surface water because the sky is being reflected. It is not, however, reflected 100% (to our perspective) as we are situated at an angle to the surface, and are therefore viewing it almost side on. Because of this we have disruptions in the surface which break up and blur the reflection. (b) Add to this the fact that the reflection is most prominent on the perpendicular and the reflection can be dulled right down. (c) The second color issue is due to the condition of the waters; in some areas of the world, the sea can appear to be a very deep blue, because of the clarity of the water and the underlying sea bed, and not necessarily because of the reflection of the sky. The surface motion is quite subtle, yet can look quite erratic, but if you break it down into its core components we can see that the motion is comprised of several wave 'sets' passing in several similar directions to one another. (d) They can be broken down further, as they have more detailed ripples on top which continuously change shape due to the top surface water being disturbed by any light winds. Finally, the lighting of the scene will have an effect on the color and shade of the water as this will affect the color of the clouds (if any), sky and any additional volumetric effects such as fogging and mist.

Creating the objects to generate this scene is about as basic as you're ever going to get. All we have to create is a simple Plane, a Sphere and an Omni light. However, we do need to add extra elements to these objects to make them behave the way we want. The sky will be generated using an animated hemispherical Sphere with a cylindrically mapped panoramic texture assigned to it. The geometry, and therefore the texture, will be deformed over time at the top most point using a twisting motion controlled by Volume Select and XForm modifiers to reduce the strength of the deformation the further away we progress from the top of the Sphere. The Sea itself will be animated using two animated Noise modifiers, each traveling at 90 degrees to one another so that the 'waves' appear irregular and cross over each other. Finally, we will create and assign textures to the scene; a single panoramic texture applied to the hemisphere, and a reflective material (generated using raytracing) with animated bump mapping, which is adjusted to create the peaks and troughs of the surface ripples on the Sea surface.

Walkthrough

PART ONE: First we will set up the scene geometry and add any modifiers necessary to animate them.

1 In the Top Viewport, create a Plane primitive with a Length and Width of 20000 and label it Sea. Set the Length and Width Segs to 50 and set the Density Render Multiplier setting to about 8. Reposition this object, if necessary, to the center of the Viewport.

Information: This basic geometry is going to be the basis of our sea surface. It has been set a very large size to give the scene a sense of scale, not only while you are creating it, but also when it is rendered. The Density multiplier is used so that we can work with a low amount of geometry in the scene, and then multiply the iterations in the plane by the multiplier setting to refine the mesh even more at render time. This is so that we can work faster in the Viewport.

2 Still in the Top Viewport, create a Sphere primitive with a Radius of 10000 (half of the Length or Width of the Plane) right in the center of the scene and label it Sky. Set the number of Segments to 64 and set the Hemisphere setting to 0.5. In the Left Viewport, drop the (now) hemisphere down about 50 units.

Information: This hemisphere is going to be the geometry on which we drop our sky texture. We have increased the amount of Segments so that we can deform the geometry, but will not be able to see any faceted polygons or stretched polygons when rendered. We have dropped the hemisphere below the Sea plane so that when the sea is animated and part of its mesh is deformed down, we do not get part of the hemisphere geometry peeking through the mesh.

3 Add a Normal modifier to the Sky hemisphere. Add a UVW Map modifier and set the Mapping type to Cylindrical. In the Left Viewport, scale the hemisphere down vertically until it is about 60% of its original height.

Information: When viewed from the Perspective Viewport, we cannot see the back faces of the Sky, so the faces need to be flipped around the other way so they can be seen. We could always use a two-sided material or force all objects to be two-sided, but that would just be overkill and would crank the render times up. We want to wrap a panoramic texture of a sky around the hemisphere so that it appears as if we have clouds in the distance and clouds overhead. The Cylindrical mapping wraps the texture around the hemisphere, but to get the clouds to appear as if they are more overhead than just in front of us, we need to squish the Sky hemisphere down a little.

4 Right Click the Play Animation button and, in the resulting panel, set the Animation Length to 200. Click OK to accept these settings. In the Left Viewport, add a Volume Select modifier and set the Stack Selection Level to Vertex. Enter this modifier's Gizmo Sub-Object and reposition the gizmo vertically in the Left Viewport so that it selects just the top ring and the top most vertex of the hemisphere. Enable Use Soft Selection and set the Falloff to 16900 and the Pinch to 1.

Information: We have extended the animation purely so we can showcase the elements that are to be animated in the scene for a longer period. The Volume Select modifier should only select the top most vertices and the rest should only be affected by the falloff. We have used a Volume Select modifier, and not an Edit Mesh or Mesh Select modifier because if we change the amount of polygons in the base geometry, the selection would go awry. But as the Volume Select modifier is using a gizmo to create a Sub-Object selection based on the gizmo's bounding box, we can change the base geometry as much as we like and the selection would still remain valid.

5 Add an XForm modifier to the stack. Turn on Auto key. Go to frame 200 and in the Top Viewport, rotate the XForm's Gizmo 30 degrees anticlockwise. Turn off Auto Key, right click the generated keyframe at frame 0 and select Z Rotation. Amend the Out curve so that it has a linear attack and click on the arrow next to the curve to send this curve style to the In curve in the next keyframe (at frame 200).

Information: Rotating the XForm modifier deforms the Sub-Object selection we have made using the Volume Select modifier. We have amended the Out curve of frame 0 (and, after passing the curve information to the In curve of frame 200) so that the rotation starts, continues and ends at a linear rotational speed. Otherwise the rotation would speed up and slow down which would look unrealistic. Why we have deformed this object this way will become apparent later on when we assign a material to it.

6 In the Front Viewport, create a Free Camera about 350 units above the Sea plane. Set the Lens Size to 28 mm by entering the value into the Lens spinner or clicking on the 28 mm Stock Lens button. Select the Perspective Viewport and press C to change it to the Camera Viewport. In the Top Viewport, move the camera back (down) about 4000 units so that we can see the majority of the scene.

Information: We have set the camera up now as we are going to set up the animation for the sea plane. Because of this, we can also add a subtle animation to the camera making it bob around to suggest that we are sitting in a boat watching the sun rise. The wide-angled lens has been used to give the scene a sense of scale.

7 Select the Sea object and add a Volume Select modifier. Set the Stack Selection Level to Vertex and set the Select By Volume to Sphere or Cylinder. Enter the Volume Select's Gizmo Sub-Object mode and reposition it so that its center is positioned where the camera is (as viewed from in the Top Viewport). Scale the gizmo down so that, in the Camera Viewport, only a couple of selected vertices are visible (so that there is a diameter of about nine selected vertices). Enable Soft Selection and set the Falloff to

about 12000 so that there is no visible soft-selection influence on the vertices around the 'horizon'.

Information: We are using the Soft Selection to control the strength of modifiers we are going to add shortly, so their strength diminishes the further away they get from the camera, therefore giving a distance effect because the eye perceives them as being the same height, just very far away.

8 Add a Noise modifier to the modifier stack and rename it Noise Left. Enable Fractal, set the Z Strength to 30, enable Animate Noise and set the Frequency to 0.05. Select this Noise Modifier's Gizmo sub-object and, in the Left Viewport, rotate the gizmo 60 degrees clockwise. In the Top Viewport, rotate the same gizmo 45 degrees clockwise. Copy and paste the Noise Left modifier and label it Noise Right. In the Top Viewport, rotate this modifier's gizmo 90 degrees anti-clockwise.

Information: We are going to create two sets of waves – one traveling diagonally to the left and one diagonally to the right. We have rotated the gizmo so that it deforms the surface by creating small crests and soft trailing waves. If we left the noise the way it was, we would not have a definable leading edge to our wave. The Frequency's setting has been reduced to lessen the speed of the animation of the Noise modifier, so its motion does not look like we have got our thumb caught on the fast forward button. We have cloned this modifier to create another series of waves going 90 degrees in the opposite direction, so the waves cross over one another.

9 Select the Noise Left modifier's gizmo. Go to Frame 200 and enable Auto Key. In the Top Viewport, enable Grid Snap and reposition the gizmo 2000 units left and 2000 units down. Select the Noise Right modifier's gizmo and reposition it 2000 units right and 2000 units down, so each modifier is traveling 90 degrees in the opposite direction to one another. Turn off Auto Key and go back to frame 0. Right click the keyframes at frame 0 and select any one of the Phase keys. Amend the Out curve so it has a linear attack (as illustrated) and click on the arrow next to this key's Out curve to send this curve information to the In curve of the next keyframe (at frame 200). Set this curve type for all position and phase keyframes for this object.

Information: As with the cloud animation, we want the sea's surface to be already moving when we begin this animation, not speeding up. The two Noise modifiers cross over each other, complementing and opposing each other as they move. Should you feel the need to, try adding a few other similar wave sizes and/or directions for them to travel.

10 Copy (not instance) the Sea plane and label it Sea Surface Position. Remove all modifiers apart from the base geometry and set the Render Density Multiplier back to 1. Add a Noise modifier and enable Fractal. Set the Z Strength to 10, enable Animate Noise and set the Frequency to 0.1. Right-click the new keyframe at frame 0 and select the Phase keyframe. Set the Out curve to a linear attack and click on the arrow next to this curve to send the same type of curve to frame 200. Right-click this plane, select Properties and turn off Renderable.

Information: We are going to be using an Attachment controller on an object that the camera is to be linked to, to sit on the water surface. We have had to use additional geometry as the Attachment controller picks out a specific face to adhere to. As the render multiplier increases the polygon count at render time, this face will not be in the same place as it was in the Viewport, but relocated elsewhere, and therefore the camera will be also. The Frequency of 0.1 is due to the sum of the other two frequencies of the two Noise modifiers in the other Sea object, so it gives us roughly the same frequency.

11 In the Top Viewport, create a Dummy helper and position it around the camera in the scene. Go to the Motion tab, highlight its Position controller and click on the Assign Controller button. In the resulting controller menu, select Attachment and click OK. In the resulting Attachment Parameters rollout, click on the Pick Object button and select the Sea Surface Position object. Click on the Set Position button and, In the Top Viewport, select a point on the Sea Surface Position object directly beneath the camera. This automatically relocates the camera. Turn off the Set Position button. Select the Camera and link it to the Dummy object. Click on the Move tool to turn off the link (as it does not auto deselect).

Information: We do not want to directly attach the camera to the Sea Surface Position object else we would not be able to move it without changing the controller back, so we use an intermediate

Dummy object to attach to the Sea Surface Position object and to link the camera to this Dummy object. Therefore our camera starts in the same position as before, and we can relocate it if necessary without any trouble.

PART TWO: With the geometry all set up and animated, we will now assign materials to the objects in the scene.

12 Open the Material Editor and label a material Sky. Set the Self-Illumination to 100 add a Bitmap map into the Diffuse slot and load in the *Water/11_Calm_Seas/Source/clouds_panorama01.jpg* file into this map. Set the U Tiling to 2, click on the Show Map in Viewport button and assign this material to the Sky object in the scene.

Information: Even though this map does not tile, we will not be looking to the sides of the Sky hemisphere so we won't see the seams. If you have enabled Show Map in Viewport, it should now be apparent why we have animated the XForm modifier on this object on top of the UVW Map modifier; if we had the UVW Map modifier on top of the XForm, the mapping would not be deformed because it would have been placed on top of the deforming mesh. If you view the scene from the camera view, you will notice that due to the falloff, it appears that the clouds on the bitmap are moving faster in the foreground than those on the horizon. However, do NOT move the camera around too far to the sides of the scene, else you will view the seam of the cloud map and also notice that the clouds are rotating around the scene so this illusion will be lost.

13 Label a new material Sea and assign it to the Sea object in the Viewport. Set the Diffuse color to RGB 117,117,117, and the Specular color to white. Set the Specular Level to 200 and the Glossiness to 30. Expand the Maps rollout, set the Reflection amount to 75 and add a Falloff map to the Reflection slot. Set its Falloff Type to Fresnel, amend the Override Material IOR's Index of Refraction setting to 0.6 and add a Raytrace map to its Side slot.

Information: As water and other liquid effects mainly show their reflections strongest on the perpendicular, we have restricted the reflection using a Fresnel (perpendicular edge) Falloff map, which has had its IOR amended so that the cut off at the edge is a lot stronger.

14 At the top of the material, set the Bump amount to 20. Add a Mask map to the Bump slot and label it Sea Bump Distance Mask. Add a Smoke map to the Map slot and label it Ripples. Set the Source to Explicit Map Channel, Size to 0.005, Iterations to 20, Exponent to 0.4 and set the Color 2 to white (originally an off-white). Go to frame 200, enable Auto Key and set the Phase to 10. Turn off Auto Key. Set the Out curve for the two new keyframes at frames 0 and 200 to a linear attack as before. Add a Gradient Ramp map to the Sea Bump Distance Mask's Mask slot and label it Sea Bump

Distance Control. Set the Gradient Type to Radial. Expand the Output rollout and enable Invert.

Information: We have masked out the bump mapping using a radial gradient, just as we used soft selection on the Noise modifiers, so the strength is reduced the further away we go from camera, therefore giving the impression of distance. We have inverted the map to flip the colors so that we have a white to black radial gradient which dictates the opacity of the mask and therefore the bump strength, without having to redesign the gradient.

15 In the Top Viewport, create an Omni light and label it Sun. Position it behind the Sky dome and, when viewed in the Camera Viewport, low to the water's plane. Check the resulting highlight in the Camera Viewport to ensure that there is just the right amount of glare. Add a Skylight light and set its color to RGB 102,123,150 (a point sampled from the cloud panorama) to illuminate the darker areas of the sea surface, and finally render off the scene.

Information: I've always stressed the use of Direct lights over Omni or Spot lights for Sun simulation due to the way their shadows are cast (Omni and Spot light shadows are fanned out; Direct light shadows are linear which is better suited to suggest the sun). However, as there are no other objects in the scene, we can use an Omni light. The main reason for this is that it does cast the best specular highlight on the Sea. Should you wish to drop in additional objects, you could disable Diffuse lighting from the light (shadows are already turned off) and double up the light with a Direct light which has Diffuse and Shadows enabled and Specular disabled. Bit of a pain, but it works best for this scene, and if you link the lights together, you can just move one and the other will follow. If you fancy being clever, you could always wire the multipliers and light colors together so if you tweak one setting, the other light's settings automatically update.

Taking it further

To complete the scene I have added a Lens FX flare, which is an adaptation of the afterfx6.lzf setting that ships with 3ds Max, with just the Glow enabled (after a few adaptations) to simulate the glowing of backlit clouds (just a byproduct of the glow effect) and to suggest the intensity of the sun. Again, as mentioned in the last step, there are no shadows cast in this scene, so if you decide to drop in any other objects then you will have to adapt the scene accordingly (don't forget about faking reflective caustics and uplighting from the water). If you really fancy showing off, do a transition from beneath to above the surface (or vice versa). Take a look at the underwater tutorial in this book, if you haven't already, and try to amend the settings for that scene to fit the lighting in this scene, or the other way around, and create a motion transition, such as the water passing in front of the camera, to create a wipe from one scene to the other. You may also want to drop in some additional fogging, such as environment or volumetric fog to haze up the lighting a little. Also, try using a volumetric lighting effect to create haze across the scene; an ideal example of this volumetric light technique can be found in the Frozen Wastelands tutorial and can be easily adapted for use in this scene. You could also render off a 1:1 (e.g. 600×600) view from this Spot light of the flipped faces of the Sky hemisphere and take it into Photoshop (or equivalent). Extract the blue, dump it on a black background, throw it into the Projector map of the Spot light and set up the Attenuation settings to work with a low density volumetric light. Flip the faces back on the Sky hemisphere (so they are visible from the camera again) and render off. The result will be volumetric rays streaming through the clouds where there (was) blue sky. A very nice effect and quite easy to do, although if you do it for the entire animation you will have to create an animated sequence for the projector to generate this volumetric effect as the cloud changes, so set the steps you did to extract the blue (etc.) as an action in Photoshop, batch job the lot and bring them back into the projector map as an IFL sequence. Simple! To illustrate this there is a completed 3ds Max file with this animated volumetric in the Source folder on the DVD-ROM.

12 Stormy seas

Introduction

Following on from the Calm Seas tutorial, we can create the complete opposite to this by generating a scene that none of us would really like to experience in real life. While the construction process for the calm sea was relatively simple, due to the high amount of materials which have been 'whipped up' by the winds, the material tree in this tutorial has dramatically increased in size more over, so the end construction of this effect is going to be a bit more lengthy. Not only are we going to create and animate the surface of the water, we are also going to generate a sky so the sea has something to reflect, even if it is a really nasty looking sky. To top it all off we are also going to add some illumination from 'lightning' which will be created by simple animated lights.

Analysis of effect

the ferocity of the wind can result in exceptionally intricate foam patterns

a

small surface waves are generated by the winds rushing over the surface in different directions

b

larger waves deform the surface waves and also travel in multiple directions

c

the foamy peaks of the large waves are created by the wind rushing over them and churning up the surface

they are more common on higher waves than smaller ones as there are no surrounding waves to shelter them

d

The actual motion of the sea's surface is dependent on the speed of the wind and the underlying sea bed. For the sake of this example, we will assume that the sea is deep so that the sea bed has very little or no influence on the surface conditions. The shape of the waves are constructed by several different wave motions, all traveling in slightly different directions. These individual larger waves, which are generated by the main force of the wind, cross over one-another and either enhance or cancel each other out; just as two opposing Sine waves would. Added to this are the smaller waves which are also opposing. These are also produced by the wind, but by it rushing over the water, pushing the surface water along. This could also be generated in a body of water, such as a bathtub, by skimming your hand over the surface; the effect is quite similar. As with the larger swell waves, the smaller waves (which are displaced by the larger waves) also intersect one another, enhancing and cancelling each other out. In addition to these waves we have additional ripples, which appear to remain almost static and deform the waves as they pass over them. They can also be seen more prominently in any foam which is kicked up by the winds at the tops of the highest waves (because they are not sheltered by the other waves). These ripples do not remain totally static; they do move slightly and are deformed and dispersed by the other wave sets. The shading of the wave is derived from its environment and the condition of the waters. Normally in this situation, the environment will be completely cloudy which would therefore virtually occlude all of the sun's light (there may well be a slight hint of the sun through the clouds), so the main illumination of the waves will be diffused from the dull backlit clouds which, when reflected in the surface, will have an adverse effect on the 'color' of the water. We also have additional splashes and spray which are kicked up by the winds; this is covered more in the Taking it further section.

Again, as with the Calm Seas tutorial, the geometry in this scene is going to be exceptionally basic; just a couple of objects are all that is required to produce this effect – the deforming plane for the sea and a hemisphere for the sky, even though it is not visible in the render (due to the camera placement), as it is reflected using raytracing. The sea's surface will be generated by multiple Smoke maps which will drive multiple Displace modifiers. These maps will be set up individually and set to two different angle offsets to create the different wave directions, and the Displace modifiers will consist of two sets – Small Waves and Swell, with the Small Wave modifiers having a higher tiling setting, therefore generating a smaller-sized wave. These maps will simply have their Phases animated to generate the motion. The surface texture will be generated using a material with a harsh specular highlight, which will be reduced, as the main key light (a Direct light) will

be of a low intensity; the main illumination in the scene coming from a Skylight light. The foamy caps of the waves will be generated using a cross-section gradient which will mix an animated Noise map (also used for the ripple bump texturing) with the surface color. To finish off the scene, additional lighting in the form of animated Omni lights (with falloff so the surrounding areas are mainly illuminated) are flicked on and off to simulate lightning in a couple of areas, giving the impression of storm clouds nearby. These lights illuminate the Sky hemisphere which, in turn, is reflected in the sea's surface.

Walkthrough

PART ONE: First we will create and animate the basic geometry in the scene and generate a skydome to be reflected in the sea's surface.

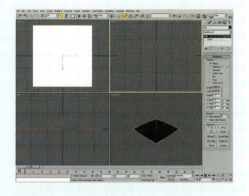

1 In the Top Viewport create a Plane primitive with a Length and Width of 5000 and label it Sea. Set its Length and Width Segs to 300. Add a UVW Map modifier to its modifier stack and set the Map Channel to 3.

Information: As the surface of our sea is going to be deforming, we need to set it up as easily as possible so we can amend any settings later on. The best way to do this is to use procedural deformations on our models. However, we do need a fair amount of polygons to get the detail we need, hence the high Segs settings. Before we deform the mesh, we need to add a texture to it so that it's also deformed. Therefore we have added the UVW Map modifier before we add any deformation-based modifiers. The Map Channel was changed to a setting that will not be used by any other modifier in the stack that we are now going to build up.

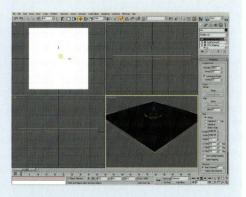

2 Add a Displace modifier to the stack and rename it Small Waves01. Set the Strength to 200 and enable Luminance Center. Set the U, V and W Tiling to 5. Copy this modifier and paste it back onto the modifier stack. Rename the copy Small Waves02.

Information: As mentioned in the Analysis section, there are more than one set of waves in the surface of the sea, therefore we are using multiple Displace modifiers to generate this; these first couple of modifiers will generate smaller waves while the ones we will add next create the larger swells. We are using Luminance Center displacement due to the amount of Displace modifiers we are going to be adding to the object. As there are a lot of them, the end result would raise the positioning of the mesh which makes handling the mesh more difficult.

3 Add a Displace modifier to the stack and rename it Swell01. Set the Strength to 1000 and enable Luminance Center. Copy this modifier and paste it back onto the modifier stack. Rename the copy Swell02.

Information: As before, we have two Displace modifiers to create the two swell waves – two large waves that pass over the displacement beneath. Again, we are using more than one displacement to break up any repetition a single displacement would create. Next we will generate the maps that will drive the motion and shape of the waves and incorporate them into these Displace modifiers.

4 Open the Material Editor and add a Smoke map to the first available material slot. Label this map Small Waves01. Set the Source to Explicit Map Channel. Set the Size to 0.5, Iterations to 2, Exponent to 1 and click on the Swap button to change the colors around. Set Color 1 to white (it is currently an off-white). Right-click the Play Animation button and set the Animation Length to 500. Go to frame 500 and enable Auto Key. Set the Smoke map's Phase to 6 and turn off Auto Key. Instance this map into the map slot of the Small Waves01 modifier. Right-click the Sea's new Phase keyframe at frame 0. Amend its Out curve to a linear attack and click on the arrow next to the curve to pass this curve information to the In curve in the next keyframe.

Information: We are using Smoke maps to generate our wave effect, because by inverting the map's colors we can create a nice peak and trough effect, which is visible once the map is assigned to the desired Displace modifier. We have reduced the amount of Iterations to reduce the detail in the displacement, else the effect will be too jagged and may well look a mess. The Exponent has been amended to define the colors more to create the desired peak and trough effect. The Phase is the key to the animation, and even though we have animated it successfully, we need to amend the keyframe information else the phase 'accelerates' and 'decelerates', which would make the scene look totally unrealistic; changing the keyframe's curve to a linear attack fixes this.

5 Copy the Small Waves01 map to a new slot in the Material Editor and rename the copy Small Waves02. Set this new map's W Angle setting to 20 and instance it to the map slot in the Small Waves02 modifier. Copy the Small Waves01 map to a new slot and label it Swell01. Go to frame 500, enable Auto Key and amend the Phase to 3. Turn off Auto Key. Copy this map, rename the copy Swell02 and set its W Angle setting to 20. Instance the relevant Swell map into its corresponding modifier's map slot.

Information: And that is all we have to do for our geometry animation. Even though the Phase of the Swell maps is lower than the other Smoke maps, due to the tiling that has been used in the Small Waves displacement, these waves do not travel as far, creating a more subtle effect, while the larger, faster moving swell displaces everything creating the desired result. As we are simply amending the existing keyframe settings at frame 500 that exist from the original copy of the map, we do not need to amend the curve information for these new maps. Additionally, instead of re-enabling Auto Key and amending the Phase value in the Map, we could simply edit the relevant keyframe's setting if so desired; the result is the same.

6 In the Top Viewport, create a Sphere with a Radius of 10000 and a Hemisphere setting of 0.5. Add a Normal modifier to the stack. Add a UVW Map modifier to the stack and, in the Left Viewport, scale the hemisphere down vertically so that it is about 40% of its original size.

Information: As we only need the sky to be present in the reflection of our object, the geometry and mapping setup does not need to be complex. We have, however, used a squashed hemisphere so that it is virtually flat (as we are using planar mapping) so that any texture stretching at the edges of the hemisphere will be reduced, so they will not be visible much (if at all) in the Sea's reflection.

PART TWO: Next we will create the materials for the sea and sky.

7 Label a new material Sky and assign it to the Sky object in the scene. Set the Diffuse color to black, enable Self-Illumination, add a Bitmap map to the Diffuse slot and load CLOUD2.JPG which ships with 3ds Max into this map. In the Output rollout of this map, set the Output Amount to 0.25 and RGB Level to 0.5. Add a Falloff map to the Self-Illumination slot and set the Falloff Type to Shadow/Light. Instance the Diffuse Bitmap map into the Shaded slot and add an Output map into the Lit slot. Set the Output Amount of this map to 2.

Information: Here we have created a low intensity self-illuminated material that has got a low intensity colored diffuse map so that it is not too bright when rendered. However, when the light from the 'lighting' is emitted (which we will set up shortly) the Falloff map creates a bright flash (courtesy of the Output map) which the reflection in the Sea will pick up.

8 Label a new material Sea and assign it to the Sea object in the scene. Enable Self-Illumination, set the Specular Level to 250 and Glossiness to 90. Add a Falloff map to the Self-Illumination slot and label it Sea SI Light Control. Set its Falloff Type to Shadow/Light. Swap the Shaded and Lit colors and add a Falloff map to its Shaded slot. Label this new Falloff map Rim Glow and set the Side color to RGB 14,21,29.

Information: We have initially designed our material so that it has a small sharp specular highlight that suggests a liquid or shiny surface. Enabling Self-Illumination allows us to use maps to change the color of the self-illumination, which we have done using multiple Falloff maps so that we have a slight rim (perpendicular) self-illumination, but (thanks to the other Falloff map) only when the object is in shadow (i.e. not in direct illumination), therefore simulating a slight translucency effect where the waves are viewed from the side.

9 Back up at the top of the material, set the Bump amount to 20 and add a Noise map to the Bump slot. Label it Sea Surface Bump. Set its Source to Explicit Map Channel and set the Map Channel to 3. Set the Noise Type to Turbulence, Size to 0.02 and Levels to 10. Go to frame 500, enable Auto Key and set the Phase to 10. Turn off Auto Key and amend the resulting keyframe's Out curve (and In curve of the second keyframe) to a linear attack as we did before.

Information: This small amount of bump mapping helps add a little more detail to the surface of the sea without having the need to refine the mesh further. As before, we need to amend the Out curve of the resulting keyframe at frame 0 and pass the curve information to the one at frame 500 so we have a linear attack resulting in a linear motion for out Phase.

10 Back at the top of the material, add a Falloff map to the Reflection slot and label it Reflection Control. Set the Falloff Type to Fresnel and amend the Mix Curve to that illustrated. Add a Raytrace map to the Side slot of this map.

Information: The use of the Falloff map in the Reflection slot is to purely mask out the Raytrace map so that it is more prominent on the perpendicular, and not so intense when the surface is viewed face-on. This results in a more effective reflection as the Diffuse map we are about to create will be more visible, resulting in a material which does not look like a completely pristine, shiny surface.

11 Add a Gradient Ramp map to the Diffuse slot and label it Sea Foam Control. Set the Map Channel to 2 and the W Angle setting to −90. Set the flag at position 50 to black and add flags colored white to positions 81 and 88. Set the Interpolation to Ease In. Right-click the flag at position 81 and select Edit Properties. Add an Output map to the map slot in the resulting pop-up and instance the Sea Surface Bump map into the Output map's map slot. Open the Output map's Output rollout and enable Invert and Enable Color Map, and amend the Color map to that illustrated. Add a UVW Map modifier to the top of the Sea's modifier stack and set its Map Channel to 2.

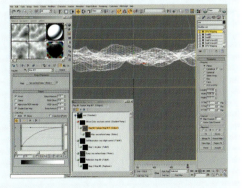

Set the Alignment to Y and click on the Fit button. Select this modifier's Gizmo and scale it up vertically in the Front Viewport so that it is about 130% of its original height. Scrub through the animation (temporarily reduce the Plane's Segs, if desired, for faster feedback) and ensure that the deforming geometry does not pass over the top or the bottom of this UVW Map's gizmo.

Information: We have set the W Angle setting to get the gradient to rotate the right way. The beauty of using a Gradient Ramp map is that you can add different maps to each flag, so you can have an entire gradient built up of different map trees. In this case we have used one flag, to create a breakup transition from white to black by using an inverted copy (using the Output map, which also adds a little more contrast) of the Bump map. The extra white key ensures we have a transition from white to this broken-up texture, which then fades to black. This Bump map is mapped onto our deforming mesh, as before, using UVW 3, while the gradient is controlled by the new UVW 2 mapping which gives us easy control over our foamy peaks; the higher the water gets, the more foamy they become. We do not want the deforming mesh to pass over the boundaries of UVW 2's gizmo, or the opposite end of the gradient will be displayed. We could work around this, but this solution works, so there's no point in trying to fix something that isn't broken.

PART THREE: Next we will illuminate the scene and, to add extra realism, we will create and animate lights to simulate lightning.

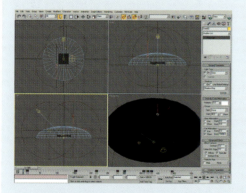

12 In the Left Viewport, create a Direct light to the left and above the Sky hemisphere as illustrated. Set its Multiplier to 0.2 turn on Overshoot in its Directional Parameters rollout. In the Top Viewport create a Skylight light set its Sky Color to RGB 14,21,39. In the Top Viewport, create an Omni light and set its Multiplier to 0. Enable Use and Show Far Attenuation and set its Start setting to 0 and End to 10000. Enable Auto Key and go to frame 3. Set the Multiplier to 5. Go to frame 6 and set the Multiplier to 0. Turn off Auto Key. Group select the resulting 3 keyframes and reposition them around frame 45. Shift-drag the keyframes to clone them several times. Vary the middle keyframe's value so it is not always the same intensity. Position the Omni light so that it is beneath the surface of the hemisphere. Copy the light and reposition it on the other side of the hemisphere so it illuminates the opposite side of the plane (i.e. left to right). Amend the position of the copy's 'lightning' keyframes.

Information: As this type of environment would be quite dark and overcast, the main key light in the scene (the sun) would be almost totally occluded, so the entire scene would be lit with diffused lighting from the backlit clouds (the Skylight light we have created). This results in the specular highlight not being as intense, until the lightning strikes. As we are not using any shadows in this scene (to save on rendering times), we do not have to extend the Falloff/Field setting of

the main key light – the Direct light in the scene. We have created the Skylight to generate a subtle illumination effect with a single color, which was point-sampled from a screenshot of the Sky material sample. Thanks to the material setup we have done for the Sky, once the sky is illuminated this way we get a large flash of white which simulates the lightning strike and cloud illumination. Don't forget to vary the intensities of the flashes else it will just look like a strobe light. Also, put in a couple of flashes one after the other to suggest a longer strike. Setting the keyframes up at the beginning of the animation is required else we would have to reposition individual keyframes which is a little more fiddly.

PART FOUR: Finally we will add fogging and a couple of post effects to colorize and amend the brightness and contrast of the scene to make it a little more intense.

13 Ensure that the base of the Sky does not intersect the deforming water by dropping the Sky down about 200 units in the Left Viewport. Create and position a camera so that its entire frame is filled with water. Enable Show in the Environment Ranges group and set the Far Range to 10000. Open up the Environment window and add a Fog effect. Turn on Exponential and set the Far% setting to 75.

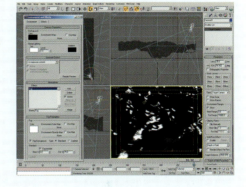

Information: We do not want to add too much fogging to the scene as this is going to be affected by the reflection and brightens the scene a little bit too much. Therefore keeping it relatively low helps reduce this unwanted brightness. You may need to amend the Far Range, depending on the camera positioning and scale of your scene, else the Fog may wash out your image. We are using Exponential fogging to get the fog to appear denser the further away from camera it is. However, this would result in a scene that is now slightly washed out. To bring it back a little, we can add some post effects to bring out the colors again.

14 Open the Effects panel and add a Brightness and Contrast effect. Set its Contrast to 0.7. Add a Color Balance effect and set the Cyan/Red setting to 10 and the Yellow/Blue setting to −10. Open up the Render panel and access the Raytracer tab. Set the Maximum Depth to 1. Access the Renderer tab and in the Antialiasing group, change the Filter to Catmull-Rom. Finally, render off the scene.

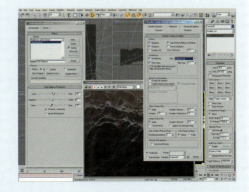

Information: By adding the Brightness and Contrast and the Color Balance effect we have, albeit very basically, color-corrected our scene. Catmull-Rom sharpens up the render a little and adds some definition to the displacement and bump mapping effects we have added.

Taking it further

The result of our efforts is quite convincing, mainly due to the use of the multiple Smoke maps designed to create the peaks and troughs of the sea. However there are a few things missing from the overall effect, namely additional water dynamics such as splashes. These could be generated by careful use of the Flex modifier, but don't expect too much in return, as the heavy amount of geometry used to generate the surface will have an adverse effect on the calculation of the soft body dynamics of Flex. The other method would be to manually fake it by performing a soft selection on the top of the waves, and using an XForm modifier to handle any wave deformation such as leading edges (as defined in the Moving Surface Water and Calm Seas tutorials). You could also do it using a Particle flow system, by getting a load of non-renderable particles to adhere to the surface of the sea and to test their motion at every frame. Once they go over a certain threshold they can spawn particles which are not fixed to the mesh but have an inherited velocity (so they are flung out) and are also affected by gravity. Quite easy to set up and effective.

The other thing that is missing is the presence of displaced surface water, namely spray. This can be generated by using a Particle Flow system on either the existing sea surface geometry, or on a clone to generate a grayscale material more accurately to distribute the particles in specific places. To do this a clipped version of the gradient, used to distribute the foam effect, could be used to define where the peaks of the waves are, so that the particles are emitted in the correct places. The particles themselves should take on two different properties which can be defined by the use of two separate materials – one to generate a fine mist on a few large billboard facing particles, and the rest on numerous small particles to generate particular water which is blown off the peak of the wave before falling back down to the surface (and instantly deleted underneath the plane geometry to keep particle counts down and therefore render times low).

Try adding a few objects to float on the surface of the water, such as a few shipwrecked people or debris bobbing up and down in the waters, by using an additional Particle Flow tutorial with a Position Object operator with a surface offset. You could even add helicopter spray and turn the entire scene into a rescue mission; simply use a noisy Gradient map assigned to a clone of the sea to emit the particles in the correct places, and a heavy Wind Space warp to displace them. You will also need to amend the surface material of the waves to account for the extra wind generated by the downdraft of the rotors; again, an animated noisy Gradient should suffice for this effect. Finally, try adding the result of the Rain tutorial to this scene, so the end result looks like a dramatic rescue in some really bad weather, or amend the Displace modifiers like the Noise modifiers in the Calm Seas tutorial to create leading waves by smearing the displacement slightly.

13 Underwater

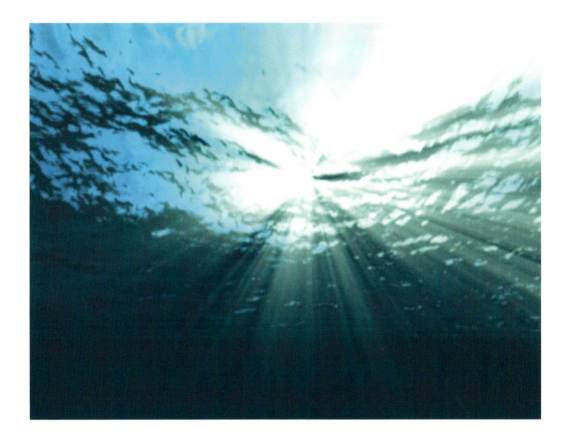

Introduction

Underwater shots are quite difficult to pull off, mainly due to different lighting conditions having a great affect on mood and visibility in the scene. In this tutorial we are going to recreate a shot of an underwater scene that has been taken just beneath the surface of the water. To do this, we are going to use a combination of lighting and materials to create the water's refraction of the exterior environment, plus volumetrics to deal with the density of the water to simulate light falloff and particular matter. To top it all off, we are going to animate the surface of the water by amending the modifiers assigned to the water's geometry and the materials, parameters to give the impression that the sea is moving over our heads.

Analysis of effect

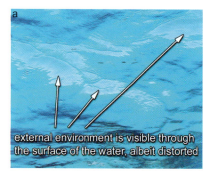

external environment is visible through the surface of the water, albeit distorted

Image courtesy of Getty Images

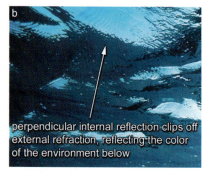

perpendicular internal reflection clips off external refraction, reflecting the color of the environment below

Image courtesy of Getty Images

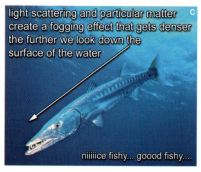

light scattering and particular matter create a fogging effect that gets denser the further we look down the surface of the water

niiiiice fishy... goood fishy....

Image courtesy of Getty Images

the sun's highlight is broken up due to the internal reflection of the sea surface

Image courtesy of Getty Images

(a) Viewing the reference material on the DVD-ROM, we can see that the external environment (the sky, clouds and sun) affects the colors of the underwater environment a great deal. Due to the close proximity of the camera to the surface of the water we can see through the distorted surface, out to the external environment. Because of this distortion and the change in refractive index of the two environments, the resulting view of the clouds and sky will become severely distorted. (b) However, we do not see all of the external environment; only what is from about half way up the frame to the top of the frame. The reason for this is due to the internal reflection of the water; like the way optical fibers carry light. This reflection is of the water beneath the camera and is viewed on the perpendicular of the sea's surface. It is (mainly) a solid color which picks out the detail of the surface, down to the smallest ripple, so we end up with the distorted refraction of the external environment, which is partly occluded by the reflection of the water below. (c) This internal reflection occludes all external refraction the further we look down into the scene. Added to this is the particular matter and light scattering which causes a fogging effect that quickly builds up as we look down along the surface of the water. (d) Finally, we have (depending on the position of the camera) a large highlight that is broken up due to internal reflection, which is generated by the sun being situated right behind the surface of the water. This creates amazing caustic effects which can be seen on the seabed, depending on the depth of the water.

The actual scene in 3ds Max is going to be relatively simple to create, mainly due to us already covering everything that we need to do in this analysis section. Due to the blue sky we are going to use (which is an image that ships with 3ds Max), we can develop colors or derivatives thereof to create fogging, which will be a simple volumetric effect controlled by camera ranges. The lighting itself will be a single Omni light, as we do not have any additional objects floating on, or submerged in, the water (else we would have to re-light our scene accordingly). To create the large bright area, we can simply position our Omni light close to a plane object with our sky bitmap assigned to it and use it to overly illuminate a spot on the plane. When refracted through the material assigned to the sea's deformed plane, we will see a bright light that is illuminating (hazy) clouds, which is the

effect we want. The sea's material will be a simple blue colored material, which ties in with the shade of the bump mapping which will be masked so that it is most prominent on the perpendicular, as mentioned in the initial analysis. The reflection will also be most prominent on the perpendicular, but this will be a single blue color set in a Falloff map. Animating the scene will be a simple case of positioning and animating a few Noise modifiers; two to control the small irregular waves, and one to drive the large swell, which is a similar technique to the other water surface effect tutorials in this book, as this procedure is an effective one to create realistic water surfaces.

Walkthrough

PART ONE: First we will create the Sky and Sea planes and animate the sea's surface using standard modifiers.

1 In the Top Viewport, create a Plane primitive in the center of the Viewport with a Length and Width of 500 and label it Sky. Set the Length and Width Segs to 1. In the Left Viewport, move it vertically upwards about 50–60 units. Add a Normal Modifier to its modifier stack.

Information: We have reduced the amount of polygons in the Sky plane's geometry because it is only a flat object, so does not require additional polygons. As we will be creating the Sea at the center of the scene, we need to relocate the position of this plane so they do not intersect.
We have added a Normal modifier to simply flip the faces of the geometry instead of having to rotate them. Either method works, so use whichever is easiest for you.

2 Copy the Sky plane, label it Sea and reposition it back at coordinates 0,0,0 so that it is dead center of the scene. In this object's base settings, set the Length and Width to 600, Length and Width Segs to 100 and the Density Render Multiplier to 5.

Information: As we have already got half of the work done for us, we do not need to recreate the plane and assign modifiers to it. All we need to do is copy the existing one and reposition it, before amending its settings a little.

3 Add a Noise modifier to the stack and rename it Noise–Wave01. Enable Fractal, set the Roughness to 0.4 and Iterations to 10. Set the Z Strength to 10, enable Animate Noise and set the Frequency to 0.01. Select this Noise modifier's Gizmo sub-object and, in the Left Viewport, rotate the gizmo 65 degrees clockwise. In the Top Viewport, rotate the same gizmo 45 degrees clockwise.

Information: We are going to create two sets of waves – one traveling diagonally to the left and one diagonally to the right. We have rotated the gizmo so that it deforms the surface by creating sharp(ish) little crests and larger trailing waves. If we left the noise the way it was, we would not have a definable leading edge to our wave. The Frequency has been reduced to slow down the Noise modifier's animation, so the wave motion is not moving too fast.

4 Copy the Noise–Wave01 modifier and label it Noise–Wave02. In the Top Viewport, rotate this modifier's gizmo 90 degrees anti-clockwise. Add another Noise modifier and rename it Noise–Swell. Set its Scale to 400, enable Fractal and set the Z Strength to 50. Enable Animate Noise and set the Frequency to 0.01.

Information: We have cloned this modifier to create the wave going 90 degrees in the opposite direction, so that the waves cross over one another. The additional Noise modifier has been amended to create the large swell motion of the sea surface, hence the large Scale value.

5 Select the Noise–Wave01 modifier's gizmo. Go to Frame 100 and enable Auto Key. In the Top Viewport, enable Grid Snap and reposition the gizmo 30 units left and 30 units down. Select the Noise–Wave02 modifier's gizmo and reposition it 30 units right and 30 units down, so each modifier is traveling 90 degrees in the opposite direction to one another. Turn off Auto Key and go back to frame 0. Right click the keyframes at frame 0 and select any one of the Phase keys. Amend the Out curve so it has

a linear attack (as illustrated) and click on the arrow next to this key's Out curve to send this curve information to the In curve of the next keyframe (at frame 100). Set this curve type for all keyframes (all Phases and all Position axes).

Information: As we are 'joining the animation' at frame 0, we want the sea's surface to be already moving, not speeding up. If we left the keyframe's curve information the way it originally was, our deformation animation would speed up and slow down, which is not what we want. To test this deformation, perform either a quick test render or run an animation preview. The result, when viewed from a distance is very subtle, but as we are going to be close to the surface we will notice any changes in deformation very easily.

PART TWO: With the animation set up for the deformation, we can now concentrate on creating the materials in our scene.

6 Open up the Material Editor, label a new material Sea–Underwater and assign it to the Sea object in the scene. Set the Diffuse color to RGB 1,70,112, the Specular Level to 223 and the Glossiness to 46. Set the Index of Refraction to 1.33.

Information: We have changed the Diffuse color to a blue which is to be consistent throughout the scene (to simulate the color of the deep water), that was generated by point sampling a color from one of the reference images on the DVD-ROM. The IOR was set at 1.33 as this is the refractive value of water.

7 Set the Bump amount to 15 and add a Mask map to its slot. Label it Sea Bump. Add a Noise map to the Map slot and label it Sea Ripple Bump. Set the Noise Type to Turbulence with a Size of 1 and 10 Levels. Click on the Swap button to change the black and white colors over. Back in the Sea Bump map, add a Falloff map to its Mask slot and label it Sea Ripple Bump Mask. Set its Front color to RGB 104,104,104.

Information: We have set this Bump map up so that it is strongest on the perpendicular, which is what is apparent in the reference material – the ripples cannot be made out very well on the surface when the water is parallel to camera, but can be clearly seen on the perpendicular, which is what the Falloff map controls.

8 Add a Falloff map to the Refraction slot and label it Bump Color Enhancement. Swap the two colors and set the Mix curve as illustrated. Add a Raytrace map to the Falloff map's Front slot.

Information: The Mix curve was amended so that this map clips off the raytraced refraction on the perpendicular, as shown in the material sample, so that the bump mapping will also stand out as there will be no refraction applied to the perpendicular of the bump mapping either.

9 Back at the top of the material, add a Falloff map to the Reflection slot and label it Sea Depth Reflection. Set the Side color to RGB 1,70,112 (the same as the material's Diffuse color) and set the Mix curve as illustrated.

Information: The Mix curve was amended to pull in the sides of the perpendicular falloff so the blue is most prominent in this map, as it represents the reflected color of the water below the camera.

PART THREE: With the Sea's material finished, we will now create the material for the sky which is refracted in the 'water', and position a light to create the sun.

10 Label a new material Sky and assign it to the Sky object in the scene. Enable Self-Illumination and add the *Sky.jpg* image (which can be found in 3ds Max's own maps collection) into the Diffuse slot. Add a Falloff map to the Self-Illumination slot and label it Sun Glow. Set the Falloff type to Shadow/Light. Amend the Mix Curve as illustrated, expand the Output rollout and set the Output Amount to 2.

Information: With the Mix Curve amended and the Output Amount increased, we have an intense self-illuminated spot (which trails off quite quickly so it won't over-illuminate the map) around the location of our light, which we will position next.

11 Reposition the Perspective Viewport so that we are looking down the Sea plane, and so that it is above us in the Viewport, with the Sea's 'Surface' clearly visible. In the Top Viewport, create an Omni Light, set its Contrast to 100 and reposition it in the Left Viewport so that it is right next to the Sky object, as illustrated. Reposition the light in the Top Viewport again (if necessary) so that it is almost dead center in the Perspective Viewport. With the Perspective Viewport active, select View>Create Camera From View, or hit CTRL+C.

Information: We have increased the Contrast of the light so that there is a more distinctive difference between light and dark colors defined by the light (such as the illumination of the Sky object). We have created a camera as we need to set up environment settings within the camera to control fogging.

12 Select the camera and set its Lens size to 28 mm. Check on Show in the Environment Ranges section. Set the Near Range setting to 200 and the Far Range setting to 510. Open up the Environment panel and set the Background Color to RGB 2,56,89. Add a Fog Atmospheric effect, set the Fog color to the same as the Background color and enable Exponential.

Information: The Lens size was set to a wider angle to give the scene a sense of scale; you do not get this with a narrow angled lens. The background color and the fog share the same setting so they can blend together nicely. Even though the fog will occlude the background color, it is useful to set this value in case we amend the Raytracer's Maximum Depth (which is advisable – a setting of 3 will suffice), as once it reaches this maximum depth, it will simply use the color of the background, which as we have set it to this blue will not stand out a lot, if at all.

13 Re-open the Material Editor and navigate to the Sea Ripple Bump map. Go to frame 100 and enable Auto Key. Set the Phase of this map to 10. Turn off Auto Key and go back to frame 0. Right click the keyframe at frame 0 and navigate to the keyframe we have just created. Amend the Out curve of the keyframe at frame 0 to a linear attack and send this curve information to the keyframe at frame 100's In curve as before. Render off the animation.

Information: We have had to animate the sea's bump mapping or it would appear as if the bump was stationary and the deformations were just passing over or through the mesh. Again, as we amended the curves of the Noise modifiers, we must also do the same for this map else its Phase will speed up and slow down.

Taking it further

We have just about nailed the effect with these few settings, especially after animating the elements in the scene. However, we can tweak the scene a little more to make it more believable. As there is a fair amount of swell going on to displace the surface of the water so much, the camera should also move around a fair amount; swaying from side to side should suffice, to suggest that the camera 'operator' is being buffeted around a little bit by the motion of the water. You may also want to add some extra translucency to the surface of the water. To do this, use a Translucent Shader that uses a dark derivative of the original material's diffuse color for the translucency color. Don't forget though to keep the translucent effect subtle because too much will wash out all of the bump effects we have tried to achieve.

The colors are almost right, but may need intensifying a little. In addition, the surface texture will not be so defined, therefore you may want to blur the scene a little by adding a Blur render effect and adding a Brightness and Contrast effect to tweak the colors a little. In the rendered example I have included on the DVD-ROM, I have put the final rendered animation through Combustion to amend the colors and to blur the image slightly. I have also extracted the bright (white) areas of the scene and added a radial zoom effect to create volumetric streaks emanating from the highlight on the water's surface from the sun.

If you do not have access to Combustion, this can be replicated using a Blur render effect, or (even better) create an action in Photoshop (if you have access to this program) to extract the white, dump it on a new layer, perform the radial zoom blur and change this new layer's blending type to Screen to overlay it back onto the original backplate. Photoshop actions are great for these kinds of basic color amendments and non-animated filtering as they can be used as a 'poor man's compositor'.

In addition to the improvements to the color, try adding additional particular matter such as floating debris that is disturbed when the swell washes over them. You may also want to add additional fogging to simulate the change in color due to deep waters. If you're really feeling adventurous,

add some fish and other life forms, such as the odd dolphin. You could even change the entire mood of the scene by amending the lighting and the colors, and adding raindrop ripples onto the surface of the water; see the Rain tutorial in this book to see how to create an effective bump map animation that would be ideally suited for this scene. This would create a really convincing stormy sea effect. Couple this with more turbulent water surface animation and you've got one dramatic scene.

At the end of the day there's not much you can do to this scene to wreck it because the volumetrics and post effects would hide any irregularities. Just don't overcrowd the scene, or you could run the risk of making it look unconvincing. The ocean is a big place, so cramming every creature in the sea into this small space would kill the scene.

14 Moving surface water

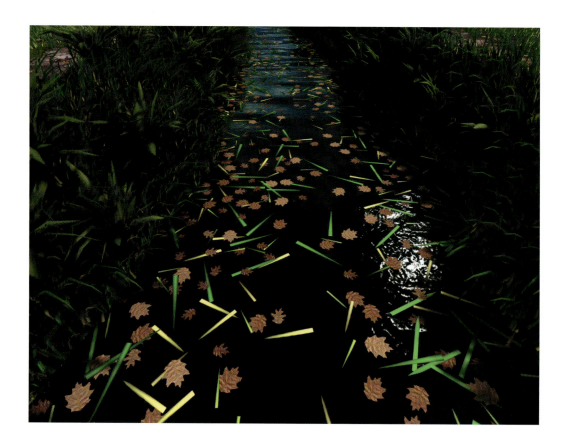

Information

This tutorial is just the first part of a larger tutorial which is spread across two elements in this book – water and earth. In this particular tutorial we are going to create a body of water which is virtually motionless but has winds affecting its surface. To simulate this we are going to use simple geometry to create the body of water, and a few modifiers to displace the surface of the geometry, therefore creating a few waves that are animated down the length of the mesh. We will also create a smaller animated surface texture to give the impression that these winds are not only displacing the surface, but are also skimming across it and whipping up the surface material of the waters. Next we will introduce a sky that is to be reflected in the surface of the water and illuminate the water accordingly to match it. Finally, we will generate a particle system to place debris over the surface. Again, please be aware that this tutorial only covers the water creation part of the above image; the rest of the tutorial continues in the Earth section's Grasses tutorial.

Analysis of effect

(a) Because of the winds, we have two resulting surface motions – a large surface displacement which is smooth and travels down the length of the water at a relatively constant speed, and a smaller surface texture which is more detailed. The larger surface displacement can take on the form of several waves, each of which travels in a slightly different direction so that they overlay one another and break up each other's pattern and regularity. (b) The smaller surface texture is caused by the wind rushing over the surface of the water and kicking it up a little. This creates an occasional 'rush' of texture. But more often than not, some winds are quite 'constant' and will therefore generate a quite consistent pattern across the surface. As this does not affect a larger mass of the surface, the main displacement of the water will pass over this surface texture and distort it. The water itself, as it is largely motionless, can change in appearance depending on the weather of previous days. (c) For example, should it have rained the day before, then any loose soil or dirt from surrounding areas will have washed into the water. As the water itself is not moving (only the surface appears to be) the dirt will sit, suspended in the water, until it finally sinks to the bottom. This may take a few days and will result in the water appearing like the chocolate lake in *Willy Wonka's Chocolate Factory*. This can have an adverse effect on the reflection of the surrounding environment due to the particular matter in the water diffusing the reflection a little. The reflection of the water, as always, is strongest on the perpendicular which means that the surface reflection will show the surrounding areas more prominently if the camera is low to the surface of the water, but will not reflect the sky as clearly as it appears more parallel to the camera due to the waves (unless there is little or no wind of course). (d) Because we are going to be basing our scene on a real-world environment, we can see that the main debris in this body of water are grasses and leaves from surrounding foliage. Therefore, we can use these leaves (the grass debris will be introduced in the next tutorial along with the banks of the canal) and float them in the water. This debris does appear to move slightly and also spins slowly as it moves, which therefore states that the entire body of water is not motionless after all. The wind simply whips up the surface of the water and not those objects floating in it; they simply pass over the deforming surface.

The geometry creation in 3ds Max is going to be pretty basic. As we only need one main body of water, we can use a simple elongated Plane primitive for the water surface. Because we want the surface texture (which will be generated by bump mapping

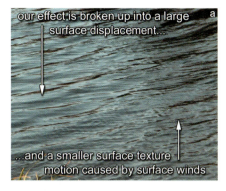

our effect is broken up into a large surface displacement...

...and a smaller surface texture motion caused by surface winds

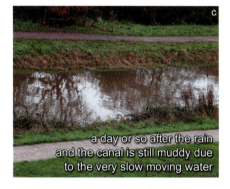

the pattern and motion of the surface displacement is quite regular, while the pattern and regularity of the surface "texture" is generated by short gusts of wind...

...which can result in patterns being run across the surface of the water as the wind rushes over it

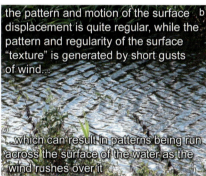

a day or so after the rain and the canal is still muddy due to the very slow moving water

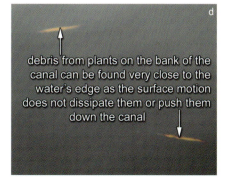

debris from plants on the bank of the canal can be found very close to the water's edge as the surface motion does not dissipate them or push them down the canal

created by an animated Smoke map and mapping gizmo) to be deformed with the surface of the water mesh, we need to place any mapping modifiers, which will control this surface texture, beneath any modifiers that deform the surface, otherwise this texture may appear to 'float' on top of the deformation. The deformation will be created by two Noise modifiers, which will be virtually identical apart from their gizmos which will be angled in opposing directions and will be animated to travel off in different directions, so that the deformations produced by these modifiers will overlap, exaggerate and cancel each other out, just like in real life. The motion of the entire body of water will be created using an Xform modifier which will be animated a short distance. The debris on the surface will be confined to the sides, near the area at which they fell; because of this we will use a particle system to distribute the debris, which will be planar-mapped particles with leaf materials assigned at random to them. We will distribute the particles over a copy of the water surface which will use a gradient to control the distribution concentration. Due to the (future) introduction of a grassy bank, and so that we have an overlap of the grass and water meshes, we will also have to inset the debris so that it will not appear like it is moving inside the bank. This can be tweaked later on, but it is always good to get the technology in place early on so we can simply amend later if necessary. The scene's lighting will consist of an array of lights which will simulate illumination from the 'sky' (a flattened hemisphere with a standard texture assigned to it), plus a single key light (a direct light) to create the sun.

Walkthrough

PART ONE: First we will create the basic geometry for the water surface and sky dome.

1 In the Top Viewport, create a Plane primitive with a Length of 2000 and a Width of 10000 and label it Water Surface. Set the Length Segs to 50 and the Width Segs to 250. Also in the Top Viewport, create a Sphere primitive and label it Skydome. Set Hemisphere to 0.5 and set the Radius to 30000. Ensure both objects are in the center of the scene.

Information: The Plane primitive has to have a fair amount of polygons so that the surface displacement is apparent when the scene is rendered. We could use a low amount of iterations in the length and width segment settings and just use a render multiplier, but as we are going to be using a clone of this geometry as a particle distributor later on, for illustrative purposes we will simply work with a higher number of polygons in the scene. The Sphere has been set to a hemisphere because we only need the top part of the sphere to represent our sky.

2 Add a Normal modifier to the Skydome hemisphere. Add a Mesh Select modifier and, using Polygon sub-object selection, select all of the polygons on the base of the hemisphere. Add a Delete Mesh modifier to remove these polygons. Next, add a Mesh Select modifier and add a UVW Map modifier to the stack. In the Left Viewport, scale this object down so that it is about 20% of its original height and move it down about 200 units.

Information: The Normal modifier has been added to flip the faces of the geometry around the other way so that they are facing inwards. Otherwise, if we rendered the scene from inside this hemisphere, we would not be able to see any faces at all. The base of the hemisphere has been removed as, again, we do not need it. The additional Mesh Select was added to clear the sub-object selection, and the UVW Map has been added to place a texture map over the top of the object. The object has been scaled down so that we only have a slight bulge to simulate the sky (so the texture is not as distorted) and has been moved down in the Left Viewport so that should any other objects be introduced to the scene later on (in the next tutorial), we will not see any of the background color.

PART TWO: Next we will add modifiers to apply the texture and to deform the surface, giving the impression that it is moving.

3 In the Top Viewport, select the Water Surface plane and add a UVW Map modifier to the modifier stack. Set both Length and Width settings in this modifier to 2000 to make its gizmo square. Right-click the Play Animation button and set the Animation Length to 200. Go to frame 200 and enable Auto Key. Enter this modifier's Gizmo Sub-Object mode and move it 3000 units to the right. Right-click the resulting keyframe at frame 0 and amend the X Position's Out curve to a linear attack, then click on the arrow next to it to pass this keyframe information to the keyframe at frame 200.

Information: The UVW Map modifier's length and width settings have been set the same so there will be no stretching of the texture that we apply to the object later on. The gizmo has been animated to add the light wind surface texture motion of the water, which will be handled by bump mapping; the keyframe information has been amended so that the animation does not speed up or slow down.

4 With Auto Key still enabled, add an XForm modifier to the stack. As this modifier automatically puts you in sub-object mode and we are still at frame 200, move the XForm gizmo 300 units to the right. Again, select the resulting X Position keyframe and amend its curve information as before and pass this setting across to the keyframe at frame 200.

Information: This modifier moves the entire body of the water across. It may seem pointless at this time, but as the particle debris will be locked to the mesh we can simulate the motion of the water by simply moving it. We have used an XForm modifier and not just animated the whole mesh because we need to animate the geometry further, and only want the deformations to be animated, not the entire mesh.

5 Go back to frame 0 and turn Auto Key off. Add a Noise modifier to the stack and set its Scale to 50, Z Strength to 90, enable Animate Noise and set the Frequency to 0.05. Enter Gizmo sub-object mode and, in the Top Viewport, scale the gizmo to about 1600% vertically. In the Front Viewport, rotate the gizmo 75 degrees clockwise, and in the Top Viewport, rotate it 15 degrees clockwise. Copy and paste this modifier, and in the copy set the seed to 1 and rotate the gizmo in the Top Viewport 30 degrees anti clockwise.

Information: The Noise modifier has been stretched out to form some long waves, and has been rotated so that it affects the surface of the 'water' at a slight tangent, generating a sharp-ish peak where the wave leads the motion with a trailing falloff. The combination of the two opposing modifiers, at slightly different angles and different seeds to one another, overlap each other and, when animated, will appear like different waveforms traveling down the canal.

6 Select the Gizmo Sub-Object of the first Noise modifier. Enable Auto Key and go to frame 200. Move the gizmo in the Top Viewport 1000 units to the right and 1000 units vertically downwards. Select the second Noise modifier's gizmo and move that 1000 units to the right and 1000 units vertically upwards so that the two gizmos are traveling in opposite directions. Turn off Auto Key. As before, amend the resulting position keyframe information's Out curves for both modifiers and also amend the Phase keyframe information.

Information: As mentioned in the last step, the opposing modifiers create multiple waves along the surface of the water. This time, as more than one axis has been animated, you will have to amend the keyframe Out curves for X and Y axes for both of these modifiers as well as both Phase keyframes.

PART THREE: Next we will create, animate and assign the water material, as well as creating the leaf debris and sky materials.

7 Open the Material Editor and label a new material Water. Set the Diffuse color to RGB 2,3,0, set the Specular Level to 250 and Glossiness to 90. Add a Falloff map to the Reflection slot and set its Falloff Type to Fresnel. Add a Raytrace map to the Falloff map's Side slot and amend the Mix Curve to that illustrated.

Information: We have set this material to a high glossy surface so that a lot of specular highlights will be picked up. The Falloff map has been added so that the Raytraced reflections are masked out a little, so they are more prominent on the perpendicular than completely face-on, and the Mix Curve amendment emphasizes the perpendicular effect but reduces the parallel effect.

8 At the top of the material, set the Bump amount to 5 and add a Smoke map to the Bump slot. Set the Source to Explicit Map Channel, the Size to 0.04, Iterations to 20 and Exponent to 0.4, and change the off-white Color 2 swatch to white. Go to frame 200 and enable Auto Key. Set the Phase to 5 and turn Auto Key back off. Assign this material to the Water Surface object in the scene. Amend the resulting Phase keyframe's Out curve, as before, to create a linear attack and pass this curve information to the keyframe at frame 200.

Information: The Smoke map's Color 2 generates the trough part of the ripple (due to the Exponent being set to 0.4) which makes the white more dominant with a small black (Color 1) peak, therefore generating the ripple. The Source was changed to Explicit Map Channel so that the animated UVW Map modifier could be used to position and animate this texture.

9 Label a new material Sky and assign it to the Skydome object in the scene. Set the Self-Illumination to 100 and add a Bitmap map to the Diffuse slot of this material. Load in the *SKY.jpg* file, which is included with the shipped version of 3ds Max, into this map.

Information: We have used the planar mapping of the Skydome sphere to stretch this map over its surface. As we are not going to see the sides of this object, and are only using it for the reflection, its detail (and any stretching) is not all that important because it will be broken up in the reflection (due to the bump mapping and surface deformation of the plane object).

10 Create a new Multi/Sub-Object material in a new material slot and label it Leaf Debris. Click on the Set Number button and set the Number of Materials to 4. Go into the first material in the Multi/Sub-Object material's slot and label it Leaf01 Top. Load in the *oakleaf01_top.jpg* included on the DVD-ROM as a Bitmap map into the Diffuse slot, and instance this map into the Bump map slot. Load in the *oakleaf01_mask.jpg map* into the Opacity slot.

Information: We are creating a Multi/Sub-Object material so that the particle system we are going to create can choose any of the materials at random. We have set the Number of Materials to 4 so that the particle system does not choose a blank material.

11 Copy the Leaf01 Top material in the Multi/Sub-Object material's first slot to the second slot and rename it Leaf01 Bottom. Replace the *oakleaf01_top.jpg* map with the *oakleaf01_bottom.jpg map* in either the Diffuse or Bump slots of the copied material. Set up the other two materials in the Multi/Sub-Object material for the Leaf02 Top and Leaf02 Bottom maps, not forgetting to rename the materials correctly and assigning the correct opacity map.

Information: As each material is virtually identical, we can set up the material's parameters in the first material and then simply clone and replace key elements in the copied versions.

PART FOUR: With the materials complete, we will now generate a particle system which will float the debris on the surface of the water.

12 In the Top Viewport, Copy the Water Surface object and label it Water Debris Distribution. Add a Push modifier to its modifier stack and set the Push Value to 10. Label a new material Debris Distribution and add a Gradient Ramp map to the Diffuse slot. Set the W Angle setting to 90 and add flags to positions 10, 12, 88 and 90. Set the flags at positions 0, 10, 50, 90 and 100 to black and the ones at positions 12 and 88 to white. Enable ShowMap in Viewport and assign this material to the Water Debris Distribution object in the scene.

Information: As the particles we are going to be using are facing particles, they need to be offset a little to get them to appear to sit on the surface but not intersect with the water geometry; hence the offset created using the Push Modifier on the plane copy. The plane has been copied not only to offset the particles, but to also distribute them so that the particles are positioned in the right places – a slight inset for any overlapping of meshes (i.e. the banks), a high amount of debris at the sides (white) diminishing to very little or none in the middle (black).

13 In the Top Viewport, create a Particle Flow system and label it Debris–Leaves. Set the Viewport Quantity Multiplier to 100 and open up Particle View. In the Birth operator, set the Emit Start and Emit Stop to 0 and Amount to 750. Overwrite the Position Icon operator with a Position Object operator. Enable Lock on Emitter, add the Water Debris Distribution object to the Emitter Objects list and enable Animated Shape and Subframe Sampling. Enable Density By Material and Separation and set the Separation Distance to 75.

Information: Using the Position Object's Density By Material (which defaults to Grayscale) the particle system will distribute the particles based on the strength of the white in the material assigned to the object(s) in the Emitter Objects list. The particles have been set to lock onto the emitter object so that when the object deforms (i.e. by moving using the XForm modifier or the Noise modifiers) they follow suit. Animated Shape tells the system that the shape will be updated every frame, and subframe sampling tells the system to update the shape between frames as well for greater accuracy. The Separation Distance has been enabled and increased so that the particles do not overlap and fight each other for space when rendered, else this will result in a flickering effect.

14 Remove the Speed and Shape operators and add Shape Facing, Spin and Material Static operators. In the Shape Facing operator, set the Size to 100 with 25 Variation. Set the Spin operator's Spin Rate and Variation to 10 with the Spin Axis set to Particle Space and set the Rotation operator's Orientation Matrix to Random Horizontal. Instance the Leaves Debris Multi/Sub-Object material into the slot in the Material Static operator, enable Assign Material ID and Random. Hide the Water Debris Distribution object.

Information: We do not need the particles to move so we have removed the Speed operator. The particles themselves are simple planar mapped particles, so a Shape Facing operator is used to generate this, and they are set to spin slightly using the Spin operator with an initial rotation offset using the Rotation operator. The Material Static operator has been set to assign a Material ID at random, and because we have a Multi/Sub-Object material assigned to it, this randomly selected ID corresponds to that Material ID in the Multi/Sub-Object material. To see all of this in action enable Show Map in Viewport for all of the Multi/Sub-Object materials, enable Show in Viewport in the Material Static operator and set the Display operator to display geometry.

PART FIVE: Finally, we will create a lighting rig to simulate illumination from the surrounding sky.

15 Turn off Cast Shadows for the particle system and turn off Cast and Receive Shadows for the Sky Dome. Turn off the particle system for the time being. In the Top Viewport, create a Direct Light at around 10 o'clock with its target dead center of the scene and label it Sun. Enable Shadows and set its color to RGB 250,245,235. Enable Show Cone and Overshoot and set the Falloff/Field to about 6000. Set the Contrast to 100, Shadow Map Bias to 0.01 and the Size to 1024. In the Left Viewport, move the light vertically so that it is above the top of the hemisphere.

Information: We have extended the Falloff/Field boundary as shadows are only cast within this boundary. The Contrast has been increased to enhance the colors in the scene, the Bias increased to tuck any (future) shadows right in behind the objects that cast them so they are not detached, and the Size increased to make the shadow more crisp, therefore suggesting sunlight.

16 In the Top Viewport, create a Direct light to the left of the scene pointing at the center of the Water Surface and label it Sky Light01. Position its target in the center of the scene. Enable Shadows, set the Multiplier to 0.05 and the color to RGB 205,220,233. Enable Overshoot and set the Falloff/Field to 6000. Set the Bias to 0.01, the Size to 256 and the Sample Range to 2. Instance-rotate this light every 22.5 degrees using the plane as a pivot point to create a full ring of instanced lights. Instance this of lights and reposition it above the original in the Left Viewport. Instance the ring another couple of times to produce almost a spherical array of lights all pointing at the center of the scene, as illustrated. Turn on the particle system again and render off the scene at a low resolution to ensure it works okay.

Information: Quite a big step for a final stage, although the method is quite simple. All we have done is set up a low intensity light that uses a color which has been point-sampled from the cloud map assigned to the Skydome. The resulting array of lights have low shadow map sizes to keep render times down, but not too low to lose detail when we add some extra objects later on in the Grasses tutorial.

Taking it further

Should you want to improve the reflection of the water you could either turn on Super Sampling for this material or, if you are feeling rather daring, enable anti-aliasing, which will allow you to blur the reflection and also add distance-based effects, such as fading out objects in the reflection that are over a distance threshold. All of which will add to the render times, which aren't all that bad at the moment, but once we have added all of the extra elements from the Grasses tutorial, you will be talking exceptionally long times, so use them sparingly. You will also want to reduce the amount of ray-trace bounces to reduce rendering times as we do not have any refractive materials in the scene and no multiple raytraced objects.

Well I guess that the next thing to do would be to head over to the Grasses tutorial further on in this book to add the banks and additional debris in the water, as well as deforming the shape of the banks and water surface so that they all follow the same contour.

15 Rain

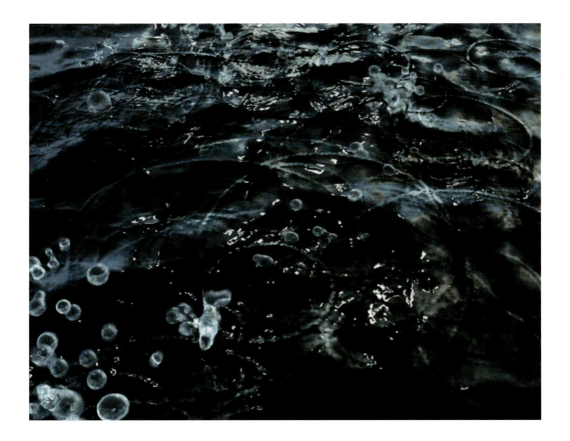

Introduction

Creating basic rain is very simple – just a large particle system to encompass the scene, crank the amount of particles up and, with a bit of motion blur, hit render. Voila! Instant rain. But what if we want our rain to interact with a surface? In this tutorial we will simulate not only the rain falling from the heavens (and being blown around a bit by the wind), but also splashes and ripples on surface water. Be warned that this scene, due to its construction, is quite CPU intensive when it comes to rendering, therefore (and also due to the construction methods used) we have split up the procedure into two main sections, so you can set one going overnight. I have already written a technique to generate this effect that was published in *3D World* magazine, issue 36. Although this tutorial uses a similar technique, it elaborates on it to generate particular water effects and more splashes, something we did not cover in the first article. There is also an example of raindrops on the 3ds Max Tutorial and Sample Files CD; while this illustrates initial particle spawning (using animated maps as the spawned ripple and deflected water), it does not deal with secondary and tertiary ripples, plus the additional effects that this tutorial generates.

Analysis of effect

ejected water droplets

secondary ripples

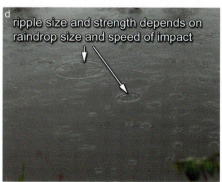

ripple size and strength depends on raindrop size and speed of impact

Due to the sheer amount of particles flying around in the scene generating the particular water and splashes, we will concentrate on a scene in which it is raining only slightly. Open up the *Water/15_Rain/Reference/Movies/rain03.mpeg* on the DVD. This clip illustrates rain on a stationary body of water – in this case a canal. It may appear that the water is moving, but this is just the surface being affected by the wind. Picking out a single raindrop to analyze the effect is quite difficult due to the amount, but, by careful observation, we can just about make out the motion. (a) The rain is affected by the wind, so is coming in at varying angles and slightly different speeds. (b) On hitting the surface, a reflected water droplet is ejected up into the air and a bubble forms to suggest that the raindrop has hit the surface with some pace. This also results in the surface water around the raindrop being displaced and forced into the air (with not as much intensity as the reflected droplet) creating the impact splash, which then falls back to the surface. (c) Upon hitting the surface, secondary splashes is created which generates additional particular water which is displaced and falls back to the surface. Upon each water droplet's interaction with the water body's surface, a ripple is formed, the size of which depends on the velocity of the water particle. (d) This normally happens a few times – the initial water impact, the secondary impact and the final tertiary impact. After which, the impact of the water particles do not have enough velocity to displace more water from the surface.

So what tools do we have in 3ds Max that can be used to emulate this effect? Well, obviously, we are going to have to make heavy use of particle systems to do the majority of the leg work for us. The initial rain particles will hit the water surface and then, using particle spawning, will generate other particles that will travel in different directions away from the initial particle impact. The original particle will bounce vertically upwards to create a nice splash and will also generate a bubble particle. Each particle that interacts with the surface will generate a ripple, which will be created using an animated scale on a flat spawned planar particle with a ring opacity map applied to it. Because we want the ripples to be on a water surface, and because we have no default way to use particles to paint a texture on another surface, we are going to have to do this in two passes – firstly to render off an animation of the ripples from the Top Viewport with our water filling the entire frame right to its edges, and secondly, reassigning it to the water surface as

a bump or displacement map which, if everything is lined up precisely, will be in exactly the right place for our splash particles.

As this effect is pretty much uniform, apart from a small amount of chaos and random motion thrown in for good measure, we can design our rain effect using a very small amount of raindrops. Once we have got this system perfected, it is then just a simple case of whacking up the birth rate of the particle system and hitting render for both passes.

Walkthrough

PART ONE: First we will create the initial scene and set up the Space Warps and basic Particle System that will drive the ripple generator.

1 In the Top Viewport, turn on Grid snap and create a Plane primitive with a Length and Width of 1000 and Length and Width Segs of 1. Create a Deflector Space Warp the exact same size and position it (if necessary) so it's over the top of the Plane. In the Left or Front Viewports, raise the Deflector above the Plane slightly. Set the Deflector's Bounce to 0.25, Variation to 50, Chaos to 50 and Friction to 25.

Information: Here we have created the background for our ripple generator – the Plane primitive. The Deflector has been placed just above the Plane so that any particles that rest on it after colliding will not be 'fighting' to be on top of the Plane – i.e. the Plane and particles would be at the same location so may flicker on and off, or appear half occluded. Moving the Deflector slightly ensures this doesn't happen.

2 In the Top Viewport, create a Gravity Space Warp. In the Left Viewport, create a Wind Space Warp. Set the Wind's Strength to 0.1 and Wind Turbulence to 1. In the Top Viewport, create a Particle Flow system the size of the Plane and Deflector and label it Raindrops. Reposition it upwards in the Left Viewport so it's got a Z height of 2000. Set the Viewport Quantity Multiplier to 100, Particle Amount Upper Limit to 10000000 and Viewport and Render Integration Steps to 1/4 Frame.

Information: This concludes the initial setup section. Here we have added gravity to cause the initial rain particles to fall from the 'sky' and added a little wind to create a more random motion, and therefore pattern when the raindrops create the ripples. The Viewport multiplier was increased so that later on we can see that our rendered ripple animation overlays exactly with our splash particles, also the integration settings are set the same so that the Viewport and render particles are in the same place (using different integration steps may yield different particle positions when working with deflectors).

PART TWO: With all the elements required to affect our particle system, we can now start designing the ripple generator.

3 Press 6 or select the particle system (if not already selected) and open Particle View. Delete the Render operator from the Raindrops Event. Rename Event 01 to Raindrops Falling. In its Birth operator, set the Emit Start to −50 and Emit Stop to 200 with Amount left at 200. Remove the Speed and Rotation operators. Set the existing Shape operator's Shape to Sphere with a Size of 4. Add a Force operator and add the Gravity Space Warp to its Force Space Warp list. Add another Force operator and add the Wind Space Warp to its list. Add a Collision test and add the Deflector to the Deflectors list in this test. Change the Display operator's Type to Geometry, if desired.

Information: A rather long step that simply introduces the Space Warps to our basic particle system. The particle's birth has been set to a negative value so that they have already been born when we start the sequence, so there is no wait for them to collide with our deflector. We have used two separate Force operators because we will need to utilize each force individually later on, so there is no point in having the two Space Warps in one operator.

4 Drag a Shape operator out to the Particle Flow canvas to create a new event. Label this new event Raindrops Initial Impact Spawn. Set the Shape operator's Shape to Sphere with a Size of 7. Add a Spawn test and label it Bubble Generator. Add another Spawn test and label it Ripple Generator.

Information: We are using numerous Shape operators, even though they are not being rendered, to drive a Blobmesh object that we will introduce later on, as the mesh this object generates takes its size from the source

geometry (in this case the Shape operators). As the initial impact of the raindrop creates a number of elements, we have to use particle spawning to generate individual particles (the unchanged Spawn tests) and multiple particles to be sent to additional events in which their properties will be changed.

5 Add another Spawn test to the event and label it Secondary Generator. Set the number of Offspring to 20 with 50 Variation, Speed Inheritance to 75 with 20 Variation and a 45 degree Divergence. Add a Send Out test to the event. Wire the output of the Collision test of the Raindrops Falling event to the input of this event.

Information: This is an important step as it drives the majority of the effect we are after. The initial raindrop particle spawns the secondary particles when colliding with the deflector (water surface). This particular spawning creates the splash that occurs as the water is displaced.

PART THREE: We can now create an event to control the ripple's properties and animate the scale of the ripple based on the particle's duration in the event.

6 Drag out a Render operator to the canvas to create a new event and label the event Raindrops Initial Ripple. Add a Shape Facing operator to this event. Set its World Space Size to 100. Add a Material Dynamic and a Speed operator, and set the Speed to 0. Add a Delete operator, enable By Particle Age and set the Life Span setting to 100 with 0 Variation.

Information: This event will create the initial large prominent ripple that occurs when the raindrop first hits the surface, so a Render operator is introduced so this event is seen by the renderer. The particle type has been changed to planar geometry that will lie on top of the deflector and have a ring texture assigned to it, which is handled by the Material Dynamic (as the material is changing based on particle age) operator. The Delete operator simply tells the system the age of the particle, so any maps or animation used can be controlled correctly.

7 Wire this event to the Ripple Generator test. Add a Scale operator above the Delete operator. Set the Type to Relative First and the X, Y and Z scale to 50. Set the Scale Variation to 10 and Sync By to Event Duration. Turn on Auto Key and go to frame 100 (you may wish to turn off the Birth operator first to speed up Viewport interaction). Set the X, Y and Z Scale Factor to 550. Turn off Auto Key. Go back to frame 0. Right-click the new X, Y and Z scale keyframes at frame 0 and amend the output curves so there is a linear attack.

Information: As the Scale Sync By was set to Event Duration, each particle passed to the event is scaled with the scale animation offset so the particle begins to scale when it joins the event, before it is deleted. The change of the keyframes is so the scale has a more abrupt scale transformation instead of ramping up the intensity. The event must be wired before the keyframes can be amended as they won't be part of the system otherwise, so they won't be able to be selected.

PART FOUR: With the initial ripple designed, we will now set up properties for the expelled particles and have them interact with the surface to generate more ripples.

8 Copy the Gravity Force operator in the first event and Paste Instanced it onto the canvas to create a new event. Label the event Raindrops Initial Impact Properties. Add a Scale operator and set the X, Y and Z Scale Factor to 75 with 50 Variation. Copy the Collision test in the first event and Paste Instanced it into this event. Wire this event to the output of the Secondary Generator Spawn test.

Information: As the deflector in our scene has very little bounce, the particles hit the surface and are brought right back down to collide with the deflector again, therefore creating another ripple, hence the need for another collision test.

9 Drag out a Speed operator to the Particle View canvas and label the resulting event Raindrops Initial Impact Rebounce. Set the Speed's Variation to 100 and check on Reverse direction. Paste Instanced a copy of the Gravity Force operator and the Collision test to this event. Wire the input of this event to the Send Out of the Raindrops Initial Impact Spawn event.

Information: As none of the previous Spawn tests delete the parent particle, this particle is passed though the previous event and out via the Send Out test, where it is given a new speed, therefore creating the motion for the rebounding water droplet.

10 Paste Instanced the Gravity Force operator to the canvas to create a new event and label the resulting event Raindrops Secondary Impact. Add a Spawn test, label it Tertiary Impact Generator and set the Offspring to 2 with a speed Variation of 25 and Divergence of 45. Add a Scale operator and set the X, Y and Z Scale Factor and Scale Variation to 50. Paste Instanced the Ripple Generator spawn test from the Raindrops Initial Impact Spawn event into this event. Paste (not instanced) a copy of the Collision test into this event and change the Test True If Particle to

Collided Multiple Times and set the # Times to 4. Wire the Raindrops Initial Impact Properties and Raindrops Initial Impact Rebounce events to this event.

Information: Another big step. The gravity has been used again so it affects this event and brings any particles passed to it back down towards the deflector. The first Spawn test creates another couple of particles when the secondary particles hit the deflector, and the Scale operator reduces them and its parent particle in size. The copied Spawn test passes its single spawned particle to the next event (in the next step). The Collision does the same after four bounces, by which time the particle will more than likely be at rest.

11 Copy and Instance Paste the Raindrops Initial Ripple event, label the new event Raindrops Secondary Ripple and wire it to the Collision and second Spawn tests in the Raindrops Secondary Impact event. In this new event, make the Material Dynamic and Delete operators unique. Set the Delete's Life Span to 50. Drag out a new Scale operator, overwriting the existing one. Set the Type to Relative First, the X, Y and Z Scale Factor to 20, Scale Variation to 10 for all axes and Sync By to Event Duration. Enable Auto Key, go to frame 50 and set the Scale factor to 220 for all axes. Turn off Auto Key and go back to frame 0. Change the attack of the output of the scale keyframes, as before.

Information: As we are creating additional ripples, we can utilize the existing ripple event we set up previously, and simply change a few settings to make the ripples less intense, such as the use of a new material, a smaller size and a shorter lifespan. At this point you may wish, if you haven't already, to set all Display operators to show particle geometry.

PART FIVE: With all ripples now generated, we can go back and add the bubble which occurs when the initial raindrop hits the waters surface with a lot of force.

12 Copy and Paste Instanced the Render operator from the Raindrops Initial Ripple event to the canvas to create a new event, labeling the event Raindrops Bubble and wiring it to the Bubble Generator Spawn test. In the Top Viewport, create a Sphere with a Radius of 13 and 16 Segments. Add a Shape Instance operator to the event and pick the Sphere as the Particle Geometry Object. In this operator, set the scale Variation to 50. Add Material Static, Speed and Delete operators. In the Speed operator, set the Speed to 0. In the Delete operator, amend the By Particle Age Life Span to 20. Hide the Sphere primitive.

Information: The final step in our particle creation. As we do not want the particle to move, any speed that was inherited or previously set has been stopped by using the Speed operator set to 0. A Shape Instance operator was used, instead of a normal shape operator, because the Shape operator's Sphere shape does not have enough faces and will appear faceted when rendered. The Delete operator has been set to a low number so the bubble particle 'pops' shortly after being born.

PART SIX: With the particle system now complete, we can create the materials which will drive the ripples, and also to set a solid color to the background Plane.

13 Minimize Particle View and open up the Material Editor. Label a material Plane Background and set its Diffuse color to Black. Assign this material to the Plane primitive in the scene. Label a new material Initial Ripple, set its Diffuse color to white and set the Self-Illumination to 100.

Information: As we do not want any particles that have passed by or around the deflector to be visible, we assign a solid black color to the background plane. As we are, at this moment, creating the ripple generator, we need a completely self-illuminated ripple material so it stands out in the render.

14 Add a Mask map in the Opacity slot of the Initial Ripple material and label it Initial Ripple Age Mask. In this Mask's Mask slot, add a Particle Age map and label it Initial Ripple Fader. Set Color 1 to RGB 225,225,225, color 2 to RGB 100,100,100 and Color 3 to black. Set the position of Color 2 to 30.

Information: As we want the ripple to fade out over time, we use a Particle Age map to control the masking of another texture; as soon as the particle is born, it is almost fully opaque, which then gradually diminishes and becomes more and more transparent, and therefore less intense at render time, until it dies.

15 Go back up to the Ripple Age Mask and add a Bitmap map to the Map slot. Load in the *Water/15_Rain/Source/ripple.jpg* map and label the Bitmap Ripple map. Open up Particle View and drag this material to the slot in the Material Dynamic operator in the Raindrops Initial Ripple event.

Information: The Ripple map was originally created using a radial Gradient Ramp map, but was replaced with a rendered version of the radial gradient as it takes longer to render procedural maps than bitmaps.

16 Copy the Initial Ripple material to a new slot and rename it Secondary Ripple. Rename the Ripple Age Mask in this material copy to Secondary Ripple Age Mask and rename the Initial Ripple Fader Particle Age map to Secondary Ripple Fader. Set this Particle Age map's Color 1 to RGB 92,92,92 and Color 2 to RGB 50,50,50. Navigate to the top of the material and drag this material to the slot in the Material Dynamic operator in the Raindrops Secondary Ripple event.

Information: As the secondary ripples are identical to the initial ripple, we can use a slightly amended copy of the original material. However, because the ripples will not be as intense, the opacity of the generated material will not be as opaque, and therefore not as intense when rendered off.

PART SEVEN: With the ripples set up, we just need to temporarily disable some of our particle elements so they are not accidentally rendered off with our ripple animated map.

17 Minimize the Material Editor and re-open Particle View (if it is not already open). Click on the light bulb icon in the title bar of the Raindrops Bubble event to turn it off so that it is not rendered at this point. Open the Render panel by pressing F10 and set the Width and Height Output Size to 500 × 500 or any other equal dimensions, depending on the speed of your machine.

Information: We do not want the Raindrops bubble to be rendered off in the ripple sequence we are developing, so we have to turn it off. The other events are not renderable (no Render operators exist in either the individual or previous events) so therefore will not be visible to the renderer.

18 In the Top Viewport, right-click the 'Top' text in the corner of the Viewport and select Show Safe Frame. By panning and zooming in this Viewport, align the Plane/Deflector boundary so it fits the outside of the safe frame exactly. Right-click the Play Animation button and set the Animation Length to 200. Specify a sequence name to output to, save the scene, and render out the animation.

Information: We will need to re-map the resulting sequence back onto our Plane map so we can use it as a bump and/or displacement map; it needs to be sized up and aligned exactly so it can be simply overlaid later on. Using the safe frames helps us line up the extremities of the plane to the canvas. This animation will take a while to render due to the amount of opacities being calculated when we get further into the animation, so I would suggest that this is run overnight.

PART EIGHT: With the animation now rendered out, we can load it back into a new version of our scene and use it as a bump or displacement map.

19 Label a new material Bubble, set the Diffuse color to black, the Specular Level to 110 and Glossiness to 55. In the Opacity slot, add a Falloff map and set the Falloff Type to Fresnel. Open Particle View, turn the Raindrops Bubble event back on and drag this material to the slot in the Material Static operator in this event. Turn off the Raindrops Initial Ripple and Raindrops Secondary Ripple events.

Information: As we are now going to render off the splashes and have already rendered out the ripples, we no longer need the ripple particles to be seen by the renderer. However, we do now need the renderer to see the bubble particle so this is re-enabled.

20 Copy the Bubble material and rename the copy Water. Remove the Falloff map from the Opacity slot. Set the Specular Level to 250 and Glossiness to 90. In the Bump slot, add a Mix map and set the Mix Amount to 25. Load in the sequence we have rendered out (or load in the *ripple_bump.avi* provided) into Color slot 1 and set the Blur offset to 0.002. Add a Smoke map to the Color 2 slot. Set the Source to Explicit Map Channel, set the W Angle setting to 90 to get it facing the right way, Size to 0.2, Iterations to 5 and Exponent to 0.5. Set Color 2 to White. Go to frame 200, enable Auto Key and set the Phase to 5. Turn off Auto Key. At the top of the material tree, set the Bump to 100. Add a Falloff map to the Reflection slot, set it to Fresnel and amend the Mix Curve to that illustrated. Add a Raytrace Map to the Side slot. Assign this material to the Plane primitive in the scene. Right-click the Phase keyframe at frame 0 and set the Out curve to a linear attack. Click on the arrow next to this curve to pass the curve information to the In curve of the next keyframe (at frame 200).

Information: The Bump map's Blur offset is increased to slightly blur the map to remove any jagged edges that may occur at render time from using a Bitmap map. The Falloff map partially masks out the Raytrace map so that the reflection is more prominent on the perpendicular. We have also created a slight moving water effect, so that it appears as if the environment is a little unpleasant. The keyframe's curve was amended so that the Phase value does not gradually increase and then gradually slow down.

PART NINE: To finish off the scene, we will add a skydome to be reflected in the water, and also set up the water splash object.

21 Label a new material Sky and set its Self Illumination to 100. Add a Bitmap map to the Diffuse slot and load in the *sky.jpg* map which can be found in Skies folder in 3ds Max's own Maps folder. Set the Output Amount to 0.75 and RGB Level to 0.5. Create a Geosphere in the Top Viewport with a Radius of 4000 and Hemisphere enabled. Label it Sky. Assign the Sky material to it and add a Normal and a UVW Map modifier. In the Left Viewport, move it down slightly so its base is below the Plane and scale it down vertically to flatten it out somewhat.

Information: We need an object or map so that the water can display a reflection, which is what this skydome is for. The intensity of its bitmap has been reduced to make the sky appear duller and more overcast. The sphere was moved down slightly so, again, the base of its hemisphere was not fighting the plane as to which polygons were going to be on top.

22 Right-click the Sky object, select Properties and turn off Cast and Receive Shadows. Create a Direct Light and position it as illustrated. Turn on Overshoot and set the Falloff/Field so that it encompasses the Plane, as shown. Set the Shadow Map Bias to 0.01.

Information: The light's Falloff/Field needs to be increased as shadows are only cast within this field. The Bias has been reduced so that the shadows are neatly tucked underneath the objects that cast them and are not detached.

23 Create a Blobmesh Compound Object in the Top Viewport, set the Render and Viewport Evaluation Coarseness to 3 and 4 respectively. Copy the Water material, label it Water Splashes. Expand the Extended Parameters rollout and set the Index of Refraction to 1.333. Remove the Bump map, assign a Raytrace map to the Refraction slot and assign it to the Blobmesh object. Add the Raindrops particle system to the Blob Objects list and turn off All Particle Flow Events. Add the Raindrops Initial Impact Properties, Raindrops Initial Impact Rebounce and Raindrops Secondary Impact events to the Particle Flow Events list in the Blobmesh object. Render off the scene in the Perspective Viewport.

Information: The final (rather large) step. As we only need certain events in the particle system to be seen by the Blobmesh object, we can specify which ones we require. Your render may come out slightly grainy where the ripples occur. To rectify this, try either increasing the Blur in the Bump map slightly, produce a larger animated map, or use Supersampling (which can increase render times, although the results are worth it). The result is a convincing ripple animation, but looks slightly out of place due to the stillness of the initial water surface. In the next section we discuss how this can be improved and made to look like the wind is affecting the surface before the rains come.

Taking it further

If you dare, try increasing the water surface's area and the amount of initial raindrops – to get a full-on rainstorm, try using a few thousand raindrops over the 200 frame period, but don't plan on doing anything with your computer for quite a while because this is going to take an absolute age to render, due to the amount of opacities having to be calculated (the actual particle system generation doesn't take much time at all) to generate the animated map.

The end result generates a very effective rainstorm effect. Also, try increasing the wind for the original rain particles to make the scene more turbulent, and also add surface waves caused by this wind to the water body's surface to suggest that the fast winds are disturbing it. You may also want to add the initial raindrops which are not currently renderable; simply re-order the particle system a little and ensure that the initial rain events are not made visible to the Blobmesh objects, else the result may get a little wayward.

In the *15_rain_taken_futher.max* scene included on the DVD, I've added additional moving water to the surface, using a technique similar to the moving water method used earlier on in the book. I've also used slight object motion blur to give the impression that the particles are moving with some velocity.

Finally, I've used the ripple sequence we have developed as Material Displacement, which does crank up the render times, but the result is worth it as it actually deforms and refines the mesh, and doesn't just produce a shading effect to simulate displacement, which is what Bump mapping does.

One thing is missing (on purpose by the way – got to get you to do something!) from the water displacement – the initial dip inwards as the raindrop hits the surface. Try creating another animated map to handle this displacement and to gradually fade out the displacement after the raindrop hits the surface, so the water dips down, then up and gradually levels out, on top of which the ripple we have already created is applied. Using a copy of the existing scene should be enough, just amend the materials assigned to the ripple generators to create this additional animated map.

Even though the ejected particles produce a nice effect, they are not totally realistic. Therefore I would suggest that you re-work the ejection system to emit particles from a ring-shaped emitter which pops up as soon as the raindrop particle hits the water surface. To do this, use an instance of a ring primitive which appears for a single frame, and get this to emit the ejected particles. In order to do this, you will have to use a Mesher Compound Object to get the ejected particles to be emitted from the mesh of the instanced geometry. It will require you to relocate all the ejected particles to a new system, as the original system will stop as soon as the ring is generated, but this should not pose much of a problem. Therefore the result would work like this: rain particles fall and hit the surface, creating a 1 frame instance of a ring (else the additional system would constantly emit particles from the ring). This ring is converted to geometry using a Mesher and a new system emits particles from the ring to generate the ejected water droplets.

16 Hailstones

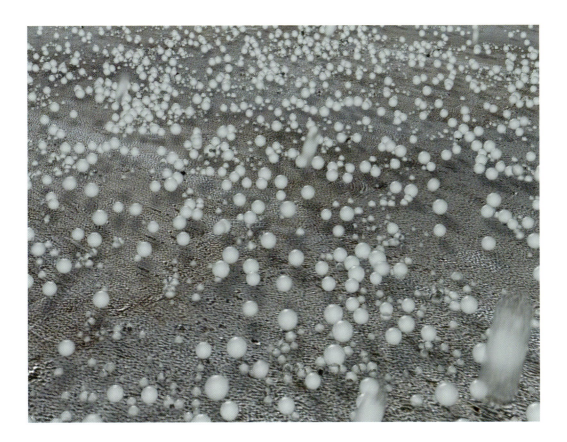

Introduction

In this tutorial we are going to simulate a realistic fall of hailstones. Creating the initial fall is pretty straightforward; all we need is a basic particle system, add a bit of gravity and wind, and there we have it. But what if we have a ground or surface interaction? Unlike rainfall, hailstones don't just splash on impact, they have a tendency to interact with the surface – bouncing off it at reflective angles and displacing each other when one hailstone hits another on a surface. Therefore we are going to have to generate a particle system that uses collision detection to create this interaction. We are also going to have to generate the right material to create a cloudy ice effect, so a basic material will not suffice because this cloudy effect is, at the majority of times, only in the middle of the hailstone. We will also create an additional interaction with the surface, with the occasional hailstone breaking up on impact.

Analysis of effect

non-linear direction of travel

existing surface water or melting ice creates a dampening effect for the bouncing hailstones

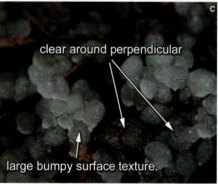

clear around perpendicular

large bumpy surface texture.

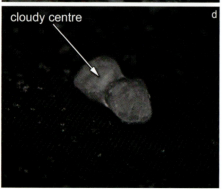

cloudy centre

(a) Open up the *Water/16_Hailstones/Reference/Movies/hail01_falling.mpeg* included on the DVD. From this clip we immediately notice that the hailstones do not fall in a linear fashion, even though you would assume them to be heavier and denser than their raindrop counterparts. As we can see from the clip, there are occasional hailstones (sometimes groups) that fall from the sky at a different angles to the others because they are affected by gusts of wind and other atmospheric effects. Granted, some have ricocheted off nearby plants (those which come in at an almost horizontal angle can be ignored from this instance), but the majority are affected by the weather. (b) Upon hitting the ground, the hailstones do one or two things – they either bounce, or depending on their size, mass or density, break up/chip off smaller pieces of ice. No matter which of these events happen, they all interact with the surrounding area; this can be seen in clip *hail02_bouncing.mpeg* and more so in *hail03_bouncing.mpeg* which is shot at a closer proximity. In these clips we can see the single bounce (caused by the existing dampening effect) which can be quite vigorous, with the rested hailstones being displaced when falling hailstones hits them. (c) The hailstone itself is quite similar to an impure ice cube due to the collation of the nitrogen and oxygen gases in the water (pure or distilled water does not create this effect). To illustrate this, take an ice cube out of the freezer and, after a quick rinse in warm water to remove any surface frosting, you will be able to see a clouded effect in the center of the cube, yet it will be clear around the edges. (d) The same effect applies to the hailstone which is illustrated in the *hail03.jpg* image on the DVD. Creating the melting procedure is beyond the scope of this tutorial (see the Taking it further section at the end of this tutorial for a way to create this effect), but suffice to say, depending on the temperature of the surface on which the hailstones come to rest, they will melt and collate as illustrated in the clips.

To simulate the falling of the hailstones, we just need a relatively basic particle system which is not too dissimilar from the previous rain tutorial's initial particle event. As with any particle work now, we are going to use Particle Flow to create the falling hailstones; we need them to react and travel across the surface slightly which, in this example, will be a basic plane (try adding extra objects for the hail to react to after you've finished the tutorial) as it will keep calculation times down. The reason we need calculation times to be low is because we are going to

need to calculate particle–particle collision detection (of sorts). To do this, we are going to use Particle Flow's Keep Apart operator with no falloff, so the particles do not avoid one another but simply bounce off each other thanks to a high acceleration limit. We will also use Particle Flow to choose which particles chip off part of the ice on impact – a small percentage will suffice as not every hailstone breaks when it hits a surface. These broken particles will be spawned and passed to an additional event where their properties, such as size and shape, will be amended slightly. The material assigned right across the board will be generated using a Raytrace material, as this material type allows us to generate internal fogging effects which we can use to simulate the internal clouding caused by gas bubbles in the ice.

Walkthrough

PART ONE: First we will create the initial scene and set up the Space Warps and basic Particle System that will affect the hailstones, making them fall in an irregular fashion.

1 Enable Grid Snap and create a Plane primitive with a Length and Width of 3000 in the Top Viewport and label it Ground. Set the Length and Width Segs to 1. Reposition it −10 units in the Left Viewport so that it is at co-ordinates 0,0,−10. In the Top Viewport again, create a Deflector Space Warp and label it Ground Bounce. Set its Length and Width to 3000 so it covers the Ground object and position it at co-ordinates 0,0,0, if it is not already, so it is hovering slightly above the Ground. Set the Bounce to 0.5, Variation and Chaos to 25 and Friction to 10.

Information: The ground is just a simple object that we need for our hailstones to come to rest on. This object has been dropped down a little because of the shape of the hailstone particles – the particle's collision with the deflector will be calculated based on its center – the surrounding geometry assigned to the particle is not considered in this instance, therefore if the deflector and plane were positioned in exactly the same place, the resulting particles at rest on the plane would be partially occluded (their bottom halves being below the plane).

2 In the Top Viewport, create a Gravity Space Warp and in the Left Viewport create a Wind Space Warp. Set its Strength to 0.5 and Turbulence to 8. Create a Particle Flow particle system in the Top Viewport with a Length and Width of 2000, set the Viewport Quantity Multiplier to 100 and label it Hailstones. Reposition it upwards in the Left Viewport about 2000 units and about 1150 units to the right in the Top Viewport.

Information: The Space Warps will affect our particles, initially with Gravity and Wind as they fall, causing them to hit the Deflector (ground) at varying angles. The particle system was repositioned to give the Wind Space Warp a chance to affect the particles adequately, while it was moved horizontally so that the 'blown' particles do not fall diagonally (due to the wind) and miss the deflector completely.

3 Open Particle View by clicking on the Particle View button in the particle system or by pressing 6. Rename Event01 to Hailstones Falling and set the Birth operator's Emit Start to −50, the Emit Stop to 200 and Amount to 2000. Remove the Shape, Speed and Rotation operators and add Shape Instance and Material Static operators.

Information: In this step we have simply removed elements that we do not require, such as speed – the Gravity Space Warp will provide us with all the speed that is required because the particles have the chance to gain momentum as they fall. The Shape Instance operator is to be used to reference geometry we will shortly create that will function as our hailstone, while the Material Static operator will be used to assign our hailstone material which, again, we will create later on. It should be noted that the amount of hailstones we are going to emit is highly exaggerated; you may wish to start the birth of the particles at an earlier frame so there are some already on the ground, and reduce the overall amount so that the scene renders faster and does not appear so 'busy'.

4 Add a Force operator and add the Gravity Space Warp to its Force Space Warps list. Add another Force operator and add the Wind Space Warp to its own Force Space Warps list. Add a Collision test to the event and add the Ground Bounce Deflector to its Deflectors list. In the Top Viewport, create a Geosphere and label it Hailstone01. Set the Radius to 10 and the Segments to 2. In the Shape Instance operator, click on the Particle Geometry Object section's None button and select the Geosphere we have just created. Set the Scale Variation to 20.

Information: We now have all the elements we have created for the scene present in the particle system – the Gravity brings the particles down to earth while the Wind affects them, adding some random motion and turbulence. When the particles collide with the deflector they will be passed onto the next event (at the moment they just bounce), which we will set up next. To view the particles with the new geometry, chance the Display operator's Type to Geometry.

PART TWO: With the basic system now set up, we will create an additional two events which will control particle dynamics and choose if the hailstone breaks off some of its ice on impact.

5 Drag out a Spawn test to the Particle Flow canvas to create a new event. Label the event Hailstone Collision and label the Spawn test Fragments. In this Spawn test, set the Spawnable to 40 and Offspring to 10 with a Variation of 100. Set the Inherited Speed to 10 with 30 Variation and a Divergence of 60. Set the Scale Variation to 50. Wire the Collision test in the other event to the input of the Hailstone Collision event.

Information: The Collision test checks to see if a particle has collided with any of the listed deflectors, and if so it passes the particle to the next event. The Fragments Spawn test picks 40% of the particles passed to it and generates a number of smaller particles with a reduced speed, therefore creating the chipped ice fragments.

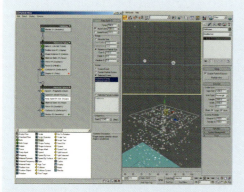

6 Add a Speed operator to the Hailstone Collision event. Set the Variation to 100 and Direction to Inherit Previous. Add a Keep Apart operator to the event. Set the Force to 500 and Accel Limit to 5000. Enable Relative to Particle Size and set the Core to 110 and Falloff to 0. Enable Selected Events and highlight the Hailstones Falling and Hailstone Collision events in the list by selecting one, holding down CTRL and selecting the other. Copy the Force (Gravity) and Material Static operators and the Collision test from the Hailstones Falling event and Paste Instanced them in this event.

Information: This step sets up and configures the interparticle dynamics. As we have already got a relative particle size, we can put in a slight boundary of about 10% so that when the particles come close they have a bit of a gap to play with and do not intersect one another. We have used a high Force and Accel Limit so that the particles react immediately to one another, and selected the two events so the particles in this event react to themselves and the falling hailstones only.

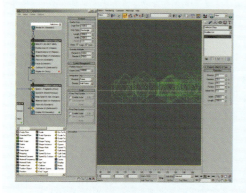

7 Copy the Force (Gravity) and Material Static operators as before and Paste Instanced them onto the canvas to create a new event. Label this new event Hailstone Chips. Add a Shape operator, set the Shape to Sphere and Size to 5. Add a Collision test to the event. In the Left Viewport, instance the existing Deflector and label the new one Deflector Chips. Move it down towards the Ground plane so it is about 5 units above the plane (corresponding to the Sphere particle shape operator's size setting) and add this Deflector to the new Collision Test in the Hailstone Chips event. Finally, wire this event to the output of the Spawn test in the Hailstone Collision event. Right-click the Hailstones event at the top of the particle system, select properties and enable Image Motion Blur.

Information: As our chipped particles only need to be small, we do not need as much detail as the larger hailstone particles, therefore a standard Shape operator can be used. A new Deflector is used so the spawned particles do not appear to float above the ground (in fact they are interacting with the first deflector) so, because of their reduced size, we need a Deflector that is positioned lower to the ground for them to interact with. Image Motion Blur has been added to the entire system by amending it in the root particle system event.

PART THREE: Now we have completed the particle system, we need to create an ice material and assign it to the system.

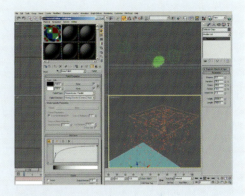

8 Open the Material Editor, create a new Raytrace material and label it Hailstone. Set the Diffuse color to black and the Transparency color to white. Set the Index of Refr to 1.309, Specular Level to 200 and Glossiness to 50. Enable the Bump and set the amount to 20. Add a Mask map to the Bump slot and label it Hailstone Bump Mask. Add a Falloff map in the Mask slot, label it Bump Falloff and set the Mix Curve as illustrated.

Information: To create an effective material for our hailstone we can use the Raytrace material type, as it has some special features that we can utilize that cannot be found in other materials. The Index of Refraction setting was amended to a value which represents the refractive properties of ice. The bump, which will be a speckled effect, is masked so that the interior of the ice can be seen more clearly in the center of the hailstone. The curve is amended to adjust the way the bump strength behaves around the center and edges.

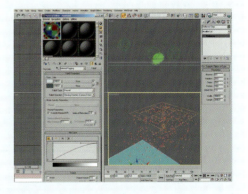

9 In the Hailstone Bump Mask Map slot, add a Speckle map and label it Hailstone Bump and set the Size to 10. Back at the top of the material, expand the Extended Parameters rollout and enable the Advanced Transparency Color and Fog options. Set both End settings to 10 and add a Fresnel Falloff map labeled Internal Fogging in the Fog's slot. Set the Front swatch's color to RGB 215,222,226 and the Side color to RGB 96,110,119. Enable Override Material IOR, enter a value of 2 and amend the Mix Curve as illustrated.

Information: The fogging is what we are using to generate the internal cloudiness of the ice, with the End settings limiting the intensity of the fog around the perimeter of the particle. The Falloff map is used to tint the material to the color of the environment, which we will set up later on. The IOR override is purely to get the Fresnel effect to falloff the way we want it to.

10 At the top of the material, ensure that the Reflect feature in the Raytrace Basic Parameters rollout has a color swatch next to it (click the tick box if it hasn't), and add a Falloff map to its slot. Label this map Hailstone Reflection Falloff and set the side slot to RGB 100,100,100. Open Particle View and select one of the Material Static operators. Drag the material from the Material Editor to the slot in this operator and select Instance when prompted.

Information: We do not want the reflection to completely cover the ice material else it may occlude some of the internal features we have set up, plus the reflection (of most materials) is more prominent on the perpendicular. As the Material Static operators are all instanced, updating one will update the rest of them.

PART FOUR: With the hailstones completed, we need to add some elements to the scene so their reflections have something to reflect.

11 Label a new material Sky and set its Self Illumination to 100. Add a Bitmap map to the Diffuse slot and load in the *sky.jpg* map which can be found in the Skies folder in 3ds Max's own Maps folder. Set the Output Amount to 0.75 and RGB Level to 0.5. Create a Geosphere in the Top Viewport with a Radius of 4000 and Hemisphere enabled. Label it Sky. Assign the Sky material to it and add a Normal and a UVW Map modifier. In the Left Viewport, move it down slightly so its base is below the Plane and scale it down vertically to flatten it out somewhat. Right-click the Sky object, select Properties and turn off Cast and Receive Shadows.

Information: We need an object or map so that the hailstones can display a reflection of their environment. The intensity of the sky's Bitmap has been reduced to make the sky appear duller and more overcast. The Geosphere was moved down slightly so the base of its Hemisphere was not fighting the Ground as to which polygons were going to be on top.

12 Load in the Concrete_Cement material which can be found in the Standard 3ds Max materials library that ships with the product. Expand the Maps rollout and in the map in the Bitmap slot, set the U and V tiling to 3. Assign this material to the Ground plane in the scene.

Information: As we need something for the hailstones to come to rest on, a concrete surface will suffice for this example. The map tiling has been increased due to the size of the plane, else the map would be stretched out too much.

13 Create a Direct Light and position it as illustrated. Turn on Shadows and Overshoot and set the Falloff/Field so that it encompasses the Plane as shown. Set the Shadow Density to 0.5 and Shadow Map Bias to 0.01. Add a Skylight light and set the Sky Color swatch to RGB 162,177,187. Right-click the Play Animation button and increase the Animation Length to 200 frames. Render off the scene.

Information: The light's Falloff/Field needs to be increased as shadows are only cast within this field. The Bias has been reduced so that the shadows are neatly tucked underneath the objects that cast them and are not detached, and the density reduced so that the shadows do not appear totally black. The Skylight has been used to globally illuminate the scene, however this works differently to the version of the Skylight in 3ds Max 5 – from version 6 onwards it works whether you have Light Tracer enabled or not; the only difference being is that we do not need Light Tracer enabled for this light to work. If you find that the scene takes too long to render, reduce the Maximum Depth in the Ray Depth Control section of the Raytracer Settings panel.

Taking it further

The resulting render gives a pretty realistic rendition of falling and dynamically reacting hailstones; however, it must be said that our scene is slightly different from the reference material because we have not concentrated on the hailstones melting after they come into contact with the ground or other surface. If we are to truly emulate the effect as accurately as possible this must be considered, unless it is clearly assumed that the hailstones are falling on a day when it is exceptionally cold (in which case, an amended smoke map to simulate frost or ice patches could be assigned to the concrete surface to give the impression of a frozen ground surface so the non-melting hailstones don't look out of place).

To create the melting ice, try adding a Melt modifier to the source geometry and animate the melt over time. As the original Shape Instance operator does not have Animated Shape enabled, the animation will be ignored. However, if you clone the operator, enable Animated Shape and place it in an event that the particle passes to (after it has been checked to see that it is at rest) then the animated melt will fire off from this point. You may also want to set up a Blend material for this event, assigned to a Material Dynamic operator with the Blend transition controlled using a Particle Age map, so it changes from the Hailstone material to water as it melts. It sounds complex, but if the system is thought out logically, and as with all aspects of CG built up gradually piece by piece, it is not a difficult task.

Also, referring back to the reference material, hailstones come in a variety of shapes and are not always perfectly spherical. Therefore, create a number of hailstone shapes using different Noise Modifiers and link them all to the main hailstone object. You can then use the Separate Particles For: Object and Children in the Shape Instance operator which will randomly select the parent or one of the child hailstones as a particle's geometry. Because of this shape you will also want to add spinning, which will stop spinning when the particle hits the ground for the second time else the hailstones will not look right when the animation is played back.

You may also find that, in places where the chips fall off the parent particles, a darker shadow is cast. This is due to Shadow maps being used. If you feel you have the CPU power, try changing the shadow type to Raytraced, and hope it doesn't take all year to render! Again, as mentioned in the first few steps, this scene is highly exaggerating the effect due to the amount of particles, so you may wish to reduce the amount and/or have some already situated on the ground.

If you have a later version of 3ds Max (7 onwards), you might want to try using the Mental Ray renderer for the reflections and sub surface scattering to create the cloudy effect and distribution of light through the material.

17 Snowflakes

Introduction

For anyone who can recall their schooldays, when you used to get snow every winter, flying down hills at the speed of sound on a polythene bag the thickness of an atom and a lovely old sledge your Grandpa made for you (the only Christmas it DIDN'T snow), this tutorial might bring back some memories. Unless you live in Alaska, in which case, sorry, more snow for you to look at! The one thing you used to look forward to as you gazed out of your window was the initial onset of falling snow – the way it falls and reacts with the air, and the way it adheres to the cold ground, gradually building up. In this tutorial we are going to attempt to recreate this with a gentle fall of snow onto a cold surface, controlling the way it falls to the way it reacts with any given surface that exists in the scene. Using a pre-rendered background (from another tutorial in this book) we can overlay our snowflakes onto this image so it appears as if it is snowing directly onto the surface.

Analysis of effect

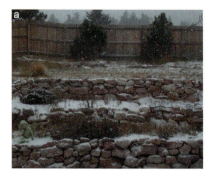

Image courtesy of Chuck Wardin

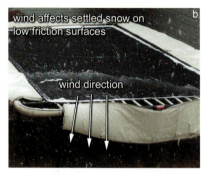

wind affects settled snow on
low friction surfaces

wind direction

Image courtesy of Chuck Wardin

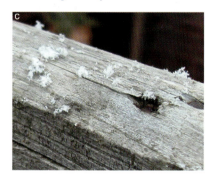

(a) Open up the *Water/17_Snowflakes/Reference/Movies/snowflake01. mpeg* included on the DVD. The first thing we notice is that the snow does not always fall in a linear fashion. Because of small, localized gusts of wind, turbulent motion can be confined to areas no more than a few meters wide. However, larger turbulence can affect all (or the majority) of the falling snow in the scene. (b) This, again, is not totally consistent throughout the duration of the event – the *snowflake05.mpeg* movie illustrates this quite clearly with the fallen snow that has settled on a large flat surface with little friction (a trampoline). Due to its wind resistance and size, the settled snow is caught in the wind again, and clearly illustrates the motion and size of the gusts that are affecting the environment. This wind strength, again, is intermittent and can suddenly die down to virtually nothing, with the snow simply falling, although is still affected by a slight breeze. This is pretty much the desired effect that we want to illustrate, but we need to know how the snowflakes are built up. (c) In the *snowflake02.jpg* image, where the snow has just started to fall, we can clearly make out the shape of the snowflake. However, if we view some adjacent foliage a few minutes later (d) in the *snowflake06.jpg* image, the individual shapes of the flakes have been lost as they have all intermingled and formed one large mass. This mass creation process is essential to get right if our scene is going to look convincing. Depending on the friction of the surface, the snow will adhere to it and build up no matter what the surface angle is, forming drifts around corners and collating on textured walls.

To simulate the falling snow, we are first going to design and construct the snowflake. This may sound like a bit of overkill, but to get the shape right means this is pretty much unavoidable. Because of this, it is really going to crank up the render times and, unless you have got a lot of memory in your computer, might even cause problems when you render the animation out (see the Taking it further section for more information). The snowflake can be constructed using a basic Scatter compound object which will distribute deformed cubes in and around another object to create the fluffy snowflake effect we need.

This object will then be used in a particle system to distribute it over the scene, which, in turn, will use Wind and (slight) Gravity Space Warps so the effect behaves as if the snow is gently falling, but there is still some wind blowing the snow around a little. The snow will come to rest on the ground, which is a pre-rendered background taken from an amended version of the Dirt tutorial further on in this book. This pre-rendered image is dropped in as a background, as the ground plane which produced the original background (using mixed

materials and Mental Ray displacement) has a Matte/Shadow material assigned so that it is visible to the renderer, but still occludes the snow partially when it hits the ground. This is also used as a deflector for the particle system. The snowflake material itself is a simple setup and utilizes the Translucent shader to create a back-illuminated effect, to give the impression that light has passed through the snowflake because of its properties. It also has a relatively strong bump to break up any harsh edges that may occur at render time. Finally, a substantial amount of motion blur is used to simulate shutter speed.

Walkthrough

PART ONE: First we will load in the initial scene and set up the Space Warps and basic Particle System that will affect the snowflakes.

1 Open up the *Water/17_Snowflake/Source/ 17_ snowflake_start.max* file included on the DVD. In the Top Viewport, create a UDeflector Space Warp and a Gravity Space Warp. Select the UDeflector, click on the Object-Based Deflector's Pick Object button and choose the Ground Plane object in the scene as the Deflector's Item. Create a Wind Space Warp in the Left Viewport. In the Front Viewport rotate it by 20 degrees so it is pointing down slightly. Set the Strength to 0.05 and Turbulence to 1.

Information: The initial scene is an amended version of the finished scene from the Dirt tutorial further on in the book. This scene was amended (long grasses removed and lighting changed a little) and rendered out as a static image. The resulting Ground Plane object is situated in exactly the right place and has the right deformation to fit the background plate, which we will load in next. The Gravity will pull the snowflakes down to the ground, which is determined by the UDeflector, while the Wind adds a slightly turbulent motion to them so they are not just traveling in a linear fashion.

2 In the Environment window, click on the Environment Map: None button and select a Bitmap map. In the resulting file dialog window that pops up, load in the *Water/17_Snowflake/Source/ snow_background.jpg* image file from the DVD. Open up the Material Editor and add a Matte/Shadow material to the first available slot. Label this material Mask and assign it to the Ground Plane in the scene. Perform a quick test render to ensure the entire background can be seen as illustrated.

Information: The background is quite suited to our scene and was refined and rendered using Mental Ray. The Matte/Shadow material was used so the plane is not 'seen' by the renderer, but will occlude any other elements in the scene (Matte) should any objects mass beneath or behind it, and will also render any shadows cast upon it (Shadow). This makes it ideal for compositing work, which is what we, in essence, will be doing.

PART TWO: With the elements in place for our particle system, we shall create the basic particle system and assign the items we have just created to it.

3 In the Top Viewport, create a Particle Flow system with a Length of 800 and a Width of 1000 and label it Falling Snow. Set the Viewport Quantity Multiplier to 100 and the Particle Amount Upper Limit in the System Management rollout to 10000000. Reposition the particle system so that it is at co-ordinates 300,25,300 – above the Ground Plane and offset somewhat.

Information: This is the basic system which will generate the Snowflakes. The system has been offset because of the strength of the Wind Space Warp we introduced to blow the particles across the scene. The Viewport multiplier has been increased so we can see all of the particles in action. If your machine slows right down after this, reduce the multiplier back to 50, or even less if desired. This will have no effect on rendering as it is only the Viewport setting we are amending. The Particle limit has been set at its maximum setting so we can increase the amount of particles right up if desired (pending memory) and not worry about the limit clipping the amount of particles.

4 Select the Falling Snow particle system if it is not already selected and click on the Particle View button or use the shortcut key 6. Rename the Event 01 event Snowflakes. Remove the Speed and Shape operators and add Shape Instance, Material Static and two Force operators. Add a Collision test to the bottom of the event. In the Birth operator, set the Emit Start to –50, Emit Stop to 200 and Amount to 10000.

Information: We have removed operators from the Snowflakes event as we do not need them in this scene – there is no need for an initial particle speed as

this will be handled by the Force operators. As we are going to create a geometry-based particle the Shape Instance operator is introduced, we need a material assigned to the particles hence the Material Static operator, and finally we need the particles to interact with a surface which is why the Collision test was added.

5 Select the first Force operator and add the Gravity Space Warp to the Force Space Warps list in this operator. Reduce the Influence setting by amending it to 50 so the effect is very, very slight. Select the second Force operator and add the Wind Space Warp to the Force Space Warps list in this operator. Select the Collision test and add the UDeflector01 to the Deflectors list in this test. In the Test True If Particle group, change the Collides Speed to Stop.

Information: We have used two separate Force operators because we need two different influence values. For separate Space Warp types like these, even though you can have more than one Space Warp in a list, it can be preferable to have more than one Force operator to introduce these Space Warps into a particle event. This is because an individual force can then be copied and instanced into another event without having to include the other force. The Collision test's Speed was set to Stop to get them to stop moving, however they will still be affected by the Space Warps in the current event. Therefore …

6 Select the Material Static operator in the Snowflakes event and Paste Instanced it onto the canvas to create a new event. Label this event Snowflakes at Rest and wire this new event to the output of the Collision test in the Snowflakes event.

Information: As we have already told the particle system to stop the particle's motion when the particle collides with the UDeflector, we do not need any additional operators in the new event, just an instance of the Material Static operator because the material is not passed from one event to the next unless they affect the entire system. Scrubbing through the time bar will illustrate that the particles simply fall from the sky with an irregular motion and stick to the ground once they hit it.

PART THREE: Next we need to create the actual snowflake. This is just going to be simple geometry as there are going to be a lot of them in the scene.

7 In the Top Viewport, create a Box primitive with Length Width and Height set to 5 and label it Snowflake. In the Same Viewport, create a Geosphere and label it Snowflake Position Generator. Set the Radius and number of Segments to 2. Add a Noise modifier to its modifier stack. Set the Scale to 1, enable Fractal and set the X, Y and Z Strength to 50.

Information: Observing some of the reference images, especially the macro shots of the snow settled on leaves, we notice that the individual snowflake formation appears to be comprised of numerous cubes, which is how we shall generate our own snowflake, with the Snowflake Position Generator Geosphere as the distribution method.

8 Select the Snowflake box object and create a Scatter Compound Object. Click on the Scatter's Pick Distribution Object and choose the Snowflake Position Generator. Set the number of Duplicates to 50 and Vertex Chaos to 2. In the Display rollout, enable Hide Distribution Object. Go to the Hierarchy tab and select Affect Pivot Only. Click on the Center to Object to position the pivot point and turn off Affect Pivot Only. Hide the Snowflake Position Generator.

Information: By default, the Scatter Compound object automatically includes a copy of the distribution object in with the distributed objects. Enabling Hide Distribution Object removes this copy as it is not required. The pivot required relocating as it was not in the center of the object – it used its original pivot point which was the center of the original box object.

9 Re-open Particle View and select the Shape Instance operator. In the Particle Geometry Object section, click on the None button and select the Snowflake Scatter Compound Object. Set the Scale % setting to 20 with 50 Variation. Hide the Snowflake Scatter Compound Object as it is no longer required.

Information: As the original particle source geometry is too big, we can reduce its initial size by using the Scale setting within the Shape Instance operator, plus add some variation. To check to see if this has worked properly, change the Display operator to show Geometry. A word of warning though – due to the high amount of geometry that will be calculated, you may want to save your scene just in case your machine runs out of memory at this stage. If so, view the particles as bounding boxes and/or reduce the number of particles born.

PART FOUR: With the particle system finished, we need to create the correct material to assign to the particle system to give the snow its white translucent effect.

10 Open the Materials Editor and label a blank material Snowflake. Change the Shader to a Translucent Shader and set the Diffuse Color to white. Expand the Maps rollout, add a Falloff map to the Opacity Slot and label it Snowflake Opacity Falloff. At the top of the material, set the Bump amount to 100, add a Speckle map to the Bump slot and label it Snowflake Bump. Set the Size to 20. Back at the top of the material, add a Falloff map to the Translucent Color slot and label it Shadow Illumination. Swap the colors, set the Falloff Type to Shadow/Light, Shaded color to RGB 188,188,190 and amend the Mix Curve to that shown.

Information: A pretty big step, but all relatively self-explanatory. We are using a Translucency shader so that any light that passes 'through' the snowflake will appear on the opposite side. As we do not want the translucent color to be too uniform we have used a Falloff map to amend it slightly, and also changed its Mix Curve to make the slightly tinted color more prominent where there are dark areas. The opacity falloff is simply to create a softer edge to the snowflake, and the Speckle map in the Bump slot adds some randomness and breaks up the shape of the Snowflake particle shape somewhat.

11 Open up Particle Flow if it isn't open already and select one of the Material Static operators. Drag the Snowflake material from the Material Editor to the empty slot in the Material Static operator and select Instance when prompted.

Information: As we have an instance of the same operator, whatever is performed on one operator will be performed on the other. We have chosen instancing from the Material Editor to the Material Static operator so, if necessary, we can tweak the material settings and it will automatically update in the Material Static operator, and therefore update the particle system.

PART FIVE: Just to add finishing touches to the scene, we will add basic lighting so that the translucency effect works with the Snowflake material correctly.

12 Hide the Material Editor and Particle View. In the Top Viewport, create a Skylight standard light and set the Sky Color's swatch to RGB 162,177,187. Still in the Top Viewport, create a Direct Light and label it Sun. Set the Multiplier Color to RGB 255,243,232, increase the Falloff Field to cover the scene and enable Overshoot. Reposition the light in the Top Viewport as shown and move it up about 700 units in the Left Viewport.

Information: As we do not require any shadows in the scene at the present time, they have not been enabled. Using shadows with the high amount of geometry generated with the particle system we have developed will consume a lot of memory, which may even make the program unstable as the memory may run out during render pre-calculations. Should you wish to include shadow casting objects in the scene at a later date, enable shadows but ensure that the particle system does not cast them – only receives them.

13 Open Particle View. Right-click the root of the Falling Snow particle system and select Properties. In the resulting panel, enable Image Motion Blur. Click OK to exit the panel and render off the entire animation.

Information: Adding a touch of motion blur will add a little extra realism to the scene, especially as we will get the occasional particle flying past the camera which, if motion blur is not enabled, will just appear as a large snowflake flicking on and off, which would look quite weird.

PART SIX: Should your machine run out of memory, there is a way to help reduce the amount of particles that 3ds Max has to calculate, and therefore reduce the polygon count without affecting the amount of snowflakes visible in the final render.

14 In the Top Viewport, create a Box that encompasses the Ground plane and just above the Particle Flow icon and label it Particle Killer. Add a Normal modifier to the stack and edit its Properties so that it is not renderable. Add a UDeflector to the scene and add the Particle Killer box to it. Open Particle View and add a Collision test beneath the existing Collision test in the Snowflakes event. Add the UDeflector to its Deflectors list. Drag out a Delete operator to the canvas to create a new event and wire this new event to the second Collision test. Label the new event Deletion. Re-render the scene.

Information: Particles outside the camera frame are not important to the render but they are still calculated at render time, therefore the geometry count can increase dramatically even though they cannot be seen, which can make the program unstable. Deleting these unwanted particles is one surefire way of reducing the geometry without having to reduce the overall amount – in fact, you may even be able to increase the initial birth rate somewhat. Ensure that the Particle Killer box does not accidentally delete particles that will land on the surface by doing a preview and a few test renders first.

Taking it further

The resulting scene gives quite a convincing effect mainly due to the actual modeled snowflake. However, further on into the animation we can see render times per frame increasing dramatically, again due to the modeled snowflake. This can result in millions of polygons which, if shadows are enabled, can

just about kill your machine, hence the lack of shadows. In this tutorial, as with the Hailstone tutorial, this effect is highly exaggerated due to the amount of particles in the scene. Try setting the Emit Start setting to a negative value, so that there are particles on the ground as soon as we join the scene. Additionally, to reduce the exaggerated feel to the scene, try reducing the overall amount of particles.

If you have a machine that is slower than most and/or do not have a great deal of memory, then instead of using modeled snow, try using facing particles. Simply replace the Shape Instance operator in the particle system with a Shape Facing operator, get it to point at the camera, and use a pre-rendered version of the modeled snowflake (render it off in the Front or Left Viewports) with corresponding opacity as the material. This will generate falling 'billboard' particles which will seriously reduce render times without the loss in quality. The only problem is the uniformity of the snowflake – every one will be the same. To get around this, try rendering off the original snowflake from different angles so we have a collection of maps – say about 10 – set up several face mapped snowflake materials within a single Multi/Sub-Object material, and use this in a Material Frequency operator to choose a different material at random.

If you have got a pretty powerful system with a fair amount of memory, try upping the particle count to something completely ludicrous and see if you can completely cover the terrain with snow. Due to the way the particle's geometry is created, all the little snowflakes will 'merge' together and form clumps with no visible edges so, if the particle amount is high enough, it is safe to say that an entire blanket of snow can be created. If you are totally sadistic, or have a system which mere mortals would only dream of, try adding snow over the result of the Grass and Dirt or Grasses tutorials. You will have to use Mesher on the grass particle system(s) to get a UDeflector to use them as a Deflector, but setting up the scene should be relatively easy. The render times on the other hand, may be a little bit more challenging. Give it a go and see how you get on.

Depending on the temperature of the ground, we might also see some slight melting of the occasional snowflake. To simulate this, try sending the occasional one, or percentage of the total number of snowflakes, to an event which will handle the melting procedure after the snowflake has come to rest on the ground. A simple change in geometry or animated Melt modifier on the original source geometry (see the Taking it further section of the Hailstone tutorial for a further explanation on this procedure) would produce effective results. You could even get the particle geometry in the melting event to convert to meta particles using Blobmesh and assign a nice water material to the object.

Try adding some extra objects in the scene, such as a fallen log or a few extra rocks and see if you can get the snow to adhere to the surfaces of these objects. Using a clone of the existing UDeflector, you can choose which object you want the particles to adhere to, and then simply add this new UDeflector to the Collision event. Easy! The resulting collation of snow does not form snowdrifts, but if you want to give this a go, try using a Keep Apart operator so that when the particles touch each other, they do not move. Again, this may take a while to calculate but the result can be very effective.

The snowflake does not necessarily come to a complete rest when hitting the surface (see the reference material (mpegs)), so try to get them to break up a little on impact; see the Hailstones tutorial for an example of this as you could easily amend it for this particle system.

As larger particles would be heavier, the Gravity Space Warp should really affect them more than smaller ones. Therefore it would be advisable to have a look at the 3ds Max 7+ MAXScript Online Reference for an example of how to affect Force operator influences based on particle scale parameters. This script is still applicable to 3ds Max 6 users, though is not available in the online help, but can be found in Borislav "Bobo" Petrov's Force Influence By Mass tutorial at *http://www.scriptspot.com/ bobo/mxs5/pflow/pflow_force_by_mass.htm* . In addition to this, the script could also affect Wind strength as smaller (lighter) snowflakes would be more affected by the wind!

18 Lava lamp

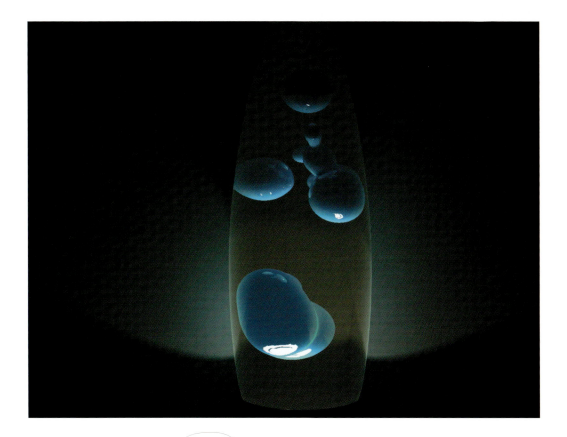

Introduction

Believe it or not, these things are actually quite a challenge to recreate. Okay, we could animate the motion of the fluid within the lamp manually, but where would the fun be in that? In this tutorial we are going to design and construct a complex particle system that will drive the motion of the liquid within the lamp, forcing it to dwell at certain areas to avoid one set of particles and be attracted to another, depending on the positioning of the particle. We will then generate the liquid effect using a trusty Blobmesh object to control the attraction and blending of the fluid, before illuminating the scene and assigning relevant materials to the objects to simulate the molten substance, clear liquid and any other elements.

Analysis of effect

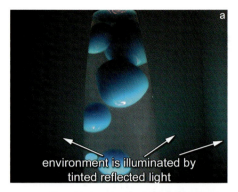

environment is illuminated by tinted reflected light

blobs move around one another when rising and falling within the liquid

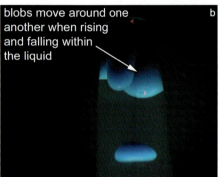

highlight is of the reflection of the bulb reflecting off of the shiny surface on the interior of the lamp's stand

suspended particles in liquid

(a) We are assuming that the lava lamp has been heated up already, else we may be in for a bit of a wait! To produce the right effect, a lava lamp must contain two insoluble substances – normally paraffin and a water/polyethylene mixture (hence the slight color tint to the solution seen in the reference material). As the paraffin and water mixture are similar in density, no motion would occur and the paraffin would just sit at the bottom. (b) Heat it up, and the density is reduced, so it therefore rises. Once it gets to the top of the bottle it begins to cool and travels back down before being heated up again somewhat and merging with the rest of the compound at the bottom of the lamp. There are two main places in which the motion slows down or stops – at the top or at the bottom of the lamp; at both locations the paraffin blob (technical term!) can merge with other blobs. When traveling up and down the lamp the individual blobs tend to avoid and move around one another. The material is quite basic – a simple shade with high reflectivity (mainly on the perpendicular) with some light passing through to the other side (translucency), which is also transmitted to the surrounding environment. (c) The highlight on the bottom of the rising paraffin does not have a single highlight in the middle, but a ring where the bulb, which is illuminating and heating the paraffin, is being reflected off the shiny surface of the interior of the stand that the lamp is sitting on. (d) The liquid in which the molten substance is situated is tinted slightly, and is colored more towards the center of the mass than on the perpendicular. It also contains small particles which are either debris or small molten particles of the rising and falling substance, but introducing these is beyond the initial scope of this tutorial (see the Taking it further section).

In 3ds Max, the trickiest problem we have got is getting the timing right for this effect, therefore we will need to split up a particle system into several key events that a particle can be passed to after a certain amount of time. Firstly, the particles need to be born; this is best done in several batches before frame 0 so that there is already some motion when we join the animation. To control the motion of the particles we can use a combination of Wind and Gravity Space Warps; Wind to get the particles to rise and Gravity to get them to fall back down. However, we need to get them to slow down when they get to the top and bottom of the lamp, so we can use a couple of Drag Space Warps to slow them down. Once they have been reduced to a certain speed, we can let the particles dwell for a short time

before passing them on to the next event so they start traveling again, and so on with the entire system looping over and over. As the particles need to be contained within a vessel, we will use a smaller version of the vessel to prevent any geometry passing through its sides. The particles will be blended together using a Blobmesh object, which will enable the geometry to merge together when they come into close contact. Finally, we will assign lighting and materials to our objects and even use a bit of GI to illuminate the surrounding areas.

Walkthrough

PART ONE: Firstly, we will load in and set up the Space Warps which will control the particles within our scene.

1 Open up the *Water/18_Lava_Lamp/Source/18_lava_lamp_start.max* on the DVD-ROM. Right-click the Play Animation button and set the Animation Length to 1000 frames. In the Top Viewport, create a UDeflector Space Warp and set its Bounce to 0. Click on the Space Warp's Pick Object button and select the LL Deflector object in the scene.

Information: We have extended the animation length so we can see the action of the elements that we are going to create for longer – as simple as that. As the animation we are going to create is going to be automatic, we can see if the 'action' is going to be further on past frame 100, hence extending it. The UDeflector has been created to confine the particles within the boundaries of the lamp so no geometry peeks through the sides. As the particle system takes collision detection from the center of the particle, we have to reduce the size of the deflector geometry else the particle geometry will poke through the sides of the lamp.

2 In the Top Viewport, create a Wind and a Gravity Space Warp in the center of the lamp at co-ordinates 0,0,0. Still in the Top Viewport, create a Drag Space Warp in the center of the lamp. In the Front Viewport, reposition the Space Warp so that it is positioned at the top of the LL Deflector object, as illustrated. Set the Time Off to 1000 and turn off Unlimited Range. Set the Linear Damping's X Axis, Y Axis and Z Axis settings to 50, each one's Range to 5 and Falloff to 200. Instance the Drag Space Warp and position it in the Front Viewport at the bottom of the LL Deflector object as illustrated.

Information: The Drag Space Warps have been added to the scene to get the particles to slow down when traveling through 'the liquid'; to form a kind of resistance to the motion and also to suggest that the particle has cooled or warmed up, so is starting to slow down. The Wind Space Warp will be used to send the particles up the lamp to suggest that they have changed densities, while the Gravity will be used to pull them back down again after a time. As with all aspects of the Particle Flow system, these Space Warps will only affect a particle when we tell them to.

PART TWO: Next we will construct the particle system which will generate the motion of the Lava Lamp's 'Blobs'.

3 Create a Particle Flow system in the Top Viewport and position it at co-ordinates 0,0,0 so that it is towards the base of the lamp and inside the LL Deflector. Set the Icon Type to Circle with a Diameter of 50. Set the Viewport Quantity Multiplier to 100 and label it Blobs. Set the Viewport Integration Step to Half Frame to match the Render Integration Step setting.

Information: We need the particle system icon to be situated within the LL Deflector mesh, else the particles will be born outside this area, and therefore will not be affected by the UDeflector. The Viewport Quantity Multiplier has been upped to 100 so we can see all of the particles working in the Viewport (as there aren't going to be many). The Viewport Integration Step was set so that the particle positioning in the Viewport is what we are going to get when rendered. As there is only going to be a small amount of particles, the extra update time caused by this change will be negligible.

4 Click on the Particle View button or press 6 to open Particle View. Turn off the Render operator in the Blobs event. Delete the Event 01 event and drag out a new Birth operator to the canvas to create a new event. Label this event Birth01 Set Emit Start and Emit Stop to −256 and the Amount to 3. Add a Send Out test to the event. Create three copies of the event and wire their inputs to the output of the Blobs event. Set their Birth operator's Emit Start and Stop settings to −200, −100 and −50 accordingly.

Information: Here we have set up a series of events which simply generate three particles at given times. This is simply to offset the positioning of the particles within the lamp, so when we view the animation from frame 0 they are already distributed within it.

5 Drag out a Position Icon operator to the canvas to create a new event and label it Initial Parameters. Add a Shape operator and set the Size to 45. Add a Scale operator and set the Scale Variation for all axes to 100. Add a Collision test and add the UDeflector to its Deflectors list. Add an Age test and set the Variation to 0. Copy the entire event and Paste Instanced it. Make the Shape and Scale operators unique. Set the new event's Shape Size to 20 and the new Scale operator's Variation to 20 for all axes. Wire this new event's input to the output of the Birth 04 event, and the input of the Initial Parameters event (the original one) to the output of all the other Birth events.

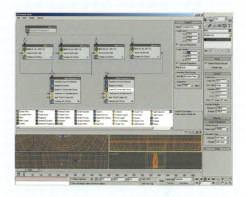

Information: Here we have set up two sets of parameters for our particles, so that the majority of the particles are large, but the last ones that are born (at frame −50) are a lot smaller than the others. Using instancing allows us to share settings across events that are common and is a good way to keep control of the system, else we may have to amend settings all over the place if we need to make any slight changes.

6 Drag out a Keep Apart operator to the canvas and label the resulting new event Rise. Rename the Keep Apart operator Repulsion. Set the Force to 50, enable Relative to Particle Size, set the Core to 100, Falloff to 10 and enable Current Particle System in the Scope section. Add a Force operator, add the Wind Space Warp to its Force Space Warps list and set the Influence to 200. Copy one of the Collision tests from one of the Initial Parameters events and Paste Instanced it into the Rise event. Add an Age test to the event, change the Particle Age menu setting to Event Age, set the Test Value to 10 and the Variation to 0. Wire the outputs of the Age tests in both Initial Parameters events to the input of this event.

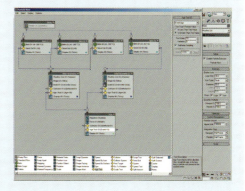

Information: Quite a large step. Here we have set up the parameters for the particles when they rise up the lamp. The Keep Apart operator forces them to avoid all other particles in this system so they move around one another. The Collision test is the same as the others and is to ensure that the particles remain inside the lamp. The Age test is set to Event Age as we simply want to release the particles from this event when they have been in there for enough time for them to be affected by the Wind.

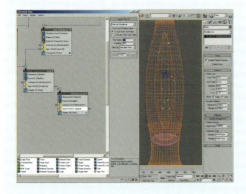

7 Copy the Repulsion Keep Apart operator and Paste Instanced it onto the canvas to create a new event. Label this new event Rise Slow Down. Add a Force operator and add the Drag01 Space Warp to its Force Space Warps list. Paste Instanced another copy of the Collision test into this event and add a Speed test to it. Enable Is Less Than Test Value, and set the Test Value to 1. Wire the input of this event to the Age test of the Rise event.

Information: Here we have passed the particles, once they have reached a certain age within the last event, to this event, in which they are slowed down thanks to the Drag Space Warp. Upon reaching a very low or almost stationary velocity, the particles will be passed to the next event (they will not be passed to the next event until they have slowed right down).

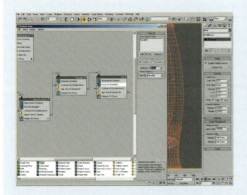

8 Select the Rise event, copy it and Paste Instance it onto the canvas to create a new event. Rename the new event Top Loiter. Make the Repulsion Keep Apart operator unique, rename it Attraction and set its Force setting to −50. Make the Age Test Unique and set its Test Value to 50. Remove the Force operator. Wire the input of this event to the Speed Test output of the Rise Slow Down event. Copy the Rise event, Paste Instanced it to create a new event and label it Fall. Remove the Force (Wind) operator, add a new Force operator and add the Gravity Space Warp to its Force Space Warps list and set the Influence to 100. Wire the input of this event to the Age Test output of the Top Loiter event.

Information: We have changed the Keep Apart operator in the Top Loiter event to a negative value so that the particles are attracted to one another. After catching their breath for a short while, they are passed to the next event and, using the Gravity Space Warp set to a low influence, gradually fall back down.

9 Copy the Rise Slow Down event and Paste Instanced it to create a new event. Label it Fall Slow Down. Make the Force operator in the Fall Slow Down event unique and replace the Drag01 Space Warp in its Force Space Warps list with the Drag02 Space Warp. Wire the input of this event to the output of the Fall event's Age test. Copy the Top Loiter event and Paste Instanced it. Rename this new event Bottom Loiter and wire its input to the Fall Slow Down event's Speed test output. Make the Bottom Loiter's Age test unique and set its Test Value to 100. Wire the output of this test to the input of the Rise event, to create a loop.

Information: These final couple of events in the particle system simply slow the particles back down again thanks to the other Drag Space Warp, and lets the particles sit there for quite a while (so they can get 'heated' back up again), before sending them back to the Rise event so they can begin their journey all over again. Playing through the animation you may notice that a particle or two may leak through the LL Deflector mesh. If this is the case, try amending the particle system's Integration Step to a lower setting. If this still does not work, try amending the Seed of one of the Position Icon operators and check through the animation until no particles leak through (I had to change it once to ensure none leaked).

PART THREE: With the particle system finished, we can now generate the final mesh.

10 In the Top Viewport, create a Blobmesh Compound Object. Set the Render Evaluation Coarseness to 6 and the Viewport Evaluation Coarseness to 10. Click on the Pick button and add the Blobs particle system to the Blob Objects list. In the Blobmesh's properties, turn off Receive Shadows.

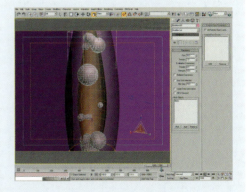

Information: A completely painless step. Okay, maybe not painless, as we now need to go right through the 1000 frames and ensure that none of the resulting Blobmesh geometry is peeking through the sides of the lamp. This is the reason we have the reduced LL Deflector size, but this still may not be small enough. Should you discover that at any point throughout the 1000 frames the Blobmesh is visible through the sides of the LL Bottle object, you will either have to amend the Position Icon operator's seed (again), reduce the size of the particles in the Shape operator, or decease the size of the LL Deflector object. I ended up reducing the Shape operator's particle size from 45 to 40. One good way to check for geometry passing through is to change the LL Bottle Mesh to See Through (in its Properties), then set the Viewport to Smooth + Highlights with Edged Faces enabled. Receive Shadows is turned off because of the material we are going to assign it (a Translucent Shader) not liking Shadow Maps.

PART FOUR: With all scene elements in place, all we have to do now is to set up the materials and the lighting in our scene.

11 In the Top Viewport, create an Omni light in the middle of the scene at co-ordinates 0,0,0 and in the Left Viewport move it down so that it is just above the Light Bulb object. Enable Shadow Maps and set the Multiplier to 0.3. Enable Use and Show Far Attenuation, set the Start to 50 and the End to 1000. Turn off Specular in the Advanced Effects rollout. In the Shadow Map Params, set the Bias to 0.001, Size to 128 and Sample Range to 30. Instance the light in the Top Viewport and move the copy upwards to the top edge of the Light Bulb object. Using the Light Bulb object as the rotation center, create another seven copies of the light around the edge of the Light Bulb.

Information: In the screenshot I have simply hidden the other objects to illustrate the positioning of the lights. What we should end up with is a ring of lights around the top of the Light Bulb object, all instanced so that they all share the same settings. They have a falloff because, if you view the reference material, the blobs at the bottom of the lamp are illuminated more than those at the top.

12 Hide the LL Deflector object as it is no longer needed. Open the Material Editor and label a new material Blobs. Set the shader to Translucent Shader and set the Diffuse Color to RGB 0,97,157. Set the Specular Level to 150 and Glossiness to 80. Set the Translucent Clr to RGB 0,23,38. Add a Falloff map to the Reflection slot and add a Raytrace map to the Falloff map's Side slot. Assign this material to the Blobmesh object in the scene.

Information: We are using a Translucent shader so we can simulate the passing of light through the blobs. Because the surface is quite shiny it is also slightly reflective. This reflection is controlled with a Falloff map so that it is stronger on the perpendicular. The colors were derived by point-sampling colors from the source material's images (plus a little tweaking).

13 Label a new material Light Bulb. Turn on Self Illumination and set the Diffuse color to white. Add a Noise map to the Self Illumination slot and set both color swatches to white. Expand the Output rollout and set the Output Amount to 1000. Assign this material to the Light Bulb object in the scene. Label a new material Lamp Casing. Set the Diffuse color to RGB 30,30,30, the Specular Level to 70 and Glossiness to 40. Set the Reflection level to 10, add a Falloff map to the Reflection slot and add a Raytrace map to the Falloff map's Side slot. Assign this material to the LL Base and LL Cap objects in the scene.

Information: Reflections of colors which have a maximum value of 255 (i.e. white) will appear dull in masked reflections like we have in our Blobs material. If we turn up the Output amount we greatly increase the value beyond 255 so that the white is not reduced in the reflection. We are simply using the Noise map to generate a solid color and to utilize its output setting.

14 Label a new Raytrace material Liquid and assign it to the LL Bottle object in the scene. Set the Diffuse and Transparency colors to RGB 207,207,196 and set the Index of Refr to 1.33. Set the Specular Level to 150 and the Glossiness to 80. Enable Color and Fog Density and set both End and Amount settings to 600 and 0.5 respectfully. Set the Fog color to RGB 207,207,196, add a Shadow/Light Falloff map to the Color Density map slot and set the Shaded slot to RGB 207,207,196. Add a Falloff map to the Reflect map slot and set the Side color to RGB 175,175,175.

Right-click the LL Bottle, select Properties and disable Cast Shadows. Go to the Adv. Lighting tab and turn on Exclude from Adv. Lighting Calculations.

Information: This material has two main properties – that it is reflective to simulate the glass casing of the lamp and that it also has the color and index of refraction of the liquid. This liquid is also tinted and fogged slightly (faded off by the use of a falloff map) to simulate density. As this is a transparent object and we are using shadow maps, we have turned off Cast Shadows or light will not pass through the object.

15 Label a new material Wall. Set its Diffuse color to RGB 223,209,186, its Specular Level to 10 and Glossiness to 20. Add a Splat map to the Bump slot. Set the Size to 10, Iterations to 3, Threshold to 0.1 and set the Color 2 swatch to white. Copy this Splat map into the Color 1 slot. Go into this new map, set the Iterations to 6, the Color 1 swatch to black and the Color 2 swatch to RGB 50,50,50. Assign this material to the Walls object in the scene.

Information: Here we have just set up a basic material to simulate a slightly textured wall. The combination of the two Splat maps breaks up the single splat map to make the texture more irregular.

16 Open the Render panel and go to the Advanced Lighting tab. Enable Light Tracer and set the Object Mult and Color Bleed to 2. Set the Bounces to 1 and render off the animation.

Information: Depending on the speed of your computer, you may want to miss out this step. Enabling bounced lighting in Light Tracer dramatically increases render times; from a few seconds to a few minutes per frame. If you feel that it is taking too long to render, but you still want bounced lighting, try reducing the Rays/Sample setting. You may also want to reduce the amount of Raytrace bounces in the Raytracer tab, as 9 is a little too high, even with the amount of Raytraced surfaces in this scene.

Taking it further

Okay, this animation does give quite a convincing motion, and the illumination and materials work very well, but the way the Blobmesh works is letting the side down a little. The main reason behind this is because it is assigned to the entire particle system. If we view the reference material, the blobs only blend together at the bottom of the lamp and (sometimes) at the top. When traveling, they move around one another and do not blend together like we have in our current animation. To rectify this, try using several Blobmesh objects to handle the individual stages – say, one for the merging at the base, one for the traveling upwards and so on. If you have labeled the events in the particle system correctly, you will not have

any problem in assigning the right events to the right Blobmesh object. As different Lava Lamps come in different colors, try changing the color of the blobs. You may also want to amend the entire material; you can get a variety of different types, from the traditional translucent material through to florescent and even ones which represent liquid metal or paint. Additionally, try changing the shape and style of the lamp itself; try creating a traditional 1960's rocket shape or convert something more modern, such as the 3ds Max teapot, into a Lava Lamp. You may also wish to add more detail to the liquid in the lamp by adding additional floating particles which are displaced by the rising and falling blobs. Additionally, try adding extra material to the liquid such as a glitter effect which you see in more modern lamps. With the amount of reflections in the scene, plus if global illumination is applied, this scene will take some time to render. Therefore, if you have access to 3ds Max 7 you might want to try converting the Lava Lamp materials to Mental Ray Glass and Blobs material to a sub surface scattering shader for a nicer result which may result in a faster rendering time, depending on the amount of samples you use.

19 Glacier

Introduction

In this tutorial we are going to be creating a procedural modeling system to create some large chunks of ice. In a normal production environment we would probably model chunks out by hand or laser scan foam models to generate the organic natural shape of the irregular terrain, however this procedural system works pretty nicely. To get the desired falloff and sub-surface illumination effects correct, we are going to be using Mental Ray to render off our scene, plus we can call on additional shaders to generate a decent water surface material and, in turn, a submergence shader to generate the effect of partially submerged ice. For the interim, we are only going to create one block of ice due to the lengthy set-up, however we can keep the (large!) modifier stack so we can go back later on and create additional ice blocks and broken fragments to create multiple ice plates at different levels. See the Taking It Further section for more information on this.

Analysis of effect

(a) For this tutorial, we are going to concentrate on "tabular" or blocks of ice that have a distinctive linear shape. This shape is due to weathering, erosion from the sea or rising temperatures, and generates a distinctive formation as if part of the object has been snapped away, forming vertical and branching lines running down the side of the block where is has fractured. This creates a contrasting pattern between the (aesthetically) smooth surface of the top surface of the ice and the linear hard-edged sides of the block which, due to its formation and interaction with the water, is tapered somewhat resulting in a larger surface at its top than at its base. (b) The top itself tends to be more jagged and detailed than that at the bottom due to weathering and erosion. The main mass of ice appears to sit at a uniform level above the surface of the water (although having some height variations), although due to its mass a substantial amount will be submerged. (c) The waters of the Arctic/Antarctic are clear, therefore we can see beneath the surface, noticing the sub-surface internal light scattering within the pure ice carried through into this medium which is tinted with a blue hue; the "strength" or distance of this scattering is determined by the size of the ice block, the ice's density and purity. (d) The water in the reference material is noticeably calm without any foam or substantial surface displacement around the floating ice which surrounds the larger tabular ice (see the Taking It Further section for more information). Overall, there is very little noticeable environment depth fogging due to the air being un-polluted, plus skies are relatively clear.

The ice geometry itself will be generated (mostly) procedurally by a Cellular map which creates the best cracked ice effects out of our full gamut of 3ds Max and Mental Ray shaders available. This will be controlled by a Gradient Ramp map to keep the ice mass to the center of the scene. This map (tree) will drive a sub-object selection on a high density plane primitive which will remove all other faces, refine further and face extrude to create the height. Next, through a series of additional sub-object selections controlled by additional Cellular maps and sub-object selection masking we will sculpt out our mass of ice, creating jagged edges and displaced surface terrain. With the sub surface scattering effects required to create the pure ice effect, we are going to use Mental Ray to render our scene. We will use color reference from the existing reference material supplied on the DVD-ROM so that our scene is as close to the reference material as possible. Because we are using Mental Ray to render off our scene, we can also utilize additional shaders for other elements. Our water surface, for

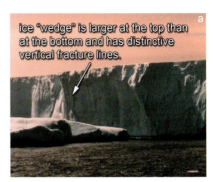

ice "wedge" is larger at the top than at the bottom and has distinctive vertical fracture lines.

Image courtesy NOAA

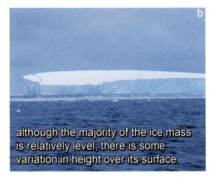

although the majority of the ice mass is relatively level, there is some variation in height over its surface.

Image courtesy NOAA

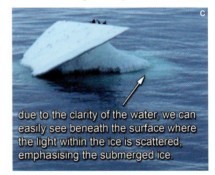

due to the clarity of the water, we can easily see beneath the surface where the light within the ice is scattered, emphasising the submerged ice.

Image courtesy NOAA

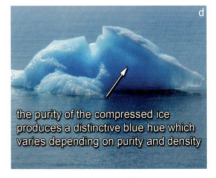

the purity of the compressed ice produces a distinctive blue hue which varies depending on purity and density

Image courtesy of NOAA

example, will be a standard Mental Ray shader (assigned to a simple Plane primitive), with additional sub-shaders controlling individual properties. For example, we will use a Glass shader as the main shader's Surface property which will be tinted and have its properties set (e.g. its Index of Refraction) for water. The surface texture will be handled with a Ocean shader as a bump map, with its properties set to generate wave sizes in relation to the size of the ice chunks, so we get a sense of scale in the scene. Finally, for this material, as the Arctic/Antarctic waters are clear, we will be able to see beneath the surface, therefore a Submerge shader will be used in the main Mental Ray shader's Volume property. Again, defining a sense of scale to the scene, the Submerge shader's properties will be set accordingly and tinted so that our semi-submerged ice geometry will appear correct. We will then add an environment map for the water to reflect, add subtle fogging and illuminate the scene with a simple Skylight and Direct light; as we are using Mental Ray and the geometry count is large, but not overly high, we can use Final Gathering which will also allow us to use Skylight lights with our SSS shader.

Walkthrough

PART ONE: First we will load in the initial scene, to establish scene scale, and set up our main selection to define the shape of our ice mass.

1 Open up the *Water/19_Glacier/Source/19_glacier_start.max* file included on the DVD-ROM and accept the unit change if prompted. Select the Plane01 object in the scene and rename it to Sea. Copy this object and rename it to Glacier_Large. Go to the Front Viewport and move this new object 50 m vertically down so that it is beneath the Sea object at co-ordinates 0,0,−50. Set this object's Length & Width Segs to 50.

Information: We are starting from an initial scene already provided to ensure that we are both working with the same unit setup. This is because we will be working with procedural materials using XYZ co-ordinates, so if our units and scaling are different we may end up with different results! The Glacier_Large object has been relocated beneath the Sea object so that when we extrude faces and displace our Glacier geometry, part of the object will be submerged beneath the surface. This will save time later on as relocating the object at this stage means we only have to move a basic primitive; once the object has numerous modifiers applied and has been refined then it becomes slower to reposition. Just thinking ahead and making life easier in the long run! We are using a copy of the Sea object (which is the extent of our scene) to create our floating ice mass which we will next control with additional modifiers and map selections so that the mass is confined to the center of the scene. The Length and Width Segs have been amended so that we can define a better selection outline with the modifiers we will add next.

2 In the Top Viewport, add a Volume Select modifier and rename the modifier to VolSel – Glacier_Large Outline. In this modifier's Parameters rollout, set the Stack Selection Level to Face. In the Selection Level group of this rollout, enable Invert and set the Selection Type to Crossing. In the Select By group, enable Texture Map.

Information: The main shape of our ice mass is going to be derived from a grayscale map (which we will design next). This map will be loaded into the Texture Map slot (hence having to enable it) which will drive the sub-object selection method chosen in the Stack Selection Level group. We have set this to face so that we get a nicer defined selection outline (plus it calculates faster!) and the Selection Type has been set to Crossing so that we get more of an (un-selected) central mass. We have inverted the selection so that we can delete the outer (selected) faces which will leave us with the central face selection. Of course we can't see anything yet as we haven't set up our selection map…

3 Open up the Material Editor and, in a clean material slot, create a Cellular map to replace the entire material. Label the map Glacier_Large Outline Selection. Set the Source mapping to Explicit Map Channel. Make the First Division Color swatch black. In the Cell Characteristics group in this map, set the Cell type to Chips, the Size to 0.3 and Spread to 0.4. Enable Fractal and set the Iterations to 20. Instance this map to the Texture map slot in the VolSel – Glacier_Large Outline modifier.

Information: We are using the default Planar mapping that the Plane primitive produces as we can immediately see in the Material Editor swatch (and also in the Viewport) what our map changes do to our selection, making it easier to control. As we only need a simple black and white texture to define our selection, we didn't need the middle grey, therefore we removed it by changing its color to black. The Cell Type was amended to Chips as this gives the best representation of fragmented ice available to us, and the Size and Spread settings amended to generate a nice combination of ice fracture size (Size) and gaps between the ice (Spread). Fractal was enabled to break up any straight edges and to also close the gaps between the ice making it more realistic. Even at this early stage we can see our selection creates a nice fragmented pattern akin to those in the reference material, however our ice runs right to the edge of the scene…

4 Add a Gradient Ramp map to the Cell slot of the Glacier_Large Outline Selection map and label it Glacier_Large Outline Mask. Set its Gradient Type to Box and design the gradient as illustrated with white colored flags at positions 0 and 45 and black flags at positions 55 and 100. In the Noise group (not the Noise rollout), set the Amount to 0.5, Type to Fractal and set the Size to 3.

Information: The addition of the Gradient Ramp map limits the amount of White in the (parent) Cellular map to a square-shaped region around the center of the map. Adding Fractal noise (again designed by using (the default) Explicit Map Channel) creates a broken effect in the gradient which generates the desired result in the overall map tree. We have used a Box gradient type as this produced a decent square (ish) shaped area for selection which produces a more realistic result than that of, say, a Radial gradient type. Our gradient has been designed to ensure that, after adding noise, the edges of the map do not have any white touching them as this would create clipping. As we wanted the ice block to be surrounded by sea, we needed to remove the outer parts of the geometry but not so that it looks like a simple mask.

PART TWO: With the outline selection established, we will begin by refining the shape of our ice mass and give it some depth.

5 Add a Delete Mesh modifier to the Glacier_Large object's modifier stack and rename it Delete Excess Outline. Add a Mesh Select modifier to the stack and rename it to Mesh Select – Clear SubObject01. Add a Meshsmooth modifier to the stack and label it Meshsmooth – Outline Refine. Next, add a Relax modifier, rename it to Relax – Outline, set the Relax Value to 1 and un-check Keep Boundary Pts Fixed.

Information: A few modifiers have been added, but each one is important to generate the overall result. The Delete Mesh modifier deletes the Sub-Object face selection that we have generated with the Volume Select modifier beneath it, leaving only the basic shape of the ice mass. The Mesh Select modifier clears the Sub-Object selection so that any modifiers we add next are performed on the entire object, not any (now deleted) Sub-Object selection which would produce incorrect results. The Meshsmooth modifier has been added to refine the mesh for selection later on and smooth out any regular linear edges that stick out at 45 degrees, and is smoothed out further with the addition of the Relax modifier, creating a more natural shape. Boundary Pts Fixed has been un-checked to smooth out the outer edges else, as the object is flat, it wouldn't have much effect!

6 Add a Volume Select modifier to the stack and rename it VolSel – All Faces. In its Stack Selection Level group, set it to Face. Add a Face Extrude modifier and set the Amount to 200. Add another Mesh Select modifier and rename it to Mesh Select – Clear SubObject02. Add a Meshsmooth modifier and set its Iterations value to 2. Turn off Isoline Display. Expand its Parameters rollout and enable Separate By: Smoothing Groups. Rename the modifier to Meshsmooth – Final Refine.

Information: We needed to add another Volume Select modifier to the stack as the following modifier, Face Extrude, only works on a Sub-Object face selection. The Volume Select modifier (once the Sub-Object mode has been chosen) by default creates a bounding box around all remaining faces within the object which are thereby selected. This selection is passed up the stack to the Face Extrude modifier which creates our object's depth (but leaves the bottom of the object's faces open, but as we aren't going to see this side of the object, we don't need to worry about capping them. The final Meshsmooth modifier in the stack creates enough polygons for us to work with (we will reduce the polygon count later on as necessary). Isoline Display is disabled so that we can easily select rows of vertices later on. We have enabled Separate By: Smoothing Groups so we don't blend the top of the geometry and the sides together; we have a nice flat top and vertical sides due to the (automatic) smoothing group assignment when we used the Face Select modifier, which we will also utilize later on!

7 Add a Volume Select modifier to the stack and rename it VolSel – Base Taper. Set the Stack Selection Level to Vertex and set the Selection Type to Crossing. Expand the Soft Selection rollout enable Use Soft Selection and set the Soft Selection Falloff to 200. Next, in the Front Viewport, enable the modifier's Gizmo Sub-Object and relocate it vertically down in the Viewport's Y axis so that the bottom line of vertices are selected and the falloff colors are as illustrated with red (selected vertices) at the bottom and cyan (Soft Selection) at the top. Next, add a Push modifier, rename it to Push – Taper and set its Push Value to −20 m.

Information: By relocating the Volume Select modifier's Gizmo (not the object itself!) and enabling Soft Selection we can control the influence of any modifiers added on top of it. By using the Soft Selection as illustrated and the Push modifier with a negative value we have created a slight taper in the mesh, however we don't want to be overzealous with the Push amount – too much and we will end up with intersecting polygons which will show up at render time. We have used this method instead of setting the Scale value in the Face Extrude modifier because of the irregular shape

of the geometry; the Scale value takes the center point to scale from by an average of the vertices selected within each element. That is to say that due to the shape we would have some areas which would taper more than others resulting in a mesh that would appear to be sheared in places instead of uniformly tapered. Anyway, our taper method creates a nice curve thanks to the Soft Selection!

PART TWO: With the basic shape of our ice mass defined, we will now sculpt out indentations and extrusions to indicate erosion and ice fracturing.

8 Add a Mesh Select modifier to the stack and rename it Mesh Select – Clear SubObject03. Add a Volume Select modifier and rename it to VolSel – Fracture Small. Set the Stack Selection Level to Vertex and enable Texture Map in the Select By group. In the Material Editor, create a new Cellular map in a blank material slot to replace the entire material and label it Glacier_Large Fracture Small. Set the Source to Explicit Map Channel, set the Cell Type to Chips, Size to 0.02 and Spread to 0.4. Instance this map to the Texture map slot in the VolSel – Fracture Small modifier.

Information: Again, we have added a Mesh Select modifier to clear the Sub-Object selection so we have the complete object selected when we apply our next modifier. The Volume Select modifier, as before, is being driven by a texture map. This one is designed to generate a selection of small cellular chunks that we can use to distort the sides of the mesh. By using the existing mapping setup, our selection is planar-mapped onto the object so that the selection is smeared down the side of the object which, when affected, will create nice extrusions. However, the selection also affects the top of the object which we will have to remove next.

9 Add a Volume Select modifier to the stack and rename it VolSel – Top Deselection. Set the Stack Selection Level to Vertex. Expand the Soft Selection rollout and enable Use Soft Selection. Set the Falloff to 100 and Pinch to 0.3. Go into Gizmo Sub-Object mode and relocate the Gizmo vertically upwards in the Front Viewport so that the top row of vertices are selected. Once positioned, set the Selection Method to Subtract. Add a Push modifier, rename it to Push – Fracture Lines and set the Push Value to 50 m.

Information: We have added the Volume Select modifier with Soft Selection so that the remaining selected vertices after the subtraction has a dithered influence, resulting in the Push'd vertices from the sides of the geometry being more prominent at the base than at (just below) the top.

10 Add a Mesh Select modifier to the stack and rename it Mesh Select – Clear SubObject04. Add a Volume Select modifier and rename it to VolSel – Fracture Indentations. Set the Stack Selection Level to Vertex and enable Texture Map in the Select By group. In the Material Editor, create a new Cellular map in a blank material slot to replace the entire material and label it Glacier_Large Fracture Indentations. Set the Source to Explicit Map Channel, set the Cell Type to Chips, Size to 0.05 and Spread to 0.4. Enable Fractal and set the Iterations to 1.02.

Instance this map to the Texture map slot in the VolSel – Fracture Indentations modifier. Instance the existing VolSel – Top Deselection modifier to the top of the stack so we now have two instances of the same modifier at different levels in the stack. Add a Push modifier, rename it to Push – Fracture Indentation and set its Push Value to −10 m.

Information: Here we have a similar setup to what we had in the previous two steps; we have created another Volume Select modifier and Cellular map to generate a (larger sized) vertex selection which has been masked/controlled by an instanced copy of the VolSel – Top Deselection modifier – we didn't need to recreate the modifier as the operation was the same: deselecting the top most vertices and dithering the remaining selection so that the vertex strength/influence was stronger at the bottom that at the top. This time, we have added a negative value in our Push modifier which creates additional indentations in the sides of our ice mass geometry.

11 Add a Mesh Select modifier to the stack and rename it Mesh Select – Clear SubObject05. Next, add a Volume Select modifier and rename it to VolSel – Side Selection. Set the Stack Selection Level to Vertex. Enable Sm Group in the Select By group and leave its value at 1. Back up in the Selection Type group, enable Crossing. Add a Mesh Select modifier and rename it to Mesh Select – Soft Selection. In Vertex Sub-Object mode, Expand the Soft Selection

rollout and set the Falloff value to 100. Add a Noise modifier, rename it to Noise – Jagged Sides and enable Fractal. Set the X and Y (not Z) Strength spinner settings to 50 m.

Information: As before, we have added another Mesh Select modifier to clear any Sub-Object selection. The Volume Select modifier is set to select the vertices within smoothing group 1: the sides of our geometry, plus adjoining vertices (thanks to the Crossing option being enabled so we get the top most vertices on the sides of our geometry selected) however because we now cannot control any Soft Selection within this modifier, we must use an additional modifier to add this ability. Because of this selection, the Noise modifier's influence is confined to a given distance (set within the Soft Selection) "inland"; if we hadn't set the Soft Selection the influence of the Noise modifier would cause vertices to overlap resulting in visible problems at render time. This modifier has been added to break up the smooth contours of the top (and sides) of the ice mass geometry so we get a more jagged edge. We haven't used Z strength as we don't want any vertical displacement which would cause the geometry to lift up or push down which would look unrealistic.

12 Add a Mesh Select modifier to the stack and rename it Mesh Select – Clear SubObject06. Add a Smooth modifier and enable Auto Smooth. Add a Volume Select modifier, rename it to VolSel – Base Faces and set the Stack Selection Level to Face. Set the Selection Type to Crossing. In the Front Viewport, enter Gizmo Sub-Object mode and reposition the Gizmo vertically downwards so that only the bottom three rows are selected. Next, add an Optimize modifier and set the Face Thresh setting to 10 and Edge Thresh to 5. In the Preserve group, enable Smooth Boundaries.

Information: The Smooth modifier has been added to generate some nice linear fracture effects which can be used later on in our Optimize modifier. Here we have added yet another Volume Select modifier and used it to select the bottom three rows of faces as visible in the Front Viewport. This is so that the Optimize modifier's operation does not stray over the sides of the geometry onto the top faces. As we have amended the Smoothing Groups with the addition of the Smooth modifier, we cannot generate the selection based on Smoothing Group information as we did before. We have enabled Smooth Boundaries in the Optimize modifier so that the chiseled effect generated by the Smooth modifier is not lost, but enhanced, thereby giving us the fractured ice effect we have been after.

PART THREE: We will now finish off the geometry for our object by adding some additional displacement to sculpt the top surface of our ice mass.

13 Add a Mesh Select modifier to the stack and rename it Mesh Select – Clear SubObject07. Add a Volume Select modifier and rename it to VolSel – Top Displace. Set the Stack Selection Level to Vertex, enable Soft Selection and set its Falloff to 100. In the Front Viewport, enter Gizmo Sub-Object mode and reposition the Gizmo so that only the top row of vertices are selected (and thereby the entire top vertices of the object) with the Soft-Selection affecting the sides of the object. Add a Displace modifier and rename it Displace – Large. Set its Strength to 50 m. In

the Material Editor, create a new Noise map in a blank material slot to replace the entire material and rename it Glacier_Large Displace Large. Set the Source to Explicit Map Channel, Noise Type to Fractal, Size to 0.5, High to 0.6, Low to 0.4 and Levels to 10. Instance this map to the Map slot in the Displace – Large modifier's Map slot.

Information: As we only want to affect the top surface of our ice mass without any stretching, we have added a Volume Select modifier to feather the influence of any additional modifiers so that we don't get any unnecessary distortion. We are using a Noise map to generate an overall displacement; as before we are using Explicit Map Channel displacement which is planar mapped using the Displace modifier's own mapping so we can immediately see our changes and control the displacement easier.

14 Add a Displace modifier and rename it Displace – Medium/Small. Set its Strength to 50 m. In the Material Editor, create a new Noise map in a blank material slot to replace the entire material and rename it Glacier_Large Displace Medium. Set the Source to Explicit Map Channel, Noise Type to Fractal, Size to 0.25, High to 0.7 and Low to 0.3. Add a Noise map in its Color 2 slot and rename this new map Glacier_Large Displace Small. Set the Source to Explicit Map Channel, Noise Type to Fractal, Size to 0.1, High to 0.785 m Low to 0.455 and set the Color 1 swatch to RGB 158,158,158.

Instance the Glacier_Large Displace Small map tree to the Map slot in the Displace – Small/Medium modifier's Map slot.

Information: Here we have performed a similar operation as the last step with an additional modifier to add finer detailed displacement on our Sub-Object selection by using nested Noise maps;

the first creates a medium-sized regular surface displacement which creates ridges over the terrain, while the sub-map generates additional detail within its parent, generating a more realistic irregular effect overall, even if it is subtle.

15 Add a Mesh Select modifier to the stack and rename it Mesh Select – Clear SubObject08. Add a Displace modifier and rename it Displace – Final. Set its Strength to 100 m and enable Luminance Center. In the Material Editor, create a new Cellular map in a blank material slot to replace the entire material and rename it Glacier_Large Displace Final. Set the Source to Explicit Map Channel, Cell Type to Chips, Size to 2, Spread to 1.2, enable Fractal and set the Iterations to 20. Instance this map to the Map slot in the Displace – Final modifier's Map slot.

Information: Whew! Our final bit of modeling to, what has now become, a monster of a stack! The final couple of modifiers clear the selection as before, and add an overall displacement (but not enough to make the bottom of our geometry stick out from under the water surface!) to break up any final uniformity that might be present and to create a more natural ice terrain formation. By using a large Cellular map we can create a decent fractal displacement with enough iterations (detail) that creates a natural effect.

PART FOUR: With our procedural modeling now complete, we will now create materials to create the appearance of ice and water when rendered.

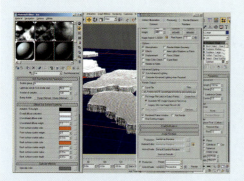

16 Open the Renderer panel and expand the Assign Renderer rollout. Change the Production renderer to Mental Ray Renderer and open up the Material Editor. In a new material slot, create a new Mental Ray SSS Fast Material (mi). Rename this new material to Ice and assign it to the Glacier_Large object in the scene. Set the Number of Samples to 128, the Overall Diffuse Coloration to RGB 240, 250, 255, the Unscattered Diffuse Color to RGB 223,245,255 and its Weight to 1.

Information: We have enabled Mental Ray in the Renderer panel so we can render with this engine and also view any edits we make in our material setup. As we are going to simulate sub surface scattering within the ice we are using a basic sub surface scattering shader. We could use a more complex SSS shader, but for this scene it is perfectly suitable. We have increased the Number

of Samples so that the SSS detail is more accurate and less noisy. The Overall Diffuse Coloration is the basic color of the object with any additional colors such as the Unscattered Diffuse Color are multiplied with this color to produce the final effect. The Overall Diffuse Coloration is normally used for darker unscattered coloring such as dark areas that block out any SSS; we don't want this, so the color value is simply tinted slightly.

17 Set the Front Surface Scatter Color to RGB 57,196,255, set its Weight to 1.5 and Scatter Radius to 30 m Set the Back Surface Scatter Color to RGB 45,95,225, its Weight to 2 and Radius to 50 m. Set the Back Surface Scatter Depth to 200 m. Expand the Specular Reflection rollout and set the Specular Color to RGB 242,255,255. Expand the Advanced Options rollout and enable Scatter Indirect Illumination.

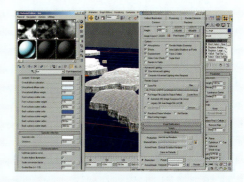

Information: The Front Surface Scatter Color has been set to simulate the scattering of light beneath the facing surface. This color has been derived from point-sampling an image from the reference material and the Radius derived from color falloff distances by comparing the distances in the reference material and in our scene scale and determining a value from this. The Back Surface Scatter Color was, again, sampled from the reference material and simulates the coloration of light passing through the object, with its Radius set to affect adjacent area and depth to simulate how far the "light" will pass through the object. The Specular Color was, again sampled from the reference material and we have enabled Scatter Indirect Illumination as we are going to be using a Skylight light later on to simulate light from the sky which requires Final Gathering to be enabled in order to function.

18 Create a new Mental Ray material in the Material Editor, label it Sea and assign it to the Sea object in the scene. Add a Glass (Lume) shader to its Surface shader slot and set its Surface Material and Diffuse colors to RGB 0.459, 0.573, 0.608. Set the Index of Refraction to 1.33. Back up at the top of this material, add an Ocean (Lume) shader to its Bump shader slot. Set the Largest setting to 20 m, Smallest to 0.5 m and Steepness to 1. Back up at the top of the material, add a Submerge (Luma) shader to its Volume Shader slot. Set the Vertical Gradation to 5 and the Density to 0.2

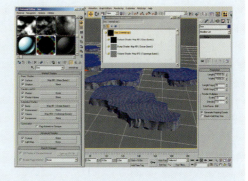

Information: We are using a Glass shader as our main surface shader as it produces quite a convincing reflective water surface result, when set to the correct color and index of refraction (IOR value). We are

using a special shader designed to simulate water surface deformation as a bump map (the age-old saying applies here – "if it's not broke, don't try to fix it!") with settings derived from the scene's scale and comparing these settings with the reference material. Again, with the Submerge shader, the falloff distances have been derived from the scene's scale and comparing these values with the reference material. The Density has been set to a low value which controls the level of falloff, namely how clear the waters are.

PART FIVE: We will now finish off the scene by setting up environment effects and illumination before rendering.

19 Create a Bitmap map in a new material slot, load in the clouds_180.bmp included on the DVD-ROM and label the map Sky Environment. Enable Environ and set the Mapping to Spherical Environment. Set its V Offset spinner to 0.25, V Tiling to 2 and un-check V Tile. In the Top Viewport, create a Skylight light, set its Multiplier to 0.5 and instance the Sky Environment map to its Map slot. Open up the Environment panel, set the Environment color to white and instance the Sky Environment map to its Environment map slot.

Information: We are going to be using a texture map to illuminate our scene as well as a main key light to simulate the sun. This map also needs to be reflected in the water for the scene to be convincing, therefore it is dropped into the Environment map slot so it can be reflected by the material assigned to the water. The map is a simple 180 degree panorama, but simply applying this will result in the map being stretched over the spherical mapping. Therefore we needed to offset and re-tile the map so it would fit correctly. The environment color has been changed as the tiling had been removed from the map, and any (visible) color beneath the map in the environment would have been black, which may have been visible in the render.

20 In the Top Viewport, create a Target Direct light, label it Sun and position it as illustrated, away from the center of the scene with its target in the middle of the scene. Enable Shadows and change the Shadow Type to Ray Traced Shadows. Set the Multiplier to 1.2 and its Color to RGB 255, 243, 229. Expand the Directional Parameters rollout and enable Overshoot and set the Falloff/Field to 10000 m to cover the entire scene.

Information: This light is our main key light to simulate illumination from the sun. We are using Raytraced shadows

as it gives us a nice contrast and clean shadow lines as the "air" is very clean. We have extended the Falloff/Field so that shadows are cast throughout the scene; if we had kept it at its original setting, we would have had illumination outside of this area (due to Overshoot being enabled), but no shadows as they are only cast within this boundary.

21 Position the Perspective Viewport to an aesthetically pleasing angle so we see down the length of the ice mass (plus some sea!) and hit CTRL+C to create a camera from this view. In the resulting camera's modifier panel, set the Far Range in the Environment Ranges group to 50000 m. Open up the Environment panel again, add a Fog Atmospheric Effect and enable Exponential.

Information: The fog is controlled by this Environment Range setting. We have set the Environment Range to 50000 m so that we have a nice long falloff of fogging, so the horizon doesn't get totally white'd out! Simply positioning the Viewport and hitting CTRL+C is easier than creating and positioning cameras!

22 Open up the Render panel and go to the Indirect Illumination tab. Enable Final Gather and set the Samples to 100 and render off the frame.

Information: We have enabled Final Gathering so that we can use the Skylight light in our scene and, in turn, indirect illumination within our Sub Surface Scattering shader (the Ice material). We have dropped the Samples value to 100 as although the geometry count in the scene is pretty high, there's no real small or fine detail that would stand out or create pixilation or grain problems when rendering out a still image. For an animated camera, see the Taking it Further section below...

Taking it further

With our main scene now established, we can now go and enhance it to add additional detail. As our glacial icebergs are so large we will undoubtedly see smaller ice blocks surrounding them where chunks have broken away from the main glacier and fallen into the sea. These medium-sized chunks will sit in the water at a lower level and will have discernable gaps between them and the main mass of ice. To create this, try duplicating our main tabular glacier and inverting the selection and, with the addition of extra selection maps to create the cracks and smaller chunks, re-engineer the construction

method to use the new selection; you will have to work your way up from the bottom of the stack to make sure each modifier is behaving itself as we have several modifiers in the stack that maintain gizmo boundaries (such as displacement), plus we will need a new Mesh Select modifier to control a new vertex soft selection. In addition to these smaller chunks, we will have blocks of ice that will form "plates" that sit even lower in the water, so we see less sea overall. Again, these can be generated by additional selections to create gaps between the main mass of ice and the medium-sized chunks.

Finally, again referring to our reference material, we will notice additional small ice blocks which sit in-between the plate ice and the ice masses where plate friction has broken off areas and/or simply fallen into the sea. By generating a grayscale distribution map from the existing geometry in the scene, we can distribute ice particles (using the same assigned ice material) in the gaps between ice chunks and plates at irregular angles and sizes by using instanced geometry as particles. This geometry can be created similarly to the main ice chunks with multiple modifiers to create the shards and irregular surface edges; with several different ones created we can import them into a particle system and rotate them at different angles to create some additional detail. Finally, we can use smaller standard particle shapes scaled vertically to generate tiny fragments of melting ice that simply sit on the surface. All of the above can be found in the Taken Further scene included on the DVD-ROM.

To improve on this even more, try animating a chunk of ice breaking away from the main mass and falling into the sea. Source reference material of glaciers breaking apart and falling into the water to see how much water is displaced and how the ice behaves as it enters the water. Additionally, try changing the surface material of the main body of ice to snow and animate some surface particle snow being blown off in gusts by using a sub-object selection of the top faces of the ice to emit the particles and several Wind Space Warps to blow the snow away like turbulent wispy smoke. You might also want to improve the surface texture of the ice blocks by adding additional bump or displacement mapping to create layers of ice (scrutinize the reference material for examples of this), or "melt" areas of ice that come into contact with the water, creating some interesting organic shapes.

Animating the camera in the scene is a little more taxing. This is because the tutorial's low Final Gather Samples setting causes flickering in an animation due to the animated camera (Final Gathering is calculated from the camera's PoV). Therefore, the amount of samples should be increased to a setting where flickering is no longer visible, however Use Falloff (Limits Ray Distance) can been enabled, with its Stop value set to 300 m (for example) which will reduce unnecessary Final Gathering calculations, keeping render times lower while reducing the flickering to a minimum.

Earth

In this section we will cover effects ranging from mountainous terrain to frozen wastelands, and even an asteroid; they all come under the same heading. We will add complex deformations to surfaces to distort and sculpt them, and use a combination of material and mapping techniques to combine different materials and scatter thousands of objects procedurally over our terrain (where relevant) to add extra realism. Finally, we will illuminate the scenes using, in most cases, faked GI and create environmental effects to add the finishing touches.

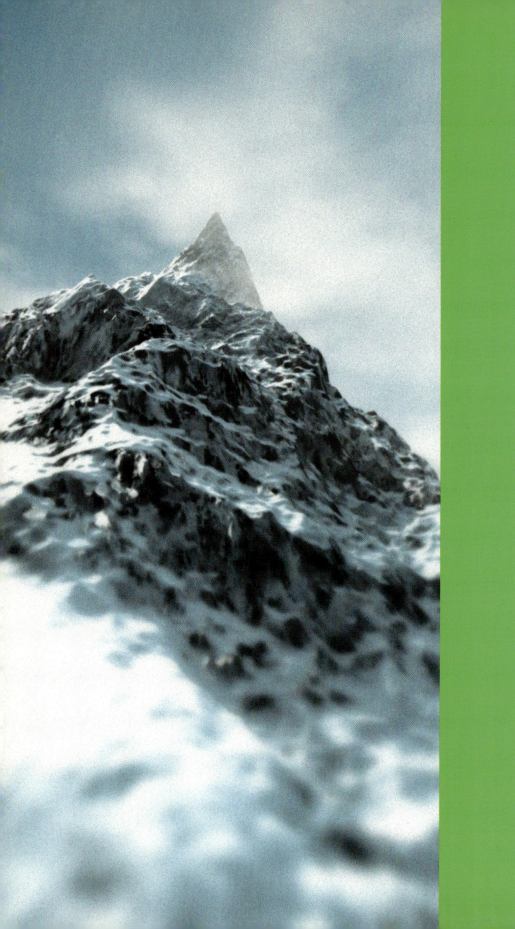

20 Volcanic terrain

Information

In this tutorial we will create a 'generic' volcano that will be generated using a displacement map. At first glance it would seem that this effect is quite easy to produce; however, upon close inspection of the resource material included on the DVD-ROM, this is not the case. We will therefore be using a combination of 3ds Max and Adobe Photoshop (or equivalent package) to generate the desired displacement map which, after construction, will be saved out and re-imported back into 3ds Max in a whole new scene, and used to raise or 'displace' certain areas of a flat plane based on the brightness of the map. After the displacement procedure, we will generate materials for the now volcano-shaped plane object using a combination of two different materials. Finally, we will assign a sunset background to the scene and illuminate it accordingly, before adding a couple of post effects to make the scene appear more dramatic, and then composite part of the background map back over the top of the render to tuck the volcano in behind some trees.

Analysis of effect

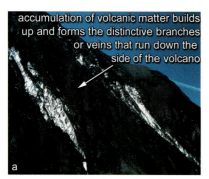

accumulation of volcanic matter builds up and forms the distinctive branches or veins that run down the side of the volcano

a

Image courtesy of United States Geological Survey

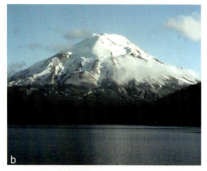

b

Image courtesy of United States Geological Survey

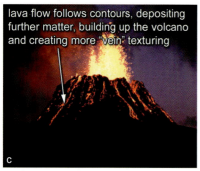

lava flow follows contours, depositing further matter, building up the volcano and creating more "vein" texturing

c

Image courtesy of United States Geological Survey

d

Image courtesy of United States Geological Survey

(a) There are several different types of volcanoes, from the smaller Cinder Cone volcanoes made up of volcanic fragments, to the large Caldera types which can have huge craters. For this tutorial, we will concentrate on the more common Composite or Stratovolcano types, which are constructed over a period of thousands of years from alternating layers of viscous lava flows, cinders, blocks and Pyroclastic flows. (b) Mount St. Helens, for example, is one of the most active Stratovolcanos (and one of the youngest), so we will base our volcano construction on this one in particular. Volcanoes are, in essence, mountains which are formed by the accumulation of the material that is ejected from within them, namely debris, lava and ash instead of the 'normal' method of uplift, crumpling, folding or erosion of terrain. These volcanoes are most commonly a conical-shaped hill or mountain which has formed around a lava vent over several thousand years. (c) Because of this accumulation of debris and volcanic matter, distinctive 'veins' can be seen down the (sometimes) exceptionally steep sides of the volcano, which give it its distinctive appearance. These are formed by the debris traveling down or falling on the sides, collecting and then hardening – one way to illustrate would be to allow a handful of sand to drop onto the ground from a short distance above. Initially, this sand would fall away, but after the ground has been covered, a peak begins to form as more sand adheres to the sand already on the ground. Most Composite/Stratovolcanos have a crater at the summit which contains a vent situated in the center. (d) Even though these volcanoes are some of the most aesthetically pleasing (because of their intricate patterns and snow-capped peaks, due to the attitudes they can reach), they are the most dangerous, thanks to their composition (which we will deal with in a later tutorial). So if you're popping out to your local volcano to take some reference snaps, be a little wary!

Because there is no map within 3ds Max that creates the branching effect that is desired to generate the correct displacement, we will have to use a combination of modeling and use some of the objects made available to us to create the branching effect. These can be produced by generating a basic shape of the volcano by amending and deforming a plane, extracting the Z-buffer information from it, then mixing the resulting image with one of the new objects that has been introduced to 3ds Max 6, namely the Foliage. By rendering off a large canvas in the Top Viewport of a tree with all of its leaves stripped away, we can get the branching effect we desire. Several different versions should be rendered off and blended together to form an effective displacement map, by taking a bit of a side-step out of 3ds Max for a short while, and working in Photoshop (or equivalent). By using a combination of blends and masks, we can use the pre-rendered

displacement map's components and additional painting to generate finer detail. We will create a map that will have the correct branching effect, which will then be loaded into 3ds Max and used to displace a simple plane primitive. This displacement will be mixed in 3ds Max with an additional procedural map to create the crater at the top of the volcano. After the displacement is complete, we will add a mixture of materials which will be blended together based on a polygon's Normal direction and position in the object, therefore creating a snow-capped volcano. Finally, we will add in a background and set up the lighting to simulate a sunset scene, adjust the contrast slightly to make the colors even more intense, and overlay part of the background back on top of the render in Video Post to mask out the bottom of the rendered volcano (as it may appear as if it is 'floating').

Walkthrough

PART ONE: First we will create the initial plane displacement template from which to extract the Z Buffer information to create our displacement map.

1 Open 3ds Max and in the Top Viewport create a Plane with a Length of 200 and Width of 1300. Set the Length Segs to 80 and the Width Segs to 520. Add a Displace modifier to the stack, set the Displacement Strength to 100 and enable Luminance Center. Label the Plane Volcano Template.

Information: This plane will be the basis of our volcano template. Creating the branching effect is relatively straightforward thanks to the foliage objects in 3ds Max 6, but we still need a surface to adhere these branches onto. We are therefore going to create a basic branching effect with displacement on this long thin plane, before wrapping it around and displacing it vertically to create our basic volcano shape.

2 Open up the Materials Editor and create a new Smoke map in one of the material slots. Label this map Vein Displacement. Set the map's Coordinates Source to Explicit Map Channel, set the U Tiling to 3 and V tiling to 0. Set the Size to 0.2, Iterations to 1 and Exponent to 0.5. Set the Color 1 swatch to RGB 128,128,128, and the Color 2 swatch to RGB 57,57,57. Drag this map to the Map slot of the Displace modifier and select Instance when prompted.

Information: As there is no vertical tiling, this Smoke displacement map creates a peaked run down the thin length of the plane. UVW mapping has been used, instead of Object XYZ mapping, as we need the map to deform (which would not happen if we stuck with Object XYZ mapping).

3 Add a Mix map to the Color 2 slot and label it Peak and Seam control. Set the Color 2 swatch to RGB 128,128,128 and add a Gradient Ramp map to the Color 1 slot. Label it Peak Control. Set the W Angle setting to −90 and the Interpolation to Ease In Out. Set the flag at position 50 to RGB 0,0,0 (black) and move it to position 70. Set the flag at position 100 to black and the one at position 0 to RGB 128,128,128. Add a flag at position 10 and set it to RGB 128,128,128 as well.

Information: We can see in the Viewport exactly what this Gradient Ramp map does – it creates a transition of the deformation assigned to the plane from the top to the bottom, with a small amount of unaffected geometry at the top due to the two grey flags. The black flags create a strong dip in the displacement at the base of the plane. The Ease In Out interpolation simply amends the way the gradient blends the colors assigned to the flags, and the Angle amendment rotates the Gradient around so it is facing the correct way.

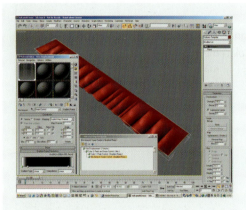

4 Add a Gradient Ramp map to the Mix slot of the Peak and Seam Control mix map and label it Seam Control. Remove the flag at position 50 and set the flag at position 0 to white. Add flags to positions 11 and 92 and set them to black.

Information: This map simply 'disables' or fades out the displacement at both ends of the plane, so when we bend the plane around itself later on, both ends will line up.

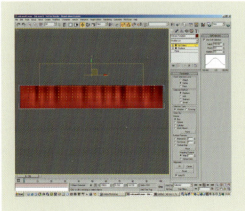

5 Reduce the number of Segs in the Plane to 8 and 52 for Length and Width accordingly and add a Volume Select modifier above the Displace modifier. Set the Stack Selection Level to Vertex and reposition the Gizmo in the Top Viewport so that the top row of vertices are only selected. Scale the Gizmo down along its width as illustrated and enable Soft Selection. Increase the Falloff so that the Soft Selection gradient illustrated in the Viewport does not affect the bottom or sides of the plane – a setting of about 180 should suffice.

Information: We have reduced the amount of iterations in the base geometry so that we can see updates in the Viewport a lot faster. We will increase these back up later on. The Gizmo has been repositioned and Soft-Selection amended so that the sides (the seam) and base (which will be the peak of the volcano) are not affected by any other modifiers we drop in the modifier stack above this selection.

6 Add a Noise modifier to the stack and label it Vertical Noise. Enable Fractal and set the number of Iterations to 3. Set the Z Strength to 50. Add another Noise modifier and label it Side Noise. Set the Scale to 200, enable Fractal and set the X Strength to 100. In the Top Viewport, rotate this Noise modifier's gizmo 45 degrees anti-clockwise, as illustrated.

Information: Thanks to the Volume Select's soft selection, the strength of the two Noise modifiers is controlled so that they do not affect the bottom (which will be the top of the volcano) or the sides (the seam). The initial Noise was added to add a slight irregularity to the height of the sides of the volcano, while the rotated Noise with a horizontal strength deforms the displacement we created further down the modifier stack. The gizmo was rotated so that the Noise was not the same all the way across the length of the plane.

7 Add a Mesh Select modifier and label it Clear Selection. Add a Bend modifier and set the Angle to 360 and Direction to 90. Set the Bend Axis to X and move the Bend's Center sub-object vertically in the Top Viewport so that it's at the top of the bent plane, therefore closing the hole in the middle of the plane.

Information: As we had a sub-object selection, this had to be cleared before any other modifiers could be added that needed to affect the entire object. The Bend sculpts the plane into a deformed disk, and offsetting its center closes the hole, therefore creating the top of the volcano. Thanks to the Seam Control map and lack of noise influence around the two sides of the plane, courtesy of the Volume Select's falloff, the two sides should line up perfectly.

8 Add a Vertex Weld modifier and set the Threshold to 1. Add a Displace modifier, label it Height Displacement, set the Strength to about 380 and enable Luminance Center. Open the Material Editor and add a Gradient Ramp map to the next available material slot. Label this map Height Displacement. Set the Flag at position 0 to RGB 206,206,206, the one at position 50 to RGB 165,165,165 and the one at position 100 to RGB 128,128,128. Add a flag at position 14 and set it to color RGB 201,201,201. Set the Gradient Type to Radial and drag this map to the Map slot in the Height Displacement modifier.

Information: The Vertex Weld modifier was added to close the seam and the top of the displaced mesh, so that any additional deformation on the mesh would not open the seam any further. The radial gradient has a gradual falloff which produces a nice rounded cap at the top of the volcano and linear sides.

9 Add a Volume Select modifier to the modifier stack, set the Stack Selection Level to Vertex and reposition its Gizmo vertically in the Front or Left Viewports so that the top most vertex is selected. Enable Soft Selection. Add a Relax Modifier, set its Relax Value to 1 and Iterations to 20. Finally, add a Mesh Select modifier to the top of the stack. Go back down to the Plane primitive at the base of the stack and increase the Length and Width Segs back to their original settings of 80 and 520 respectfully.

Information: The Soft Selection simply ensures that only the top few vertices are selected to be Relax'd. The Mesh Select modifier simply clears the selection for Viewport interaction speed purposes. With the number of polygons in the volcano set to a low value, it appears as if the top of the volcano has been flattened. The high amount of relax was included due to the use of the proper amount of Segs in the Plane Primitive at the bottom of the modifier stack. Note that increasing the Segs amount will cause 3ds Max to hang for a short period, while it calculates the Vertex Weld modifier. This is to be expected.

10 Open up the Effects panel and add a File Output render effect. Set the Channel in the Parameters section to Depth, click on the Files button and specify the filename as *volcano_template.tif*. Open the Render panel and set the Width and Height of the Output Size to 3000. In the Top Viewport, right click the Top text in the top left of the Viewport and select Show Safe Frame. Center the mesh in the middle of the Viewport and render out the image in the Top Viewport. Save the max file as *volcano_template.max*.

Information: As we only require the depth map from this particular scene, we do not need to specify an output in the Render panel. The File Output Render Effect saves out the Z Buffer information for the render, which we can now load into Photoshop and add extra detail. The screenshot for this step illustrates the rendered frame; the File Output image is not displayed as it is simply output to the file.

11 Reset 3ds Max and, in the Top Viewport, create a Foliage object and change its type to Generic Oak. In the Modifier panel, turn off the tree's leaves. Copy the tree and change its seed by clicking on the New button and reposition if necessary to get the center of the trees aligned correctly in the Top Viewport. Open the Material Editor and assign a self-illuminated white material to the trees. Create and position a Camera in the Left Viewport and position it at the top of the Trees. Change the Lens size to 5 mm to generate a large Field of Vision, change one of the Viewports to Camera view and render off the image to a 3000 × 3000 canvas. Save this image out as a .tif file.

Information: This may sound like a complex step, but all it simply contains is the construction of two objects, a simple material assignment and camera positioning. The wide-angled lens was used to create some large thin branches stretching out to the sides of the image. The White self-illuminated material is to ensure we have a white on black branching effect with no shading.

PART TWO: With the relevant Z-Buffer and vein images, we can load them into Photoshop (or equivalent) and add extra detail to our map.

12 Open the saved *volcano_template.tif* file into Photoshop and apply a subtle Gaussian Blur filter to remove any harsh edges. Create a new layer and set its Layer Blending type to Screen. Drop the opacity of the layer down a little and, with a small brush, work your way outwards around the existing large veins emanating from the center creating smaller branches from each large vein. Blur the small veins slightly to match the blur of the background layer.

Information: Referring back to our reference images, we notice that this type of additional vein effect is commonplace, therefore needs to be created. A few simple strokes with a brush will suffice as we only need to suggest that these veins exist – the more prominent ones will be from the next image we load in …

13 Load in the saved branches image we generated. Select all, copy and paste it into our main canvas. Hit CTRL+T (transformation) and increase the size of this layer to about 150% of its original size. Make a copy of the layer, set its Layer Blending Type to Screen and rotate the layer about 45 degrees. Perform this operation again so we have an even distribution of veins coming from the center of the map. Collapse these branches down to a single layer. Change the opacity of the layer to about 20% and Gaussian Blur it slightly. Select the Background layer, Select All and copy (CTRL+C). Select the collapsed branch layer and add a layer mask. Select the Channels tab, enable the Layer Mask and paste in the copy of the Background layer. Hit CTRL+I to invert the mask.

Information: Another big step, but not all that complex. Here we have imported the pre-rendered image and simply distributed it around the map to create more branches. After blurring to remove any hard edges, we have used an inverted copy of the background layer to mask out the veins, so they are more intense on the darker areas of the map to 'raise them up' slightly.

14 Clone the branches layer and un-link the layer and layer mask. Gaussian Blur the layer (not the layer mask) some more. Change the layer's Blending Type to Lighten and set the Opacity to 10. Copy the background layer and re-order the layers so that it is situated on top of all of the other layers. Set its Blending Type to Multiply.

Information: This creates the two main extremes – the lighter cap, generated by the clone of the veins, and the darker surrounding areas. Because of the way the blending types work, a lot of the intensities are maintained so we can get slightly sharper peaks which trail away quite quickly.

15 Finally, we need to remove the harsh edge around the base (the perimeter) of the volcano displacement map. Either, using the Magic Wand tool select the black area on the background layer, feather the selection and fill the selection black on a layer situated on top of all other layers, or in a layer situated on top of all other layers paint out the hard edge with a large soft brush that is set to black. Save the Photoshop file to maintain all the layers should we need to tweak the image later on, and save a flattened version that we can load back into 3ds Max.

Information: We need to remove the harsh edge around the perimeter of the map so, when the map is used as a displacement map in 3ds Max, there is no sudden 'step' from the dark surrounding areas to the sides of the volcano. Even though we will be masking out the bottom of the volcano later on, it is still good practice to remove this 'step' in the map in case the map is used in a different scene at a later date.

PART THREE: With the main displacement map completed, we can load it back into 3ds Max and use it on simple geometry to generate our final terrain mesh.

16 Back in 3ds Max, reset the scene and create a Plane in the Top Viewport with a Width and Length of 2000 with 200 Length and Width Segs. Label it Volcano Displaced. Add a Displace modifier and label it Terrain Displacement. Open the Material Editor and in a blank slot load in the flattened map you saved from Photoshop (or load in the *volcano_displacement.bmp* file included on the DVD). Label it Terrain Displacement, set the Blur Offset to 0.005, and drag it to the Map slot in the Terrain Displacement modifier. Set the modifier's Displacement Strength to 1000.

Information: Our hard work creating the map has paid off – now we can use the displacement map on whatever level of geometry we like. Because our volcano's shape is now material based, we can amend the geometry at the base level to add (or reduce) the amount of polygons in the scene at will and the mesh will be automatically updated. Should you feel that the Viewport update times are too slow, simply reduce the number of segs, then increase them back to normal at render time, or just increase the Plane's Render Multiplier (more on this in the Taking it further section).

17 In the next available slot in the Material Editor, create a Gradient Ramp map and label it Crater Displacement. Set the Gradient Type to Radial Interpolation to Ease In, Noise Amount to 0.1, Size to 5 and Type to Fractal. Add a flag to position 25 and set it to black, move the flag at position 50 to position 73, add a flag at position 65 and set it RGB 58,58,58, and set the key at position 100 to RGB 128,128,128. Add a Displace modifier to the stack and label it Crater Displacement. Scale down its gizmo to about 30% to create the inset crater. Set the Strength to 600, enable Luminance Center and drag the Crater Displacement Gradient Ramp map to the Map slot in this modifier.

Information: As we only want to displace the top part of the volcano, we can use a displacement that has Luminance Center enabled – this takes the middle grey (RGB 128,128,128) as not affecting the mesh – anything lighter than this will raise the mesh and anything darker will lower the mesh. A radial gradient pivots around the left-hand side of the gradient design, so the outskirts will be the mid-grey color that does not affect the mesh, so only the center is displaced.

PART FOUR: With the mesh now complete, we will move onto creating the materials for our volcano.

18 In the next available slot in the Material Editor, create a new Top/Bottom material, label it Volcano and assign it to the Volcano Displaced plane in the scene. Set the Blend to 5 and the Position to 70. Label the material in the Top slot Snow and set its Diffuse color to white. Add a Speckle map in the Specular Level slot, swap the black and white colors and amend the black color now in Color 2 to RGB 196,196,196. Label the map Snow Specular. Back up in the Snow material, set the Bump amount to 999 and instance the Terrain Displacement Bitmap map into the Bump Slot.

Information: Referring to our reference material, we notice that depending on the height of the volcano, some (if not a lot of) snow appears on the top and sides of its terrain. Using a Top/Bottom material allows us to mimic this in 3ds Max depending on the angle of the polygons in the mesh – those facing up will receive the snow (Top), while the others will receive the other material we are about to create (Bottom). We have also raised the threshold of the Top/Bottom so that the heavy snow forms around the tops of the peaks. The Speckle map was introduced to break up the material as we will have rough and smooth surfaces which results in different specular information, and the instance of the displacement map drives the bump map to add extra detail to the terrain at render time without having to crank up the geometry count excessively.

19 Add a Blend map in the Top/Bottom's Bottom slot and label it Side Volcano Blend. Instance the Snow material into the Material 2 slot. Label the material in slot 1 Rock and add a Mix map to the Diffuse slot. Label it Detail Snow Rock Mix and add a Falloff map to the Mix slot. Set the Falloff Direction to Local Z-Axis and amend the Mix curve as shown. Label this map Detail Mixer.

Information: The additional Blend material has been added to create snow on the raised areas of the displacement map, where the geometry is not fine enough to pick out all of the detail. The Mix map in the Diffuse slot of the Rock material performs pretty much the same task, emphasizing the map in the Bump slot, which we will set up next.

20 Add a Mix map to the Rock materials Bump slot, label it Rock Bump Mix and set the Mix Amount to 50. Instance the Terrain Displacement map to the Color 1 slot and add a Noise map to the Color 2 slot. Label this Rock Small. Set the Source to Explicit Map channel, Noise Type to Fractal, Size to 0.01, High to 0.7, Low to 0.3 and Levels to 10. Add a Noise map to the Color 2 slot and label it Noise Large. Set the Source to Explicit Map channel, Noise Type to Fractal, Size to 0.03, High to 0.6, Low to 0.4 and Levels to 10.

Information: To add extra bump to the rock surface, in this step we have mixed two different sized Noise maps together to create a non-uniform map. In addition to this, this Noise map tree has also been mixed with the existing displacement map to add extra detail to the rock on the sides of the volcano.

21 Add an Output map to the Mask slot of the Side Volcano Blend material and label it Displacement Intensity. Instance the Terrain Displacement map to the Output map's Map slot. In the Output map's Output rollout, turn on Enable Color map and amend the curves to those illustrated.

Information: The displacement map has been intensified and its colours amended a little, using the Output map to intensify the white and trail the black off a little. This intensifies the white in the map around the center (and therefore the top of the volcano), which is used to control the mixing of the Snow and Rock materials, therefore creating a solid snow cap when rendered.

PART FIVE: Next, we will add a background environment map to the scene and set up lighting and cameras to match the background map.

22 Open up the Environment panel and click on the Environment Map slot. Add a new Bitmap map and load in the *volcano_backplate.jpg* from the DVD-ROM. With the Perspective Viewport selected, press ALT+B or go to Views>Viewport Background. Enable Use Environment Background and turn on Display Background. Arc Rotate and pan the Perspective Viewport so that you are looking up the Volcano slightly (as the background image is pointing slightly skyward). Once positioned correctly, press CTRL+C or go to Views>Create Camera From View. Set the resulting camera's lens to a stock 35 mm.

Information: We have loaded in the background image and positioned the volcano so that we can overlay the trees at the bottom of the image over the base of the volcano. Re-compositing the scene at the end will make it more believable because it places the volcano in situ.

23 In the Top Viewport, create a Direct light and label it Sun. Set the color to RGB 255,248,240, enable Shadows, turn on Overshoot and expand the Falloff/Field to encompass the displaced plane. Set the Shadow Map Bias to 0.001 and Size to 2048. With the Target situated in the center of the volcano, move the light outwards in the Top Viewport. Go to the Camera Viewport and move the light vertically until it is overlaid exactly with the brightest part of the sunset background.

Information: The color of the light was derived by viewing the background image and point-sampling the color from the brightest part of the sunset. The low shadow bias pulls in the shadows so they are tight around the faces that cast them, and the high shadow map size ensures the shadow is crisp. A Direct light is used to simulate the Sun as its shadows are cast out linearly, and not fanned out like a Spotlight or Omni Light.

24 Clone the light by shift-moving it to the left in the Camera Viewport to the far left of the brightest point on the background and reduce the Multiplier to 0.25 and the Shadow Map Size to 512. Increase the Sample Range to 20. Create an instanced clone of this light on the other side of the brightest point. Copy this light (not instanced) and reduce the Multiplier to 0.03, the Shadow Map Size to 256 and turn off Specular. Reposition it so that it is half-way up the Camera Viewport. Instance the Environment Background map to a slot in the Material Editor and click on the View Image button. In the copy of the background image that appears, hold down the right mouse button and point sample a color from where this new light is situated. Memorize the RGB values and enter them into the light's color swatch.

Information: By creating a number of lights closely positioned together, we have created a basic faked area light effect for the main light source. The secondary light source of the sky has had its Shadow map size reduced as we only need diffused shadows, and the Specular option turned off as we require a diffused light, else our volcano will be covered in highlights once the next step is complete.

25 Create a ring of instances of this light around the volcano by rotating at snapped angles around the volcano by using the volcano's axis as a pivot point. Copy this ring, move the ring copy up, sample another color and set the light's color accordingly. Perform this another time for a ring of lights lower down in the scene as illustrated.

Information: By using instanced lights for each ring, so that amending one light amends the settings for the rest of the ring, we can edit the settings as desired later on without having to amend every single light. When the arrangement is complete, we will have created a similar effect to what a Sky Light would generate, but we have added extra detail to our shadows for the primary light which would be more difficult with a Sky Light and would take a lot longer to render.

26 Select the Camera Viewport and open the Effects Panel. Add a Brightness and Contrast Effect to the Effects list and set the Brightness to 0.35 and Contrast to 1. Render off a single frame.

Information: Adding this render effect hides any irregularities we might have, and is also more aesthetically pleasing as it brings out the colors of the background and the contrasting shades illuminating our volcano's material. This may take a little while to render due to the amount of shadows being cast in the scene. If it is taking too long for your liking, try reducing the size of the shadows and the Sample Range settings of the lights in the scene by half.

PART SIX: Finally, as the background is occluded by the volcano, we will composite the render with the background to overlay part of the background back on top.

27 Open Video Post and click on the Add Scene Event button. Click on the Add Image Input Event button and load in the *volcano_backplate.jpg* image as before. Highlight both of the events and click on the Add Image Layer Event button. Select Alpha Compositor from the menu and load in the *volcano_backplate_mask.jpg* image. Change the Mask type to Luminance and click OK to exit the panel. Add an Image Output Event, if desired, and render off a single frame.

Information: The Alpha Compositor overlays the image on top of the render (the result of the Scene Input Event), using the Mask map to control how the images are put together. The resulting image is the volcano rendered off against the sunset background (as in the standard render), with the composited trees from a copy of the background image added on over the top. You will notice a negligible difference in background image intensity because the copy of the background image that is loaded into Video Post and overlaid does not have the Render Effect applied to it. To rectify this, try using a Video Post Contrast filter on it.

Taking it further

Because the shape of the volcano is derived from the deformation generated by the main displacement map, there is not much else we can do to the overall shape of the volcano, apart from, perhaps, refine the detail in the displacement by increasing the size of the displacement map and adding extra detail

to it in Photoshop. In addition, we could create an extra map in Photoshop to control additional procedural bump mapping around the sides of the peaks that run down the sides of the volcano.

Because of this extra detail, we could (and should) increase the amount of detail of the plane geometry in the scene to remove the soft edges of the slopes along the sides of the volcano. As all of the modifiers in the Volcano object's stack are non-destructive (i.e. they do not amend the geometry by adding or deleting polygons, for example), we can simply amend the geometry at the base of the modifier stack and the information will automatically be passed back up. Even though we can adjust the number of iterations in the base geometry, this will have an adverse effect on Viewport interaction. Therefore we can simply increase the Render Multiplier setting which will just add extra detail to the mesh at render time and will not affect what we see in the Viewport at all – a value of 3 should suffice. This has its pros and cons – pros in the fact that an exceptional amount of detail can be added to the mesh, cons in the fact that we can up the setting a little too much and run out of memory. In addition, it is easy to forget that we have increased the multiplier setting and added extra 'finishing tools' such as Meshsmooth on over the top of the modifier stack, refining the mesh even further. This spells instant death for the program (after about a 1/2 hour calculation time), so ensure you label the mesh accordingly so that you know at first glance that it has been amended this way.

Depending on how high you determine your volcano is, you may want to add some cloud formation around the crater (and fogging to desaturate any colors) so that it appears like the crater has a high altitude. Have a look at the cloud formation in the Mountain tutorial further on in this book, and see how the Volumetric Cloud was controlled and distributed to give an irregular shape around the mountain's peak. Don't forget though, should you want this volcano to erupt, this cloud will be quickly dispersed, so you may wish to use static particles to create the cloud formation instead, which could be affected (set in motion and fade out somewhat) around the areas where the volcano erupts.

Depending on the reference material used, you may wish to add steam emanating from the crater at the top of the volcano, and also drop in a few steam vents down the sides, to suggest that the volcano is becoming active. You may also want to add lava shooting out of the top and splattering down the sides – try creating a Particle Flow system that ejects individual particles from the crater, spawning trails as they fall, which break up on impact with the sides of the volcano. Another system could be created to handle lava flow down the side of the volcano which, if the volcano's mesh (or a low polygon version of it to increase interaction times) is used, will create natural channels of lava streams flowing from the crater down to ground level. This leads us on nicely to the Volcanic Eruption and Pyroclastic Flow tutorials later on in this book in which we will use the scene we have just constructed.

21 Lava

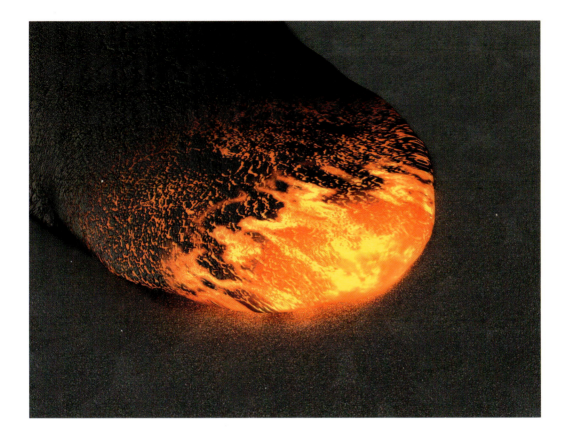

Introduction

There are a few main types of Lava flow – the most common being either the slow moving and 'bulging' Pahoehoe type or the 'rocky' A a type which forms solid blocks of lava that roll, crack and frequently break. In this tutorial, we are going to simulate Pahoehoe lava, creating the animated material and animation as it creeps across a surface. Granted, there is already an existing example of this effect on the 3ds Max CD-ROM; however, it does not show exactly how this effect really works, and mainly uses deformation and an animated object to illustrate the lava surging forward. In this tutorial we will animate the lava expanding and traveling right across the scene and, as it travels, the areas exposed to the air will appear to harden in relevant places, which will be created by setting up a complex material tree and using material blending to achieve the desired effect. As this lava progresses across the surface it will illuminate the surrounding areas, which we will use 3ds Max's GI to generate as the geometry count in the scene is not all that high, so render times will not be affected all that much.

Analysis of effect

Pahoehoe lava can form different effects

weak spot in lava crust

Image courtesy of United States Geological Survey

smoke and fire are present due to the combustible material in the road's surface

Image courtesy of United States Geological Survey

as the lava cools, it forms a thin shell which is prone to cracking, revealing the molten lava pushing through

Image courtesy of United States Geological Survey

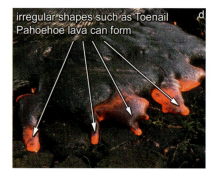

irregular shapes such as Toenail Pahoehoe lava can form

Image courtesy of United States Geological Survey

(a) Pahoehoe lava can take on many forms – from a ropy effect, swirls, coils, entrails, blisters and overlaid creases to a smooth surface, only broken up by the texture of the hardening lava. We will concentrate on the latter as it is about the most basic to set up in 3D. Analyzing the reference material, we can see that the effect is made up of three main features – the motion, the 'hot' area and the 'cold' area. The motion itself appears as if the lava is reaching out; in fact it is caused by the amount of lava behind pushing it forward. (b) Because of this, the leading edge of the lava flow does not appear to cool at all, but the surrounding areas do. Upon being exposed to air, the lava rapidly changes color and loses its glow, forming a thin crust around the exposed areas. This crust builds up gradually, hardening more and more until all of the thin glowing cracks have hardened. (c) This results in a material which appears to be solid, but can still deform – which, when it does, cracks open again revealing the molten rock inside. Because of the way the pressure from the rear end of the flow pushes the leading edge forward, irregular motion, and therefore shapes, can occur; given enough time to harden, the lava will find the weakest point in the crust to begin the trail again, therefore the trail may cease in one direction, then continue in another. (d) Just for informative purposes, Pahoehoe lava can form into 'A'a lava if the conditions are correct, from which it cannot be reversed.

As the progression of Pahoehoe lava is irregular, with it surging forward while it expands, we need to think how to generate this effect correctly. At first glance you would think that a simple animated FFD modifier would suffice to create the desired result. Unfortunately, this can stretch out the geometry so much that the end result looks slightly smeared. To get around this, we will use a particle system to generate the initial contours and motion of the lava, and use a deformed (scaled) Blobmesh Compound Object to create the final surface. As the particles travel across the surface they will leave a trail which the Blobmesh can reconstruct, therefore creating the correct shape. To add extra deformation, we can add a large Noise modifier to the Blobmesh so that it deforms further and expands irregularly as it is 'traveling'. The materials to drive the overall effect will be slightly more complex than some of the other effects, mainly because we have to get the cracking effect right to ensure the final rendered image looks convincing. To do this, we will use the map that we are going to use (partially) as the diffuse map. As this map already has cracks in it, by increasing the output of the map and clipping off the light and dark areas, we can generate a decent map to control the distribution of the glowing cracks, which should diminish (using masking) as the lava that is exposed to the air

is cooled down. Finally, as the lava will be traveling along a surface, we need to illuminate the surface slightly, which we can do using Light Tracer. Now most will know that I'm not a great fan of GI and prefer to light scenes the 'traditional' way, but in scenes like this it does have its uses as, due to the geometry count not being all that high, render times will not be adversely affected.

Walkthrough

PART ONE: First we will create the basic scene, laying out the ground, and Space Warps required to drive our particle system.

1 Enable Grid Snap and in the Top Viewport, create a Plane with a Width and Length of 1000 and label it Ground. Create a Deflector Space Warp with the same dimensions, set the Bounce to 0 and overlay it so that it is exactly over the top of the Ground plane. Select the Ground Plane and add a UVW Map modifier to it and set the U and V tile spinner settings to 20.

Information: Here we have simply created a surface for the lava to be rendered on, with a Deflector to tell the particle system, that we will create shortly, where the ground is. We could use the Plane itself as a deflector, but using the standard Space Warps, and not geometry, ensures that the particle system updates faster. The Bounce was set to O as we do not want the lava bouncing all over the place.

PART TWO: Next we need to create the initial particle system that will drop a single particle onto the Ground plane which will travel forward and create the trail we require.

2 Create a Gravity Space Warp in the Top Viewport. In the Left Viewport, create a Particle Flow particle system and label it Lava Generator. Reposition the particle system so that the entire icon is situated above the Deflector and Ground plane. In the Top Viewport, reposition the particle system so that it is to the left-hand side of the Deflector and Ground plane but is still situated over them. Set the Particle system's Quantity Viewport Multiplier to 100.

Information: We need to create a single particle to drop onto the surface, so the entire Particle Flow icon needs to be above the Deflector, so that it can rest on it, else the emitted particle may be born beneath the Deflector, in which case it will simply fall. The system was created in the Left Viewport because we need to tell the particle(s) which way to travel – in this case, the direction of the icon.

3 Press 6 or click on the Particle View button. In the root event of the Lava Generator system, turn off the Render operator. Rename the Event 01 event Particle Placement. In the Birth operator, set the Emit Start and Emit Stop settings to −30 and the Amount to 1. Remove the Speed, Shape and Rotation operators and add a Force operator. Add the Gravity Space Warp to the Force operator's Force Space Warps list.

Information: We have reduced the amount of particles to 1 as we only need one flow of lava in the scene. The negative time at which the particles were born was so that the particle simply 'appears' on the ground when we start from frame 0 (because it has been given adequate time to travel from its place of birth down to the ground) which has been made possible by introducing the Force operator and the Gravity Space Warp. Currently, the particle passes right through the Ground as there isn't anything in the particle system yet to tell it to interact with the Deflector.

4 Add a Collision test to the Particle Placement event and add the Deflector to the Deflectors list. Drag out a Speed operator to the canvas to create a new event and label the new event Travelling Particle. Wire this new event to the output of the Collision test in the Particle Placement event. Set the Speed operator's speed to 10.

Information: As soon as the particle interacts with the Deflector it is passed to the next event, where it is given a slow motion in the direction of the particle system's icon arrow. As the Gravity no longer affects the particle, we have no more need for the Collision test in this event as the particle is simply moving out in a straight line. However, should additional influences be used to make the particle's motion erratic, such as using a Wind Space Warp, then the Gravity and Deflector must be re-introduced to this event.

5 Add a Shape operator to the Travelling Particle event and set the Shape to Sphere with a size of 15. Create a Spawn test, enable By Travel Distance, set the Step Size to 0.1 and the Inherited Speed to 0. In the Display operator in this event, set the Type to Geometry to see the shape of the particles in the Viewport.

Information: In this step we have told the particle system how big the main source particle will be, which will pass the information on to the Blobmesh object, therefore telling it how big it is. As this particle will be, in essence, the leading edge of the lava flow, we need to create trailing particles of random sizes which need to grow out of the main leading particle, which will be handled by the next event. The speed inheritance was set to 0 so that the spawned particles do not drift off.

6 Drag out a Scale operator to the canvas to create a new event, label the new event Trail Scale Variation and wire this new event to the output of the Spawn test. Set the Scale Type to Relative First and Sync By to Event Duration. Go to Frame 40 and enable Auto Key. Set the Scale Factor to 110 and the Scale Variation to 50 for all axes. Turn off Auto Key. In the Display operator in this event, set the Type to Geometry to see the shape of the scaled particles in the Viewport.

Information: We have introduced the scale in this event, and not in the Spawn test, because we want the resulting shape to deform to the scale variation and not be immediately scaled, which may cause the Blobmesh object that we will create to 'jump' to fit the new particle in with the rest of the derived mesh, which will cause it to twitch. Synch By was set to Event Duration so that the new spawned particles begin to scale as soon as they have entered this event.

PART THREE: With the particle system set up, we need to smooth over the surface of the system and deform it.

7 In the Top Viewport, create a Blobmesh Compound Object. Add the Lava Generator particle system to the Blob Objects list and set the Viewport Evaluation Coarseness to 3 to match the Render Coarseness setting. In the Left Viewport, scale the Blobmesh object down vertically to about 25% and reposition the Ground plane down so that the majority of the Blobmesh is sitting on top of it, as illustrated. In Particle Flow, change the Birth operator's Emit Start and Emit End to −100.

Information: We have reduced (and therefore refined the mesh) the Viewport Relative Coarseness as we will need to add modifiers later on and ensure that none overlap the Blobmesh's geometry. If both settings are different, there is a chance that what we set up as correct in the Viewport may not hold true when rendered, so it is better to be safe than sorry. We have had to move the Ground and not the Blobmesh as the Blobmesh geometry will automatically fit the particles the next time the frame is updated or a setting amended. The Emit Start and Emit End have been set back to −100 to allow for the Blobmesh to grow first. If you scrub forward with the original settings, you will notice that the mesh grows then expands along the direction of the particle motion. This is not desirable so, by amending the birth time, enough time has been allowed for the mesh to grow.

8 Right-click the Play animation button and increase the Animation Length to 200 frames. Go to Frame 200, add a UVW Map modifier and label it Leading Edge Control. Scale the modifier's gizmo up by about 5%. Add another UVW Map modifier and label it Texture Lock. Scale the modifier's gizmo up by about 5% and set its Map Channel ID to 2. Add a Noise modifier, enable Fractal, set the X and Y Strength settings to 100 and amend the modifier's Scale setting to generate a large subtle distortion.

Information: We moved forward to frame 200 (just extending the animation purely to see the effect longer) and set the UVW mapping at that size so we can design the maps around them without having to worry about tiling. There are two UVW Map modifiers as we will need to animate the position of one to handle the glow at the front of the leading edge, and the second to keep the texture of the hardened crust in place. The Noise modifier is limited to deform only along the X and Y axis so it spreads out across the Ground. By scrubbing through the animation we can see the Noise in action as it deforms the mesh while grows.

9 Still in the Top Viewport, go back to frame 0 and turn off the Noise modifier by clicking on the lightbulb icon next to it. Go to the Leading Edge Control UVW map's gizmo and move it so that the right-hand side of the gizmo is just 'leading' the mesh. Go to frame 200 and turn on Auto Key. Reposition the gizmo so its right-hand side is in front (as at frame 0). Turn off Auto Key. Go back to frame 0, right-click the new keyframe at frame 0 and select the Blobmesh's X Position keyframe in the resulting menu. Amend the Out curve so it has a linear attack as illustrated (a

diagonal line going from top to bottom, left to right) and click on the arrow next to this curve to pass the curve type to the In curve of the keyframe at frame 200.

Information: Quite a big step, but not all that complicated. We have simply animated the position of the first UVW Map modifier and amended the keyframe curves so that the Gizmo's motion does not speed up and slow down – it now starts off straight away and finishes abruptly, ensuring that the Gizmo does not overtake the Blobmesh's mesh (which is also traveling in a linear motion by design) and vice versa.

PART FOUR: Now that we have all the geometry set up in the scene, we can create and assign materials to drive the lava effect.

10 Turn the Noise modifier back on and open up the Material Editor. In the first blank slot, create a Blend material and label it Lava. Assign it to the Blobmesh object in the scene. Label the material in the Blend's Material 1 slot Lava Shell and set its Diffuse color to black. Set the Specular Level to 40 and Glossiness to 15. Add a Bitmap map to the Diffuse slot and load in the *GRYDIRT1.JPG* file that can be found in 3ds Max's own Ground Maps folder that ships with the product. Set the Map Channel and U Tiling to 2. Label this map Shell Diffuse.

Information: As there are two main stages to the effect – the leading hot edge and the cooled shell – we need to create two materials and then blend the two together using additional maps. The Diffuse color was set to black as we will reduce the amount of the influence the bitmap has, so we get a subtle shade variation. As this Diffuse map does not follow the leading edge, the Map Channel ID is set to the number that corresponds to the Map Channel ID of the UVW Map modifier that doesn't move. The U tiling has been increased to 2 as the UVW map's width is twice the size of the height. In the screenshot, I have changed the particle system to display ticks so that we can see the entire shaded mesh, and the Show Map in Viewport has been enabled for this map so we can see it in action.

11 Back up at the top of the Lava Shell material, set the Diffuse slot's amount to 10. Copy the Diffuse slot to the Bump slot and set the Bump amount to 50. Label the new Bitmap in the Bump slot Lava Shell Bump. Enable Color map in the Output rollout and amend the Color map to that illustrated.

Information: We create a copy of the Diffuse map, not an instance, as we need to amend the properties of the map. The output Color map was edited by adding a couple of extra points and making a hard linear step to create a harsh transition from light to dark, therefore making the bump a lot more crisp with the raised areas more distinguishable.

12 In the Lava Blend material go to the material in the Material 2 slot and add an Advance Lighting Override material. Label it Lava Illumination Intensity and set the Luminance Scale to 10. Go to this material's Base Material and label it Molten Lava. Turn on Self-Illumination and set it to RGB 255,75,0, set the Specular Level to 40 and the Glossiness to 15.

Information: The Advanced Lighting Override material has been introduced purely to tell Light Tracer (which we will enable shortly) that the light being emitted from its Base Material is 10× stronger than normal. Illustrated in the reference material, the molten lava has a specular highlight roughly the same as the hardened shell, therefore this material's Specular Level and Glossiness have been set to the same settings as the Lava Shell material. Even though we will replace the Self-Illumination swatch with a map, Light Tracer and the Advanced Lighting Override material still take this into consideration.

13 Expand the Maps rollout, add a Noise map to the Diffuse slot and label it Molten Lava Color. Set the Coordinates Source to Explicit Map Channel and the Map Channel ID to 2. Set the U Tiling to 2 and change the Noise Type to Fractal. Set the Noise Size to 0.1 and Levels to 10. Set the Color 1 swatch to RGB 255,0,0 (red) and Color 2 to RGB 255,130,0 (orange). Turn on Enable Color map and design the Color map, as illustrated.

Information: This map is also locked to the static UVW Map modifier that is assigned to the Blobmesh object in the scene. The weird looking Color map, with its peaks and troughs, creates a fiery pattern with varying intensities.

14 Back up at the top of the Molten Lava material, instance the Noise map in the Diffuse slot into the Self Illumination slot. Set the Bump amount to 999 and add a Mix map to its slot. Label it Molten Lava Bump, set the Mix Amount to 50 and Instance the Molten Lava Color Noise map into the Color 2 slot.

Information: The high amount of bump has been used to pick out the detail of the two mixed maps, creating a fiery texture. These additional maps will control the bump around the blend, such as in the cracks and any extra larger cracked areas we introduce.

PART FIVE: With the key elements of our material set up, we now need to blend the two together so that they are mixed correctly and that the Bump maps show indentations around the blending areas.

15 Add a Mix map to the Color 1 slot of the Molten Lava Bump map and label it Cracks Mixer. Add a Mask map to its Color 1 slot and label it Small Cracks Mask. Copy the Lava Shell Bump map into the Map slot of this Mask map and rename it Small Cracks. In the Output rollout, enable Invert and amend the Color map as illustrated.

Information: The additional Mix map is introduced so that we can mix together the small cracks created by the amended copy of the bump map from the Lava Shell material (which has been amended to make a slightly more gradual transition from light to dark, and inverted so that the cracks are white, which when used as a Bump map, means they are indented) and another map we have yet to introduce. This Small Cracks map will be masked so it does not cover the entire object, only a portion which we want.

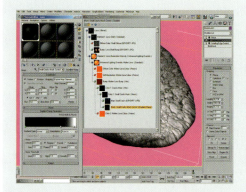

16 In the Small Cracks Mask's Mask slot, add a Gradient Ramp map and label it Small Cracks Mask Control. Move the flag at position 50 to position 70 and set its color to black. Add another flag at position 96 and set its color to white. Set the Interpolation to Ease In.

Information: As the UVW Map gizmo with Map Channel ID 1 follows the deforming Blobmesh across the scene, the Gradient Ramp map, which is also set to Map Channel 1, follows accordingly, therefore drawing out and fading out the static Small Cracks map in the Small Cracks Mask's Map slot.

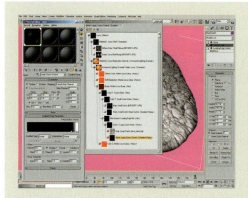

17 In the Mix slot of the Cracks Mixer map, add a Mix map and label it Leading Edge Mix. In the Color 1 slot, add a Mask map and label it Large Cracks Mask. Add a Bitmap map to its Map slot, load in the *lava_noise.jpg* bitmap from this tutorial's Source folder on the DVD and set its Map Channel ID to 2. Expand the Output rollout and set the Output Amount to 2. Label this map Large Cracks. Add a Gradient Ramp map to the Large Cracks Mask map's Mask slot, label it Large Cracks Control, move the flag at position 50 to position 87 and set its color to black. Add a flag at position 97 and set its color to white.

Information: A large step, but still relatively self-explanatory. We have added another Mix map to control the leading edge intensity, and to get it to break up into large cracks by using a bitmap which is masked out by a gradient. As with the other gradient, this one also follows the growing Blobmesh, so therefore 'draws out' and fades out the bitmap. The bitmap itself is a straight render of a Noise map. This is used instead of a Noise map because in 3ds Max they work in 3D space, and as the underlying geometry is deforming, the map changes, even if it is held in place using a UVW Map modifier which would generate a rippling effect which is not what we want.

18 Add a Gradient Ramp map to the Leading Edge Mix map's Mix slot and label it Leading Edge Control. Move the flag at position 50 to position 91 and set its color to black. Add a flag to position 98 and set its color to white. Navigate right back to the top of the material tree and instance the Cracks Mixer map into the Lava material's Mask slot. Perform a quick test render in the Perspective Viewport to check if the material is set up correctly.

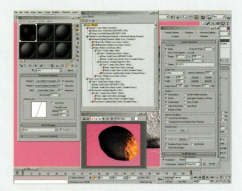

Information: The final Gradient Ramp map mixes a solid white color with the masked noise map, therefore creating a solid white leading edge which breaks up into the noise. The entire Cracks Mixer tree is used to control the blending of the two materials together as this tree creates the cracks in the Bump map for the Molten Lava material and therefore can be used to drive the blending of the materials. This results in an interesting effect, where the cracks display the Molten Lava material and are also indented by the corresponding copy of the map tree in the Bump map.

PART SIX: Finally, we can assign a material to the Ground plane and illuminate the scene with 'sunlight' and use Light Tracer to generate illumination underneath the leading edge of the lava flow.

19 In a new material slot, load in the Concrete_Asphalt material from the standard 3ds Max material library and assign it to the Ground Plane. In the Top Viewport, create a Skylight light. Also in the Top Viewport, create a Direct Light, enable Shadows and set its Multiplier color to RGB 255,245,232. Enable Overshoot, go to frame 200 and set its Falloff/Field so that it encompasses the entire Blobmesh. Set the Shadow Map Bias to 0.01 and Size to 1024 and, in the Left Viewport, move the light upwards so it represents the Sun's position at roughly 11 a.m.

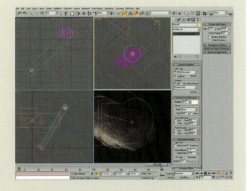

Information: The Skylight light is purely used to create Global Illumination from a simulated sky, tinting the scene slightly blue. The Direct light we have just created will simulate the main key light in our scene, namely the Sun. The Shadow Map size has been increased to add more detail to the shadow and also to make it more hard-edged, like shadows cast by the Sun. The Falloff/Field has had to be increased else shadows will not be cast outside this area, and Overshoot enabled so that the rest of the scene is illuminated with the light, even though shadows are still confined to the Falloff/Field boundary. To ensure the object is properly situated inside the Falloff/Field boundary, try changing one of the Viewports to the Direct light so you can see exactly what the light sees. You can then reposition and/or amend the light's settings as necessary.

20 Open up the Render Panel and go to the Advanced Lighting tab. Select Light Tracer from the pull-down menu and increase the amount of Bounces to 1. Render off the animation with the trailing end of the lava just off frame so it appears as if the lava has originated from a distance away.

Information: The final step. Enabling Light Tracer is a simple procedure, but configuring it is a whole different area – see the online help that ships with 3ds Max for more information. Suffice to say, the end (rendered) result is convincing, especially as the lava appears to grow from the leading edge and spread out. The additional bounce in Light Tracer generates the glow underneath the leading edge; should you feel that this is too intense, reduce the amount we set in the Advanced Lighting Override material. Also, if you feel it is taking too long to render, reduce the amount of Rays/Sample in Light Tracer, although this will reduce the quality of the bounced light.

Taking it further

The main problem we have is the amount of texture stretching at the front of the lava flow. This is due to the planar mapping used for the main texture of the lava crust and also for the noise Bitmap map.

Referring back to the reference images, you will notice that this type of lava can form very interesting shapes. Again, as we have produced the animation using a particle system, the sky is pretty much the limit as to what shapes we can create – it's just a simple case of modifying the particle system and the geometry will be automatically amended due to the Blobmesh object 'covering' it. Try creating an effect such as Toenail Pahoehoe lava trails by creating an animated scale of the trailing particles, and get the particles to divide into multiple trails to create the individual toenails. The main problem would be in the application of the mapping – but this could be worked around using multiple animated mapping Gizmo's to control the positioning of the hot areas, or these areas could be defined by creating an animated map mix from the source geometry using particle age to create a gradient through the trailing particles, which is then used in the material assigned to the Blobmesh object. Alternatively, creating and animating light positioning will also generate the desired gradient which may yield better results.

Depending on what type of surface the lava is passing over, there may be the occasional burst of flame, or even constant licks of flame around the leading edge of the lava trail. Depending on the material, different smoke, as illustrated in the reference material, will rise from the leading edge and from the lava trail itself. To create this, try using a Volume Select modifier on the Blobmesh object, using the main lava Blend material's Mix map to generate the selection. From this, an additional particle system can be created and used to generate the fire and smoke. As this map follows the leading edge, the selection will follow this edge and gradually trail off, therefore confining the fire and smoke to this area. Alternatively, increase the amount of detail in the ground plane and use an animated selection method on it, so that fire and smoke emit directly from the burning ground material.

22 Grass and dirt

Introduction

Personally, I don't like gardening. Maybe it's because my fingers aren't green enough or I'm developing an allergy to natural light or something, but I just don't feel the call to tend the earth outside my house. I'm 'giving it back to nature'! This tutorial originated from one of the times I was dragged (kicking and screaming) outside to cut the grass and, while trying not to run over the electric cable (never done THAT before, honest!), noticed how the soil intermingled with the grass; there wasn't a fade or linear transition from grass to soil, but each one reached out to the other along the cracks in the ground. The result is this tutorial. Which reminds me. Better finish mowing the lawns at some point this year!

Analysis of effect

terrain can dry up and crack due to lack of rainfall causing broken areas in the turf

constant wear and tear on the turf can kill off the root and lead to barren patches snaking their way into the main body of the turf

even on cultivated turf, leave it to grow for a while and longer blades of grass become more visible, plus the occasional weed takes root

clumps of grasses are most visible on wild or un-tended turf; this is a cultivated area which has not been tended for many months

(a) The main things to concentrate on are terrain surface, color, clumping, length and distribution, the surface can be rather irregular, which has an adverse effect on distribution. For this example, we will assume that the soil has dried out. Originally, the soil would have simply cracked due to the lack of moisture, but as moisture returns, because of the collation of water in these cracks grass begins to thrive again in these areas, before spreading outwards. (b) Unless the grass is watered regularly, we tend to get intermittent patches of turf and dirt. These patches are normally the cause of the grass roots losing moisture and the soil drying out. An additional cause would be due to excessive 'wear and tear' on the grass; for example on the verge next to a footpath. The surface grass would be worn down so much that it dies back, and the only remaining living grass in this area would be in the cracks where no-one has trodden on it. (c) The length of the grass is not consistent; we get large and small clumps of similar grasses, and the occasional blade that grows twice as fast and twice as high as the rest. There is a general consistency in color across the terrain, depending on if the grass was manually sown or not. (d) Maintained areas, such as lawns and playing fields, normally consist of one or two varieties of grass, to give an unbroken stretch of color, but if it is wild then many different types will populate the surface leading to a range of different shades, styles and textures. This entire section, plus these images, may sound like a gardening lesson, but it is important to understand the distribution of the grass as we will need to use this knowledge shortly.

The two materials for the grass and dirt will come straight out of the 3ds Max standard library; materials which have been used time and time again, but hopefully when we have finished with them they will not be all that recognizable. Using an amended copy of the dirt texture in one of the materials, we can use a gradient to control the main legwork of the transition, with the cracks in the dirt enhanced and used to fade (in places) from one material to the next (with additional noise from the gradient used to break it up a little). This transition map will be used as a map to control the blending of the two materials, each of which will have material displacement from their own diffuse texture, or an adaptation of it. We will also load in and distribute (using the Blend map we have created) blades of grass, which were created in an additional tutorial, to add extra detail. These individual blades will be added using a Particle Flow system, which will use the gradient we have generated to distribute particles based on it's

grayscale information. We can also break the gradient up a little using a couple of Noise maps to create clumps of grass, which will be generated by a bolted on section to the particle system that utilizes some of the existing settings.

Walkthrough

PART ONE: First we will create the basic geometry for the terrain and assign relevant modifiers to aid the material displacement.

1 In the Top Viewport, create a Plane primitive and label it Grass Distribution. Set the Length to 700 and Width to 800, with both Length and Width Segs set to 5. Add a Noise modifier to the Modifier Stack and set the Scale to 200. Enable Fractal and set the Roughness to 0.3 and the Z Strength to 10.

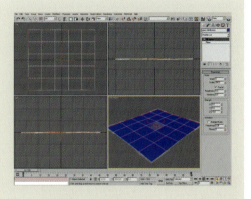

Information: Here we have created a basic low polygon terrain for our grass to be emitted onto. As we are going to be using particles (as described in the analysis) we do not need the geometry to be too high. We have, however, deformed the shape a little so it is not totally flat.

2 Instance this object and label it Grass Clumps Distribution. Reference copy either one of the instances and label it Grass and Dirt. Select both of the instances, right click and select Properties. Turn off Renderable. Select the Grass and Dirt object and add a Tessellate modifier to the stack above the Reference line in the modifier stack. Set the Iterations to 4. Finally, add a Disp Approx modifier to the stack and click on the Low Subdivision Preset.

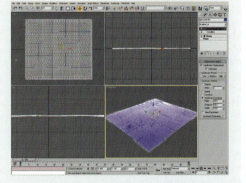

Information: We have used instances for the two emitters as they can both be low polygon geometry. The renderable reference copy has had its geometry refined using material displacement (controlled by the Displacement Approximation modifier – set to low for the time being; depending on the speed of your machine you may want to turn this up later on) so there are enough polygons for the material displacement to work with so it looks effective (else the displacement will just be a bit of a bulge). We have used a reference copy for the rendered version as we can amend the geometry of the base plane(s) if we want to change the shape of the terrain. This amendment goes to the instances and the reference copy automatically.

PART TWO: The final thing to do to set up the scene is to create lights and a camera and position them.

3 Right-click the text in the top left of the Perspective Viewport and select Show Safe Frame. Rotate and Pan this Viewport until the entire Grass and Dirt plane fills the Viewport completely. Press CTRL+C to create a Camera from this view. Drag out a Direct light in the Top Viewport so that its target is in the center of the plane geometry. Label it Sun and reposition it vertically in the Left Viewport so that it is simulating light in the early morning, as illustrated. Enable Shadows and set the light's color to RGB 255,243,232. Increase the Hotspot/Beam so it (and the Falloff/Field setting) completely encases the plane geometry. Set the Shadow Map Bias to 0.001 and the Size to 1024.

Information: We have enabled the Safe Frame so we can see what the frame will look like with the render settings (the output canvas size) applied, so when we create the camera we do not have any background showing. A Direct light is being used as its shadows are cast linearly – they do not fan out like Omni or Spot lights which suggest that the light is at a close proximity. The Hotspot (and therefore the Falloff as it increases this setting as well) has been extended, else the intensity of the Hotspot will fade away to the Falloff's distance. It has also been extended so that the Falloff setting is outside that of the plane geometry, as this setting/boundary is the limit as to where shadows are cast for this light. The Shadow Map Bias has been reduced to pull in the shadows tight around the objects that cast them (as we are going to be having a lot of small objects in this scene), and the Size has been increased to add more detail.

4 Enable Grid Snap (if not already enabled) and in the Top Viewport, create a Target Direct Light to the left-hand side of the planes and drag its target to the center of the scene. Enable Shadows, set the Multiplier to 0.04 and color to RGB 178,222,255. Enable Overshoot and set the Falloff/Field to 700. Turn off Specular, set the Shadow Density to 0.6, Shadow Map Bias to 0.01, Size to 256 and Sample Range to 4. Still in the Top Viewport, instance the light so that it is the same distance from the planes on the top side, so that it is at right angles to the original. Reproduce this so you have four lights all at right angles to one another.

Information: We have used low intensity lights due to the final amount that we will be using in the scene. If the light intensity is too high, the entire scene will be washed out. We do not need specular highlights from each light in our array so this option is turned off. The Shadow Map Size was reduced to keep rendering times down.

5 Enable Angle Snap and set the angle snap setting to 2.5 degrees. Select all of the four instanced lights and rotate clone them three times by 22.5 degrees to form a complete ring of lights. Select all of these lights (not their targets) and in the Left Viewport move them up slightly. Shift-move them to clone a new ring so the new ring is positioned above the original. Perform this task another couple of times to create another ring of lights and another one beneath the plane, pointing upwards.

Information: A lot of lights have been introduced to create a global illumination lighting effect, with multiple lights emitting multiple shadows. Because of the number of shadows in the scene coming from all directions, the collation of shadows around detailed areas, such as the bases of the displaced dirt and blades of grass, will ensure that these areas become slightly darker thanks to the amount of shadows being cast upon them. However, due to the geometry count, this will crank up the render time, so you may wish to turn off the shadows for some of the lights (you will have to make these unique in order to do this else all of the shadows will be turned off). Alternatively, reduce the size of the shadow map further to speed up render times or even halve the amount of lights in the lighting rig; in which case increase the Multiplier of the remaining lights accordingly.

PART THREE: With the scene elements complete, we will now set up the materials for our terrain blending.

6 Open the Material Editor and create a new Blend material to the first available material slot. Label it Grass and Dirt and assign it to the Grass and Dirt object in the scene. Add the Ground_Grass material from the default 3ds Max material library to the Material 1 slot. In this material, copy (not instance) the Diffuse map to the Displacement slot and set the Displacement amount to 30. Go into this map and set the Blur Offset to 0.02.

Information: We are using the standard materials from the 3ds Max library purely to save time. If you feel that this material is not up to scratch later on, try replacing the texture with some of your own. We have blurred the displacement map so that the displacement does not appear jagged.

7 Add the Ground_Grey_Dirt2 material from the default 3ds Max material library to the Material 2 slot of the Grass and Dirt material. Set the Displacement slot's setting to 10 and add an Output map to this slot. Instance this material's Diffuse map into the slot in the Output map, and label the Output map Dirt Displacement. Expand this map's Output rollout, turn on Enable Color map and amend the curve as illustrated.

Information: 3ds Max allows us not to be 'destructive' with our scene if we can help it – for example, cloning an instance of the map within another map, which is what we have done here. We need to clip off the dark and light regions of the texture to add more definition to suggest where the cracks are in the texture which, by amending the Output map, is what we have achieved.

8 At the top of the material tree, add a Gradient Ramp map to the Mask slot of the Grass and Dirt material and label it Grass and Dirt Mixer. Set the W Angle setting to 90. Reposition the flag at position 50 to position 37 and set it to black. Add additional flags at positions 59 and 83 and set them to RGB 114,114,114 and white accordingly. Set the Noise Amount to 0.4, enable Fractal and set the Size to 2 and Levels to 4. Right-click the flag at position 59 and instance the Dirt Displacement map to its Texture slot.

Information: We have designed a transition from one material to the next, using a Gradient Ramp map because it allows us to insert textures as flags within the gradient. Instead of using a fade from one color to the next within the gradient, we have used a fade which includes the intensified dirt texture. Because of this, the cracks in the texture are added to the mask, so the grass texture (the black area in the screenshot) fades into the cracks of the dirt texture.

PART FOUR: Next we will create and assign materials to the particle emitters.

9 Label a new material Grass Distribution and assign it to the Grass Distribution object in the scene. Add an Output map to the Diffuse slot of this material, label it Material Blend Invert, expand the Output rollout and enable Invert. Instance the Grass and Dirt Mixer map to this map's Map slot.

Information: As the particle system we are going to create distributes particles based on grayscale maps, we have to invert the map as the grassed area is controlled by the black area of the gradient. However, as this is controlling the other material, which we do not want to mess up, we can simply invert it by adding it to an Output map that has the ability to invert a map's colors. Even though the Grass Distribution object is not able to be rendered, it still has to have the material assigned to it so that the particle system can grab the grayscale information of the material assigned to it.

10 Label a new material Grass Clumps Distribution and assign it to its namesake in the scene. Add a Mix map to the Diffuse slot, label it Grass Clumps and instance the Material Blend Invert map to the Mix Amount slot. Add a Noise map to the Color 2 slot of the Grass Clumps map and label it Clumps Breakup. Set the Source to Explicit Map Channel, set the Noise Type to Fractal, Size to 0.06, High to 0.65, and Low to 0.649. Expand the Output rollout, turn on Enable Color map and set the curve, as illustrated, so it clips off the dark and light areas of the map. Copy this map to the Color 2 slot, go into the copy, label it Clumps and set the Size to 0.03.

Information: We still want the clumps of grass to be distributed in the same area, but we also want them to be restricted to small patches. Therefore the initial Noise map breaks up the light area of the (inverted) gradient, and the small Noise map creates small patches in the remaining light areas. The result is an irregular distribution (due to the nested Noise maps) that is only in the grassed areas, be it in the main grassed area or in a crack in the dirt where other grass is 'growing'.

PART FIVE: Finally, we will load in some grass geometry and materials and design a particle system to distribute the blades of grass across the terrain.

11 Merge in all of the Grass objects in the *Earth/22_Grass_and_Dirt/Source/grasses.max* file included on the DVD-ROM. In the Material Editor, select a new material and click on the Pick Material From Object button and select the Grass01 object to load in its material into the Material Editor. In the Top Viewport, create a Particle Flow system and label it Grasses.

Information: The grass objects we have loaded have been extracted from the result of a tutorial in this book, in which we create and distribute the grass over a different terrain using a similar technique. We have extracted the Grass01 material as we will be using it for the clumped grasses later on (add the Source folder as a map path if the grass maps are not correctly loaded).

12 Open Particle View and rename Event 01 to Grass. Select the Birth operator and set the Emit Stop to 0 and Amount to 10000. Remove the Position Icon, Speed and Shape operators. Add a Shape Instance operator, click on the None button and select the Grass01 object in the scene. Enable the Object and Children options, set the Scale to 20 with 50 Variation and enable Multi-Shape Random Order. Add a Position Object operator and add the Grass Distribution object to its Emitter Objects list. Enable Density By Material and enable Delete Particles in the If Location is Invalid group. In the Rotation operator, set the Orientation Matrix to World Space, set the X setting to 90 and Z to 360 with 90 Divergence, enable Restrict Diverg. To Axis and set the X and Y Divergence Axis to 0.1 and Z to 1.

Information: Here we have used the grayscale information of the Grass Distribution object to distribute our particles (grass). Because all of the source grass objects are linked to the Grass01 object, we only need to add this parent object as we can set the particle system to use the child objects automatically. We have used Multi-Shape Random Order to distribute the blades of grass randomly, instead of doing it in order. We have had to amend the Rotation operator to get the blades of grass orientated the right way, and also to allow some random rotation so they are not all facing the same direction. To see the grass in action (well, 50% of it anyway as we have a Viewport % reduction set to 50%), set the Display operator to display geometry.

13 Turn off the particle system, copy and Paste Instanced the Grass event. Rename the copy Clumps and wire it to the output of the Grasses root event. Make the Birth, Position and Display operators unique and change the color of the particles in the Position operator. Set the Birth operator's Amount to 2000. In the Position Object operator, remove Grass Distribution from the list and replace it with Grass Clumps Distribution. Add a Scale operator and turn off the Scale Factor's Constrain Proportions. Set the Y and Z Scale Factor settings to 30 and the Scale Variation for all axes to 20. Add a Material Static operator to the event and instance the Grass01 material from the Material Editor to the slot in this operator.

Information: Again, instancing the original settings allows us to share settings across two objects. However, there are some elements in the particle system which we need to make unique, such as the emitter object. We did not need to make the particle type unique because of the Scale operator – using this, we can simply overwrite the scale set in the Shape Instance operator. As, by default, the Shape Instance operator uses the source geometry's material, we need to overwrite this again (as we do not want to break the instance) with the sampled Grass01 material; most clumps of grass are of the same type of grass (as illustrated in the reference material), therefore a single material can be assigned.

14 Turn the particle system back on. Select the Distribution planes and the Grass objects and hide them. Render off the scene using a small canvas setting. You may feel that the dirt is too light due to the amount of lighting in the scene. If this is the case, reduce the Diffuse map's RGB Level to 0.7 or 0.6. You may also want to increase the detail in the material displacement; if so, choose another preset in the Displacement Approximation modifier.

Information: Just a quick step to tidy up the scene at the end of the construction process. Even though the distribution objects are not renderable, it is always best to hide non-required objects so as not to clutter up the scene. Didn't your mother ever teach you to clean up after yourself?! Performing a low resolution test render is always essential to check out any problems. I'd advise you to disable the particle system first before rendering to check out the displacement and lighting, and once this is deemed to be okay, turn the particles back on and render away.

Taking it further

The main thing that we could do to improve our scene is to add some extra debris to it, such as rocks situated in and on the surface. Depending on how they are positioned and how long they have been there, the grass may have grown around the sides of the rocks, so we will have some strands of grass in those areas pointing away from the rock. If the grass gets cut, there may be longer strands of grass around these rocks where the blades of the grass cutter/mower could not reach. If the rock is partially buried in the ground, then we may just see the top of it peeking through, with dirt over the areas where the two items would intersect. The grass around this area would not be deformed, but it can't grow over the surface of the rock, so a map designed to reduce the amount of particles around the intersecting rock would have to be introduced.

Currently, the scene only extends to the extremities of the rendered frame. Extending it should not be a problem, as it is simply a case of increasing the geometry size and therefore having to tile the textures else the grass will look tiny (plus spread out thinly) and the dirt cracks and grass texture huge. However, we will come across some tiling and repeats in the texturing and displacement. Therefore, try mixing multiple grass and dirt texture maps and introduce additional gradients, to blend with the current one, to control the transition from grass to dirt and vice versa.

Try adding additional plant life to the scene, maybe a few wild flowers that could be simple low polygon geometry, and could be controlled by a separate distribution map so they are scattered (in small bunches of about three to six flowers) irregularly over the scene. As we are using maps to control the distribution of our grass and, should you decide to introduce it, flowers, you could create a whole image of flowers or grasses based on this technique, using different grasses for red green and blue colors so you could even do a representation of a Van Gogh in dirt, grass and flowers with enough scattered objects … might take a little while to render though!

Don't forget that from 3ds Max 7.5 we also have access to Hair and Fur which opens up a whole new area for creating foliage, so it would be advisable to look into this as a solution for any further advanced scenes, such as getting the plants to be affected by winds.

So the next time you're asked 'politely' to mow the lawn, you have a valid 'can't – it's research' excuse.

23 Grasses

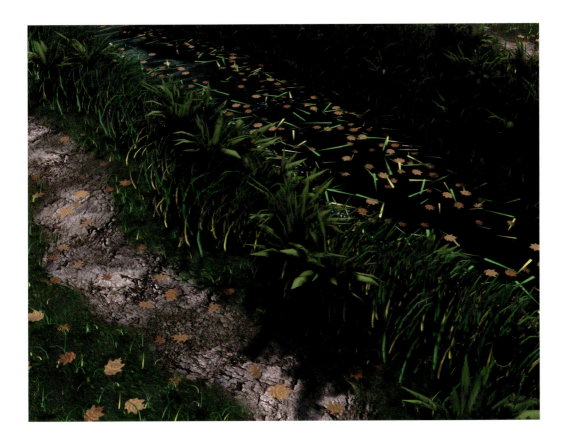

Information

This tutorial is a continuation of the Moving Surface Water tutorial earlier on in this book, in which we generated a moving surface and slow moving body of water. In this tutorial we will take the scene that we developed (or load in the finished file provided) and add a grass bank either side of the water that consists of a mass of uncut grasses around the sloping bank and irregular tufts of grass around a towpath that runs alongside the canal. To create these effects we will use a combination of basic deformation modeling, materials, displacement and particles.

Analysis of effect

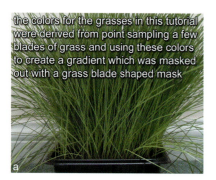

the colors for the grasses in this tutorial were derived from point sampling a few blades of grass and using these colors to create a gradient which was masked out with a grass blade shaped mask

a

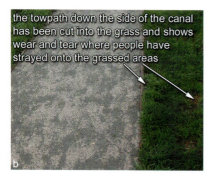

the towpath down the side of the canal has been cut into the grass and shows wear and tear where people have strayed onto the grassed areas

b

because of lack of maintenance on the banks of the canal, a wide variety of long grasses and plantlife has grown

c

just some of the debris that is either floating on top of or is just slightly submerged beneath the (virtually) static waters of the canal

d

(a) For this section of the tutorial we are going to continue basing the effect on the same reference scene. The reference material provided concentrates more on the grassed areas and not so much on the water effect, as this has already been covered, however there is some material pertaining to this effect as we need to sort out any additional floating debris in the water. First of all we have a footpath which will have to be channeled into the grass so that it runs alongside the canal. As this is a public footpath, it will be well used and worn, so the sides of the path will be ragged somewhat. (b) The first type of grass is a short type that appears to be maintained. This is almost the same color throughout without much patchiness (this is covered in the Taking it further section), however it does contain a few clumps of grass where the surface has not been all that well maintained. (c) The grass itself will be cut using certain equipment that will not be suited to cut at angles, therefore the grasses along the dipping bank of the canal will be much longer than those alongside the path. As these long grasses have been left to grow wild for a substantial amount of time, we will have large clumps of similar grasses/plants mixed in with different varieties of grass which have spread over the surface, leading to a mixture of different greens over the banks. (d) Due to the close proximity of these long grasses to the water, some blades of grass will die and fall into the water. Again, as with the leaf debris in the first tutorial, this floating grass debris will stay rather close to the bank as the water does not move very fast at all; the surface may move quickly due to the winds, but this does not affect the motion of the debris which will just pass over the displacement without moving laterally, and will just rotate ever so slightly.

After loading in the initial scene – the final scene from the first part of this tutorial – we can take the original water geometry and modify it to form one of the banks, by using basic deformation to create the curved side. After which we will create a channel along the middle of the top of the bank using displacement, which we can also use as a Mix map to control the blending of two materials – the grass and dirt materials. The grass clumps and long grassed areas will be distributed using particles based on greyscale information of materials assigned to cloned copies of the bank which will be used as distribution objects. The grasses themselves will be simple low polygon deformed planes that we will assign pre-created textures to, then deform and replicate to create different versions of the material to assign to different designs of grass. Finally, we will use an adaptation of the existing debris particle system to create the floating debris from the long grasses using instanced geometry and random material assignment on the distributed particles.

Walkthrough

PART ONE: First we will load in the previous scene and create the banks of the canal by modifying the existing water geometry, and deforming all of these planes to put a few subtle bends in the canal.

1 Continue with your existing scene from the Moving Surface Water tutorial (number 14) or load in the *Earth/23_Grasses/Source/23_grasses_start.max* file included on the DVD-ROM (this file is identical to the Moving Surface Water's Finished file). Turn off the existing particle system and hide the lights. Copy the Water Surface object, move it vertically up 2300 units in the Top Viewport and label it Bank01. Remove all four modifiers from this copy. Open the Material Editor, select a blank material, click on the Get Material button and drag the NONE material to the Bank01 object.

Information: To ensure everything is lined up, we can simply copy the existing geometry and modify it slightly. We have removed the material from the copy just to keep things neat. We have also turned off or hidden unnecessary objects that would obscure our view or take time to update when we are working in the Viewport.

2 Set the Length of the Bank01's plane to 3000 and set the Length Segs to 60 to keep the iterations more or less square. Add a UVW Map modifier to the stack. Go into its Gizmo sub-object and rotate the gizmo 90 degrees anti-clockwise. Click on the Fit button to get the gizmo to fit the mesh again. Next, add an FFD(box) modifier and click on the Set Number of Points button. Set the Length Points to 6 and the others to 2. In the Left Viewport, select all of the FFD modifier's Control Points apart from the ones over the water object, raise them by about 400 units and move them in a little before dropping the end one down a bit to create the curved bank as illustrated.

Information: We have rotated the UVW Map gizmo as the gradient we are going to use to control the material blending runs lengthways down the UVW Map, therefore needing to be

positioned in the right place (we could also have left the gizmo the way it was and rotated the map instead by amending a setting in the map's Angle setting). We have placed the map beneath the FFD modifier so the map could be deformed as well. If we had placed it on top of the FFD modifier the planar map would be smeared down the side of the bank instead. We have reduced the amount of points in the FFD modifier as we did not need them. You can only go as low as two points – one for each end of the object. When deforming the object, ensure you have both points selected by marquee-selecting all relevant points and not just CTRL-clicking individual ones in the Left Viewport, else you may not select both points on either end of the object, which is what is required.

3 Add a Displace modifier to the stack, set the Strength to 30 and enable Use Existing Mapping. Open the Material Editor and create a new Gradient Ramp map in an available material slot. Label this map Footpath and set the V Tiling to 3. Set the Noise Amount to 0.03 and enable Fractal. Set flags 0 and 100 to white, relocate the flag at position 50 to position 46 and create flags at positions 43, 57, and 60. Set the flags at positions 43 and 60 to white (100 is already white) and the others to black. Instance this map to the Map slot in the Displace modifier. In the Left Viewport, drop this object down about 20 units.

Information: We are using the gradient to create a channel in the deformed plane; actually, we are leaving the channel where it is and displacing everything else on the plane as we have got a white exterior to the gradient (displaced) and a black channel (not displaced). We have enabled Use Existing mapping so that the deformed mapping displaces the geometry outwards and not just upwards. We have dropped the Bank down so that it fully intersects the water.

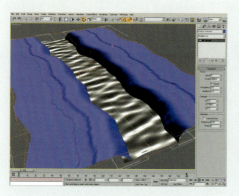

4 Add a Noise modifier to the stack and set its Scale to 560. Enable Fractal and set its X and Y Strength settings to 100. Select Pick from the Reference Coordinate System menu and choose the Water Surface object to place it as an option in the Reference Coordinate System menu. Change the Use Pivot Point Center to Use Transform Coordinate Center and, with Bank01 still selected, and Water Surface selected in the Reference Coordinate System menu, click on Mirror.

Select Y as the Mirror Axis, Copy in the Clone Selection group and click OK to accept these settings. Change the Use Transform Coordinate Center back to Use Pivot Point Center, unhide the Water Debris Distribution and select it, plus the two Banks and the Water Surface plane. Assign a Noise Modifier and set the Scale to 3000. Enable Fractal and set the Iterations to 2 and the Y Strength to 1000. Hide the Water Debris Distribution object again.

Information: The first Noise modifier is designed to add some irregularity to the shape of the bank by using a low intensity noise. We have changed reference coordinates so that we can use the Water Surface's pivot point as a mirror axis for the copy of the bank. We have copied, and not instanced or referenced, the original Bank object as we need to apply a Noise to both of them, and the water, so that they all deform together to create an irregularly shaped terrain which the canal flows through. If we used a reference or instance, the result would be a mirror of the Noise which would bring in the sides of the canal which is not what we want.

PART TWO: With the bank geometry set up, we will use the map designed to generate the path trench to mix two standard library materials together (the grass and dirt) and assign them to the Bank objects.

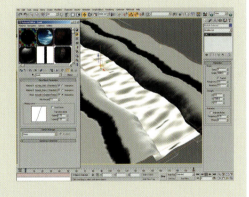

5 Open up the Material Editor and add a Blend material to an available material slot. Label it Bank. Instance the Footpath map into its Mask slot. In this material's Material 1 slot, add the Ground_Grey_Dirt2 material from 3ds Max's default materials library and add the Ground_Grass material to the Material 2 slot from the same library. Assign this Blend material to the two Bank objects in the scene.

Information: We are going to start off with an existing material setup that has the basic parameters already established for us. After which we can modify these quite easily to remove any repetition in tiling texture, and to tint the maps slightly in places if desired.

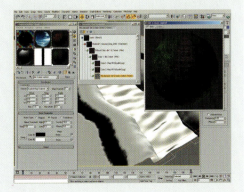

6 Go into the Ground_Grey_Dirt2 material in the Material 1 slot of the Bank material and click on the Bitmap map in the Diffuse slot. Click on the Bitmap button in this map, add a Mix Map to this slot and Keep the existing map as a sub-map when prompted. Name this map Dirt 1 & 2 Mixer. Click on the Bitmap map in the Color 1 slot and add another Mix map, keeping the old map as a sub-map again. Label this new Mix map Dirt 2 Mixer. Copy the Bitmap map in the Color 1 slot to the Color 2 slot. In the

Bitmap map in the Color 1 slot, set the U Tiling to 6 and the V Tiling to 18. In the Bitmap map in the Color 2 slot, set the U Tiling to 4 and the V Tiling to 12. Expand the Output rollout for these two Bitmap maps and set the RGB Offset to −0.2. Add a Noise map to the Mix map slot and label it Dirt 2 Mixer Control. Set the Source to Explicit Map Channel and set the V Tiling to 3. Set the Noise Type to Fractal with a Size of 0.06, High of 0.7, Low of 0.3 and 10 Levels.

Information: Here we have created a map tree, forcing the original map as a sub-map several times as we need to mix it to remove any tiling repeats. The map has to be tiled else it will appear too big in the scene, giving the impression that the scene is very small. Therefore, to remove the tiles, we mix two copies of the same map – one with a low tile and one with a higher tile. The RGB Offset has been reduced to darken the map down a little without having to re-edit the map. Using the Noise map we can mix the two maps together at random therefore creating a map with no visible repeats. The Noise map has its High and Low settings amended to clamp off and fade from one color to the other, and therefore one map to the next, else it would just smudge the maps together. Each map is tiled in a multiple of three as the Bank objects are just over three times longer than they are wide.

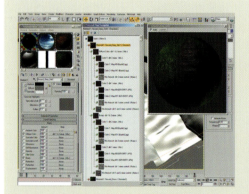

7 In the Dirt 1 & 2 Mixer map, copy the Dirt 2 Mixer into the Color 2 slot and label it Dirt 1 Mixer. Replace the file in both of the Bitmap maps in this Mix map's Color 1 and 2 slots with the *grydirt1.jpg* file that comes with 3ds Max. Rename the copied Dirt 2 Mixer Control to Dirt 1 Mixer Control, set the Size to 0.05 and the Phase to 5. Copy this Noise map into the Mix slot of the Dirt 1 and 2 Mixer map and label it Dirt 1 and 2 Mixer Control. Set the Size to 0.08, the Low to 0.4 and the Phase to 10. Instance the entire map tree in the Diffuse slot into the Bump slot and set the Bump amount to 60.

Information: As both *grydirt1.jpg* and *grydirt2.jpg* maps are similar, we can mix them both together to create a map that does not show any repeats. We have used slightly different Noise map settings each time to break up the maps randomly, so one Noise map overlaps another and so on, creating a totally random map. The Bump map setting has been increased because we need the surface to appear rougher.

8 Go into the Ground_Grass material in the Material 2 slot of the Bank material and click on the Bitmap map in the Diffuse slot. Click on the Bitmap button in this map, add a Mix map to this slot and Keep the existing map as a sub-map when prompted. Name this map Grass & Grass Tint Mixer. Click on the Bitmap map in the Color 1 slot and add another Mix map, keeping the old map as a sub-map again. Label this new Mix map Grass Mixer. Copy the Bitmap map in the Color 1 slot to the Color 2 slot. In the Bitmap map in the Color 1 slot, set the V Tiling to 3 and

randomly amend the U and V Offset settings. In the Bitmap map in the Color 2 slot, set the U Tiling to 2 and the V Tiling to 6 and randomly amend the U and V Offset settings. Add a Noise map to the Mix map slot and label it Grass Mixer Control. Set the Source to Explicit Map Channel and set the V Tiling to 3. Set the Noise Type to Fractal with a Size of 0.1, High of 0.7, Low of 0.3 and 10 Levels with a Phase of 20.

Information: As with the dirt map setup, we have performed the same task on the grass map, albeit with different settings; this time we are using a lower tiling setting (we needed a high tiling setting before to make the dirt appear more like small debris) and larger Noise mix map size, but are also randomizing the surface by using a random offset for the map's positioning.

9 Copy the Grass Mixer map into the Color 2 slot of the Grass & Grass Tint Mixer map. Rename this Grass Tinted. Amend the Tiling in the Bitmap map in the Color 1 slot to 2 and 6 for U and V tiling, and throw in a random number for the U and V offset in this map and also for the Bitmap map in the Color 2 slot of the Grass Tinted map. Rename the Mix Noise map as Grass Tinted Mixer Control and amend its Size to 0.05 and Phase to 40. In the Grass Tinted map, click on the Mix button and add an RGB Tint map. Keep this map as a sub-map when prompted and amend

this tint map's green color to RGB 95,255,0 to add more yellow to the map.

Information: Here we have copied the map tree we have already set up and added some additional random variables for the offsets and Noise to make another unique map without any tiling repeats. Adding the RGB Tint map allows us to generate a new colored map without having to load in a new file – we can simply reuse the assets we have already got.

10 Add a Noise map to the Grass & Grass Tint Mixer map's Mix slot and label it Grass & Grass Tint Mixer Control. Set the Source to Explicit Map Channel and set the V Tiling to 3. Set the Noise Type to Fractal with a Size of 0.5. Set the High to 0.87, Low to 0.185 and Levels to 10. Instance the Grass & Grass Tint Mixer map tree into this material's Bump slot and set the Bump amount to 60. Finally, change the Shader type to Oren-Nayar-Blinn.

Information: The use of the less clamped Mix Noise map causes the two tinted green maps to blend more into one another which gives us a 'slightly maintained' look – i.e. the majority of the grass is okay, but some of it has started to die. The Oren-Nayar-Blinn shader has been used to diffuse the shading of the surface a little more and to make it look a little more textured.

PART THREE: Next we will model out the basic grass blade geometry and create materials to assign to them.

11 In the Front Viewport, create a Plane primitive with a Length of 200 and Width of 20. Set the Length Segs to 4 and the Width Segs to 2. Label this object Grass01. Collapse the mesh down to an Editable Poly. In the Top Viewport, go into Vertex sub-object mode, select the outer vertices and move them down a little to form an upturned V. In the Left Viewport select rows of vertices and move and rotate them to bend the plane over so it resembles a drooping blade of grass. Finally, in the Front Viewport, reduce the width of the grass blade by selecting the outer vertices and moving them in towards the center.

Information: Here we have modeled the outline shape of a simple blade of grass. We need not worry about fine detail as the object is going to be very small in the scene, and is also going to be replicated a few thousand times so we need the geometry count to be as low as possible.

12 Go to the Hierarchy tab, click on the Affect Pivot Only button and move the Pivot down so that it is just above the base of the object. Deselect the button Clone this object six times and amend the vertices on each so some droop more and some stand taller as illustrated. Finally, select Grass objects 02 to 07 and link them to Grass01.

Information: We have relocated the pivot point so that the grass objects are distributed with this point touching the distribution surface. If it was not relocated then, when the grass is distributed over a surface, half of it would be occluded. Grass objects 02 to 07 are linked to Grass01 because of the way Particle Flow distributes objects – it can pick an object at random from objects linked to the chosen object.

13 Open the Material Editor and in the first blank slot add a Double Sided material and label it Grass01. Set the Translucency to 50 and label the Facing Material Grass01A. Set the Glossiness to 13. Add the *grass01_diffuse.BMP* map to the Diffuse slot and the *grass01_opacity.BMP* map to the opacity slot. Add an Output map to the Specular Level slot and set its RGB Level to 0.46. Instance the opacity map to the slot in this map. At the top of the Double Sided material, instance the material in the Facing Material slot into the Back Material Slot.

Information: We have created a Double Sided material and not just enabled two-sided in a standard material so we can simulate some translucency, where the light passes through the grass and illuminates the other side. The colors of the diffuse texture maps were derived from the reference material included on the DVD-ROM. We have had to use a mask for the Specular Level else there would be highlights where the object would be transparent.

14 Copy this Double Sided material another couple of times and label them Grass01, 02 and 03 accordingly. Also, label the sub-materials accordingly as well. Replace the *grass01_diffuse.BMP* (etc.) maps with *grass02_diffuse.BMP* and *grass03_diffuse.BMP* maps and so on for the opacity maps, so each map fits the right material. Next, clone these three materials another four times and label them 04 to 07 accordingly. Add RGB Tint maps as we did with the Bank's grass maps and tint the maps slightly so they do not appear like the original maps.

Information: Even though we have only got enough maps for three materials, we can add extra maps to tint the assets that we have to create some brand-new materials. We should now have a total of seven individual Double-Sided materials labeled Grass01 to Grass07 with sub-materials labeled from Grass01A to Grass07A which a particle system can use to pick at random, so therefore we now have 49 different strands of grass – seven different models and seven different materials all mixed together.

PART FOUR: We will now create and distribute the grass over the canal banks and also drop some extra debris in the water.

15 Select the Bank01 and Bank02 objects and instance them, labeling them Bank01 Grass Distribution and Bank02 Grass Distribution respectfully. Create a new material, label it Bank Grass Distribution and assign it to these two objects. Add a Gradient Ramp map to the Diffuse slot and relocate the flag at position 50 to position 41. Set this and the flag at position 100 to black. Add a flag at position 27 and set this and the flag at position 0 to white.

Information: As illustrated in the screenshot, this gradient shades the copies of the Banks so that the sloping areas next to the water are white, telling the particle system (we are going to create shortly) that particles can be created there.

16 Select the Bank01 and Bank02 objects and instance them, labeling them Bank01 Clump Distribution and Bank02 Clump Distribution respectfully. Label a new material Bank Clump Distribution, assign it to these two objects and add a Noise map to its Diffuse slot. Set the Source to Explicit Map Channel, V Tiling to 3, Size to 0.01, High to 0.391, Low to 0.39. Swap the colors and add a Mask map to the Color 1 slot. Instance the Footpath map into the Map slot and enable Invert Mask. Copy the Bank Grass Distribution Gradient map into the Mask slot and rename it Bank Overlap. Set the V Tiling to 3, set the Noise Amount and Size to 0.2 and enable Fractal. Move the flag at position 27 to position 16 and the flag at position 41 to position 29.

Information: We have used previously created assets (the footpath and a modified version of the bank grass distribution) to 'subtract' from a Noise map to generate a speckled map that will be used

to distribute small clumps of grass over the grassed areas. So there is no abrupt transition from the short grass to the large, the short clumps have been extended into areas containing the larger clumps.

17 Press 6 to open Particle View and create a new Standard Flow. Label this Bank01 and rename Event01 Bank01 Grass. Select the Birth operator and set the Emit Start and Emit End to 0, and Amount to 8000. Remove the Position Icon, Speed and Shape operators. Add a Position Object operator, add the Bank01 Grass Distribution to the Emitter Objects list and Enable Density By Material. Set the Display operator to show Geometry.

Information: We have removed the unnecessary operators as we do not need the particles to move, nor do we want a standard particle shape. By using the grayscale information in the material assigned to the emitter object, we can distribute the particles over the white area(s) on the object and the particles will also reduce in density the more towards gray and black we progress.

18 Select the Rotation operator and set the Orientation Matrix to World Space. Set the X setting to 90 with a Divergence of 45. Enable Restrict Diverg. To Axis, set the Y Divergence Axis to 0.1 (X is already set to 1) and Z to 1. Add a Shape Instance operator to the event. Click on the Particle Geometry Object's None button and select the Grass01 object. Enable Separate Particles for Object and Children, set the Variation to 50 and enable Multi-Shape Random Order. Add a Material Static operator to the event and enable Assign Material ID and Random. Create a Multi/Sub-Object material named Grasses with seven material slots, instance each Grass material into the slots in this Grasses material and instance it into the slot in the Material Static operator.

Information: We have set the Rotation operator to rotate the grass geometry around the right way and to add an angle variation of 45 degrees based on values up to 1, with 0 being the least influential (i.e. no variation) and 1 being the most (the maximum setting that we have set of 45 degrees). As we have multiple objects linked to the one main Grass object, we can set the system to pick a child shape at random (the Random Order setting instead of being distributed in order, e.g. spelling out a name with particles). All of the Grass materials are also chosen at random via the randomly chosen Material ID which corresponds to an ID in the Multi/Sub-Object material.

19 Hide the Grass objects. Copy the Bank01 Grass event, Paste Instanced it and rename the copy Bank01 Small Clumps. Make the Birth, Position Object and Rotation operators unique. In the Birth operator, set the Amount to 10000, remove the Bank01 Grass Distribution from the Position Object's Emitter Objects list and replace it with the Bank01 Clump Distribution object. In the Rotation operator set the Divergence to 180 and set the X Divergence Axis to 0.1. Add a Scale operator and set the Scale Factor and Variation to 25 for all axes. Wire the output of the Bank01 root event to the input of this event.

Information: We have used instancing for the entire cloning of the event so that we can keep some of the original operators, as the settings can be shared and are relevant for both distributed particles. However, some are not the same, such as the number of particles and the objects used to distribute them so these are made unique and their settings amended. We have also added a Scale operator to shrink the particles down a fair bit, but without affecting the instanced Shape Instance operator.

20 Copy and Paste Instanced this event. Label the new copy Bank01 Large Clumps and make the Birth, Position Object, Scale and Material Static operators unique. Set the Birth's operator's Amount to 1000, remove the Bank01 Clump Distribution from the Position Object's Emitter Objects list and replace it with the Bank01 Grass Distribution object. Enable Distinct Points Only and set the Total to 100. Set the Scale's Scale Factor to 150 for all axes, turn off Scale Variation's Constrain Proportions and set X to 300 and Y and Z to 30. Instance copy the Grass01 material from the Material Editor to the material slot in the Material Static operator in this event and turn off Assign Material ID. Wire the output of the Bank01 root event to the input of this event.

Information: Here we have also made the Display operators unique and have amended each one's colors so that we can see the distribution of the objects more easily. As before, instancing has been used to share settings across operators, but some have to be made unique so that we can amend their settings. The Scale operator has Constrain Proportions disabled so that we can get some irregular widths of the grasses/plants, and a single material is assigned to this distribution so that we get patches of solid color to suggest multiple bunching of grasses or plants over the bank.

21 Select all of the Bank01's events and wiring and instance them to create a new particle system; rename it Bank02 (if necessary). Rename the new events accordingly. Make all of the Position Object operators in the Bank02 events unique and replace the Bank01 scene objects in these event's operators with their Bank02 counterparts. Make the Rotation operator in the Bank02 Grass event unique and set the Z Orientation to 180. Wire the new events to the Bank02 root event if the wiring has not been properly cloned.

Information: Instead of duplicating the entire system, there are some events in the initial Bank system which could be used to distribute the grasses on the opposite sides, by simply doubling the Birth operator's amount and adding the distribution object to the correct Position object. However, this would not work for the Bank Grass distribution as the grasses have to point in the correct direction, so the rotation operator would have to be unique. Therefore …

22 Remove the wire between the Bank02 root event and the Bank02 Grass event, and delete the Bank02 Small Clumps, Bank02 Large Clumps and Banks02 root events. Wire the Bank01 root event to the input of the Bank02 Grass event. In the Bank01 Small Clumps event, double the Amount in the Birth operator and add the Bank02 Clump Distribution object to the Position Object operator's Emitter Objects list. In the Bank01 Large Clumps event, double the Amount in the Birth operator and add the Bank02 Grass Distribution object to the Position Object operator's Emitter Objects list.

Information: A little bit of house cleaning and the system looks a lot tidier and concise, and even though the render times would not make much, if any, difference it is still worthwhile to keep things this way so we do not get lost later on should we decide to re-visit the scene.

23 Hide all of the distribution objects in the scene as they are no longer needed. We can now re-enable the Debris–Leaves system. In Particle View, copy this system, Paste Instanced it to create a new system and label it Debris–Grass. Make the Birth and Position Object operators unique, set the Amount to 1000 and overwrite the Shape Facing operator with a Shape Instance operator. In the Position Object, amend the Seed. Remove the Material Static operator and replace it with an instance of the Material Static

operator from the Bank01 Small Clumps event. In the Top Viewport, create a Plane with a Length of 200 and Width of 20 and label it Grass Debris with the Length and Width Segs set to 1. Add this object to the Shape Instance operator in the Debris–Grass system and set this operator's Variation to 50. Finally, hide any unnecessary objects and create a slow moving camera panning over the water, making sure not to see any background or sky in the process, and render out the animation.

Information: Again, we can re-use assets that we have already created. The original debris system was designed and created in the original water surface tutorial and the majority of this can be re-used as they also apply to the extra debris that we are introducing. The only things that need to be amended are the particle type, which is a flattened out version of the grass geometry, a higher number of debris for this type and different materials which are instanced from another event having been previously created.

Taking it further

The end result of our canal is a quite convincing effect, although it looks rather 'clean'. The grass seems like fresh turf and the long grasses are very green and saturated, so you may feel like reducing the saturation of the colors either by amending the texture maps or changing the tint maps a little to reduce their intensity. The bank texture could be dirtied up a little more by mixing an additional soil map or two to the overall material tree by using a large Noise map to control the blending.

As well as reducing the saturation of the grasses on the bank, due to the debris being sat in the water for some considerable time, they will have become waterlogged and will therefore start to degrade. The grass especially will fade and become more translucent, so try to create an additional set of materials for this debris that represents these types of organic matter.

You may also want to drop extra debris into the water, such as the occasional particle, and perhaps even the odd branch or twig floating down the canal, or caught in the side of the bank. Additionally, with all of the elements in the scene, the one thing that sticks out like a sore thumb is the lack of wind affecting the grass. You may want to look into using animated modifiers, such as a Bend or Noise in the source geometry, and offset their animation a little in the particle system so there is a little variety in the motion. You will, however, need to assign a global wind across all of the grass, so that it deforms them all as it passes like a kind of wave effect. Don't forget that from 3ds Max 7.5 we also have access to Hair and Fur which opens up a whole new area for creating foliage, so it would be advisable to look into this as a solution by designing a hair system to mimic our grass blades and foliage (or by referencing them within the hair system!). By making the hair system more rigid we can apply winds to the system and have them flex accordingly while still maintaining their shape.

Because there are leaves in the water you may want to add in a tree or two along the side of the bank, or even just hint that a tree exists nearby by adding a Gobo (a light mask or projector) to cast a shadow of a tree onto the terrain. You may also wish to drop in extra foliage around the banks of the canal – try using a scaled down foliage object; a tree will suffice without the branches or trunk so you just have a mass of leaves.

If you are feeling really adventurous, try adding a boat traveling down the canal, displacing the water and therefore the particles (Hint: use some UDeflector Space Warps to get the particle debris

to interact with the hull of the boat). Alternatively, try killing the main key light so all we have got is low-level diffused lighting, and add the Rain tutorial in this book to this scene to make it more dramatic. In addition to these raindrops affecting the water, you could use the Shape Mark operator to create puddles on the banks of the canal, all driven by the same particle system.

Additional patches of grass could be easily added by creating another particle system; a clone of one of the existing ones would suffice, and distribute them, say, down the sides of the footpath, or even in the footpath dirt to represent weeds or patches of grass where seed has settled and clumps of grass have grown. You could even use the knowledge gained from the Grass and Dirt tutorial and amend the Blend material to get the grass to work its way through the cracks in the dirt.

There really is a huge amount we could do with this scene and the more detail we add, the more realistic the scene will become, so add as much as possible.

24 Frozen wastelands

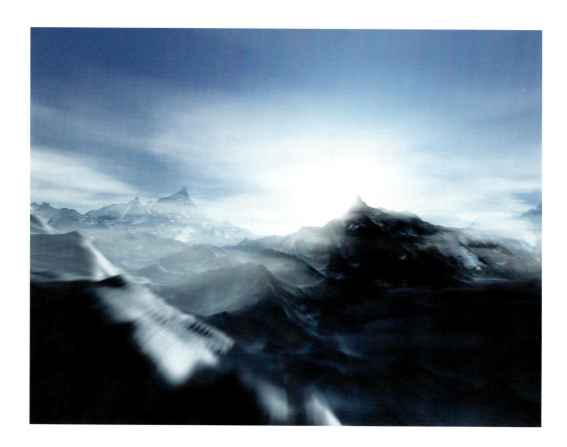

Introduction

In this tutorial we are going to take a little break from trying to recreate a scene as realistically as possible, and attempt a stylized render of an arctic scene. The end result of this tutorial is similar to a previous article I wrote for *3D World* magazine, but with different techniques and material setup to produce the final result. Throughout the walkthrough we will concentrate on lighting the scene using a large lighting rig to simulate global lighting from the surrounding sky dome, setting up the geometry which will be deformed using maps designed in the Materials Editor and also utilized in the materials we assign to the geometry, before finishing with how to tint the render using optical effects, adding volumetrics to create cloud and glows with light rays, and post effects to increase the contrast to make darker areas and the scene's colors stand out.

Analysis of effect

(a) The majority (if not all) of the terrain we will be designing will be covered in snow and ice, so any rock effects can be ignored. Depending on the density of the snow and ice in the reference material, we can see (in some images) a clear illustration of a blue tint in some of the ice. This is because water is, believe it or not, actually blue and not tinted this way just because of the reflection of the sky in the water, plus, due to the compacted ice, there is very little (if any) air in the ice due to being compacted under high pressure. (b) The actual shape of this terrain forms several drifts, not too dissimilar from sand dunes due to the snow forming around the sides of the mountains, which produces a curved 'ramp' up the side of the mountain and a sharp ridge across the top. This ridge is not linear, but quite an irregular shape due to the underlying shape of the mountain. The mountain range itself is broken up somewhat; with large 'open' spaces where there is very little disturbed snow/ice with a small amount of surface texture where small drifts and displacements in the terrain are (being) formed. (c) Depending on the lighting conditions, the entire scene can be completely blown out (causing snow blindness) or is quite contrasted, clearly showing reflected light from the blue sky, which can be a very intense blue due to the altitude, and air quality. (d) Finally, due to the altitude of the mountains, we can have a substantial amount of cloud coverage on a variety of layers. This, in turn, leads to rays of light being cast as the sun peeks behind mountains, casting shadows through the cloud and through any snow in the air.

As with any terrain construction we will generate the overall shape from basic geometry; in this case a simple Plane primitive with a fair few polygons. As we do not need to see all of the detail in the Viewport, we can use this particular primitive's Render Multiplier, which allows us to increase the density of the geometry at render time by utilizing a simple value that the renderer takes and multiplies the iterations we have already set by this value. This allows us to work at a low polygon density in the Viewport to keep update times low. To generate the shape of the mountains, we are going to use a combination of two modified Smoke maps, as these are the best kind of maps to generate the mountain peaks and falloff effect that we require. Even using two maps; one for the main displacement and the other to add extra detail and to break up any repetition, the scene would still be too uniform. We will therefore use an extra couple of Smoke maps which will generate 'breaks' in the uniformity of the displacement, creating open areas of untouched snow. We will design a couple of materials to be assigned to our terrain – one of a smooth snow surface which will be nothing more than an exceptionally basic material and

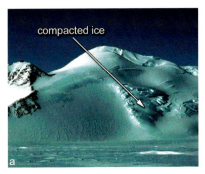

Image courtesy of United States Geological Survey

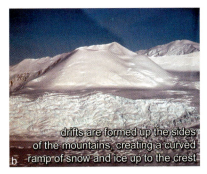

Image courtesy of United States Geological Survey

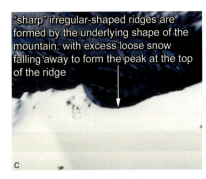

Image courtesy of Tim Johnston

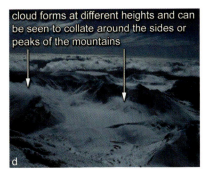

Image courtesy of Tim Johnston

the other the same material but with the displacement map tree assigned as bump mapping. We will mix them together based on Normal direction and use a modified version of the displacement map to clamp off the map a little and generate a mask for some white smooth snow caps. Finally, after lighting the scene with a lighting rig that is tinted to the color of the sky, we will add a few volumetric gizmos around the scene to position volumetric fog to simulate cloud, before adding some contrast and a Video Post effect in the form of a basic lens flare glow to add some intensity and haze to the scene.

Walkthrough

PART ONE: First we will create the basic scene geometry for the terrain and sky and assign any modifiers they require for them to function correctly.

1 In the Top Viewport, create a Plane primitive in the center of the Viewport with a Length and Width of 8000, Length and Width Segs of 100 and label it Arctic. Set its Density Render Multiplier to 6. Add a Displace modifier to its modifier stack and set the Strength to 1200 and enable Luminance Center. Right-click the Play Animation button and increase the Animation Length to 200 frames.

Information: Here we have created the basic terrain geometry and added the main tool which will enable us to deform the surface of the mesh to create the mountains. The Render Multiplier has been increased so there are six times more polygons when this mesh is rendered to add more detail to the surface. Luminance Center is enabled purely to drop the mesh down a little once the displacement map has been assigned to it as it takes (by default) a mid-grey color to be this value. We have increased the length of the animation to give us ample time to fly over the surface of the terrain and to take in the air.

2 In the middle of the Top Viewport, create a Geosphere with a Radius of 18000 and 4 Segments. Label it Sky. Turn on Hemisphere and add a Normal modifier. Add a UVW Map modifier and set the mapping Alignment to Y. Click on the Fit button in the UVW Map modifier to resize the modifier's Gizmo to fit the mesh. In the Left Viewport, move this object down 2000 units and scale it down vertically to 30% of its original size. Right-click this hemisphere, select properties and turn off Cast Shadows and Receive Shadows.

Information: Using an object in the scene as the sky instead of using an Environment background allows us to use fogging (standard and volumetric), and enables us to position and arrange the background color(s) easier. The Cast and Receive Shadows options have been turned off as this object should not receive any shadows, which will save the renderer calculation time.

PART TWO: Next we will generate the displacement map tree for the terrain using several Smoke maps.

3 Open the Material Editor, create a new Mix map in the first available material slot and label it Mountain Designer. Add a Mix map to its Color 2 slot, label it Mountain Range Control and set the Mix Amount to 50. Add a Smoke map to this new map's Color 1 slot and label it Mountain Range. Set the Source to Explicit Map Channel and the U, V and W Tiling to 2. Set the Size to 1, Iterations to 20 and Exponent to 1. Swap the colors and set the Color 1 slot to white. Copy this map into the Color 2 slot of the Mountain Range Control map and label it Mountain Range Irregularities. Set the V Offset to 0.5.

Information: The Mountain Range Control Mix map is to simply blend the two Smoke maps together equally. They are slightly offset so that it breaks up the uniformity of the overall map.

4 Add an Output map to the Mix Amount slot of the Mountain Designer Mix map and label it Range Breakup Control. Expand the Output rollout, click on Enable Color map and design the Color map as illustrated. Add a Smoke map to the Output map's Map slot and label it Range Breakup Small. Set the Source to Explicit Map Channel, Size to 0.4, Iterations to 20 and Exponent to 1. Swap the Colors and copy this map into its Color 1 slot. Go into this map copy and label it Range Breakup Big and set the Size to 0.8 and Iterations to 5. Set the Color 1 swatch to white. Instance this entire map tree to the Map slot of the Arctic plane's Displace Modifier.

Information: The two Smoke maps create an irregular map of dark and light patches. We have introduced the Output map as the Smoke maps do not have their own Output feature. The Color map has been designed to make the dark areas darker but with a small amount of light patches coming through to add a little bit of texture to the surface (the small bulge in the Color map) and

the large ramp up at the end of the Color map is to generate the slope up the mountain side. With this material assigned to the Displace modifier it is easy to see how simple it is to create effective terrain by mixing a few maps together.

PART THREE: With the terrain geometry now complete, we will design the Sky's material and the terrain's snow material tree and assign them to the scene.

5 Label a new material Sky and assign it to the Sky hemisphere in the scene. Turn on Show Map in Viewport. Increase the Self-Illumination to 100. Add a Gradient Ramp map to the Diffuse slot and label it Sky Color. Set the W Angle setting to 90. Set the color of the flag at positions 0 and 50 to RGB 40,45,73 and reposition the flag at position 50 to position 14. Add a new flag to position 64 and set its color to RGB 116,132,149. Set the color of position 100 to RGB 213,218,223.

Information: As we have Show Map in Viewport enabled, whatever changes we make to our material we can see in the shaded Viewport. Here we can see the gradient in action as it forms a horizon line and shaded sky. The colors were point sampled from an image in the reference material which was at low level light and a medium to high contrast which is what we are trying to achieve. Because we have used Planar mapping, the gradient is 'projected' right across (not around) the gradient.

6 Label a new Top/Bottom material Arctic and assign it to the Arctic plane in the scene. Set the Blend to 5 and Position to 85. Label the material in the Top Material slot Smooth and set its Specular Color to white. Set the Specular Level to 15 and Glossiness to 20. Add a Falloff map to its Diffuse slot and label it Snow Tint. Set the Falloff Type to Shadow/Light and set the Shaded color to RGB 116,132,149.

Information: As our mountains will have smooth and rough snow surfaces, we need to mix them together. Firstly, we are using the Top/Bottom material to assign smooth snow to the majority of the geometry facing the sky. The other material (the Bottom Material slot) deals with the side facing geometry which we will sort out next. Observing the reference material, some shaded areas of the snow-covered landscapes are tinted a little, so by using the Falloff map set to Shadow/Light in the Diffuse slot, we are able to replicate this.

7 Add a Blend map to the Bottom Material slot of the Arctic map and label it Snow Cap. Instance the Smooth map into the Material 2 slot of this Blend map and copy (not instance) the same material into the Material 1 slot. Label this new material in the Material 1 slot Rough. Set its Bump amount to −999 and instance the Mountain Range Control Mix map into the Bump slot. Add an Output map to the Snow Cap material's Mask slot, label it Snow Cap Control and instance the Mountain Designer map into this map's Map slot. Expand the Output rollout, turn on Enable Color map and design the Color map, as illustrated, to enhance the white areas of the Mountain Designer sub-map.

Information: As we already have the basic setup for our snow, we do not need to replicate it, but we do need to introduce additional bump mapping, hence the material copy. Bump mapping takes a light value as a setting that is depressed inwards, so as we are using light values in the displacement to raise surfaces, we need to use a negative bump when using part of the displacement map to get it 'facing' the right way. We have clipped off the Mountain Designer map using an Output map to enhance the highest parts of the displacement map, (the peaks) and can use this resulting map as the Mask for the Snow Cap Blend material to add additional smooth snow to the tops of the mountains.

PART FOUR: To give the scene some scale, we will create and position volumetric fogging to simulate a cloud layer.

8 In the Top Viewport, create a Sphere Gizmo Atmospheric Apparatus and set its Radius to 1000. Scale this helper down vertically in the Left Viewport to about 25% of its original size and position it so that its base is half way up the side of one of the smaller mountains. Clone this gizmo another six times and position them around the scene so they overlap, varying their scale or Radius a little.

Information: These Atmospheric helpers are going to be the basic positions of the clouds in our scene. We have scaled them down so that they do not appear as large balls of cloud, but flat layers of cloud instead. We have also varied the sizes of the cloud to remove any uniformity.

9 Open up the Environment panel and add a Volume Fog to the Atmosphere rollout's Effects list. In the Volume Fog Parameters rollout, click on the Pick Gizmo button and add all of the Sphere Gizmos. Set Soften Gizmo Edges to 1, enable Exponential, set the Density to 1 and set the Max Steps to 20. Change the Noise Type to Turbulence, set the Size to 500, Low to 0.36 and Uniformity to −0.25. Set the Fog's color to RGB 213,218,223.

Information: We increase the Soften Gizmo Edges so that the shape of the gizmo is feathered out. Exponential was used to increase density depending on distance, so the further into the cloud, the more dense it appears. Max Steps was reduced to decrease the rendering time at the expense of a little quality, but this is negligible. The Low setting was increased to add a little more texture to it, uniformity was reduced to create more distinct puffs of cloud and the Size increased to make these puffs a lot larger. Finally, the color was changed to match that in the sky dome's horizon color.

PART FIVE: Next we will create the lighting in the scene by setting up a lighting rig to simulate illumination from the sky and the sun.

10 In the Top Viewport, create a Target Direct Light to the bottom of the plane and position its target at the center of the plane. Label this light Sun and reposition it vertically in the Left Viewport so it represents a sunrise (or sunset). Enable Shadows and Overshoot and set the Falloff/Field to 3000 to encompass the entire plane. Set the Shadow color to RGB 27,30,34, Shadow Map Param's Bias to 0.01 and Size to 2048.

Information: Overshoot was used so that areas outside the Falloff/Field would be illuminated, and Falloff/Field was increased as shadows are confined within this boundary – no shadows will be cast outside this area. The Shadow map Bias was reduced to reduce any detachment of shadows from the objects/faces that cast them, and the Size increased to simulate a crisp detailed shadow emanating from the sun. The Shadow color was amended to tint it slightly blue.

11 Enable Grid Snap (if not already enabled) and in the Top Viewport, create a Target Direct Light to the left-hand side of the plane and drag its target to the center of the plane. Enable Shadows, set the Multiplier to 0.05 and color to RGB 116,132,149. Enable Overshoot and set the Falloff/Field to 3000. Turn off Specular, set the Shadow Map Bias to 0.01, Size to 512 and Sample Range to 20. Still in the Top Viewport, Instance the light so it is the same distance from the plane at the top side, so that it is at right angles to the original. Reproduce this so you have four lights all at right angles to one another.

Information: We have used low intensity lights due to the final amount that we will be using in the scene. If the light intensity was too high, the entire scene would be washed out. The light's color was taken from a color setting from the Gradient Ramp map assigned to the sky. We do not need specular highlights from each light in our array so this option is turned off, else we would have numerous specular highlights over our scene, whereas we only need one – the sun. The Sample Range was increased to blur the shadows a fair amount to remove any hard edges.

12 Enable Angle Snap. Select all of the four instanced lights and rotate clone them by 45 degrees to form an additional four lights. Select all of these lights (not their targets) and in the Left Viewport move them up slightly. Shift-move them to clone a new ring so the new ring is positioned slightly above the mountains. Perform this task another couple of times to create another ring of lights and another one beneath the scene, pointing upwards.

Information: A fair amount of lights have been introduced to create a global illumination lighting effect with multiple lights emitting multiple shadows across the mountains. We have used large maps to keep detail, but diffused them to remove artifacts. Should you feel the render is taking too long, halve the size of the Shadow Map Size and the Sample Range respectfully so the result of the blur is proportionate (if a little degraded).

PART SIX: With the scene virtually complete, we will add a volumetric light to create a misty stylized effect and a contrast post effect to bring out the colors in the final render.

13 Create a Camera with a wide-angled lens (about 20–28 mm) in the scene and position it on the opposite side of the terrain facing the sun, so the sun is just peeking over the mountains. Copy the Sun Direct light and label it Sun Volumetric. Set the Multiplier to 0.1 and turn off Overshoot. Change the Light Type to Spot and set the Hotspot/Beam to 0.5 and Falloff/Field to 10. Enable Use and Show Far Attenuation and set the Start to 0 and End to 30000. Change the Shadow Map Size to 1024 and reposition this light's target to the camera's location. In the Environment panel, add a Volume Light effect, click on the Pick Light button and add the Sun Volumetric light. Turn on Exponential.

Information: Here we have a thin light that is pointing directly at the camera. This is so the volumetric light that is emanating from it does not completely wash out the entire scene, but keeps it confined to the camera's field of view. If the camera ducks behind a mountain, then there will be a subtle volumetric light cast around the sides of the mountain, but we will still have the resulting glow from this light around the sides of the mountain; something you would not be able to do easily with lens flare glow effects.

14 Open the Material Editor and create a Gradient Ramp map in one of the available slots. Label it Volumetric Light and set its Gradient Type to Radial. Set the color at position 0 to white and the color at position 100 to RGB 61,81,166. Move the flag at position 50 to position 26 and set its color to RGB 99,148,208. Instance this map to the Projector Map slot of the Sun Volumetric light.

Information: Instead of creating a Glow post effect, we can design our glow using volumetrics which will not turn off when occluded by additional objects in the scene. We have added to the stylized look by having a bright white center which will illuminate and add to the cloud volumetrics before falling off to a blue which will tint the scene.

15 Open up the Effects panel and add a Brightness and Contrast effect to the Effect list. Set the Brightness to 0.4 and Contrast to 1. Finally, assign Image Motion Blur to the relevant elements in the scene, such as the terrain and sky. Link the target of the Sun Volumetric light to the camera and animate the position of the camera travelling over the terrain. Render off the animation with a sharp Anti-Aliasing filter, say a Catmull-Rom for example.

Information: We have added a Brightness and Contrast effect to bring out the detail and the colors in the scene. As the camera will be moving in the scene, we need the volumetric effect to follow the camera, so all we need to do is to link the target of the light to the camera. We are using a sharp Anti-Aliasing filter to help bring out the detail, even though we are blurring with Image Motion Blur.

Taking it further

To keep render times down and to prevent geometry being too textured (as we can handle any of that using bump mapping), we should keep the geometry down as low as required. As there is no actual rock in this scene, just heavy bump mapping we do not need exceptionally high polygon counts. However, if you do want to resort to high polygon geometry and displacement for added detail, but are experiencing high render times, try baking off the landscape to a Normal map and apply the result to the lower polygon terrain. This will also produce a cleaner result as the bump shading will not just be a bunch of dark blotches, but contoured and highlighted surfaces which will look a lot nicer and realistic. Bear in mind that to create a decent normal map for this size of terrain you will need a pretty large map size!

Depending on the amount of wind we want to introduce to the scene, we could add extra volumetric fogging around the low areas of the terrain and assign a noisier volumetric to them to simulate snow being disturbed. You will also want to add a slight wind motion to the existing volumetrics. Also, try placing smaller confined volumetric gizmos around the scene so they are situated around the peaks of the mountains.

Currently, we are using the same map that is being used to displace the geometry as the Bump map, just in case any detail in the map is not being picked out in the displacement. You could also add finer detail to the Bump map by mixing additional Smoke and/or Noise maps to the existing Bump map tree so some areas of the snow appear finer and rougher. You may also want to change the texture of some areas of the snow, like making it glisten a little more and adding translucency to simulate ice. Try using a translucent shader to simulate this and mix them together using smoke and/or carefully positioned decal gradient maps.

25 Mountain

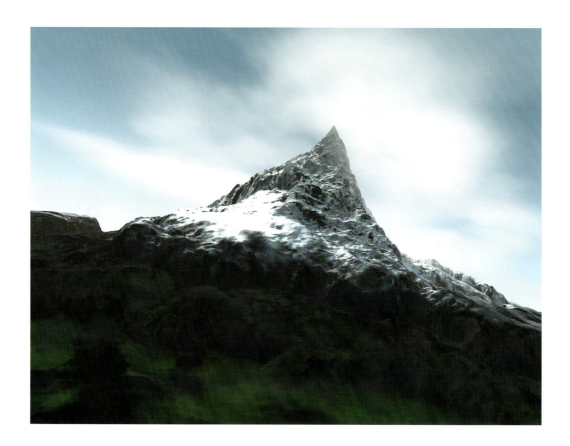

Introduction

The geometry in this scene is going to be about as basic as you are going to get, but the polygon count is going to be in the millions to get the best result! Firstly we will use a displacement map to create the basic shape of the terrain, and then overlay another to create the shape of the mountain's peak. Next we will create several individual materials and use the existing displacement maps to add extra texture to their surface, then use additional blending materials to mix them together a certain way, to give the impression of multiple levels of terrain, each blending and overlapping into the next. Finally, we will create a basic sky environment which is shaded in a way that gives the impression the image was 'taken' at a high altitude, before illuminating the scene with a lighting rig to simulate illumination from the sky, adding air desaturation fogging and cloud around the peak.

Analysis of effect

(a) Observing the reference material on the DVD-ROM, it is apparent that mountain terrain comes in several 'tiers' – a snow cap, fragmented snow with intermittent areas of rock, rock with small areas of snow, solid rock and greenery (trees etc.). These tiers tend to bend together depending on the terrain, for example the fragmented snow appears to settle mainly on the top of the mountain and any other rock faces that are more horizontal than vertical. (b) As we progress further down the mountain, the rock begins to peek its way through and small areas of snow can be seen to rest on the sides of the rock – they are actually at rest on small (near) horizontal areas that jut out from the mountainside. (c) The further down we progress the more rock is visible and less snow (due to temperature) and the more greenery is present. These green areas are, again, more prominent on near-horizontal areas while the more vertical faces of the mountain do not have much, if anything, growing on them. (d) Due to the altitude and temperature of the mountain's peak, a collation of cloud tends to form around this area which would be good to simulate and fly through in our final animation.

Another excellent example of mountains is in *The Lord of the Rings – The Two Towers*, which uses the Southern Alps on the South Island of New Zealand for its breathtaking scenery. It is definitely recommended that this is viewed while attempting this tutorial as it depicts the ideal mountain we are trying to emulate.

We want to make the terrain construction as simple as possible so we can adjust the density of the terrain's mesh so that it is low when working in the Viewport and a lot higher when rendered. Because of this, we do not want to physically model the terrain, but use deformation to sculpt the landscape to the desired result. To generate the terrain we can use a simple Plane primitive object and assign a couple of modifiers to handle the main deformation – one to generate the peak and the other to handle the base terrain. And that's pretty much your lot as far as modeling goes. The main trick comes in the materials and the sheer amount of polygons required to generate the displacement. As we have three distinct levels to the source material, we will generate three main levels to our material tree and mix between them. Firstly, we will have the solid snow material, which will simply be a solid color that will use one of the displacement maps as a Bump map to generate some texture. Secondly, we will have a basic rock texture which, again, will be a single color with the other displacement map as a Bump map. Finally we will have the 'greenery' which will consist of a slight noise as its diffuse color and a displacement map as its Bump map. And that's it. Quite a simple set up, but we now need to blend them together. Using a combination of Blend and Top/Bottom materials, we can create (from top to bottom) a solid snow cap, a rock and snow mix, solid rock, and a rock

Image courtesy of United States Geological Survey

Image courtesy of United States Geological Survey

Image courtesy of United States Geological Survey

Image courtesy of Tim Johnston

and greenery mix. By using cylindrically-mapped gradients around the mountain we can control the mixture between materials by designing the levels in our gradient.

As we have a mountain that is exceptionally high, try clipping off the snow caps and change the lower part of the mountain to a 'normal' terrain with grass, trees and rocks. On most mountain ranges, the level at which snow is formed is quite consistent; creating a band right across the range where the snow level begins, so this could be generated using a simple gradient (with a little noise to break it up somewhat). You may want to use another Top/Bottom material to generate the distribution of green areas over rock, with the green areas on the top and the rock distributed on the side. Blend this new material with the existing one with a gradient controlling the blend to generate a quite effective result.

Walkthrough

PART ONE: First we will create the basic Plane primitive and assign the required modifiers.

1 Turn on Grid Snap. In the Top Viewport, create a Plane Standard Primitive with Length and Width spinner settings to 2000 and Length and Width Segs set to 50 and label it Mountain. Reposition it (if necessary) so that its co-ordinates are 0,0,0; directly in the center of the scene. Set the Density multiplier between 5 and 20, depending on the speed of your computer.

Information: We are working with quite a low polygon terrain at the moment, until we comes to render the scene. As we are using the Density multiplier, whatever setting we have dialed into the segments spinners will be multiplied by the value we have entered into the Density setting when the scene is rendered. It might be worthwhile setting this Multiplier to a low setting at first and then gradually upping it (once the scene is complete) to check your render times and if your machine can handle calculating the millions of polygons. The Multiplier setting in the screenshot is very high so start lower and perform some test renders first.

2 Add a Displace modifier to the stack and rename the modifier to Terrain Displace. Set the Strength to 100. Add another Displace modifier and rename it Peak Displace. Set the Strength to 500 and enable Luminance Center.

Information: We need two separate displacements to generate our terrain – one handles the small lower terrain and the other generates the large peak displacement. The Peak Displace modifier has Luminance Center enabled purely to illustrate the

difference between having it enabled or not. With it enabled, grayscale colors of RGB 128,128,128 are classed (as default) as neutral; values higher than this will displace the mesh up, values lower will displace it down. I'm going to have it enabled, you may or may not choose to, but in this particular tutorial it makes little difference, apart from the positioning of the geometry.

PART TWO: With the geometry all set to go, we can now deform it by creating maps to be dropped into the Displace modifiers.

3 Open up the Material Editor and create a new Noise map in the first available slot. Label it Terrain and set the Source to Explicit Map Channel. Set the Noise Type to Fractal and Size to 0.2. Set the High to 0.7, Low to 0.3 and Levels to 10. Click on the Swap button to change the color swatches over, expand the Output rollout and click on Enable Color map. Add extra points in the Color map and amend them so they form a slight stepping design as illustrated. Instance this map to the Map slot in the Terrain Displace modifier.

Information: As we are using the mapping generated by the Displace modifier, we need to reduce the Noise map's Size. Amending the High and Low settings clips off the colors a little, so we have got larger areas of solid color, and less areas for the transition from one color to the next. The Levels have been increased to add more detail and the Color map enabled to create several 'steps' with curved tops going from one color to the next so, when rendered, we will see several levels of terrain that appear to have been formed by erosion.

4 In the next slot in the Material Editor, create a Mix map and label it Peak. In the Color 1 slot, add a Gradient Ramp map and label it Peak Shape. Remove the middle flag and set the flag at position 0 to white and the flag at position 100 to black. Set the Gradient Type to Radial, the Noise Amount to 0.1, Size to 10 and set the Type to Turbulence. Open the Output rollout, turn on Enable Color map and amend it, as illustrated, to change the control of the gradient mixing.

Information: The flag colors were set purely for illustrative purposes. As they will both have Noise maps, these colors make no difference to the end result. The Color map was amended as no Interpolation setting was suitable for what we require – a gradual build-up to a peaked color.

5 Right click the flag at position 0 and select Edit Properties. Add a Noise map to the slot and label it Peak Shape Top. Set the Source to Explicit Map Channel, Noise Type to Fractal, Size to 0.1, High to 0.75 and Low to 0.25. Set the Color 1 swatch to RGB 200,200,200 and the Color 2 swatch to RGB 218,218,218. Add a Noise map to the Peak Shape gradient's flag at position 100 and label it Peak Shape Bottom. Set the Source to Explicit Map Channel, Noise Type to Fractal, Size to 0.25, High to 0.5, Low to 0.25 and Levels to 10. Set the Color 2 swatch to RGB 22,22,22.

Information: Even though we have got a slight noise across the gradient, this is too uniform, so we need to break it up a little. To do this, we have added two extra Noise maps – one to each flag – and so therefore they are mixed together. As they represent the colors at each end of the gradient, they have to be colored accordingly – light and dark. Again, these are clipped a little to create a raised area as in the other displacement map.

6 Add a new Gradient Ramp map to the Peak Mix map's Color 2 slot, label it Peak Cap and set the Gradient Type to Radial. Set the flag at position 100's color to black and reposition the flag at position 50 to position 9. Set its color to RGB 206,206,206 and the flag at position 0 to RGB 218,218,218. Set the Noise Amount to 0.3, Size to 5, enable Turbulence and set the Levels to 10. Open the Output rollout, turn on Clamp and Enable Color Map and amend the map as illustrated.

Information: Again, we will introduce another Noise map to this gradient, but in this case we will only be using it in one slot (the one at position 9). We will therefore have a transition from solid color which will break up and become another color the further we progress down the gradient. Again, we have a slight noise assigned to the gradient anyway which will break up the entire gradient a little to remove any form of repetition and/or regularity. Clamping has been enabled to level off any values that are too high (capping off the mountain) and the Color map has been amended again to correspond with the blending in the other gradient map so they do not oppose one another. This one is slightly stronger to bring out any rough detail.

7 Right-click the flag at position 9 and select Edit Properties. Add a Noise map to the available slot and label it Peak Rough. Set the Source to Explicit Map Channel, Noise Type to Turbulence, Size to 0.001, High to 0.75, Low to 0.5 and Levels to 1. Set the Color 1 swatch to RGB 200,200,200 and the Color 2 swatch to RGB 206,206,206. Add a Gradient Ramp map to the Mix slot of the Peak map and label it Peak Mix Control. Set the flags at positions 50 and 100 to black, add a flag at position 23 and set it and the one at position 0 to white. Set the Gradient Type to Radial,

the Noise Amount to 1, Size to 5, enable Fractal and set Levels to 10. Turn on Enable Color Map and amend the curve as illustrated. Instance the Peak map tree to the Map slot in the Peak Displace modifier.

Information: The Peak Rough map does exactly that – just adds a slight amount of roughness to the displacement down the sides of the mountain. This will not be visible on our low polygon version in the Viewport, but will be visible at render time. The Peak Mix Control gradient blends the two Gradient Ramp maps together so that the base map (the Peak Shape map) gradually builds up before (relatively) abruptly forming the Peak Cap map, so we have a rough mountain top with more subtle displacement lower down, where the other displacement map takes over. If we had both maps rough, the result would be slightly chaotic.

PART THREE: We will now create the material tree to handle the change in terrain surface as we progress further down the mountain.

8 Create a new Blend material in the Material Editor, label it Mountain and assign it to the Mountain in the scene. Label a new material Snow and set its Diffuse color to white. Add a Speckle Map to the Specular Level slot and label it Snow Speckle. Click on the Swap button to change the colors around and change the black in the Color 2 slot to RGB 196,196,196. Instance the Peak map tree into the Bump slot in this material and set the Bump amount to 20.

Information: The Blend material is going to be the final material structure that controls the three materials we need to build up the mountain; the Snow material is one of them. Because the Peak displacement map is highly detailed, we can use this as the Snow's Bump map. The Bump map has been reduced from 30 to 20 so that the material is not too dark in the bump places when rendered.

9 Label a new material Rock and set its Diffuse color to RGB 35,35,35. Set the Bump amount to 300 and add a Noise map to it. Label it Small Rock and set the Source to Explicit Map Channel. Set the Noise Type to Fractal, Size to 0.01, High to 0.7 Low to 0.3 and Levels to 10. Copy this Noise map into the Color 2 slot and label the new map Large Rock. Set the Size to 0.03, High to 0.6 and Low to 0.4.

Information: This material is designed to run down the sides of any raised areas of the mountain as well as being on the upper faces, so we get a nice textured terrain. We have used a two stage Bump map so that the regularity of one map is broken up by the other.

10 Label a new material Greenery, add a Noise map to the Diffuse slot and label it Greenery Color. Set the Source to Explicit Map Channel, the Noise Type to Fractal, Size to 0.05, High to 0.6, Low to 0.385 and Levels to 10. Set the Color 1 swatch to RGB 44,51,22 and the Color 2 swatch to RGB 24,51,22. Instance the Terrain Noise map into the Bump slot and set the Bump amount to 150.

Information: Again, we have utilized an existing map as a texture in an additional material. As this material will be situated at the base of the terrain, we have used the displacement map that is most prominent in these parts. The Noise map was added to the Diffuse slot to break up the uniformity of the single color. Typically, these two colors will also need to be mixed with other colors to get a more convincing effect (which you may wish to do) but in this instance it will suffice.

11 Go back to the Mountain material, add a Blend material to the Material 1 slot and label it Snow Cap. Instance the Snow material into this material's Material 1 slot, add a Top/Bottom material in the Material 2 Slot and label it Snow and Rock. Instance the Snow material to the Top Material and the Rock material to the Bottom Material. Set the Blend to 5 and Position to 85.

Information: Here we have set up the mix between the snow and rock (using the Top/Bottom

material), but we still need to control the blend between the Snow and Rock and the solid Snow material in the Snow Cap material. This material controls the position that the solid snow cap breaks up a little and reveals rock on the side of the mountain.

12 Add a Gradient Ramp map to the Mask slot of the Snow Cap material and label it Snow Cap Control. Set the Map Channel ID to 2 and the V Tiling to 2. Set the W Angle setting to 90, the Noise Amount to 0.39, Size to 5, enable Turbulence and set the number of Levels to 10. Set the flag at position 50 to black and move it to position 43. Add a flag to position 52 and set it to white. Add a UVW Map modifier to the Mountain and set its Mapping to Cylindrical, Map Channel to 2 and click on the Fit button to resize the modifier's gizmo. Select the gizmo and, in the Left Viewport, scale it up vertically by 10%.

Information: Clicking Show Map in Viewport enables us to see this map in action. As we are using a different mapping type, we have to use a different Map Channel ID for the modifier and the corresponding map(s) so they talk to one another properly. The result is that the map is wrapped around the mesh; the tiling has been increased to remove any stretching around the peak and the modifier's gizmo scaled up so there is no clipping should the rendered geometry (which will be higher than the geometry viewed in the Viewport) pass beyond the boundaries of the gizmo.

13 Copy (not instance) the Snow Cap Control map into the Mountain map's Mask slot and label it Mountain Snow Rock Control. Amend the V Tiling to 4, reposition the flag at position 52 to position 80 and the one at position 43 to position 70. Amend the Noise Amount to 0.2 and the Size to 1. Add a Blend map to the Mountain's Material 2 slot and label it Base. Copy the Mountain Snow Rock Control into this Blend material's Mask slot and label it Base Control. Set the V Tiling to 3 and the Noise Amount to 0.19. Remove the flag at position 80 and reposition the one at position 70 to position 82.

Information: As we have set the majority of settings for these two gradients in the previous gradient, we can simply copy and tweak the settings a little. These two maps control the two additional material levels in our overall material – the first one states where the snow ends and the solid rock begins (the main one at the top of the material tree), and the second one controls the solid rock and rock/greenery mixing.

14 Instance the Rock material into the Base material's Material 1 slot. Add a Top/Bottom material to the Material 2 slot and label it Rock and Greenery. Instance the Greenery material to the Top Material slot and the Rock material to the Bottom Material slot. Set the Blend to 10 and the Position to 80. Navigate to the Snow and Rock Top/Bottom material and make the Rock material in the Bottom Material unique. Label it Rock Snow. Add a Mix map to the Diffuse slot, label it Rock Snow Mix and set the Color 1 slot to RGB 27,27,27. Add a Falloff map to the Mix slot and label it Rock Snow Control. Set the Falloff Direction to Local Z-Axis and amend the Mix Curve as illustrated.

Information: Finishing off the material with a pretty big step. Here we have created another Top/Bottom material which mixes between the Rock and Greenery materials, depending on which way the geometry faces, so we have rock on the side of the base of the mountain and greenery on the top. The Rock material was amended for the top of the mountain to add extra snow to the detail generated by the Bump map by using a Falloff map set to Local Z-Axis (which works in the same fashion as a Top/Bottom material). This was not added before so we could make overall changes and utilize the existing material throughout the material tree before going back in and tweaking the settings on the unique material.

PART FOUR: Next we need to create a sky dome to encompass our scene to give the impression that we are at a high altitude. Because of this, we also need to generate a collation of cloud around the top of the mountain and some environment fogging.

15 In the Top Viewport, create a Geosphere primitive in the center of the scene with a Radius of 6000 and label it Skydome. Enable Hemisphere and add a Normal modifier. In the Left Viewport, scale the mesh vertically so that it is 20% of its original height and reposition it 400 units down so that it is below the mountain. Add a UVW Map modifier. Set the Alignment to X and click on the Fit button to resize its gizmo.

Information: As we will introduce fogging to the scene, we need a low skydome so that the fogging does not get too intense if we look up the mountainside, but appears more intense if we look across the scene, hence the flattened hemisphere. As we are simply going to be applying a gradient to the Skydome, a simple UVW Map will suffice to project this gradient onto the hemisphere.

16 Label a blank material Skydome and assign it to the Skydome hemisphere in the scene. Set the Self Illumination to 100 and add a Gradient Ramp map to the Diffuse slot. Label it Sky and reposition the flag at position 50 to position 59. Set the flag at position 0 to white, the one at position 59 to RGB 0,146,255 and the one at position 100 to RGB 0,62,110.

Information: As we have just used a linear gradient with the UVW Map modifier, the gradient is projected right across the hemisphere. As we are simulating a high altitude, the gradient is designed to go to a darker blue to simulate the reduction in atmosphere, while the intense blue and white simulate the air density and atmosphere falloff.

17 Create four large Sphere Gizmos (Atmospheric Apparatus Helpers) with Radius values between 500 and 1000, scale them down vertically so they are about 20–50% of their original height and arrange them around the peak of the mountain as illustrated. Open up the Environment panel and add a Volume Fog to the Atmosphere rollout's Effects list. In the Volume Fog Parameters rollout, click on the Pick Gizmo button and add all of the Sphere Gizmos. Set Soften Gizmo Edges to 1, enable Exponential and set the Max Steps to 50. Change the Noise Type to Fractal, set the Levels to 6, Size to 1000 and Uniformity to −0.25.

Information: We increase the Soften Gizmo Edges so that the shape of the gizmo is feathered out a little. Exponential was used to increase density depending on distance, so the further we get into the cloud, the more dense it appears. Max Steps was reduced to decrease the rendering time at the expense of a little quality, but this is negligible. Uniformity was reduced to create more distinct puffs of cloud and the Size increased to make these puffs a lot larger.

18 Create a Camera in the Top Viewport and position it near the base of the mountain, looking up. Set the Lens size to 28 mm, turn on Show in the Environment Ranges section and set the Far Range to 8000. In the Environment panel, add a Fog Atmospheric Effect to the Atmosphere rollout's Effects list, enable Exponential and set the Far % to 95.

Information: We have amended the camera's lens size to a wide-angled lens to give the scene

a sense of scale. The fogging is reduced to 95% so that it does not completely shade the sky, so we still have some blue visible should the horizon be viewed.

PART FIVE: Next we will illuminate our scene with a single key light to simulate the sun, and arrange a faked global illumination system to simulate light from the sky.

19 In the Top Viewport, create a Target Direct Light to the right-hand side of the mountain and position its target at the center of the mountain. Label this light Sun and reposition it vertically in the Left Viewport. Enable Shadows and set the light's color to RGB 255,245,231. Enable Overshoot and set the Falloff/Field to about 1500 to encompass the mountain. Set the Shadow Map Param's Bias to 0.001 and Size to 2048.

Information: Overshoot was used so that areas outside the Falloff/Field would be illuminated (should any be introduced). Falloff/Field was increased as shadows are confined within this boundary. The Shadow Map Bias was reduced to prevent any detachment of shadows from the objects/faces that cast them, and the Size increased to result in crisp, detailed shadow.

20 Enable Grid Snap (if not already enabled) and in the Top Viewport, create a Target Direct Light to the left-hand side of the mountain and drag its target to the center of the mountain. Set the Multiplier to 0.03 and color to RGB 178,222,255. Enable Overshoot and set the Falloff/Field to 1200. Turn off Specular, set the Shadow Map Bias to 0.01, Size to 256 and Sample Range to 8. Still in the Top Viewport, Instance the light so that it is the same distance from the mountain at the top side, so that it is at right angles to the original. Reproduce this so you have four lights all at right angles to one another.

Information: We have used low intensity lights due to the final amount that we will be using in the scene. If the light intensity was too high, the entire scene would be washed out. The light's color was taken by sampling a color from the background, and then entering the settings into the light. We do not need specular highlights from each light in our array so this option is turned off. The Shadow Map Size was reduced to keep rendering times down and the Sample Range increased to blur this map a little more.

21 Enable Angle Snap and set the angle snap setting to 2.5 degrees. Select all of the four instanced lights and rotate clone them three times by 22.5 degrees to form a complete ring of lights. Select all of these lights (not their targets) and in the Left Viewport move them up slightly. Shift-move them to instance a new ring, so the new ring is positioned slightly above the mountain. Perform this task another couple of times to create another ring of lights above, pointing down, and another beneath the mountain, pointing upwards. Render off the scene.

Information: A lot of lights have been introduced to create a global illumination lighting effect, with multiple lights emitting multiple shadows. Because of the number of shadows in the scene coming from all directions, the collation of shadows around detailed areas will ensure that these areas become slightly darker (due to the amount of shadows being cast upon them).

Taking it further

The initial mesh preparation period may take a few minutes, but this is to be expected with the high Density setting in the Mountain plane's base settings. After which, the render time will drop dramatically as the mesh does not deform, therefore will not need to be re-calculated for the next frame. Due to the amount of detail in the scene, I would suggest that you use a Catmull-Rom filter when rendering because this will bring out the detail that we have worked so hard to produce.

We have used cylindrically mapped gradients, instead of copies of the radial gradients (which would seem more logical to use) to control the terrain levels, because we need to add a transition right across the terrain. If we had used a copy of the radial gradient we would not have been able to achieve this effect as it works from the inside–out; half of one raised area may be covered in snow and the other half with greenery, which would look weird.

Even though we have designed the change in materials, the end result can be further improved. Currently we are using a basic combination of colored materials to generate the change in terrain, but this has its limitations, especially when viewed from close quarters. Therefore you may wish to add extra detail around the base of the mountain by introducing additional texture maps to the terrain, giving the impression of a detailed surface with lush green vegetation, before it falls off and becomes barren due to the altitude. This barren area could also be improved with the addition of extra texture maps. However you will have to be careful when assigning these maps; you'll have to set up additional map co-ordinates else if you simply assign them with the current mapping, they will be stretched across or over the mesh. Saying that, if you feel confident with creating multi-layered procedural maps (which you should be if you've gone through some of the other tutorials in this book, as there are a ton of them), try creating a rock and/or foliage texture this way using Object XYZ mapping, as the texture will not be smeared over the mesh using this mapping type, or if you are competent using multiple mapping techniques (such as using relaxed UVW mapping) you should be able to map bitmap textures over the terrain with a little bit of effort. In addition to this, you may also want to use 3ds Max 7.5's

Hair system to distribute and animate foliage such as grasses, trees and bushes around the base of the terrain, using the relevant material areas as emitters. You may also want to utilize material displacement, which may increase rendering times, but the results are exceptional (drop the base plane's density down though first!). Should you feel like it is taking too long to render the material displacement, try converting the scene to use the Mental Ray renderer as its displacement is a lot nicer than the standard renderer, and also yields better results. If you are rendering out an animation instead of a single still image, you might want to look into baking any fine terrain displacement to a Normal map for added realism but with lower render times.

Depending on how loose you feel the snow is on the peak, you could simulate gusts of wind blowing the snow off; have a look at the reference material in the Snowflake tutorial to see how snow behaves in the wind. To get particles to emit from the peak, use either a Volume Select modifier (as the mesh density is adjusted at render time) to select a small area of vertices or polygons at the top of the peak by amending the positioning of the Volume Select's Gizmo, or create a proxy object with a grayscale texture assigned to it that a Position Object operator could use to emit particles based on the grayscale strength. Using either one of these emission methods, facing particles (to reduce polygon count and help keep render times low) can be generated that are affected by a Wind Space Warp and are blown off at a tangent. With a low opacity material assigned to them, the result can be very convincing. You may want to go the whole-hog and use the Volume Select or grayscale proxy object (or even the renderable mesh now) to select all (or most) of the snow (use a combination of the Blend material's Gradient Ramp maps to control this selection) to emit the particles so that they are blown from the sides as well. If this is the case, they will need to be blown around the sides of the mountain top; therefore you will also need to introduce a low polygon non-renderable version of the mountain as a deflector for the particles so they don't pass right through the mountain but are forced around it.

Now you have got one mountain created, try creating an entire mountain range. It may sound like a daunting task, but shouldn't be too difficult to modify this tutorial to create several peaks.

26 Asteroid

Information

In this tutorial we are going to recreate an asteroid that appears to have been captured by a probe or extremely powerful telescope. We will also be basing our scene on enhanced and/or false color images of asteroids, which illustrate the colors of the asteroids based on compositional variances and/or different materials; either way, it makes the end result more aesthetically pleasing. Firstly, we will create the basic asteroid and generate an initial displacement for it to get the rough shape laid out. As we do not want to have to handle a lot of detail in the Viewport, we are going to use material displacement to take care of the fine detail by designing our own multiple layered crater maps, so we can produce large craters, working right down to the small impacts, plus some additional debris which has formed on the surface of the asteroid. Because of this type of medium, our end render will have to be degraded a fair amount, with blurring and additional noise.

Analysis of effect

the "traditional" way we
view asteroid footage

Image courtesy of NASA

greyscale

exaggerated /
false color

Image courtesy of NASA

surface texture appears slightly
matted but quite smooth, with areas
between larger craters only showing
a few small craters along with a slightly
bumpy surface

Image courtesy of NASA

just the one light in the environment and
no other objects to reflect light ensure
that the shadow is crisp and totally black

Image courtesy of NASA

(a) Contrary to what you may have seen in the movies, we do not see these huge spiky vicious-looking asteroids with razor-sharp teeth hurtling towards us. In real life, the majority of the footage we see are the black and white grainy animations with a low frame rate; however, like electron microscope imagery there are false or exaggerated color images which show these asteroids in a whole new light. (b) Instead of looking slightly textured the asteroids appear, in these false colored images, quite smooth; almost like a pebble you would pick up from a beach, with a few image marks on them. These marks are mainly shaded a light gray-green color which, according to the image source, simulates rock, while the rest of the asteroid is made up of a orange-brown material which also seems quite smooth (until you get very close up) which, we are told, is disturbed surface material (dirt) or regolith. (c) The surfaces of the asteroids are pitted with different sized craters, each one with a raised lip to suggest displaced matter. There are also large areas of untouched but slightly irregularly textured surface material between the larger craters which have the occasional small impact, but that's about all that is visible when viewed from a distance. (d) The main illumination is from the sun, which casts a single crisp and intense shadow right across the asteroid, so that there is no illumination whatsoever where there is shadow; we do not want the backlit 'where on earth is the light coming from?' Star Trek school of space lighting in this type of scene because we are trying to mimic real footage.

To generate the basic shape of the asteroid, we can use a simple deformation on a Geosphere primitive. To do this, and to ensure that there is no pinching of the mesh or linear deformation (which you would get if you used a Noise modifier), we need to use a procedural map set to X, Y and Z mapping co-ordinates to displace the geometry. This will take on the form of a couple of nested Noise maps to break up any repetition a single map would generate. The resulting geometry can then be illuminated – we will use a single Direct light to simulate the sun; there is no other lighting in the scene, and as there are no other objects to reflect light, any shadowed areas will be completely black, as in the reference material. The craters will be created using multiple Cellular maps, nested one inside the other, going from large to very small, which also have Noise maps to break up any solid colors that define the shape of the craters. To generate the geometry refinement required to use these maps, we will use material displacement which will refine and displace the mesh at render time. We can also use this displacement map tree to drive the mixing of two groups of Noise maps; one for the rock and one for the regolith on the surface of the asteroid, as defined in the reference material. Sample colors

can be taken from the reference material so we get our colors as close to the original material as possible. These mixed maps will also be controlled by a subtle speckling to add a few random patches of alternate color. Finally, we will degrade the quality of the image by adding a few render effects; some grain to add 'unwanted' color to the image, a little blur to smudge this color in with the main image, and finally the main addition of grain.

Walkthrough

PART ONE: First we will create the initial geometry of the asteroid and set up the camera and lighting in the scene.

1 Right-click the Play Animation button and set the Animation Length to 200. In the Top Viewport, create a Geosphere primitive and label it Asteroid. Set the Radius to 100 with 20 segments. Add a UVW Map modifier to this object's modifier stack. Set the Mapping type to XYZ to UVW. Add a Displace modifier to the stack and set the Strength to 100 and enable Luminance Center and Use Existing Mapping. Finally, add a Disp Approx modifier and click on the Medium Subdivision Preset.

Information: This sounds like quite a big step to start off with, but we are hardly amending any settings at all. What we have created is the basic mesh (the Geosphere) as our asteroid geometry. We are going to be using XYZ mapping co-ordinates (to remove any pinching in the maps we assign to the geometry) for our displacement on the mesh. As there is no XYZ to UVW option in the Displace modifier, we can use a standard UVW Map modifier to choose this mapping type, then select Use Existing Mapping in the Displace modifier. We have enabled Luminance Center so that we can raise and lower surfaces of the asteroid's terrain without displacing the entire mesh, by just brightening or darkening a neutral grey in places. The Disp Approx (Displacement Approximation) modifier is used to refine and displace the geometry based on a map used in a material we will assign to the object. We have used a Medium level of detail as we need a fair amount of refinement, because we have a lot of curved surfaces to displace.

2 Enable Auto Key and go to frame 200. In the Front Viewport, rotate the Asteroid 125 degrees clockwise. Turn off Auto Key. In the Top Viewport, create and position a camera near to the Asteroid's surface with its target close to the center of the Asteroid. Enable Auto Key again at frame 200 and reposition this camera so that it rotates around the side of the Asteroid object against the object's motion (or at a tangent). Turn off AutoKey.

Information: We are setting the camera up now so that we can position the light accordingly in the next step.

Animating the Asteroid object is not a necessary step to completing this tutorial, but it does yield an interesting result when the animation is rendered to see the crisp shadow cast by the sun pass over the irregular terrain of the Asteroid.

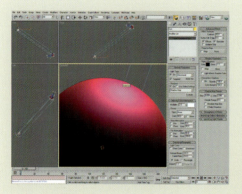

3 In the Top Viewport, create a Direct light a fair distance away from the Asteroid object and position its target right in the middle of the Asteroid. Label it Sun. Enable Shadows, set the Multiplier to 2 with a color of RGB 247,250,255, and increase the Hotspot/Beam setting so that it also increases the Falloff/Field to encompass the entire Asteroid (plus a bit extra to be on the safe side). Set the Shadow Map Bias to 0.001 and the Size to 2048 with a Sample Range of 8. In the Camera Viewport at frame 0 and with the light still selected, click on the Place Highlight tool and run your mouse over the surface of the Asteroid to reposition the light so that it illuminates the perpendicular of your Asteroid object as illustrated.

Information: We have created and positioned a tinted (blue to simulate light in space – just a simple aesthetic) and intensified Direct light as it uses linear shadows; the other lights available have shadows that fan out, which gives the impression of a light which is at a close proximity, not a million miles away such as the sun. We have also increased the Shadow Map Size to create nice harsh detailed shadow with very little or no feathering, which is tucked in nicely behind the geometry that casts the shadow due to the very small Bias size. We have increased the Hotspot/Beam and Falloff/Field settings past the Asteroid so that the light does not decay from one setting to the other. We have also extended them so that shadows are cast right across it; shadows are only cast within the Falloff/Field boundary.

PART TWO: With the basic scene all set up, we will now create the map tree to deform the surface of our asteroid.

4 Open the Material Editor and add a Noise map to the first available material slot. Label it Asteroid Displacement Large. Set the Noise Type to Fractal and the Size to 120. Add a new Noise map into the Color 1 slot and label it Asteroid Displacement Small. Set the Type to Fractal and Size to 40. Set the Color 2 swatch to RGB 91,91,91. Go back to the Asteroid Displacement Large map and drag this map to the Map slot of the Displace modifier. Select Instance when prompted.

Information: With the combination of two Noise maps, we have broken up the repetition and similarities of just a single map. This therefore creates large and small displacements in the surface of the Asteroid mesh, making it more irregular.

PART THREE: Now our mesh is complete, we can now create the finer detail on our asteroid using material displacement and add some color to it, all using a single material.

5 Label a new material Asteroid and assign it to the Asteroid object in the scene. Set the Specular Level and Glossiness to 5 and enable Self-Illumination. Expand the Map's rollout and set the Displacement amount to 50. Add a Mix map to the Displacement slot and label it Asteroid Displacement. Add a Splat map to the Mix slot and label it Mounds. Set the Iterations to 3, Color 1 to black and Color 2 to white (for reference purposes only). Add a Noise map to the Color 2 slot and label it Mounds Texture. Set the Noise Type to Fractal, the Size to 1 and the Color 2 slot to RGB 55,55,55.

Information: We need our asteroid to give off a small amount of sheen (as illustrated in the reference material), so we have designed a low intensity diffused specular highlight. The Displacement slot is what drives the Displacement Approx. modifier, which is what is going to control the craters and other texturing on the Asteroid's surface. We have created the additional surface texturing by adding a Splat map and breaking it up with a Noise map, to create small irregularly sized and distributed mounds over the surface.

6 Add a Mix map to the Color 1 slot of the Asteroid Displacement map and label it Craters Noise Mixer. Add a Noise map to the Color 1 slot and label it Noise Breakup Dark. Set the Noise Type to Fractal, Size to 10, Color 1 to RGB 12,12,12 and Color 2 to RGB 25,25,25. Add a Noise map to the Color 2 slot of the Craters Noise Mixer map and label it Craters Noise Breakup Light. Set the Noise Type to Fractal, Size to 5, Color 1 to RGB 220,220,220 and Color 2 to RGB 232,232,232.

Information: This Mix map and two Noise maps are to break up any repetition in the craters, which we will design momentarily. Even though the craters will contain multiple Noise maps to break up their texture, there will be some repetition, so these two Noise maps control the light and dark colors which pass up the map tree; where there is a light color the Noise Breakup Light map is used, where there is a dark color the Noise Breakup Dark map is used, and a mixture for colors in-between.

7 Add a Cellular map to the Craters Noise Mixer map's Mix Amount slot and label it Big Craters. Set the Size to 200, Spread to 0.1, Bump Smoothing to 0, Enable Fractal and set the Iterations to 1.07. Set the Roughness to 0.13 and the High setting to 0.97. Add a Noise map to the Cell Color's slot and label it Big Craters Noise. Set the Noise Type to Fractal, Size to 10 and Levels to 10. Set Color 1 to RGB 101,101,101 and Color 2 to RGB 122,122,122. Instance this map to the first Division Color slot in the Big Craters map.

Information: We are going to be creating the different sized craters in layers, starting with the largest ones and working our way down in size. The Cell Characteristics have been amended to increase the size, reduce the spread (else it would cover the entire surface) and add some variation to the size by using fractal and adaptive settings. The high threshold was reduced to clip off the blurring of the edges of the crater a little (as has the Bump Smoothing reduction). The Roughness was increased to add a bit more irregularity to the shape of the crater. Finally, as we want a large color for our large crater, we need to add a slight noise to it, hence the presence of the two copies of the Big Craters Noise map, which adds a little bit of texture to the surface of the big craters thanks to the very slight difference in color in the Noise map(s).

8 Copy the Big Craters map into its own second Division Color slot, go into it and label it Medium Craters. Remove the two Noise maps from the Cell Color and the first Division Color slots. Set the Size to 100 and the Spread to 0.15. Set the Cell Color's swatch to black and the first Division Color swatch to white.

Information: We have kept the majority of the existing settings in the Big Craters map because we can keep some consistency throughout the map tree, plus there is no point in re-entering the same settings when we can just reuse what we have already set up. We have, however, decreased the size of the cells (or craters) and therefore increased the spread, which packs more in and reduces the amount of space between each cell. We have also amended the colors to create an indentation in the middle of the cell and an outward displacement (the ring around the cell) to suggest displaced material after the impact.

9 Copy this map to the second Division Color slot. Go into this new map and label it Small Craters. Set its Size to 60. Add a Noise map to the Cell Color slot and label it Small Craters Noise. Set the Noise Type to Fractal, Size to 0.1, Levels to 10 and Low to 0.5. Set Color 1 to RGB 30,30,30 and Color 2 to RGB 45,45,45. Back in the Small Craters map, set the first Division Color to RGB 201,201,201.

Information: Again, we have got the original settings of the craters still intact so we do not need to modify them. We have simply reduced the size of the craters again, and also reduced the height of the displaced terrain around the crater, which uses a Noise map to create its depth.

10 Copy this map into the second Division Color slot. Go into this new map and label it Tiny Craters. Set the Size to 20, Spread to 0.2 and turn off Fractal. Remove the Noise map from the Cell Color slot, set the Cell Color swatch to RGB 163,163,163 and the first Division Color swatch to RGB 226,226,226. Add a Noise map to the second Division Color slot and label it Tiny Craters Noise. Set the Noise Type to Fractal, Size to 0.05, High to 0.75, Low to 0.125 and Levels to 10. Set the Color 1 swatch to RGB 205,205,205 and the Color 2 swatch to RGB 220,220,220.

Information: Again, we have created some smaller craters; these being the smallest of the lot, although the same conditions apply with an indentation and a ring of debris around its edge. The Noise map in the second Division Color slot is to texture the remaining untouched surface of the Asteroid which has no craters to give it a slightly bumpy surface.

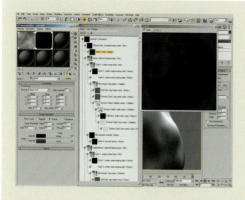

11 Instance the entire Asteroid Displacement map tree into the material's Bump slot and set the Bump to −30. Add a Mix map to the Diffuse slot and label it Asteroid Surface Mixer. Add a Noise map to the Color 1 slot and label it Rock. Set the Noise Type to Fractal, Size to 30, Low to 0.4 and Levels to 10. Set Color 1 to RGB 39,42,36 and Color 2 to RGB 66,93,92.

Information: Light colors generate positive displacement but negative bump mapping, so we use a negative bump map to get the map facing around the right way again. We have added a Mix map to the diffuse slot to mix two colors together – the green and orange/brown colors from the asteroids in the reference material, but we cannot just mix single colors as they would look too uniform. Therefore, we will use a combination of maps to blend them together to remove any uniform pattern over the surface. In this step we have just created the green color to simulate rock (according to the caption which accompanies the reference images).

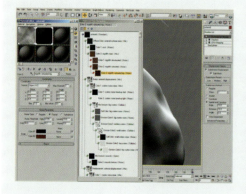

12 Add a Mix map to the Color 2 slot of the Asteroid Surface Mixer, label it Regolith Mixer and set the Mix Amount to 50. Add a Noise map to the Color 1 slot and label it Regolith Desaturated. Set the Noise Type to Fractal, Size to 20, Levels to 10, Color 1 to RGB 86,69,51 and Color 2 to RGB 144,112,91. Copy (not instance) this map into the Color 2 slot of the Regolith Mixer map and label it Regolith Saturated. Amend the Noise Size to 10, High to 0.725, Low to 0.2 and Color 1 to RGB 34,18,0. Copy this map into the Color 2 slot, go into it and label it Regolith Saturated Big. Set the Size to 50 and the Color 2 slot to RGB 108,65,26.

Information: Regolith (top soil) is situated over the surface of the asteroid in different color intensities, hence the need to create different sizes and to break up the repetition of a single Noise map. The colors were determined by point-sampling colors from one of the reference images provided on the DVD-ROM.

13 Add a Mix map to the Mix Amount slot of the Asteroid Surface Mixer map, label it Rock/Regolith Control and set the Mix Amount to 40. Add an Output map to the Color 1 slot and label it Crater Definition. Instance the Asteroid Displacement map into this map's Map slot. Enable Color map and amend the curve, as illustrated, so that it intensifies the dark and light areas of the sub-map, making the transition between light and dark more abrupt.

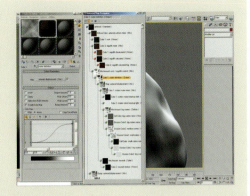

Information: Observing the reference material, we notice that there are a few light green areas around the craters on the surface of the asteroid, therefore we can use the displacement map we have created to generate the same effect. We have added an Output map to define the colors a little more to remove any blurring of the transition from one Diffuse color (rock) to the other (regolith). We are simply mixing the two maps together in the Rock/Regolith Control map as we just want them to blend them together in places, plus have some areas which are not as intense as others.

14 Add an Output map to the Color 2 slot of the Rock/Regolith Control map, label it Rock/Regolith Distribution, turn on Enable Color map and amend the curve, as illustrated, so we have a gradual transition from black to white and a larger area of white from the sub-map. Add a Speckle map to the Map slot and label it Rock/Regolith Speckle Small. Set the Size to 100. Add a Speckle map to the Color 2 slot and label it Rock/Regolith Speckle Large. Set the Size to 200. Add a Noise map to the Color 2 slot of this map and label it Rock/Regolith Breakup. Set the Noise Type to Fractal, Size to 60, High to 0.5 and Levels to 10.

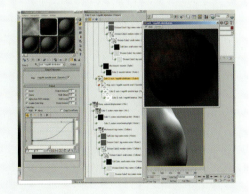

Information: We have used multiple Speckle maps to break up any repetition, and a Noise map to totally disrupt it so there are large areas without any speckle effect, just as the reference material illustrates. As we cannot control the falloff from black to white in a Speckle map, we have to use an additional Output map to handle this. The result is a distribution of the two Diffuse colors which is irregular but also covers areas in and around the craters.

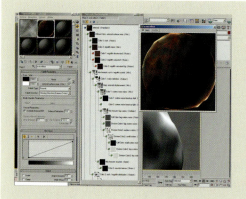

15 At the top of the material tree, add a Falloff map to its Self-Illumination slot, set it to Shadow/Light and label it SI Mask. In the Lit slot, add another Falloff map, change its Falloff Type to Fresnel and label it SI Rim Effect. Instance the entire Asteroid Surface Mixer map tree into the Side slot of this map. Set this Falloff map's Output amount to 5.

Information: Here we have used an enhanced instance of the surface color which is only displayed on the perpendicular, thanks to the Fresnel falloff map. This map (which creates the rim glow) is masked by the additional Shadow/Light Falloff map to only display the effect where light is cast upon it, therefore not displaying it in areas which are in shadow.

PART FOUR: Finally, we will add a few post effects to degrade the image to make it look like it has originated from a few million miles away.

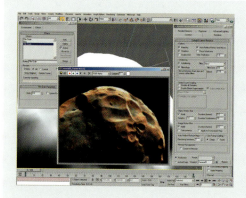

16 Open the Effects panel, add a Film Grain effect and set the Grain to 1. Add a Blur effect and set the Uniform amount to 1. Add another Film Grain effect and set the Grain to 0.4. Finally, open the render panel and go to the Renderer tab. Set the Anti-Aliasing Filter to Blend, set the Filter Size to 4 and the Blend to 0.15. Render off the animation.

Information: We have added two lots of grain; firstly to add a variation in color across the image, which is then blurred slightly. The second grain application degrades the image further once the blur has been applied so the image appears like it has been converted from another medium, such as a print, photo or other electronic format. The Blend Anti-Aliasing filter has been reduced in strength as the blurring is handled by the post effect, but is still slightly blurry to remove any harsh edges and artifacts from the render.

Taking it further

As we have based our asteroid on enhanced color images, it is not much of a problem to revert it back to the 'traditional' grayscale images which are more commonly found on websites and in TV documentaries when illustrating that we're all going to die soon from a big rock in the sky. It's just a simple case of removing the diffuse map tree and replacing it with a reduced version of the displacement map

(a simple instance of the displacement map tree into the slot in an Output map will suffice, which will give us the opportunity to reduce the intensity of the map tree without affecting the displacement).

Effects wise, there's not much else we can do to the scene to make it look more realistic, unless we take a complete u-turn and go for the hyper realism of simulating that we are actually flying around the asteroid, and not viewing some footage from a probe. In which case you may wish to remove the existing render effects, add a background image of a star field (etc.) and use Catmull-Rom anti-aliasing to enhance any edges in the scene and make detail stand out more.

It is not uncommon for asteroids themselves to have satellites, so you may wish to introduce small bodies circling the asteroid. If you are feeling really adventurous, you could set up an asteroid field particle system and have this large asteroid run right through the field so the small particles are attracted to its mass, and fragment on impact with it, leaving additional debris flying everywhere. This would result in quite high rendering times, because you would have to use geometry as a deflector for the particle system, but would also yield an extremely dramatic effect. To cut down the render times but without compromising too much on quality, try amending the modifier stack to refine the mesh using a Meshsmooth modifier and use geometry displacement by removing Disp Approx modifier from the stack and using a standard geometry displacement modifier. The existing Displacement map tree can be removed from the material tree and applied it to the Displace modifier. Next, we can bake out the high polygon asteroid terrain displacement to a Normal map for added realism but with lower render times, and apply it to a lower polygon version of the asteroid with basic geometry displacement.

Air

Quite a vague topic and difficult to pinpoint, this section covers a wide range of effects, from Cigarette Smoke to a Pyroclastic Flow. Even though some of the tutorials in this section are not necessarily 100% air-related, they do possess some similar characteristics and/or air effects in their physical appearance or motion, so are therefore entirely relevant. See the DVD-ROM for more air effects in the Videos section.

27 Cigarette smoke

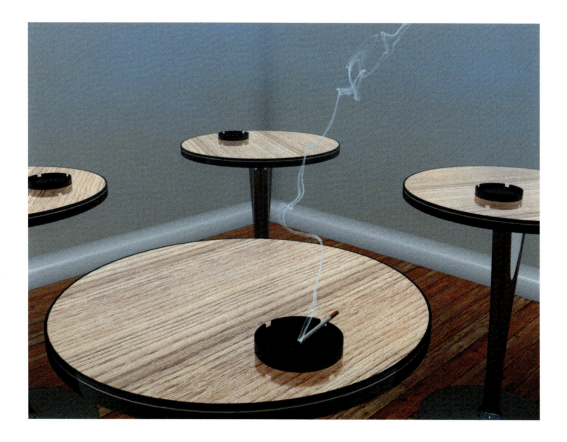

Introduction

There have been numerous cigarette tutorials available for a long time; one of which is even
included in a tutorial which comes with 3ds Max. However, none of these deal with multiple
streams of smoke. Therefore, in this tutorial we are going to create these multiple smoke streams,
emanate from multiple moving points around the end of a cigarette, and to generate the faded
long and thin stream of smoke which trails next to a single stream, using particle spawning as an
emitter for more spawning particles. Each of these streams are going to be passed through to
additional events which are going to control their motion and shape using Space Warps. The
entire effect is going to be based in a smoky café; the same place we bought our lemonade
earlier on … they seem to let anybody in there these days!

Analysis of effect

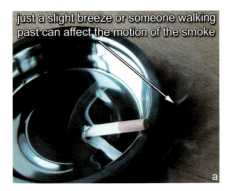

just a slight breeze or someone walking past can affect the motion of the smoke

a

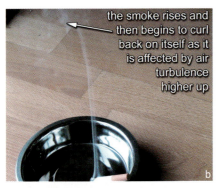

the smoke rises and then begins to curl back on itself as it is affected by air turbulence higher up

b

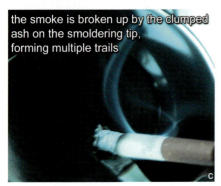

the smoke is broken up by the clumped ash on the smoldering tip, forming multiple trails

c

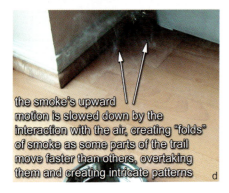

the smoke's upward motion is slowed down by the interaction with the air, creating "folds" of smoke as some parts of the trail move faster than others, overtaking them and creating intricate patterns

d

(a) Cigarette smoke is quite unlike any other smoke formation, forming intricate patterns as it rises through the air and is affected by pressure, turbulence and third party interaction; even breathing can affect its shape. The smoke is, obviously, emitted from the smoldering end of a cigarette, which is burning in more than one place. Because of this, multiple streams of smoke are emitted at the same time. (b) As these trails are very close together, they can appear to form a single mass of rising smoke; this is mainly due to the individual trails being broken up after traveling up the cigarette, depending on if the cigarette is tilted somewhat (see the Taking it further section for a continuation on this effect). (c) The individual trails are emitted as they have to pass through the surrounding ash on the tip of the cigarette. This breaks up the trail a little and allows some of the rising smoke to dissipate away from the main trail. This can form thinner yet longer trails which interact with the air the same way as the thicker trails, but are simply less dense. It is the breakup and formation of these smaller, thinner, yet wider trails that defines the appearance of this type of smoke and is something we definitely should concentrate on to emulate. As the smoke rises, the surrounding particles in the air affect its shape and motion; in a confined environment with very little or no disturbance in the air the smoke will create long emission trails before its rising velocity is dampened by the resistance of the air particles against the smoke particles and the shape of the smoke is broken up to form a hazy cloud. (d) With a little more air turbulence the smoke bobbles a little as it is being emitted and forms small intricate trails which appear to double back on themselves and create detailed arcs. Additional air turbulence will break these shapes up further with larger arcs, forming even more intricate shapes, before higher air turbulence finally breaks them up as before.

The main driving force behind the smoke effect is obviously going to be Particle Flow, mainly because it gives us the ability to produce multiple trails with ease. If we were producing a single trail we could use the legacy particle system, mainly due to its ease of use and low set up time. The trails themselves will be emanated from the end of the cigarette which will move around the end geometry (a hemisphere), leaving small motionless trails as they go. These trails will themselves be passed onto another event which will spawn particle trails from these small trailing particles, which will result in a long and thin band of particles. Additional smaller emission trails will be generated to produce the thicker rising trail which the more transparent thin smoke follows. All of

these rising particle trails (not the emission ones) are passed to another event which will drive their animation. To randomize this we will use multiple Wind Space Warps; one small one to add some tiny random turbulence, a larger one to create the large turbulent shapes, and finally a horizontal Wind so that, after a time (derived by particle age) the particles are blown aside by higher air turbulence; all of which will be dampened by a Drag Space Warp to suggest air resistance. Lastly, because of the smoky atmosphere we will add a volumetric effect or two to suggest that people have been smoking in the room for a while.

Walkthrough

PART ONE: First we will load in the initial scene and set up any Space Warps required to drive the motion of our smoke.

1 Open the *Air/27_Cigarette_Smoke/Source/27_cigarette_smoke_start.max* file included on the DVD-ROM. In the Top Viewport, create a Wind Space Warp. Set its Strength to 0.5, Turbulence to 0.8, Frequency to 0.9 and Scale to 0.02. Copy this Space Warp and set its Strength to 0.2, Turbulence to 0.4 and Frequency to 5.

Information: We have created the Wind Space Warps in the Top Viewport so that they are created facing upwards and will make the particles we will introduce later on rise as they have a slight strength. Three main factors affecting the design of the smoke are contained within these Space Warps, and those are the Turbulence, Frequency and Scale. The Turbulence tells the system how random the shape should be, the Scale smooths or breaks up this turbulence effect and the Frequency scales the turbulence by increasing the number of times the turbulence repeats itself. As we have two different frequencies, we will have a higher frequency within a smaller frequency, therefore creating a small vigorous effect that is deformed by a larger effect.

2 In the Left Viewport, create another Wind Space Warp. In the Front Viewport, rotate it 157.5 degrees clockwise. Set its Strength to 0.5, Turbulence to 0.4, Frequency to 0.9 and Scale to 0.02. In the Top Viewport, create a Drag Space Warp. Set the Time On to −200 and the Time Off to 1000. Set the X, Y and Z Axis settings for the Linear Damping to 30.

Information: We have created another Wind Space Warp to catch the particles (after a certain time) and blow them sideways with some turbulence to break them up a little.

As we are using a fair amount of wind, we need to slow the particles down to simulate air resistance. To do this we need to use a Drag Space Warp. It has got a negative Time On setting as we are going to start emitting particles at frame −200 and 1000 frames gives us ample time to see the smoke form intricate shapes (anything lower just doesn't seem long enough).

PART TWO: Next we will generate a material for the smoke and add some volumetric effects to suggest the smoky environment.

3 Open the Material Editor and label a new material Cigarette Smoke. Set the Diffuse color to RGB 95,120,150 and enable Self-Illumination. Set the Opacity setting to 10. Expand the Maps rollout of this material and add a Falloff map to the Self-Illumination slot. Label this map Smoke Light Illumination. Change the Falloff Type to Shadow/Light and set the Lit slot's color swatch to RGB 205,212,222. Expand the Output rollout and set the Output Amount to 2.

Information: We have set up the smoke's material so that it is virtually transparent and is tinted a desaturated light blue. It has also been set so that when illuminated directly its colors will be emphasized with a lighter version of the same blue. This is to suggest the tiny smoke particles catching the light, as they do in real life. We have also set the Output amount to a higher value to intensify the illumination of these particles.

4 In the Top Viewport, create a Sphere Gizmo Atmospheric Apparatus right in the middle of the 'room' with a Radius of about 6000. In the Left Viewport, move this Gizmo vertically upwards so that its center corresponds to the ceiling of the room. Scale it down by 50%.

Information: This Gizmo has been introduced to the scene to position and control volumetric smoke. It has been positioned right at the top of the scene as that is where its density is strongest and therefore where the smoke from other cigarettes will rise to. However, it has been set to a large size so this smoke can linger in the scene.

5 Open the Environment panel and add a Fog Atmospheric Effect. Set the Fog Type to Layered and set the Top to 2700, Density to 100 and Falloff to Bottom. Set the Fog color to RGB 95,120,150.

Information: Here we have added a gentle layered fogging effect using the color of the smoke so that it is least dense at the bottom of the room and densest at the top. The Top setting was derived from the positioning of the Sphere Gizmo which is placed at the top of the room. Bottom falloff has been used to get the effect to fade from the top setting to the bottom setting.

6 Add a Volume Fog Atmospheric Effect. Click on the resulting Volume Fog Parameters' Pick Gizmo button and select the Sphere Gizmo in the scene to add it to this Atmospheric Effect. Set Soften Gizmo Edges to 1, enable Exponential and set the color to RGB 95,120,150. Set the Density to 2 and Noise Type to Turbulence. Set the Uniformity to −0.2, Levels to 5, Size to 1000.

Information: Using the Sphere Gizmo, we have positioned and set the area where there will be low density volumetric fog to simulate patches in the cigarette smoke that has risen and dispersed. We have set the Soften Gizmo Edges to 1 to feather off the boundary of the gizmo, else the fog would not diminish as much as desired; there would be a cut-off. We have set the Uniformity to −0.2 to break up the fog and to add some patches, and we have increased the Size so the fogging is not made up of small repetitive patches.

PART THREE: Finally we will generate the particle system to create the individual smoke trail generators, emit the trails and then assign the Space Warps to control their motion.

7 In the Top Viewport, create a Particle Flow system and label it Cigarette Smoke. Set the Viewport Quantity Multiplier to 25, Expand the System Management rollout and set the Particle Amount Upper Limit to 10000000 (the maximum setting).

Information: Even though we have reduced the Viewport Quantity multiplier to a lower setting, the way this works is that it only reduces the amount of initially born particles visible to the Viewport, therefore, if we have

100 particles born and we set it to 50%, 50 particles will be viewed. But if these 50 particles all spawn trailing particles, the Quantity multiplier will not reduce the amount of spawned particles per emitter particle. We have set the Particle Amount Upper Limit to its maximum setting as we will be using a lot of particles, so do not want the system to stop emitting once it hits the original cut-off amount.

8 Press 6 or click on the Particle View button. Rename the Event 01 event to CS Emitter Generator. Select the Birth operator and set the Emit Start and Emit Stop to −200 and Amount to 4. Remove the Position Icon, Speed, Rotation and Shape operators. Add a Position Object operator and add the Ash object to the Emitter Objects list.

Information: We have set the particle birth to a negative value as we want some smoke to be already emitted as we join the scene, but this can lead to update lags as we progress through the construction process. If you do not want this, set the Emit Start and Emit Stop to 0 to get the particles to be born from frame 0 or turn off the system during construction. We have removed operators that we do not need; we are only using this particular event to create trailing particles; they are not to be rendered, hence the lack of a Shape operator.

9 Turn off the particle system. Add a Speed By Surface operator and set it to Control Speed Continuously. Set the Speed and Variation to 0.5 and add the Ash object to the Surface Geometry list. Set the Direction to Parallel to Surface. Add a Spawn test, set it to By Travel Distance with a Step Size of 0.1 and set the Inherited Speed to 0. Copy and Paste this test and set the By Travel Distance Step Size to 0.05 and the Inherited Speed to 25 with 10 Variation.

Information: We have turned off the particle system as these two Spawn tests produce a lot of particles. As the next event or two are going to delete the majority of them, we can turn the system back on after we have set up the next couple of steps. We have set up two separate Spawn tests to generate the two types of trail – the first produces the wider (more transparent) trail due to the emitter particles being spaced out and not spawning as many as the other spawn test, as this second one has a lower distance to travel before it spawns an emitter particle and also bunches them up a little by using inherited speed.

10 Drag out a Delete operator to the canvas to create a new event. Label the event Transparent Trail Emitter. Set the Delete operator to By Particle Age with a Life Span of 100 with 0 Variation. Add a Spawn test to the event, set it Per Second with a Rate to 100 and set the Inherited Speed to 0. Drag out a Delete operator to the canvas to create a new event. Label the event Thin Opaque Trail Emitter. Set the Delete operator to By Particle Age with a Life Span of 30 with 0 Variation. Copy the Spawn test in the Transparent Trail Emitter and Paste

Instanced it into this event. Wire the Transparent Trail Emitter event's input to the Output of the first Spawn test in the CS Emitter Generator event, and wire the input of the Thin Opaque Trail Emitter to the output of the second Trail emitter in the CS Emitter Generator event.

Information: Still keeping the particle system turned off, we have told the original Spawn tests to delete after a certain amount of time, so we get a certain length trail emitter generated from the positions of these spawned particles. These particles will spawn the trails using the instanced Spawn test we have just created.

11 Drag out a Shape Facing operator to the canvas to create a new event and label this event CS Smoke Rising. Wire the two Trail Emitter events to the input of this event. In the Shape Facing operator, click on the Look At Camera/Object button and select the existing camera in the scene and set the Size to 0.5. Add a Force operator and add the Wind01 and Wind02 Space Warps to its Force Space Warps list. Add another Force operator and add the Drag Space Warp to its Force Space Warps list. Add a Material Static operator and instance the Cigarette Smoke material

to its material slot. Set the Display operator in this event to display geometry. Turn the particle system back on.

Information: We are using facing particles as our particle type because they have the least amount of geometry and can be set to look directly at the camera to produce the maximum amount of surface space for our assigned material. We have only used the first two Wind Space Warps as we need the smoke to rise a little first; a short time later the particles will be passed to another event where the third Wind Space Warp will affect them. The Drag was kept in a separate operator as we will need to amend a copy of it, whereas we need the Wind settings unaffected.

12 Add an Age test to the event and set the Test Value to 60 with 0 Variation. Select the two Force and the Material Static operators, copy them and Paste Instanced them onto the canvas to create a new event. Label this event CS Dispersion and wire it to the output of the other event's Age test. Make this new event's Force operator, containing Drag Space Warp, unique and set its Influence to 2000. Add a Force operator and add the Wind03 Space Warp to its Force Space Warp list. Add a Delete operator to the event, set it to By Particle Age and set the Life Span to 300 with 100 Variation. Right click the Play Animation button and set the Animation Length to 1000 to match the Time Off of the Drag Space Warp. Render off a few hundred frames of the animation.

Information: After a short period of time, approximately 2 seconds or so, the smoke will have risen and have been caught by the passing air generated by the additional Wind Space Warp. As this affects the motion of the particles as well, and would speed it up, we have used an amended copy of the Drag Space Warp and doubled its influence, making the Drag stronger. We have also got an additional copy of the original Force operator with the two Winds inside, because the particles have been passed to another event and would not be affected by these Space Warps. The same can be said for the Material Static operator, so it too had to be dropped into this event. The Delete operator is set to thin the particles out once we get to a ripe old age of 300 so it appears as if they dissipate into the cloud of smoke around the ceiling.

Taking it further

Even though we have an exceptionally large number of opacity-mapped particles and a fair amount of raytracing, the render times do not take all that long because of the size of the particles and the fact that they do not overlap much. If this amount of particles overlapped then the render times would have been high.

The effect does not necessarily need to be improved, because the particle motion and materials are just about right for the conditions in the scene and the angle of the cigarette. As mentioned in the analysis, if the angle of the cigarette was steeper, the smoke would pass along (and around) the length of the cigarette before rising into the air. To simulate this we can use a Speed by Surface operator to get the particles to follow the length of the cigarette, and using a Wind Space Warp to add a little variation to the motion, to make the smoke a little wispier, and after a certain time (particle age) we can pass the particles to another event which has the main Wind and Drag Space Warps in it. Again, it is just a case of analyzing the effect and breaking it down into its core components; such as 'this happens, then this happens, then this and then this happens, and so on until we can get it right.

Depending on the conditions of the environment, you will need to amend the smoke's Space Warps considerably. For example, if you place the cigarette in an external location, or somewhere near a door, you are going to get gusts of wind affecting the smoke quite frequently, which will disperse it more quickly. In which case you may want to bypass the event with the rising smoke and go straight to the event with the horizontal Wind Space Warp (obviously amending the Delete operator's settings accordingly), so that the smoke does not have time to 'casually' rise into the air; it is vigorously blown aside.

28 Tornado

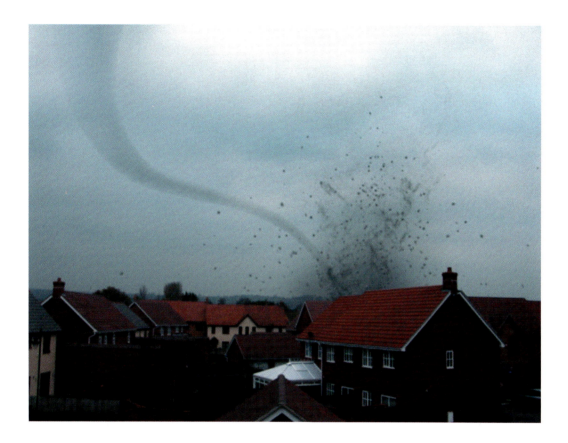

Information

This housing estate isn't having much luck is it? First it gets set on fire and now a tornado comes to visit! In this tutorial we are going to create a funnel tornado which is causing havoc behind a row of houses, kicking up dirt and debris and sucking up the ground material, colorizing the base of the tornado. In order to create the desired effect we are going to use a combination of geometry, an exceptional amount of particles to create the wispy debris, and also a little bit of spline IK and skinning to control the animation of the funnel. Even though there are a lot of particles flying around in the scene, due to their size they will not take all that long to render.

Analysis of effect

dust and debris is sucked up the funnel, thereby "polluting" the color of the base of the tornado

Image courtesy of Getty Images

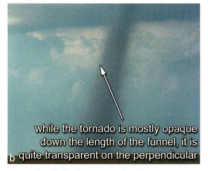

while the tornado is mostly opaque down the length of the funnel, it is quite transparent on the perpendicular

Image courtesy of Getty Images

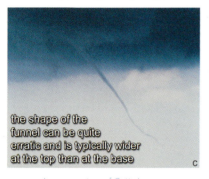

the shape of the funnel can be quite erratic and is typically wider at the top than at the base

Image courtesy of Getty Images

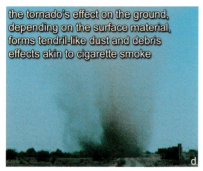

the tornado's effect on the ground, depending on the surface material, forms tendril-like dust and debris effects akin to cigarette smoke

Image courtesy of Getty Images

(a) The initial idea was to have several different twister-esque effects in this book – a tornado, a dust devil and a water spout. However, while researching the effect it became apparent that they are all very similar; some even identical albeit from different materials (dust, earth, debris, water, etc.) which form the effect. Tornados come in all shapes and sizes, though for this one we are going to concentrate on the 'traditional' funnel shape, which stretches down from the sky before coming into contact with the ground, producing a swirling cloud of debris that hasn't been sucked up into the main body of the tornado. (b) The funnel itself, for this particular type, is quite opaque down the middle of the length of the tornado; however, the sides are more wispy because the water vapor and debris are seen as less dense from our point of view. The shape of the funnel is tapered a fair amount, producing a wider cone at the top of the funnel and a point at the base, because of which there is less visible water vapor and as such the thinner area becomes more transparent than that the top. (c) The funnel can be quite erratic, with the top of the tornado remaining 'stationary' and turning the bottom most point races across the ground which rips up anything that comes into its path. The debris caused by this motion is either caught and absorbed into the bottom half of the tornado, with the color of the debris spreading up it, or is flung outwards. (d) Because of the turning motion of the tornado, the ground which is being affected is churned up and any loose dirt which is not sucked up by the tornado or flung outwards forms complex tendril shapes, not dissimilar from cigarette smoke, which disperse into the air over time.

As the funnel we are emulating is quite opaque, we can use geometry to generate the basic shape, and materials to add any extra detail such as any differences in opacity or texture. However, if the tornado was considerably larger, we would more than likely have to replace the entire geometry with a particle system; we will use this to some extent by using the geometry as an emitter to create a faint cloud effect rotating around the geometry to break up any harsh edges around the sides of the funnel and to create a more wispy effect. As we want the top of the funnel to remain mostly stationary, fixed to a certain point in the cloud overhead, we can use skinning and spline IK to deform and animate the position of the base of the funnel so that it travels along the ground. Linked to a specific node in the spline will be the particle systems to generate the dust and debris kicked up by the funnel traveling along the ground. These will be controlled by a Vortex Space Warp to get them to spin and a turbulent Wind Space Warp to create tendrils of dust as they rise into the air. As the entire sky is overcast and the dust, debris and cloud translucent,

we can forego any complex lighting setup; a simple non-shadow casting Skylight will suffice, with a single low-intensity Direct light used to generate the diffused sunlight (the positioning derived from observing highlights in the scene) which will be mainly used on the funnel to create subtle shading. Finally, as with the Oil Based Fire tutorial, we can tuck the entire render behind a row of houses using Video Post to composite a masked copy of the backplate on top of the render.

Walkthrough

PART ONE: First we will load in the basic scene in which we will create and animate the funnel geometry.

1 Open up the *Air/28_Tornado/Source/28_tornado_start.max* file on the DVD-ROM. In the Top Viewport, create a Cylinder with a Radius of 80 and a Height of −1500 directly in the center of the scene (we are using a negative value so later settings work correctly). Set the Height Segments to 15 and Sides to 25. Reposition it in the Left Viewport so that the top of it is situated 1000 units above the ground at co-ordinates 0,0,1000. Label this cylinder Funnel.

Information: Our basic scene has a positioned camera which relates to the camera position that was used to take the background image. Also in the scene is a ground plane (which simulates the ground) that has a Matte/Shadow material assigned to it so that it is not visible when rendered, but will occlude any wayward geometry that passes beneath it. We have also got 200 frames in our animation to play with which gives us ample time to produce some interesting motion. The Cylinder has been created at a relatively low detail so that we can generate our deformations easily, and also smooth out any problems with them later on by adding geometry refinement. The Cylinder has also been repositioned so that the top of it is off camera and is roughly where the low level clouds are situated.

2 With the Funnel object selected in the Left Viewport, go to the Character menu and select Bone Tools. Click on Create Bones in the Bone Tools panel and in the resulting IK Chain Assignment rollout in the Command Bar, change the IK Solver to Spline IK Solver and enable Assign To Children. Create about six or seven bones so that they are roughly the same length down the middle of the Funnel object from top to bottom. Right-click to cancel the construction

process and, in the resulting Spline IK Colver pop-up, amend the number of Spline Knots to 5 and click OK.

Information: We are using Spline IK to distort our cylinder as it is a lot easier to set up and control than, say, Path Deform or any other deformation-based modifier for this particular scenario. It also allows us to link additional objects to the points that drive the spline's deformation which we can utilize later on.

3 Add a Skin modifier to the Funnel's modifier stack and add all of the bones in the scene to it. Click on the Edit Envelopes button and amend the envelopes for each bone so that the envelope for one bone influences its adjacent bones with the falloff envelope. With all envelopes edited, in the Front Viewport amend the positioning of the bottom most Point helper that was generated by the Spline IK system so that it is sitting on top of the Plane and amend the rest of the Point helpers to form a curved formation, as illustrated, so that the base of the Funnel object is pulled up and situated just below the bottom of the Plane object.

Information: As the Spline IK amends the positioning of the bones, and therefore affects the Skin modifier in the Funnel object, any problems due to bad vertex assignment, creasing, stretched vertices (etc.) will be apparent at this stage and can be easily amended by tweaking the envelopes a little. However, do not worry too much about it; we are simply using Skin and Bones as a means to an end and as we are going to be adding modifiers galore to the stack it does not need to be perfect. Saying that, the bottom most helper does need to be positioned on the Plane object as we will be linking objects to it later on. At this stage we can see how the Funnel deformation is going to work; the next stage is to give it the correct characteristics.

4 Select the Cylinder at the base of the modifier stack and add a Taper modifier so that it is situated between the Cylinder level and the Skin. Set the Amount to −0.82 with a Curve of −1.63. Go to the Taper's Center Sub-Object, and in the Left Viewport reposition it about 2500 units vertically downwards so that the Funnel shape is inverted. Turn off the Skin modifier and add a Volume Select modifier between the Taper and Skin modifiers. Set the Stack Selection Level to Vertex and reposition its

Gizmo Sub-Object so that the bottom most ring of vertices are selected. Enable Use Soft Selection and increase the falloff so that the majority of the Funnel geometry is affected, apart from the topmost ring of vertices, as illustrated.

Information: Amending the positioning of the Taper's Center gizmo flips the influence of this modifier around so that we have got our desired shape. We have added the Volume Select modifier to relax the influence of the Skin modifier around the top of the Funnel so that it does not distort it too much when we animate it later on.

5 Add an XForm modifier between the Cylinder base and the Taper modifier. In the Top Viewport, enable Auto Key and go to frame 200. Rotate the XForm modifier's Gizmo 2000 degrees anti-clockwise. Turn off Auto key and go back to frame 0. Right-click the resulting generated keyframes at frame 0 in the time bar, select the Z Rotation keyframe and amend the Out curve to a linear attack. Click on the arrow next to the curve to pass this curve information to the In curve of the next keyframe (at frame 200).

Information: We have added an XForm modifier to rotate the geometry without rotating the object, therefore any parameters we have already set up will still distort the object accordingly, but the geometry will be rotating within this deformation. This rotation has been introduced to allow particles to adhere to the rotation which we will set up later on. The Out curve of the rotation keyframe at frame 0 has been amended so that the rotation does not speed up (or slow down at frame 200). Note that I have also hidden the bones as we can control their influence on the geometry using the Spline IK Point helpers.

6 Re-enable the Skin modifier. Turn on Auto Key and animate the positioning of the base Point helper over the 200 frames so that it reaches out across the scene in the Front Viewport and back again (do NOT animate it moving up or down in either the Front or Left Viewports – keep it level on the Plane). Add some slight irregular side-to-side motion in the Left Viewport so that the Funnel is not just deforming in one direction. Animate the other point helpers as well so the Funnel contorts and doubles back on itself a little over the 200 frames. Turn off Auto Key.

Information: We can even animate the positioning of the topmost helper to move the entire Spline setup across the scene as, if we have the Volume Select modifier set up correctly, this will not influence the top most vertices of the Funnel (or only slightly) as the Volume Select modifier's falloff prevents this from happening.

7 Add a Mesh Select modifier to the top of the stack to clear the sub-object selection. Add a Meshsmooth modifier and set its Iterations to 1. Go back to the bottom of the stack and add a Slice modifier below the XForm modifier. Reposition its Slice Plane at the top of the Funnel object so that it is just below the top capped end of the cylinder and set its Slice Type to Remove Top.

Information: Even though we can assign the Meshsmooth to the entire mesh, adding the Mesh Select modifier just tidies things up a little, removing the sub-object selection. We have added the Slice modifier to the stack so that the top of the funnel is not distorted and smoothed over by the Meshsmooth modifier. This also ensures that any particles we distribute over the surface of the Funnel will be around the sides and not at the top. Again, just a bit of housecleaning.

PART TWO: Next we will create, position and link Space Warps to the funnel (as necessary) to influence any particles we will create later on.

8 In the Top Viewport and at frame 0, create a Vortex Space Warp directly over the bottom Point helper and link the Space Warp to the helper. Set the Time On to −100, Time Off to 200 and Taper Length to 400. Set the Axial Drop to 0 with a Damping of 1.2, the Orbital Speed to 0.3 with a Damping of 2 and a Radial Pull of 0.5 with a Damping of 0. Enable CCW to match the rotation direction of the Funnel's XForm modifier.

Information: We have created and positioned the Vortex Space Warp so that it is situated exactly where the Tornado touches the ground. By linking it to the bottom helper it will follow the deformation of the Funnel object, therefore generating a vortex around this point. It should now become apparent why we did not want the helper to be animated vertically (along the Z axis) else this Space Warp and any other objects such as particles, will be positioned incorrectly. I'm not going to go into the ins and outs of the Vortex's features – if you are unsure of any part of it, please check the documentation that ships with the product as it explains the features in detail.

9 In the Top Viewport, create a Deflector Space Warp which completely covers the Plane object in the scene. Set its Bounce to 0.5, and set Variation, Chaos and Friction to 25. Still in the Top Viewport, create a Wind Space Warp. Set its Strength to 0, Turbulence to 0.1, Frequency to 5 and Scale to 0.01. Create another Wind Space Warp and set its Strength to 0.05, Turbulence to 0.3, Frequency to 2 and Scale to 0.05. Finally, still in the Top Viewport, create a Gravity Space Warp.

Information: We have created two slightly different Wind Space Warps to control the formation of the debris particles; one to create neat tendrils and the other to counteract this and break them up a little while they are being affected by the Vortex Space Warp. Any 'heavier' debris which is being churned up by the Funnel rushing over the ground will be flung outwards by the Vortex come crashing back down to earth by the Gravity Space Warp, and collide with the Deflector Space Warp, which has had its default parameters amended so that it affects particles as if it were an irregular and rough surface.

PART THREE: We will create and position lighting to simulate the overcast sky at this stage to reduce scene update times when there are a lot of particles present.

10 In the Top Viewport, create a Skylight light and set its Sky color to RGB 185,193,199. Still in the Top Viewport, create a Direct light to the left of the camera and position its Target close to the center of the Plane, just behind the Funnel object. In the Left Viewport, reposition this light vertically upwards about 1700 units. Enable Shadows, set its Multiplier to 0.35 and color to RGB 240,243,249. Enable Overshoot and set the Falloff/Field to 1500. Expand the Advanced Effects rollout and set the Soften Diff. Edge to 100. Set the Shadow Map Bias to 0.01 and Size to 128.

Information: The Skylight light has been created and colored to represent the sky of the background image (the color was derived from point-sampling a color off the background image). The positioning of the Direct light is as such so that it corresponds to the highlight visible in the roof glass of a conservatory built onto the rear of one of the houses in the foreground. This light's color was derived from a sampled color from this glass reflection and then intensified a little. Overshoot is used to illuminate any geometry which passes outside the Falloff/Field boundary; this boundary is set to encompass the scene as any object situated outside of it will not receive or cast shadows from this

light. Soften Diff. Edge is used to diffuse the boundary between light and dark shading on an object. The Shadow Map Bias has been reduced to tuck in any shadows behind the objects that cast them to prevent them from being detached. The Shadow Map Size has been reduced to speed up rendering times at the expense of shadow quality. Just to make sure the light is positioned correctly, amend a Viewport so that you are viewing the scene from the Direct light. Even though the cloud is virtually covering the entire sky, there is a suggestion of the presence of the sun which will be used to shade the Funnel and some of the particles.

PART FOUR: Next we will create the particle systems required to generate the debris and wispy cloud effects and bind them to their relevant objects so they behave accordingly.

11 In the Top Viewport, create a Particle Flow system and label it Funnel Cloud. Press 6 to open Particle View. In the new particle system's Birth operator, set the Emit Start and Emit End to 0 and set the Amount to 500. Replace the Position Icon operator with a Position Object operator, enable Lock On Emitter and add the Funnel to its Emitter Objects list. Enable Animated Shape and Subframe Sampling. Enable Surface Offset and set the Max setting to 50. Remove the Speed and replace the Shape operator with a Shape Facing operator. Click on this operator's Look At Camera/Object button and select the scene's Camera. Set the Size to 300 with 20 Variation and set the Orientation to Allow Spinning. Add a Material Static operator and set the Display operator to show geometry to see this particle system in action.

Information: Ensure that the Rotation operator is above the Shape Facing operator or the facing particles will not point the right way until the second frame. By locking the particles onto the geometry, they pick a point on the surface and track it as it deforms. Thanks to the XForm modifier, the particles rotate around the Funnel giving the impression that they are caught in a vortex that follows the contour of the Funnel and, due to the Surface offset settings, we have these particles spread out around the Funnel. Subframe Sampling is used so that the particles follow the deformation of the geometry more accurately, but if you have a slower machine it is advisable to disable this feature.

12 Set the Display operator back to showing ticks. In the Top Viewport, create another Particle Flow system and label it Touchdown Dust. Set its Icon Type to Circle and Diameter to 10. Set the Viewport Quantity Multiplier to 10, expand the System management rollout and set the Particle Amount Upper Limit to 10000000 and the Render Integration Step to Frame. Position this particle system in the same place as the Vortex Space Warp and link it to the Spline IK's bottom Point helper as before. In the Left Viewport, raise the particle system up a little (about two units) so that it is just off the 'ground'.

Information: As this particular particle system is going to be responsible for creating an exceptional amount of particles, we have reduced the percentage of particles visible in the Viewport to speed up Viewport interaction and also increased the Render Integration Step which speeds up collision calculations at the cost of accuracy. As this system needs to simulate the dust cloud that the tornado churns up as it sweeps along the ground, we need the particles to be emitted from this exact ground interaction point, hence the positioning and linking to the helper which drives the ground positioning deformation of the Funnel object.

13 Re-enter Particle View and rename the Touchdown Dust system's Event 01 event to Tendrils. Set the Birth operator's Emit Start to −100, Emit Stop to 200 and Amount to 100000. In the Position Icon operator, enable Distinct Points Only. In the Speed operator, set the Speed to 10 with a Variation of 5. Enable Reverse and set the Divergence to 10. Replace the Shape operator with a Shape Facing operator, add the Camera as its Look At object and set its Size to 5 with a Variation of 10 and set Orientation to Allow Spinning. Add a Spin operator

and set its Spin Rate and Variation to 50. Add a Force operator and add the Vortex to its Force Space Warps list. Add another Force operator and add both Wind Space Warps to its Force Space Warps list. Add a Material Dynamic operator. Add a Delete operator and set it to By Particle Age with its Life Span to 100 and Variation to 50. Finally, add a Collision test and add the Deflector Space Warp to its Deflectors list.

Information: As we already have the Funnel on the ground, we need the debris and dust to exist as soon as we join the scene, hence the negative Emit Start setting. As Space Warps are the main driving force behind this system, we only need the Speed operator to add a little extra chaos to the tendrils to break them up a little. Again we are using facing particles, but this time we will assign a dynamic material (which we will create shortly) to the system which will cause the particles to fade

as they age. We have split the Forces into two separate groups – Vortex and Wind – as we will utilize the same Wind settings in another event using instancing, but we'll need to amend the Vortex Force operator's influence in the other event so we will need to keep it separate. The Collision test has been added purely to prevent any particles from passing beneath the emission point. This is highly unlikely due to the Space Warps settings that are present in the event, but the scene may be amended later on so it is better to set it up now.

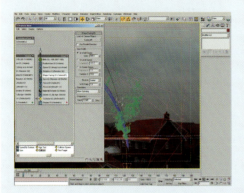

14 Select the Tendrils event and create an instance of it. Rename this new event Cloud. Make the Birth, Position Icon, Shape Facing, Material Dynamic and Display operators unique. In the Birth operator, set the Amount to 100. Turn off Distinct Points Only in the Position Icon operator, set the Shape Facing's Size to 500 and amend the Display operator's color for Viewport reference. Wire the output of the root of the Touchdown Dust system to the input of the Cloud event. Set both Display operators to show Geometry to see this system in action. Set them back to display ticks afterwards to speed up Viewport interaction.

Information: This event is designed to simulate the dust cloud which surrounds the tendrils, therefore suggesting that not all of the dust that is kicked up forms these intricate shapes. However the general motion is the same as they are both caught in the vortex created by the tornado. Because of this we can share settings across these two events albeit making a few amendments; as we are creating a large cloud effect, we can do away with thousands of particles and cheat a little by using large facing particles and a planar-mapped material to simulate the dust cloud, which we will create shortly.

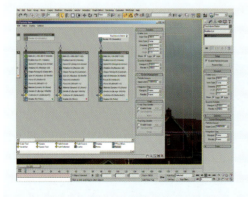

15 Select the Touchdown Dust root and the Cloud event and instance them to create a new system and event. Rename the new system Touchdown Debris, select it in the scene and link it to the bottom Point helper in the scene as before. Set the Viewport Quantity Multiplier to 100. Back in Particle view, if the wiring is broken from the new system and the copy of the Cloud event, wire them together and rename the event Debris. Make the Render, Birth, Position Icon, Speed, Spin, Force (Vortex) and Display operators unique. Amend the Display operator's color.

Information: Again, as we have the majority of the leg work done for us, we can simply instance the relevant settings and make the ones which need amending unique. There are other operators

that we do not need, or need to change their type completely. These will be amended in the next step. We have had to re-link the particle system to the helper as cloning the system this way made it link to the IK Chain object in the scene, which is not what we want. As the particle system's icon had not moved, it is just a simple case of re-linking it.

16 Set the Birth operator's Amount to 5000 and the Position Icon operator's Location to Pivot. Amend the Speed operator's Speed to 300 with 200 Variation with a Divergence of 60. Replace the Shape Facing operator with a Shape operator and set its Shape to Cube with a Size of 2. Add a Scale operator and set the Scale Variation to 100 for all axes. Amend the Spin operator's Spin Rate and Variation to 150. Add a Force operator, add the Gravity Space Warp to its Space Warps list and set its Influence to 200. Amend the Force (Vortex) operator's Influence to 300.

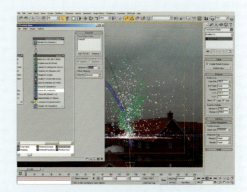

Replace the Material Dynamic operator with a Material Static operator and remove the Delete operator.

Information: By increasing the speed and its Divergence setting and reducing the influence of the Vortex Space Warp, the Debris particles are flung outwards before they come crashing back down to earth due to the presence of the Gravity Space Warp in the Debris event. As these particles are going to be picked up and tossed around a fair amount, we have had to increase their Spin rate accordingly. In addition, these particles will not fade or die, so the Material Dynamic operator has been replaced with a Material Static operator and the Delete operator removed. You may wish to replace the Collision test with a Collision Spawn test to get the debris to smash into pieces when it collides with the ground, but bear in mind that the ground is going to be occluded by the composited foreground houses so any particle spawning effects may well be occluded or unnoticeable.

PART FIVE: Next we will set up the materials for the geometry and particle systems before sorting out shadow casting options.

17 Open the Material Editor and label the first available blank material Funnel Cloud. Enable Face Map and set the Diffuse color to RGB 170,172,172. Add a Mask map to the Opacity slot, label it Funnel Opacity and add a Gradient map to the Map slot. Set the Gradient Type to Radial with a Fractal Noise Amount of 0.5 and Size of 5. Add a Gradient map to the Funnel Opacity map's Mask slot and set it to Radial. Set the gradient's Color 2 to RGB 4,4,4 and Color 3 to RGB 8,8,8. Instance this material to the slot in the Funnel Cloud system's Material Static operator.

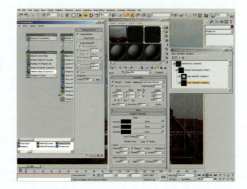

Information: As these particles are not set to fade or die and are constantly changing positions around the Funnel geometry, we do not need a complex material setup. However, due to the particle count and need for a wispy smoke effect, the material should be almost transparent to create a subtle mist around the Funnel. Note that as the Shape Facing operator generates mapping coordinates we do not need to have Face map enabled, but it is useful to have in case we generate a (legacy) system that does not have this feature and we use this material on that object.

18 Label a new material Tendrils, enable Face map and add a Particle Age map to the Diffuse slot. Label it Tendrils Color, set Color 1 to RGB 31,29,27, Color 2 to RGB 78,66,54 and Color 3 to RGB 155,145,135. Add a Mask map to the Opacity slot, label it Tendrils Opacity and add a Particle Age map to its Mask slot. Label this map Tendrils Opacity Control and set Color 1 to RGB 70,70,70, Color 2 to RGB 30,30,30 and Color 3 to black. Add a Gradient map to the Mask's Map slot and label it Tendrils Opacity Shape. Copy the Color 2 swatch into Color 3 and set the Gradient Type to Radial. Instance this material to the slot in the Material Dynamic operator in the Tendrils event of the Touchdown Dust system.

Information: The tendril effect in the reference material changes color over time, so we have introduced a Particle Age map to the Diffuse slot to emulate this. Even though these particles are tiny, they may still be viewed at close quarters, so we need to assign a map to remove any harsh edges, which the gradient does adequately.

19 Copy the Tendrils material and label the copy Dust Cloud. Rename the Mask map in the Opacity slot to Dust Cloud Opacity and the Particle Age map in this map's Mask slot to Dust Cloud Opacity Control. Set its Color 1 to RGB 30,30,30 and Color 2 to RGB 15,15,15. Rename the Gradient map in the Dust Cloud Opacity map's Map slot to Dust Cloud Opacity Shape and click on the Gradient button next to its name. Add a new Mask map and select Keep Old Map as Sub-Map when prompted. Label the new Mask map Dust Cloud Opacity Mask and swap the Map and Mask slots so the Gradient map is in the Mask slot. Add a new Gradient map to the Map slot and label it Dust Cloud Fractal Opacity. Set its Gradient Type to Radial, Noise

Amount to 0.5, Size to 5 and enable Fractal. Instance this material into the slot in the Touchdown Dust system's Cloud event's Material Dynamic operator.

Information: As before, we can take the existing settings and amend them slightly. As the tendrils and dust are both being emitted from the same 'point' (where the Funnel sweeps along the ground) they will be made up of the same material. Therefore, their basic material properties will be identical; the only differences being the size and texture of the dust, which has been amended by tweaking the opacity of this material copy.

20 Label a new material Debris and set its Diffuse color to RGB 102,95,89. Instance this material to the Material Static operator in the Touchdown Debris system. Label a new material Funnel, add a Gradient Ramp map to its Diffuse slot and label it Funnel Dirt. Set the W Angle setting to 90 to get the gradient facing the right way, remove the flag at position 50 and add flags at positions 15, 35 and 70. Set the flag at position 0 to RGB 31,29,27, position 15 to RGB 78,66,54, position 35 to RGB 155,145,135 and positions 70 and 100 to RGB 189,193,196. Add a Falloff map to

the opacity slot of this material, label it Funnel Side Opacity and swap its colors. Add a Gradient Ramp map to the Front slot, label it Funnel Base Opacity, set its W angle setting to 90 and set the flag at position 50 to white. Amend the Interpolation to Ease In.

Information: As the particles are tiny and move around erratically, we do not need to set up a complex material for the Debris, just a basic material to tint it a little. The gradients in the Funnel material consist of two sets of colors which correspond to the cloud color, and the three colors we have set up in the Tendril and Dust Cloud material's Diffuse Particle Age maps. As this dirt and debris is being sucked up the funnel, its colors amend accordingly, hence the use of the same colors in our Funnel's gradient.

21 Right-click the flag at position 50 and select Edit Properties. Add a Noise map to the map slot in the resulting flag information's pop-up and label it Funnel Texture. Set its Source to Explicit Map Channel, Map Channel to 2, Noise Type to Fractal and Size to 100. Turn off all particle systems, go to frame 200, enable Auto Key and set the Phase of the Noise map to 2. Go back to frame 0, turn off Auto Key and turn the particle systems back on. Assign this material to the Funnel object, right click the keyframes at

frame 0 and select its Phase. Amend the Out curve setting to a linear attack and pass this curve information to the In curve of the keyframe at frame 200. Add a UVW Map modifier to the Funnel above the Slice modifier, set its Mapping to XYZ to UVZ and set its Map Channel to 2.

Information: To remove the single solid texture to the Funnel, we have added a little variation in texture by animating one of the flags in the opacity map of the Funnel's material. This will create a varying opacity as the Funnel turns and distorts. We have had to add a UVW Map modifier to the Funnel because as the object moved or distorted, due to the way Object XYZ mapping works, the texture would have just 'floated' on top of the object. Therefore using XYZ to UVW mapping we can lock it to the geometry and distort it with the other modifiers we have got further up the stack.

22 Back in Particle View, right-click the Funnel Cloud system and select Properties. In the resulting pop-up, turn off Cast Shadows and Receive Shadows. Turn off Cast Shadows and Receive Shadows for the Touchdown Dust system's Cloud event by right-clicking this event (not the system root), selecting Properties and turning it off as before.

Information: As these particular particles are designed to be virtually transparent, any light would simply pass right through them. In addition, because they cover a large amount of the scene, any existing geometry would be completely in shadow if shadow casting were left enabled for these particles (Shadow maps do not handle opacities).

PART SIX: Finally we will set up Video Post to overlay part of the backplate on top of the render to put the tornado in situ.

23 Open Video Post, click on the Add Scene Event button and click OK to add the camera input. Click on the Add Image Input Event button and load in the *tornado_background.jpg* image. Highlight both of the events and click on the Add Image Layer Event button. Select Alpha Compositor from the menu and load in the *tornado_background_mask.jpg* image. Change the Mask type to Luminance and click OK to exit the panel. Add an Image Output Event if desired and render off the animation.

Information: The Alpha Compositor overlays the image on top of the render (the result of the Scene Input Event), using the Mask map to control how the images are put together. The result is the Funnel and particles being rendered off against the background that is set in the environment, with the composited houses from a copy of the background image added on over the top.

Taking it further

We have pretty much perfected this effect, mainly thanks to the sheer amount of particles used and because our reference material illustrated the effect perfectly. We could, however, try adding a few extra effects to complement the scene. Currently, the top of the funnel disappears off camera; try blending it into the cloud layer, by either fading the top of the funnel a little so the texture and color blend together, or by applying the texture to a plane positioned to represent the sky with a Camera Map modifier assigned. This way you can deform the mesh of the sky around the top of the funnel and get them to blend together. However, bear in mind that this would now appear as if the tornado is some distance away so you may have to create a different mask to overlay the backplate back on top of the render, as the current one is designed to just overlay the houses in the foreground; in the amended version you will need to include some of the foliage in the background. You may also need to desaturate the colors a little to suggest atmospheric density because the dirt and debris will be further away; either perform this task by amending the materials, use environment fogging or perform the color correction in post, the latter of which is most advisable as we can see any tweaks we make to the image automatically, therefore saving time.

You may want to completely change the appearance and ferocity of the tornado so that it appears like some of the reference movies. In which case, set the existing funnel so that it is not renderable and create a particle system (or clone the existing wispy funnel system) that distributes particles down the length of the funnel. You can then use these particles, which adhere to the funnel's surface, to emit trailing particles which are affected by the Wind Space Warp, therefore creating the wispy effect. This will result in an unbelievable amount of particles but, again, due to their size they will not take long to render.

Try putting the tornado in different environments, such as a desert or wasteland to form a dust devil, or (and this would look really good if you could pull it off), have the tornado move from land to water, and amend the particle materials accordingly so that the tornado sucks up water, forming a water spout. The technology behind the particles will not change, just the way the materials are distributed throughout the entire tornado effect. You may also want to create additional debris effects; try creating instanced geometry of broken masonry, wooden planks, branches, grasses and so on. The more relevant the debris is to the scene, the more convincing it will appear.

29 Eruption

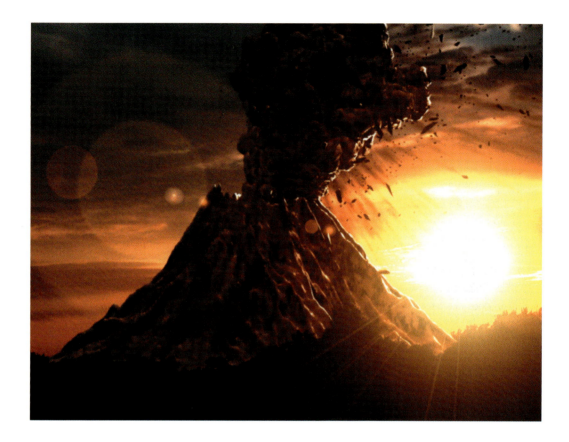

Information

With the Volcano mesh already created earlier on in this book, we are going to take the scene that we have constructed and, using Particle Flow, generate a volumetric cloud effect by designing an individual smoke puff and animating it using a particle system to simulate a large eruption from its crater. As the resulting plume of ash and smoke originates from deep inside the volcano, the cap of the volcano will have been fragmented resulting in a shower of rock debris, which we will also have to generate. This falling debris will consist of different sized matter so some will travel faster than others. Because of this we will take the existing copy of the volcano mesh and generate a deflector based on its terrain so the debris can interact with it. It should be noted that there are similarities to the construction of this scene to that in the next tutorial in both the settings and the information contained in the text; this is intentional as both scenes generate an ash cloud which is created using the same techniques but with different characteristics. These scenes have also been designed so that merging the two effects together is a relatively simple procedure; see the Taking it further section for more information.

Analysis of effect

I have to stress that sourcing initial eruption footage is difficult as there are very few movie cameras pointing at a volcano just as it starts erupting for the first time. Therefore the footage and images have been sourced from volcanoes that have already erupted. However, the initial eruption process can be determined from eyewitness accounts and scientific research, and it goes a little something like this. (a) The eruption is caused by a build up of gases deep inside the volcano which, when released, generate an explosive force that shatters the cap (the crater) of the volcano, showering thousands of pieces of rock into the air. (b) The exhaust gases, mixed with hot ash, debris and smoke, rush out of the vent and into the air at an exceptional rate and immediately billow outwards, creating a huge detailed plume of ash which appears to slow down and gradually rise up into the atmosphere, while the volcano is still churning out gases thereby adding more volume to the ash cloud. (c) The cloud itself is highly detailed due to its size and is virtually opaque, albeit from a slight transparency around the perpendicular of each puff of ash. This suggests that the ash is not totally dense, which is also apparent due to a slight translucency effect with some light passing inside the cloud and dissipating. (d) It should also be noted that the initial explosion does not necessarily fire debris and ash directly upwards; there is a slight to exaggerated ejection angle more often than not.

We are going to use the existing Volcano scene that we have created earlier on in the book, but before we begin construction, we are going to have to make a few amendments to speed up rendering times by reducing the quality of the shadows because the amount of geometry produced by the particle system will be very high. The particle system will in fact consist of three individual systems, all emitted from one place. First we have the ash plume, which will use instanced geometry of a Blobmesh object for each particle which is sculpted to look like a billowing puff of ash. This shape is derived by creating several scattered spheres over a larger sphere and applying the Blobmesh to the resulting compound object. The other particle systems will create the debris; one, again using instanced geometry, to create fragments, and the other using simple cubes to create tiny debris which is effective when viewed from a distance. These particle systems will be ejected at an angle so that the main eruption debris and ash cloud travels outwards at a tangent. Affected by gravity, the debris particles (some of which trailing facing particles to generate dust trails) will fall back down to earth and collide with the side of the volcano, so a low polygon version of the volcano mesh will be used to speed up interaction calculations. The materials assigned to the debris particles will be quite basic, because they are moving so

crater dome - upon eruption, this material shatters and is ejected with the volcanic gases

a

Image courtesy of United States Geological Survey

the eruption originates from a single point and immediately expands

b

Image courtesy of United States Geological Survey

depending on the density of the cloud, a slight translucency can be seen around the perpendicular

c

Image courtesy of United States Geological Survey

prevailing winds can affect the direction of the column as well as the initial ejection angle

d

Image courtesy of United States Geological Survey

fast that any detail would be difficult to pick out. The ash cloud's material will incorporate a Smoke map to generate the complex texture of the cloud, and some self-illumination to produce a rim-glow effect to simulate light passing through the more translucent edges of the smoke. In the Pyroclastic Flow tutorial we will use a similar setup but with a Translucent shader. In this tutorial's scene, due to the high contrast, we will create a similar effect using this self-illumination technique (which is also present in the Pyroclastic tutorial, but the results are different due to the different shader used). We are also using this to simulate transparency; actual transparency will not be used due to the amount of time it would take to calculate transparency at render time for the amount of overlapping geometry in the ash cloud. See the Taking it further section in the Pyroclastic Flow tutorial for more information on this matter.

Walkthrough

PART ONE: First we will load in the initial scene and amend some of its properties in order to keep render times low.

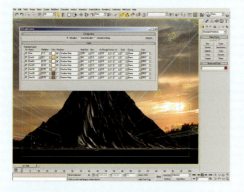

1 Open the final scene you have previously created for the volcano (tutorial #20) or load in the *Earth/20_Volcanic_Terrain/Source/20_volcano_ finished.max* file from the DVD-ROM. Re-save the scene as *29_eruption.max*. Go to the Tools menu and select Light Lister. In the resulting panel, disable the shadows for the bottom three sets of lights and amend the Map Size to 64 for all lights apart from the top Sun light with the largest Map Size; amend this one to 256. Set the Sample Range (Sm.Range) setting to 4 for each light. Close the panel when completed.

Information: It should be noted that even though the initial frames of the animation will not take all that long to render, the further we progress into the render the longer it is going to take as there will be more particles present in the scene. The main culprit behind this is the sheer amount of shadow casting lights in the initial scene, and the time it takes them to prepare before rendering. They are not entirely to blame; the reason they are taking so long is because of the amount of geometry in the Ash Cloud system. Therefore, to reduce render times we have drastically reduced the Shadow Map Sizes and the Sample Range of the lights, and have turned shadows off for a fair few of them. This will result in a faster render at the expense of shadow quality and density. Alternatively, you may wish to create a different set of lights purely dedicated to illuminating the particles, so as not to compromise on quality for the volcano. The choice is up to you.

PART TWO: Next we will generate the geometry that will be distributed using the particle systems we will create shortly.

2 In the Top Viewport, create a Geosphere with a Radius of 25 and 4 segments. Create another Geosphere with a Radius of 5 and 2 segments and label it Ash Puff. Check on Base to Pivot. With this Geosphere still selected, create a Scatter Compound Object and select the first Geosphere as the distribution object. Set the Number of Duplicates to 30. In the Transforms rollout, set the Rotation to 360 for the X setting and enable Use Maximum Range, Scaling to 75 in the X setting and check on Lock Aspect Ratio.

Information: Here we are simply creating a basic template for the shape of a single particle. Base to Pivot is used to get the scattered spheres to sit on top of the distribution sphere, and the rotation used to create different intersections on the main sphere, so the surface will be smoothed out differently when we apply the Blobmesh object in the next step.

3 Create a Blobmesh object. Set the Size to 8 and the Render and Viewport Evaluation Coarseness to 11. Add the Ash Puff Scatter object to the Blob Objects list. Go to the Hierarchy tab, click on the Affect Pivot Only button then click on Center to Object. Turn off the Affect Pivot Only button. Add a UVW Map modifier to the Blobmesh and set its Mapping Co-ordinates to Shrink Wrap.

Information: We have used a Blobmesh object as it conforms roughly to the shape of our scatter object, therefore creating the (rough) shape of a puff of smoke. The detail has to be quite low due to the particle count; millions of polygons could be generated very easily which would bog down the system. However, if you feel your machine can handle large polygon counts at render time, feel free to lower the coarseness, therefore refining the mesh and making the cloud more detailed. We have re-aligned the pivot point of the Blobmesh object so that it is situated in the center of the mesh. This is essential since the particle system takes this pivot point as the particle center, which would result in a wayward motion for our particles if the center was not aligned. UVW mapping has been added as we need to add a material which utilizes mapping to our particles.

4 In the Top Viewport, create a Box primitive about 200 units in size for all Length, Width and Height settings with 3 Length, Width and Height Segments. Label it Fragments01 and clone it another three times. Collapse each box down to an Editable Poly and deform each mesh by pushing, pulling and target welding vertices together to create four individual shards. Select the three copies and link them to the original Fragment01 object.

Information: The particle system that we will design later on will reference the Fragments01 geometry and use it, and the other objects that are linked to it, to randomly distribute them throughout the particle system, therefore removing the need to set up four separate systems for four separate fragments.

PART THREE: Next we will add some Space Warps to the scene to control the behavior of the particles, and set up objects so that they interact with them.

5 In the Top Viewport, create a Gravity Space Warp. In the Front Viewport, create a Wind Space Warp and rotate it 15 degrees anti-clockwise in the Left Viewport. Set its Strength to 0.01, Turbulence to 0.1 and Frequency to 2. In the Top Viewport again, create a UDeflector Space Warp. Set the Bounce to 0.25, Variation to 20, Chaos to 25 and Friction to 5.

Information: The Gravity Space Warp will force the particles (the cloud emitters – rocks and debris) to fall downwards while the UDeflector, which generates a slight variance and reduction in motion due to the Friction setting, prevents them from passing through the sides of the volcano as they fall. The Wind Space Warp is used to add a small amount of motion turbulence to the ash cloud to break it up a little.

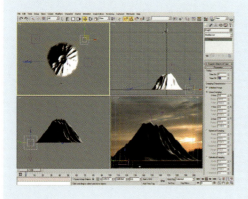

6 Right-click the Play Animation button and set the Animation Length to 200. Copy the Volcano and label it Volcano Deflector. At the bottom of this copy's modifier stack, set the Length and Width Segs to 100. Select the UDeflector, click on the Pick Object button and select the new Volcano Deflector object. Create a Drag Space Warp and set the Time Off to 200. Set the Linear Damping for all axes to 2.

Information: Using the existing high polygon volcano as a deflector would take forever to calculate, so particle

deflection will be performed on a lower polygon version to help speed up render times a little, as there will be fewer calculations to make. The Drag Space Warp is used to dampen the motion of the ejected particles so they are emitted at a high velocity, but decelerate due to air resistance. After our debris particles fall they hit the UDeflector which will tell the particle system to generate more fragments to simulate the original fragments breaking up and kicking up more debris.

PART FOUR: With all of the scene elements now created we will create the particle systems which will generate the eruption cloud and fragments.

7 In the Top Viewport, create a new Particle Flow system and label it Eruption. Set the Viewport Quantity Multiplier to 100. Using the Normal Align tool, reposition the particle system's icon so that it is situated right inside the crater at the top of the Volcano, as illustrated. Rotate the icon if necessary so that it is pointing down and to the left. Expand the particle system's System Management rollout and set the Upper Limit to 10000000.

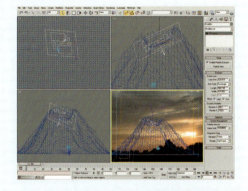

Information: Using the Normal Align tool allows us to place the icon right at the top of the Volcano without having to manually reposition it; a couple of clicks and it is situated perfectly. However, we will need to amend the rotation slightly so we can get it facing the right way – the Normal Align forces the icon to face downwards, so we will leave it facing in that direction and simply reverse the direction of the emitted particles in our system. I have hidden the original Volcano mesh so we can see the positioning of the particle system's icon, else the dense mesh would occlude it. The Upper Limit has been set at its maximum setting so we do not have any limitation as to the amount of particles we can have in our system.

8 Click on the Particle View button or press 6 to open Particle View. Select the Birth operator, set the Emit Stop setting to 200 and the Amount to 1000. In the Position Icon operator, set the Location to Pivot. Ensure that the pivot of our particle system is not underneath the Volcano Deflector mesh in the scene. In the Speed operator, set the Speed to 400 with 200 Variation, enable Reverse and set the Divergence to 25.

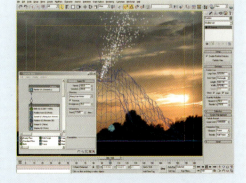

Information: Scrubbing through the animation using the timebar, we can already see the ejection particles taking shape. Due to the variation in speed, some particles will overtake others, therefore breaking up any uniformity in the cloud and occluding the individual smoke puffs, thereby blending them together.

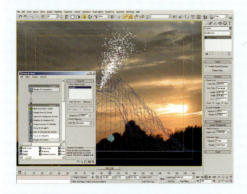

9 Replace the Shape operator in the event with a Shape Instance operator, add the Blobmesh object as its Particle Geometry Object and set the Scale Variation to 25. Add a Force operator to the event, add the Drag Space Warp to its Force Space Warps list and set the Influence to 1300. Add a Spin operator and set the Spin Rate and Variation to 25. Add a Force operator to the event and add the Wind Space Warp to its Force Space Warps list.

Information: The billowing effect that we have generated consists of the Spin operator, forcing the particles to slowly rotate and giving the impression that the ash cloud is expanding internally, and the Drag Space Warp which has had its influence enhanced a little, simulating air resistance. This illustrates that we can amend the original Space Warp's settings and then enhance them more in the particle system, this is useful if more than one operator referenced the single Space Warp in the scene as they could all have different influences and we could simply amend the setting of the Space Warp to affect all of the operators. Another way to create the billowing effect would be to use a Keep Apart operator, but as we are dealing with a lot of particles it would result in slow calculation times.

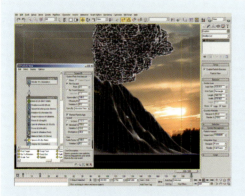

10 Add a Material Static operator and a Scale operator to the event. Set the Type to Relative First, and the Animation Offset Keying to Particle Age. Go to frame 20 and enable Auto Key. Set the Scale Factor to 200 for all axes. Go to frame 200, set the Scale Factor to 300 for all axes and turn off Auto Key. Go back to frame 0 and add a Spawn test to the event. Set its Spawn Rate And Amount to Per Second and set the Rate to 0.5, Inherited Speed to 150 with a Variation of 10 and Divergence of 30.

Information: The Material Static operator has been added so that we can add an Ash material to the particle system, which we will design later on. The Scale operator has been added to give an initial sudden burst of scaling, so that the particles suddenly double their size and then continue to grow over the next 180 frames, relative to their birth. The Spawn test has been added to create additional detail to the cloud, so we have got some particles which expand outwards from the main body of the cloud due to the increased Inherited Speed, but the Drag Space Warp slows them down again before they can break away completely and become visible as individual particles. Again, there has been some randomness added to the scale to break up the cloud a little more. The screenshot shows the particle system using the Blobmesh as the Display operator has been set to display geometry. Be aware that the Spawn test produces multiple duplicate particles for each individual particle, therefore greatly increasing the particle count and therefore the geometry count. If your machine is of low spec, increase the coarseness in the Blobmesh or reduce the Spawn's Rate, or turn the test off completely if all else fails.

11 Copy the root node of the particle system and paste it to create a new empty particle system. Rename it to Fragments. Add a Birth operator to the canvas to create a new event and wire this to the output of the Fragments system. Set its Birth operator's Emit Stop to 0 and Amount to 1000. Copy the Position Icon from the other system's event and Paste Instanced it into this event. Add a Speed operator and set the Speed to 400, Variation to 250, enable Reverse and set the Divergence to 25. Add a Shape Instance operator, add the Fragments01

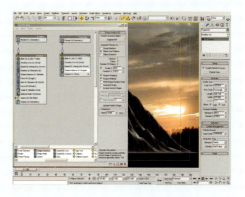

geometry as its Particle Geometry Object, enable Separate Particles for Object And Children and set the Scale to 20 with 100 Variation.

Information: We have copied the existing system's root node as this node contains the Icon position information and all other basic parameters, such as its Upper Limit. As we want this system to emit in exactly the same place, we can save time by not having to create and position a new system by borrowing from the existing one. As the Fragments01 geometry has several child objects linked to it, we can use it to randomly distribute the linked objects throughout the system.

12 Add a Rotation operator and a Spin operator to the event. Set the Spin Rate to 200 with 50 Variation. Add a Material Static and a Force operator. Add the Gravity Space Warp to the Force operator's Force Space Warps list and set the Influence to 50. Add a Spawn test, set it to By Travel Distance and set the Step Size to 4. Set the Inherited Speed to 20 with 5 Variation. Add a Collision Spawn test to the event, add the UDeflector to its Deflectors list, set the Offspring to 2, Inherited Speed to 75 with 25 Variation and a Divergence of 45. Set the Scale Factor

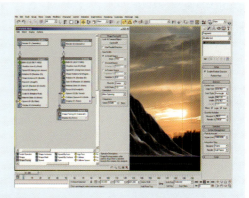

to 75 with 25 Variation. Drag out a Shape Facing operator to the canvas to create a new event and wire the input of this event to the output of the Fragment system's Spawn test. Set the scene's Camera as the Shape Facing's Look At object and set the Size to 10 with the Orientation to Allow Spinning.

Information: Adding the Rotation and Spin operators sets a random initial orientation and a fast spin, so that the fragments travel and spin with some vigor. The Force operator's Influence has been reduced so that it affects the particles subtly, therefore giving the scene and fragments a sense of scale by not sending them crashing back down. The Spawn test has been added to spawn trailing particles, which have been passed to the next event where their characteristics will be set up, and the Collision Spawn test added to break up the fragments and create a few more due to some of the volcano's surface being smashed a little on impact.

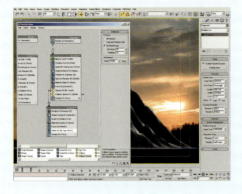

13 Add a Rotation operator to the top of the event (above the Shape Facing operator). Add a Scale operator to this new event and set its Type to Relative First, Scale Variation to 25 and Animation Offset Keying to Event Duration. Go to Frame 10, enable Auto Key and set the Scale Factor to 300. Turn off Auto Key and go back to frame 0. Add a Material Dynamic and a Force operator and add the Wind Space Warp to its Force Space Warps list. Add a Delete operator and set it to By Particle Age with a Life Span of 20 and leave the Variation set to 10.

Information: We have had to drop the Rotation operator above the Shape Facing operator else the initial born particle will not align itself with the camera properly. The scale has been animated as before, but this time only over a short duration, which matches the Delete operator's setting. This ensures that the fragments spawn short trails which spread out (scale) due to wind dissipation. These particles are then deleted, which tells any Particle Age maps which we will introduce later on how to distribute its colors across the particle system.

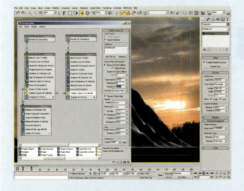

14 Copy the Fragments root system and paste it to create a new system. Label this new system Debris. Copy and Paste Instanced the Fragment system's first event and wire it to the Output of the new Debris system. Make the new event's Birth, Speed, Spin and Force operators and the Collision test unique and delete the Spawn test. Set this new event's Birth Amount to 5000, the Speed operator's Speed to 300 and Divergence to 35. Replace the Shape Instance operator with a Shape operator with its Shape set to Cube and a Size of 2. Add a Scale operator and set the Scale Variation to 100 for all axes, set the Spin operator's Spin Rate to 300, the Force operator's Influence to 20 and set the Collision Spawn's Offspring to 5 with 100 Variation.

Information: As we have got the main legwork done in setting up the basic structure of the Debris system, all we need to do is to amend some of the settings to make the system unique. However, we have shared a lot of the settings between more than one system because they do share the same properties, such as being emitted from the same point and (will) have the same material assigned. We have added a little variation from one system to the next so that it appears as if the ash cloud has blasted the smaller particles and the shards outwards. These smaller particles travel further and are therefore less heavy so their speed and gravity influences have been amended accordingly, plus the spin has become faster due to its size and shape. Upon hitting the surface of the volcano, they will break up more on impact, hence the higher spawning amount.

PART FIVE: Finally we will create and assign the materials for the particle systems.

15 Hide the Fragment01 geometry, its siblings (not the particle system), the Blobmesh, its Template geometry and the Volcano Deflector object. Un-hide the original Volcano object if it was hidden. Open the Material editor and label a new material Debris and instance it to the slot in one of the Material Static operators in either the Fragment or Debris systems. Label a new material Trails, enable Face Map and set its Diffuse color to RGB 247,243,227. Add a Mask map to its Opacity slot and add a Gradient Map to the Map slot. Set its Gradient Type to Radial and set the Noise

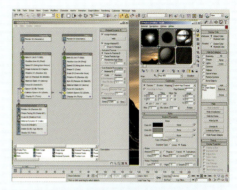

Amount to 0.3, Size to 7.7 and enable Turbulence. Add a Particle Age map to the Mask map's Mask slot. Set Color 1 to RGB 20,20,20, Color 2 to RGB 10,10,10 and Color 3 to black. Instance this material into the Material Dynamic operator in the Fragments particle system.

Information: As the objects are moving quite fast, we only need to assign a generic color to them, and the standard default material color (RGB 150,150,150) does the job perfectly. If we amended the lighting and the contrast in the scene, we would more than likely have to amend it somewhat and/or assign a more complex material as the same color would be more visible. The Trails system is very transparent due to the sheer number of particles being spawned and because we want a wispy dust trail emanating from the ejected fragments, which disperses and fades thanks to the Particle Age map.

16 Label a new material Eruption Cloud. Set the Shader to Oren-Nayar-Blinn, the Specular color to RGB 225,216,190, and enable Self-Illumination. Add a Falloff map to the Diffuse Slot, label it Eruption Ash Color Falloff and set its Front slot to RGB 233,232,228 and Side slot to RGB 203,202,196. Back at the top of the material, set the Self Illumination slot's setting to 30 and add a Falloff map to the slot. Label this Eruption Ash Shadow Illumination. Set the Falloff Type to Shadow/Light and the Shaded color to RGB 133,125,119. Add a Falloff map to its Lit slot and label

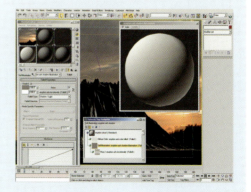

it Eruption Ash Rim Intensify. Set the Front color to RGB 133,125,119 and the Side color to RGB 203,202,196.

Information: The Falloff maps are used to create a color tint on the perpendicular (like the ash in the reference material) which is emphasized by adding a map to the Self-Illumination slot to intensify it

around the areas of direct illumination. These colors were derived from observing and point-sampling the colors in the reference material. The initial Falloff map in the Self-Illumination slot is designed to slightly tint the shaded areas while the illuminated surfaces utilize an additional Falloff map to produce a feathered color effect, suggesting that the ash cloud is less dense around the sides as this rim effect simulates a basic diffused scattering effect.

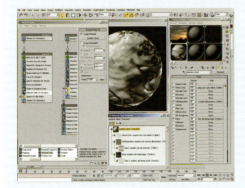

17 At the top of the material, set the Bump amount to −50 and add a Smoke map to the Bump slot. Label it Eruption Ash Bump Large. Set the Source Coordinates to Explicit Map Channel, the Size to 0.2, Iterations to 3 and Exponent to 0.7. Copy this Smoke map to the Color 2 slot and label it Ash Bump Small. Set the Size to 0.002, Iterations to 20, Exponent to 1, the Color 1 slot to RGB 185,185,185 and Color 2 to white. Instance this material to the Material Static operator in the Eruption system.

Information: Here we have a combination of two smoke maps which are of different sizes. The sizes are set so that as the instanced geometry is scaled up in the particle system, the smaller Smoke bump map will become more prominent so there will be no overall loss of texture detail or increased texture scaling.

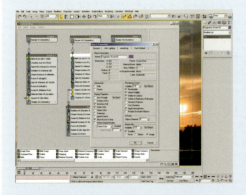

18 Back in Particle Flow, select the Fragments system, right click its root node and select Properties. Turn off Cast Shadows and Receive Shadows. Select its first event, view its properties and enable Image Motion Blur. Turn off Cast and Receive Shadows and enable Image Motion Blur for the Debris system. In the Eruption system simply enable Image Motion Blur and render off the scene via Video Post as in the original Volcano tutorial.

Information: Due to the amount of lights in the scene and because of the sheer number of tiny particles flying around, having these particles cast shadows is like having a fly cast a shadow onto the earth from outer space. Therefore having these enabled is just a waste of CPU power, so we can just turn them off. However they should be left on for the main eruption stack. Finally, Image Motion Blur should be enabled to all of the particles apart from the trails; as they are transparent, any Image Motion Blur applied to them will reveal the shape of the facing particle and result in a smear across the image. Note: You may need to reload the images in Video Post to point the events (including the compositor's maps) to the correct image locations.

Taking it further

Even though we have reduced the shadow detail to speed up the render times, you may feel that the scene is still taking too long to render. To rectify this, you could either reduce the number of lights (and increase the multiplier settings of the remaining lights to achieve the same illumination), or turn off shadows for every other light so that the overall number of shadows affecting the ash cloud is reduced. Alternatively, for drastic measures, try turning off the Shadow options in this Ash Cloud system's properties so the light preparation stage takes a fraction of the time.

You may also want to speed up the render by reducing the amount of spawned/collision spawned particles in the three systems, which will reduce the time it takes to calculate the scene before actual rendering.

Should you wish to progress further with this scene, in the next tutorial we are going to generate a Pyroclastic Flow which will be emitted from the top of our Volcano, creating a plume of ash before it falls and results in a fast moving debris cloud racing down the side of the Volcano. As the scene scale is identical to this we will utilize the original Volcano scene. You could take the scene you have just constructed in this tutorial and add the Pyroclastic cloud without much hassle. In fact, you could skip the construction of its Ash puff geometry as we have already created one for this tutorial, and also use the existing ash material instead, as the next tutorial's ash material utilizes translucency due to the scene's lighting and background image being amended. One suggestion though, instead of firing off the Pyroclastic system at frame 0 as suggested in the next tutorial, extend the length of this scene's animation and introduce the Pyroclastic system at, say, frame 200 which gives us ample time for the initial eruption ash stack to grow to a decent height. Bear in mind though that we are adding a lot more geometry to the scene which will result in longer render times, mainly due to the light preparation times and not the actual rendering process.

Try adding erupting lava to the scene; this will not happen at the initial eruption, but shortly afterwards with an additional eruption plume (not as dense), resulting in a constant shower of glowing molten rock which will harden slightly in mid-air and will shatter in a shower of sparks when it hits the sides of the volcano. Because of the need of thousands of particles interacting with the UDeflector in the scene, it is advisable that you only attempt this if your system is quite powerful since the geometry preparation times will be painful.

The velocity of the erupting particles are not constant in real life once the volcano has been active for a time; the actual ejected clouds of ash seem to pulse frequently as the lava cap of the volcano hardens then disintegrates over and over again. To simulate this effect, try animating the Speed operator's Speed setting manually by setting keyframes, or navigate to its Speed controller in the Curve Editor and replace it with a subtle Noise controller to generate the gentle pulsing effect.

If you have a later version of 3ds Max, it might be worthwhile using Render to Texture to bake out a normal map of the high polygon cloud puff and apply that to a lower res puff to seriously reduce rendering times!

30 Pyroclastic flow

Information

We are going to take the work that we did in the tutorial and adapt it to add a large ash cloud erupting and flowing down a side of the Volcano. After replacing the background image, repositioning the scene's camera so that it faces up the side of the volcano for dramatic effect, amending the lighting accordingly to match the change of background and adding any desired volumetric effects to suggest altitude, we will design and distribute a particle system around a specific area and get it to eject at a high velocity, decelerate, collapse and roll down the side of the volcano. We will create the 'puffs' of ash as geometry using a low polygon template to drive a Blobmesh object to create a solid puff of smoke. After which we will design and assign a detailed, yet quite simple smoke map to the particle system. It should be noted that there are similarities to the construction of this scene to that in the previous Eruption tutorial in both the settings and the information contained in the text; this is intentional as both scenes contain an ash cloud which is created using the same techniques but with different behavioral properties. These scenes have also been designed so that merging the two effects together is a relatively simple procedure.

Analysis of effect

(a) Firstly we will cover the science bit. Pyroclastic flows are generated in one of three ways. Firstly, after a volcanic eruption, a huge vertical column of ash can form which can reach high altitudes and should this get too heavy in places, collapses and runs down the side of the volcano at breakneck speeds. Another way is during the fall of fresh lava and rock debris, which can cause numerous flows at the same time. The other way is by part of the volcano collapsing, generating a large plume of ash which then (again) gets too heavy and runs down the side of the volcano. (b) Due to the amount of debris kicked up by this collapse, there is a large distribution of coarse fragments that travel at high speeds down the side of the volcano resulting in a turbulent cloud of deposited ash that grows and rises (and also follows somewhat). This underlying basal flow (debris) is barely visible when compared to the size of the ash cloud, which is exceptionally impressive and detailed. Aesthetically, the resulting ash cloud is a thick medium-grey substance that appears to be virtually solid and self-shadowing with slight light distribution within the cloud. (c) Continuously billowing and growing, the cloud tends to catch the light (when in direct illumination) somewhat with a slightly brown hue on the perpendicular, depending on the time of day and weather conditions. (d) The flow grows exceptionally quickly as it is churned up by its interaction with the sides of the volcano and can quickly envelop the entire side, leading to an impressive yet deadly display. It should be noted that the color of the flow depends on the color of the volcano and how it was formed. For more information on this and to utilize it in our own system, please view the Taking it further section.

As we have got the majority of the legwork done for us in the form of the construction of the volcano, all we need to do is to generate the particle system and materials assigned to them. Firstly, we need to replace the background and change the lighting in the scene so that it corresponds with this new background. The main reason that we will change the background is so that we can see the falling ash that we are trying to create more clearly. With a lighting situation like this, extra detail can be picked out which is ideal, especially for the highly detailed ash cloud that we need to introduce. This ash effect will be generated by a combination of procedural bump maps that are used in a material that handles the change in color depending on the camera angle to the smoke puff as described in the initial analysis. This material will be assigned to a particle system that will be emitted from a positioned Particle Flow icon at the top of the Volcano object. This mesh will also act as a deflector for the particles to interact with, so to keep calculation times down we will create a low polygon version

collapsed stack

Image courtesy of United States Geological Survey

falling debris kicks up huge clouds of ash

Image courtesy of United States Geological Survey

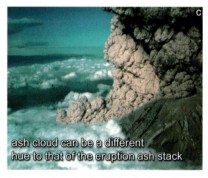

ash cloud can be a different hue to that of the eruption ash stack

Image courtesy of United States Geological Survey

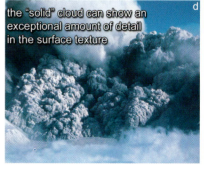

the "solid" cloud can show an exceptional amount of detail in the surface texture

Image courtesy of United States Geological Survey

(which won't be rendered) for them to interact with. The emitted particle is ejected at a high velocity and gradually slows down due to air resistance, upon which an additional particle is spawned which falls from the ash stack and slides down the slope, billowing out as it travels thanks to an animated Scale operator. Multiply this process with a few thousand particles and we will have created a system which (aesthetically) mimics the collapse of an ash stack.

Walkthrough

PART ONE: First we will load in the scene we have previously created, amend the background, add some volumetric effects and change the lighting to match.

1 Open the final scene you have previously created for the volcano (tutorial #20) or load in the *Earth/20_Volcanic_Terrain/Source/20_volcano_finished.max* file from the DVD-ROM. Re-save the scene as *30_pyroclastic_flow.max*. Press H to open up Select By Name, select all of the lights in the scene and delete them. Open up Video Post and click on the New Sequence button to clear it out. Open up the Materials Editor and select the Background Bitmap map (the sunset). Replace this map with the *Air/30_Pyroclastic_Flow/Source/pyro_cloud_bg.jpg* file on the DVD-ROM.

Information: A large step to start off with, but quite easy. All we are doing here is loading in an existing asset and removing items that we do not require. As we are changing the background, we need to replace the lighting in the scene. We have cleared out the Video Post queue as we no longer need it; just a quick bit of housecleaning.

2 Select the camera and reposition it so that, in the Top Viewport, it is to the left of the volcano, looking up its side, as illustrated. In the Top Viewport, create a Sphere Gizmo Atmospheric Helper with a radius of about 540 and scale it down vertically in the Left Viewport so that it is about 40% of its original height. Position this helper at the top of the volcano along the side which the camera faces. Clone this helper another four times, and position another around the top of the volcano and the rest around the bottom, amending the scaling (but keeping the scaling uniform) so we have some larger helpers around the base as illustrated.

Information: A lot of clips of Pyroclastic flows that we see in documentaries and other footage are shot from the ground, so we reposition our camera to create a similar dramatic shot. The addition of the atmospheric helpers are used to position areas of Volumetric Fog to simulate cloud. These helpers are positioned to create the impression of two layers of cloud – one formation at the top of the volcano, and the other around the base, so it appears as if the top of the volcano is exceptionally high up.

3 Open up the Environment panel and add a Volume Fog to the Atmosphere rollout's Effects list. Label it Cloud. In the resulting Volume Fog Parameters rollout, click on the Pick Gizmo button. Press H to enter Select By Name and add all of the Sphere Gizmos. Set Soften Gizmo Edges to 1, enable Exponential and set the Max Steps to 50. Change the Noise Type to Fractal, set the Levels to 6, Size to 1000 and Uniformity to −0.25.

Information: We increase the Soften Gizmo Edges so that the shape of the gizmo is not apparent – the boundaries of the gizmo are 'blurred' somewhat (or 'feathered'). Exponential was used to increase density depending on distance, so the further away we get into the cloud, the more dense it appears, otherwise the effect would appear too linear. Max Steps was reduced to decrease the rendering time at the expense of a little quality, but this is negligible. Uniformity was reduced to create more distinct puffs of cloud and the Size increased to make these puffs a lot larger. Coupled with the softened gizmo edges, this works effectively. The result, when we come to render the scene, will be of the pyroclastic cloud flowing down the side of the volcano and passing through the cloud.

4 In the Top Viewport, create a Target Direct Light to the side of the volcano and position its target at the center of the volcano. Label this light Sun and reposition it as illustrated to match the main key light position of the background plate. Enable Shadows and set the light's color to RGB 255,233,211. Enable Overshoot and set the Falloff/Field to about 1500 to encompass the volcano. Set the Shadow Map Param's Bias to 0.01 and Size to 1024.

Information: We have created, positioned and slightly tinted a Direct light to simulate the main key light (the sun) in the scene. Overshoot was used so that areas outside the Falloff/Field would be illuminated (should any be introduced). Falloff/Field was increased as shadows are confined within this boundary. The Shadow Map's Bias was reduced to limit any detachment of shadows from the objects/faces that cast them, and the Size increased to result in a nice crisp shadow.

5 Enable Grid Snap (if not already enabled) and in the Top Viewport, create a Target Direct Light to the left-hand side of the volcano and drag its target to the center of the volcano. Enable Shadows, set the Multiplier to 0.03 and color to RGB 144,167,181. Enable Overshoot and set the Falloff/Field to 1055. Turn off Specular, set the Shadow Map Bias to 0.01, Size to 64 and Sample Range to 4. Still in the Top Viewport, Instance the light so that it is the same distance from the volcano at the top side, so that it is at right angles to the original. Reproduce this so you have four lights all at right angles to one another.

Information: We have used low intensity lights due to the final amount that we will be using in the scene. If the light intensity was too high, the entire scene would be washed out. The light's color was taken by point-sampling a color from the background image right out of the materials editor and then entering the settings into the light. We do not need specular highlights from each light in our array so this option is turned off. The Shadow Map Size was reduced to keep rendering times down and the Sample Range increased to blur this map a little more. It should be noted that even though this Shadow Map Size is low, it may not be low enough, as there will be an exceptional amount of geometry in the scene once the particle system has been developed, resulting in the shadow preparation time taking longer than the render itself. Therefore you may wish to lower the size even more. Perform a test render at the end of the tutorial and judge for yourself.

6 Enable Angle Snap and set the angle snap setting to 2.5 degrees. Select all of the instanced lights and rotate clone them three times by 22.5 degrees to form a complete ring of lights. Select all of these lights (not their targets) and in the Left Viewport move them up slightly. Shift-move them to clone a new ring so the new ring is positioned above the volcano. Perform this task again to create another ring above these lights and another one beneath the volcano, pointing upwards. Remove the Brightness and Contrast render effect, open the Render Panel and go to the Renderer tab. Change the Filter to Catmull-Rom and perform a test render.

Information: A lot of lights have been introduced to create a global illumination lighting effect with multiple lights emitting multiple shadows. Because of the number of shadows in the scene coming from all directions, the collation of shadows around tight areas will ensure that these areas become slightly darker as there will be less light illuminating them. This array of lights is similar to

what a Skylight light can produce, but at a fraction of the rendering times. Perform a quick render to check rendering times – should you feel that it is taking too long, reduce the size of one of the instanced lights Shadow Map Size by half (and therefore the rest of the array's settings). Don't forget that the use of the volume fogging will also increase rendering times a little. Catmull-Rom filtering was used as it produces a nice sharp render which is suited for this type of scene.

PART TWO: Next we will set up the elements in the scene that will affect our particle system.

7 Hide all of the lights for the time being to unclutter the scene. In the Top Viewport, create a Gravity Space Warp. In the Front Viewport, create a Wind Space Warp. With this Space Warp still selected, rotate it 15 degrees anti-clockwise in the Left Viewport. Set its Strength to 0.01, Turbulence to 0.1 and Frequency to 2. In the Top Viewport again, create a UDeflector Space Warp. Set the Bounce to 0.25, Variation to 25 and Chaos to 50. In the Top Viewport, create a large Deflector Space Warp at the base of the Volcano.

Information: The Gravity Space Warp will force the particles (the cloud emitters – rocks and debris) to fall downwards while the UDeflector, which generates a slight variance in motion, prevents them from passing through the sides of the volcano as they fall. The Wind Space Warp is to add a small amount of motion turbulence to the ash cloud to break it up a little. The Deflector Space Warp is added as a simple collision detection object to keep particle counts down. As this is situated off-camera, we can set the particle system to delete any particles which collide with it, as they are no longer required (unless we start animating the camera position that is).

8 Copy (not instance) the Volcano and label it Volcano Deflector. At the bottom of its modifier stack, set the Length and Width Segs to 100. Select the UDeflector, click on the Pick Object button and select the new Volcano Deflector object. Create a Drag Space Warp and set the Time Off to 400. Set the Linear Damping for all axes to 2.

Information: Using the existing high polygon volcano would be instant death for our computer, so we are using particle deflection on a lower polygon version to help

speed up render times a little, as there will be fewer calculations to make. The Drag Space Warp is used to dampen the motion of the ejected ash cloud so these particles are emitted at a high velocity, but decelerate due to air resistance and then billow out. After our particles fall from the ash plume they hit the UDeflector which has slight bounce but no friction so the particles would be traveling too fast; their acceleration is reduced by the use of the Drag Space Warp else they would just constantly accelerate and the animation would be over too soon.

PART THREE: Next we will create our Pyroclastic flow and Debris systems using the low polygon volcano's sub-object selection as an emitter.

9 Right-click the Play Animation button and set the Animation Length to 400. In the Top Viewport, create a new Particle Flow system and label it Pyroclastic Flow. Set the Icon Type to Circle with a Diameter of 50. Set the Viewport Quantity Multiplier to 10, expand the System Management rollout and set the Upper Limit to 10000000. Reposition the particle system's icon using the Normal Align tool to place it at the top of the Volcano, as illustrated.

Information: We have set the Upper Limit so that there is no clipping on the amount of particles we can have in the scene (else particles will just stop being born once the given amount has been born). As we are using geometry as a deflector, we may get some particle leakage through the mesh, so reduce the Integration Step to check for collisions at a lower interval, therefore reducing the chance of the odd particle slipping through. Note that I have amended the color of the Volcano Deflector mesh to differentiate it from the original Volcano mesh in the scene (this step shows the original Volcano mesh hidden for illustrative purposes). We have set the Animation Length to 400 to showcase the effect as the particles will not begin to fall for a time after initial ejection. If you have a slower machine, you may not want to render off all 400 frames as this would take quite a while.

10 Rename the Event 01 event to Ash Plume. Set the Birth operator's Emit Stop to 400 and Amount to 7000. In the Speed operator, set the Variation to 200 (Speed is the default 300), check on Reverse and set the Divergence to 25. Overwrite the existing Shape operator with a Shape Instance operator and set its Scale to 30 with 25 Variation (we will add the geometry to this operator later on). Add a Force operator and add the Gravity Space Warp to the Force operator's Force Space Warps list. Set the Influence to 10%. Add a Spin operator to the event and set the Spin Rate and Variation to 25.

Information: The Force's influence has been reduced from 1000 to 10% (1000% is the same as 100% influence on a legacy particle system) so the particles are dissipated a little and give the impression that they have some mass. The low Spin Rate ensures that these particles tumble slowly as there will be numerous intersecting particles spinning; if they spin too fast the end result would look chaotic.

11 Add a Scale operator and set the Type to Relative First and the Animation Offset Keying Sync By to Particle Age. Turn off the entire particle system for the moment (to prevent particle update lags), go to frame 20 and enable Auto Key. Set the Scale Factor to 250 for all axes. Go to frame 400 and set the Scale Factor to 600 for all axes. Turn off Auto Key, go back to frame 0 and re-enable the particle system. Add a Force operator, add the Drag Space Warp to it and set the Influence to 2200. Add another Force operator and add the Wind to it.

Information: As we want our ash cloud to grow substantially as soon as it is emitted, we add a Scale operator which has its animated Scale Factor offset by the particle's age, so as soon as the particle is born it is immediately scaled up creating a billowing effect, and continues to grow until the end of the animation. The Drag Space Warp's Force operator has had its Influence increased so it affects the particles motion more; we will use its original settings later on in another operator in another event so it is handy to be able to amend the Influence and not the Space Warp itself. The Space Warps have been split into separate Force operators so we can use copies and/or instances of them later on in other events; grouping them together in one operator would result in an amended influence affecting all of them in that operator which is not what we want.

12 Add a Material Static operator to the event. Add a Speed test to the event and set the Test True If Particle Value to Is Less Than Test Value and set the Test Value and Variation to 20. Select the Scale, all three Force operators and the Material Static operator, copy and Paste Instanced them onto the canvas to create a new event. Label this event Slow Ash Plume. Wire the output of the Speed test to the input of this event. Add a Spawn test to the top of this new event, set the Offspring to 2, Inherited Speed to 25 with 50 Variation and 45 Divergence.

Information: The Speed test checks the velocity of the particles, and if they are below the given threshold passes them to the next event where they are duplicated and given differing velocities, ready to be passed on to another event which we will create next. This Slow Ash Plume event has been introduced purely to keep the same number of particles in the plume with the same characteristics (hence the instancing of the operators from the initial event), but to spawn additional particles which will be set to fall back to earth.

13 Copy the Rotation, Gravity Force, Drag Force and Material Static operators from the Ash Plume event and Paste Instanced them onto the canvas to create a new event. Label this event Flow. Make the new Force operators unique and set the Influence of the one containing the Gravity to 75 and the one containing the Drag's Influence back to 1000. Add a Scale operator and set its Scale Factor to 75 with 10 Variation for all axes. Add another Scale operator and set its Type to Relative First, the Scale Variation to 25 for all axes and the Animation Offset Keying to Event Duration. Turn off the particle system again, enable Auto Key and go to frame 400. Set the Scale Factor to 300 for all axes, turn off Auto Key and go back to frame 0. Re-enable the particle system. Add a Collision test and add the Deflector to its Deflectors list. Drag out a Delete operator to the canvas to create a new event and label it Clean Up. Wire the output of the Collision test to the input of the Clean Up event. Add another Collision test to the Flow event beneath the existing Collision test and add the UDeflector to its Deflectors list. Wire the output of the Slow Ash Plume event's Spawn test to the input of the Flow event.

Information: Here we have sent all of the particles from the Spawn test to an event which makes them fall back down to earth and interact with the UDeflector. However, we have had to set the particle scale to 75%, else the particles will inherit the scale of their parent; as we want the particles to be spawned from inside their parent and not suddenly appear, the first Scale operator resets them while the second animates them, as before (without the initial burst of scale this time). The second also has a reduction in scale due to its variation; the particles may be scaled back up and suddenly appear over their parents! The first Collision test uses the Deflector at the base of the Volcano which is off camera to pass any particles that hit it to an event which deletes them; this feature is introduced to keep geometry counts down as we no longer need to calculate these particular particles.

PART FOUR: With the particle systems designed, we now need to design the particle 'puff' and assign this to the particles.

14 Temporarily hide the two volcano meshes. In the Top Viewport, create a Geosphere with a Radius of 25 and 4 segments. Create another Geosphere with a Radius of 5 and 2 segments and label it Ash Puff. Check on Base to Pivot. With this Geosphere still selected, create a Scatter Compound Object and select the first Geosphere as the distribution object. Set the Number of Duplicates to 30. In the Transforms rollout, set the Rotation to 360 for the X setting and enable Use Maximum Range, Scaling to 75 in the X setting and check on Lock Aspect Ratio.

Information: Here we are simply creating a basic template for the shape of a single particle. Base to Pivot is used to get the scattered spheres to sit on top of the distribution sphere, and the rotation used to create different intersections on the main sphere so the surface will be smoothed out differently when we apply the Blobmesh object.

15 Create a Blobmesh object. Set the Size to 8 and the Render and Viewport Evaluation Coarseness to 12. Add the Ash Puff Scatter object to the Blob Objects list. Go to the Hierarchy tab, click on the Affect Pivot Only button then click on Center to Object. Turn off the Affect Pivot Only button. Add a UVW Map modifier to the Blobmesh and set its Mapping Co-ordinates to Shrink Wrap. In Particle View, select the Shape Instance operator, click its None button and select the Blobmesh object.

Information: We have used a Blobmesh object as it conforms roughly to the shape of our scatter object, therefore creating the (rough) shape of a puff of smoke. The detail has to be quite low due to the particle count; millions of polygons could be generated very easily which would bog down the system. However, if you feel your machine can handle large polygon counts at render time, feel free to lower the coarseness, therefore refining the mesh and making the cloud more detailed. We have re-aligned the pivot point of the Blobmesh object so that it is situated in the center of the mesh. This is essential since the particle system takes this pivot point as the particle center, which would result in wayward motion for our particles if the center was not aligned. UVW mapping has been added because we now need to add a material which utilizes mapping to our particles.

PART FIVE: Finally, we will create and assign materials to the particles to make them look more detailed.

16 Hide the Scatter, distribution and Blobmesh objects and unhide the original Volcano mesh. Open the Material Editor and label a new material Ash Cloud. Set the Shader to Translucent Shader and set the Specular color to RGB 225,216,190, the Translucent Clr to RGB 27,25,24 and enable Self-Illumination. Add a Falloff map to the Diffuse Slot, label it Ash Color Falloff and set its Front slot to RGB 233,232,223 and Side slot to RGB 203,202,196.

Information: We are using a Translucent shader because, even though there isn't much translucency in the ash cloud, it does reduce any dark patches that would be present with the high amount of bump mapping we are going to use to generate a smoke texture. The Falloff map is used to create the color tint on the perpendicular (mentioned in the Analysis section), which we will emphasize by adding a map to the Self-Illumination slot to intensify it a little.

17 Back at the top of the material, set the Self Illumination slot's setting to 30 and add a Falloff map to the slot. Label this Ash Shadow Illumination. Set the Falloff Type to Shadow/Light and set the Shaded color to RGB 60,56,54. Add a Falloff map to its Lit slot and label it Ash Rim Intensify. Set the Front color to RGB 133,125,119 and the Side color to RGB 203,202,196.

Information: These colors were derived from observing the colors in the reference material. The initial Falloff map is designed to slightly tint the shaded areas to complement the translucency, while the illuminated surfaces utilize an additional Falloff map to produce a feathered color effect, suggesting that the ash cloud is less dense around the sides as this rim effect simulates a basic diffused scattering effect.

18 Set the Bump amount to −50 and add a Smoke map to the Bump slot. Label it Ash Bump Large. Set the Source Coordinates to Explicit Map Channel, the Size to 0.2, Iterations to 3 and Exponent to 0.7. Copy this Smoke map to the Color 2 slot and label it Ash Bump Small. Set the Size to 0.002, Iterations to 20, Exponent to 1, the Color 1 slot to RGB 185,185,185 and Color 2 to white. Select one of the Material Static operators in the particle system and instance the Ash Cloud material to the slot in this operator. Right-click the root node of the particle system, select Properties and enable Image Motion Blur. Render out the animation.

Information: Here we have a combination of two Smoke maps which are of different sizes. The sizes are set so that as the instanced geometry is scaled up in the particle system, the smaller Smoke bump map will become more prominent so there will be no loss of texture detail. Adding Image Motion Blur to the particles blends them together a little and disguises any harsh edges and artifacts that may exist in the mapping, plus it suggests that the particles are moving at a high speed.

Taking it further

Even though we have got a lot of particles generating the flow effect, some individual particles will be visible as they fall from the stack. To rectify this, and this is only if you have a decent computer, increase either the amount of initial ejected particles so more particles fall from the stack, or increase the number of spawned particles and their speed divergence to fill in any gaps in the cloud. Alternatively, if your machine isn't all that great, replace the first Scale operator in the Flow event with a Shape Instance operator (with the same Scale settings as the replaced Scale operator), clone the existing Blobmesh object and reduce its detail by increasing the Evaluation Coarseness to, say, about 20 and use this in the new Shape Instance operator. Therefore, as the polygon count of the falling ash has been almost halved, you can increase the amount of spawned falling particles; adding a little variation to the way they fall will help fill in any areas. Alternatively, increase the scale of the falling particles over time to fill in the gaps.

Because of the amount of particles present in our scene, and the type of geometry used as particles to create the individual ash cloud 'puffs', render times per frame can increase the further we progress into the animation. The geometry count is the main culprit behind this which could be reduced (to a certain extent) depending on the render's canvas size; you could get away with a low detailed 'puff' with a small canvas, but with larger canvases you will have to set the geometry count higher to reduce any visible linear edges in the ash cloud. Increasing the detail in the Blobmesh objects will have an effect on the number of polygons in the scene – even by increasing the detail slightly will generate an exceptional amount of polygons (due to the particle count). To get around this, you may want to reduce the amount of particles in the scene by lowering the amount initially born, or percentage spawned, but bear in mind that this will result in less particles making up the flow which may cause gaps in the falling ash cloud.

The large amount of lights will also have an effect on render times because of the sheer number of shadows that will have to be calculated, so you may want to prevent them from casting shadows on the particles, or set the particles not to receive (or cast) shadows to remove self-shadowing.

Currently, our scene simulates a Pyroclastic flow that has occurred due to the top of the volcano collapsing and resulting plume falling. As mentioned in the Analysis section, another cause of this would be because of the huge erupted ash stack collapsing and falling down the side of the volcano. Try simulating this by using a combination of the particle system we have just created and the eruption ash cloud system in the Eruption tutorial in this book. As both scenes are of the same scale (due to the source scenes for both tutorial being the result of the Volcano tutorial) and use relatively similar setups for both particle systems, you shouldn't have much trouble getting the erupted stack to collapse. You can pass particles from multiple systems to the same events, so try having two types of Pyroclastic flow. It might sound a little like overkill, but the resulting scene of a collapsing ash stack and collapsing volcano creating huge plumes of ash and smoke is bound to be exceptionally impressive. Watch out for particle (and therefore polygon) counts though as they are bound to be killers, especially with the amount of lights in the scene.

Try changing the material of the volcano to give the impression that all of the snow has melted and formed a Lahar (mudslide). Also, add extra steam, cloud and venting ash from pockets down the sides of the Volcano and create falling debris which also kicks up ash plumes as they travel. Depending on the position in the cloud, some trailing parts may be wispier than others, so consider incorporating a little transparency around these areas. Be warned though that due to the amount of particles flying around, this will crank up the render times as the renderer will have to work out a ton of opacities on a ton of geometry. One way around this is to convert the scene to use the Mental Ray renderer as it works nicer with multiple transparencies, or simply use a clone of the system with low opacity facing particles to create a dust effect around each ash particle.

You may also want to convert the crater collapse plume into an eruption, in which case reduce or remove the Drag Space Warp's influence on the emitter particles so that they continue traveling upwards. In which case you will need to reduce their velocities a little, otherwise the emitter particles will move too fast and look unrealistic as the Space Warp is not slowing them down as much/any more.

The initial ejected material is of a dark hue, however, after a time this material splits into two components – a rising vertical eruption column and the falling pyroclastic flow, each of which has a different material. The heavier material that falls back down to earth has a visibly different color – a slightly more brown hue to suggest dirt and debris – while the rest of the plume changes into a lighter material of ash, smoke and steam (etc.) and continues to rise. Therefore try assigning different materials to the particle system, so we have one main material for the initial ejection which turns into the lighter ash and steam material using a Particle Age map and a Material Dynamic operator. The heavier pyroclastic flow material would also be controlled by a Particle Age map and would change color from the darker material to a slightly lighter and browner material as the particle falls.

If you have a later version of 3ds Max, it might be worthwhile using Render to Texture to bake out a normal map of the high polygon cloud puff and apply that to a lower res puff to seriously reduce rendering times!

Appendices

- The next step and further reading

- Plug-in solutions

The next step and further reading

I would recommend that even when you are out on a normal day you take a camera with you so you can take a picture of that amazing sunset or pollution haze, depending on where you live. As before, take as much reference material as possible should you wish to recreate it in 3D so you have a better understanding of the effect when you get the images back to the studio. Also, take a pencil and paper out so you can make notes about the effect while you are viewing it. Alternatively, if you have a small digital video camera you could just give a quick running dialogue of the effect about what is happening. You may look like an idiot but if it helps you recreate that effect better later on, 5 minutes of strange looks are worth it!

Above all, have fun. 3D is simply another medium that the artist can work with and, like working with brush, paint and canvas, it takes time to hone your skills. Persevere and you will succeed. Hopefully by the time you get to this part you will have a firm grasp on what to look for and how to break down and analyze your own reference material and that when you are out on your travels you will start to view the world through a different set of eyes.

There are numerous 3ds Max books out there; some great, some not so great (I hope you class this one in the former category!), but, to my knowledge, there aren't any which solely covers the natural elements. Therefore, my main suggestion would be not to go out and spend a fortune on books, but to go out and observe the natural world in all its beauty. Yes we have some reference material on the DVD-ROM, but there is only so much I can shoot in the allocated time I have had to produce this book. Take a camera or video camera if you have one and shoot as much reference material of an effect that you can. If you have the opportunity, shoot it in different lighting conditions, different times of the day, different exposures and so on. By analyzing all of these scenarios you will start to understand what generates the effect, how it behaves and how we can recreate it.

For further reading I would therefore suggest that you get your hands dirty and read up on the science behind creating these natural effects. Granted, some of it may be right over your head (a lot of it is way over mine) but nevertheless it does make for interesting reading. I would also suggest that you look at a lot of landscape photography books, simply to expand your horizons and to view places you have never visited; Yann Arthus-Bertrand's *The Earth from the Air*, for example, is an exceptional work and is very highly recommended.

Computational Fluid Dynamics – John D. Anderson
Elementary Fluid Dynamics – D.J. Acheson
Turbulent Flows – Stephen B. Pope
Geophysical Fluid Dynamics – Joseph Pedlosky
A First Course in Fluid Dynamics – A.R. Paterson
An Introduction to Fire Dynamics – Douglas Drysdale
A Professional's Guide to Pyrotechnics: Understanding and Making Exploding Fireworks – John Donner
Principles of Fire Behavior – James G. Quintiere

Blaze: The Forensics of Fire – Nicholas Faith

Introduction to Mathematical Fire Modelling – Marc Janssens

Volcano (Eyewitness Guide) – Susanna Van Rose

The Earth from the Air – Yann Arthus-Bertrand

Understanding Flying Weather – Derek Piggott

Atmosphere, Weather and Climate – Rodger Barry

Introductory Oceanography – Harold V. Thurman and Elizabeth A. Burton

Fundamentals of Physics and Chemistry of the Atmosphere – Guido Visconti

A Short Course in Cloud Physics – R.R. Rogers and M.K. Yau

The Blue Planet – Andrew Byatt, Alastair Fothergill, Martha Holmes and Sir David Attenborough

Cloud Dynamics – Robert A. Houze

The Colour Encyclopedia of Ornamental Grasses: Sedges, Rushes, Restios, Cat-tails and Selected Bamboos – Rick Darke

Grasses, Ferns, Mosses and Lichens of Great Britain and Ireland – Roger Phillips and Sheila Grant

Grasses (New Plant Library) – Jo Chatterton and Trevor Scott

Form and Foliage Guide to Trees and Shrubs – Susin Chow

The Watercolourist's A–Z of Trees and Foliage: An Illustrated Directory of Trees from a Watercolourist's Perspective – Adelene Fletcher

World's Top Photographers: Landscape – Terry Hope

First Light: A Landscape Photographer's Art – Joe Cornish

Large Format Nature Photography – Jack Dykinga

Plug-in solutions

Even though this book is designed to get you to use your knowledge gained in the Analysis sections in areas of 3ds Max in a way in which you may have not done so before so that we did not have to use a plug-in, there will come a time where you will have to either get your hands dirty and either code a script or plug-in yourself to do the job, or purchase one of the excellent off-the-shelf plug-ins. Here I have mentioned but a few of the plug-ins and third party solutions that are out there; bear in mind that due to the production time of this book some additional plug-ins may be released and/or some withdrawn between the time I wrote this (Xmas 2005) to the time you are reading it. I have also only mentioned products that are currently available to be licensed and not in-house developments as these are often kept close to the studio's chest! There are also several freeware and open source projects out there which give excellent terrain generation and mesh output for importing into 3ds Max.

Afterburn – www.afterworks.com
This plug-in needs no introduction and is one that I would turn to at a moment's notice due to the sheer range of effects that can be created with it. I could waffle on and on about its features, but there is no point as you have more than likely seen it used in several feature films ranging from *Armageddon* to the *Matrix* series. Hats off to Kresimir for continuously developing this product while the competition has faded away.

Phoenix – www.chaosgroup.com
While Afterburn is more suited to creating volumetric cloud, smoke and explosion effects, Phoenix deals with the other fire effects such as wood or gaseous based fires.

Aura – www.chaosgroup.com
The next generation system from Chaos Group, producing fluidic voxel effects for complex fire and realistic smoke.

Flowline – www.flowlines.info
Originally designed as an in-house tool by German VFX house Scanline, Flowline has recently been tried and tested in production with excellent results for fire, water and other fluid-based effects.

Real Flow/Real Wave – www.nextlimit.com
As 3ds Max currently has no native fluid dynamics system, Real Flow is an alternative giving us the ability to import scene data from 3ds Max and apply almost any fluid-based system ranging from pouring liquids to floods and with the inclusion of Realwave we can simulate large bodies of water and have breaking waves, splashes and the like with relative simplicity.

Glu3D – www.3daliens.com
Another fluid based system, however this time directly within the 3ds Max Viewport and integrated within Particle Flow making it an ideal solution for 3ds Max pipelines and for those who don't want to have to keep exporting mesh data to external programs.

Dreamscape – www.afterworks.com
Another plug-in from the developers of Afterburn, you can expect the same kind of exceptional quality. The sea shaders are exceptional and can simulate deep oceans, foamy peaks, large bodies of water

and sub-surface effects quickly and easily. You can even throw objects onto the surface and have them interact with it, or even propel them across the surface, creating wakes as they move. Not only does Dreamscape produce water effects, it also has a very nice terrain designer and new materials which allow us to create a variety of terrain effects. Perfect for creating mountainous terrain. The beauty of this is that we can also render off the terrain as a voxel, which means there is virtually no geometry so it renders an exceptionally high quality terrain in a fraction of the time it would take to render off the mesh equivalent. We can also design a wide range of cloud effects and use Afterburn technology to produce 3D volumetric clouds which converts the normal 2D cloud layer and converts it into a 3D volumetric; perfect for backlit sunset effects.

Index

Also available from Focal Press and Autodesk

Autodesk Combustion 4 Fundamentals Courseware

Provides:

A companion DVD that includes Combustion workspace files and project footage to make learning easy

- Heavily illustrated tutorials
- Detailed explanation of the principles behind the tools
- Expert advice—written by Autodesk Courseware Developers, Product Education Technical Writers, and Autodesk Training Specialists who know the product inside and out!

Whether this is your first experience with Combustion software or you're upgrading to take advantage of the many new features and tools, this guide will serve as your ultimate resource to this all-in-one professional compositing application. Much more than a point-and-click manual, this guide explains the principles behind the software, serving as an overview of the package and associated techniques.

Written by certified Autodesk training specialists for motion graphic designers, animators, and visual effects artists, Combustion 4 Fundamentals Courseware provides expert advice for all skill levels.

July 2005: 189 X 246 mm: 520 pages: Paperback:
0-240-80785-5

To order your copy call +44 (0)1865 474010 (UK) or +1 800 545 2522 (USA) or visit the Focal Press website: **www.focalpress.com**